JOHN HEDGECOE the new manual of PHOTOGRAPHY

JOHN HEDGECOE the new manual of PHOTOGRAPHY

LONDON, NEW YORK, MUNICH, MELBOURNE, DELHI

Project editor Tracie Lee Davis

Senior art editors
Phil Gilderdale, Alison Shackleton

Design assistant Jenisa Patel

> Managing editor Adèle Hayward

Managing art editor Karen Self

Category publisher Stephanie Jackson

DTP designers<u>Gemma Casajuana Filella, Rajen Shah</u>

Production controller Mandy Inness

> Associate writer Chris George

Assistant to John Hedgecoe Jenny Hogg

2008 EDITION

Produced for Dorling Kindersley by Sands Publishing Solutions 4 Jenner Way, Eccles, Aylesford, Kent ME20 7SQ

Project editor David Tombesi-Walton

Art editor Simon Murrell

This edition published in 2008

First published in Great Britain in 2003 by Dorling Kindersley Limited 80 Strand, London WC2R ORL

A Penguin Company

2 4 6 8 10 9 7 5 3

Copyright © 2003, 2008 Dorling Kindersley Limited, London

Text copyright © 2003, 2008 Dorling Kindersley Limited and John Hedgecoe

Photographs copyright © 2003, 2008 John Hedgecoe

All rights reserved. No part of this publication may be reproduced, stored in a retrieval system, or transmitted in any form or by any means, electronic, mechanical, photocopying, recording, or otherwise, without the prior written permission of the copyright owners.

A CIP catalogue record for this book is available from The British Library

ISBN 978 1 4053 3476 1

Colour reproduced by Colourscan, Singapore Printed and bound in China by Hung Hing

See our complete catalogue at www.dk.com

Contents

8 Introduction

The camera

- 12 What is a camera?
- 14 Choosing a camera

The elements of photography

- 38 Lenses
- 68 Focusing
- 76 Exposure
- 86 Depth of field
- 92 Shutter speeds
- 110 Film
- 132 Lighting

The art of good photography

- 176 Composition
- 230 Colour

Special projects

- 254 Still life
- 258 Portraits and people
- 284 Architecture
- 296 The natural world
- 312 Animals
- 318 Sport

Advanced photography

- 336 The studio
- 344 Specialist techniques

Post production

- 356 The darkroom
- 368 Digital imaging
- 394 Appendices
- 398 Glossary
- 410 Index
- 416 Acknowledgments

Introduction

Photography is probably the most accessible and rewarding of all forms of art. It can record faces or facts or just tell stories. It can shock, entertain, and educate. It can capture, and elicit, emotions, and it can record details with accuracy and speed.

Although the basic principle of photography has not changed, continual developments in camera design mean that it has never been easier to take a successful picture. Technology, however, is only a tool. However clever the camera becomes, it is the photographer using it, and the choice of subject, that decides how the shot is framed, and when the shutter is fired. This creative process can turn the mediocre snapshot into a breathtaking picture. Most of the pictures in this book were taken with uncomplicated, medium-priced, digital and 35mm single lens reflex cameras, although many of the studio shots were taken with medium-format cameras (with film or digital backs).

To be a good photographer you need to see the world in a more comprehensive way than other people. Recording the three-dimensional moving world as a flat, static image is like translating a story from one language to another. It needs the realization that the world is alive, vital, and energetic, open to new ideas and artistic interpretation. No two photographers will approach the task in quite the same way, even if they use the same conventions and rules.

This book sets out to be a comprehensive manual to the creative and technical skills that are needed to take pictures of practically any subject. It assumes no prior knowledge, but aims to provide a reference for all the key techniques that are ever likely to be used, even by a serious photographer. Unlike many other modern books on photography, *The New Manual of Photography* has in-depth sections on the equipment and

technology. Although using a particular type of camera or lens cannot guarantee better pictures, the equipment that you use puts limitations on the way you can tackle a subject. Understanding the strengths and weaknesses of different cameras, lenses, and accessories will allow you to take better pictures, and have fewer failures. This is particularly true with newer technologies, such as the latest high-speed autofocus particularly favoured by sports photographers. These facilities need a new approach to picture taking if you are going to capitalize on the benefits.

Photography is always evolving. New styles and approaches are discovered, or come back into fashion. Advances in science and computer technology, meanwhile, bring new techniques and ideas. The biggest revolution in photography in my lifetime has been in digital imaging. Not only has this brought a new breed of camera, but it also allows images to be instantly seen and displayed, stored and manipulated in a wide variety of ways. This book provides a guide to how technologies new and old can be used to improve your pictures.

Equipment and techniques, however, are just the beginning. It is the photographer that matters most of all. Familiarizing yourself with your camera controls, with depth of field, with the effects of lighting on form, are steps that the photographer must try to master (although there is always more to learn). It is only through familiarity with the basics, however, that you can achieve successful shots. The huge number of photographs and ideas in this book will be a constant inspiration as your skills improve, and as you find your own strengths and favourite styles.

John Hedgewe

The camera

Understanding how a camera works is the key to making the most of its functions and creating photographs that surpass your expectations.

It also informs your choice of camera: digital, compact, SLR, or more specialized.

What is a camera?

In comparison with much of the equipment that is used in the modern world, the camera is probably among the simplest. Even the most sophisticated digital cameras still have have traditional mechanical and optical components, and for most pictures the photographic enthusiast has only to worry about just two or three simple

controls. However, despite this apparent simplicity, there are hundreds of different types of cameras available today, in a wide variety of designs. They offer a huge range of levels of sophistication and dozens of different features – but the cost can also vary from that of a pocket calculator to that of a brand-new car.

Parts of a camera

Cameras have a number of different features in common, whether they are conventional cameras that use film or digital cameras that use a chip. The first feature that lies in the light's path from subject to camera is the lens. This transforms the crude results acquired from a pinhole (*see below*) into an image that is sharp and well defined right across the focal plane, or the flat surface where the film or digital capture device is placed. This lens is, in fact, made up of several different lenses arranged into groups.

As light follows a straight path through the lens to the light-sensitive chip or film, a separate viewfinder is usually necessary so you can see what will be recorded. This may be no more than a basic window, or it may be a miniature television screen showing exactly what is being framed.

The two essential photographic controls offered by every camera are the aperture and the shutter. The aperture is the pinhole through which the light enters; on most cameras the size of this diaphragm is variable, so that the amount of light, and therefore exposure, can be controlled. The other exposure control is the shutter – a gate that can be controlled so that it can be opened for a precise amount of time, again affecting how much light reaches the focal plane.

How a camera works

This diagram shows you the main features of a typical camera and explains what each feature does. Most of these facilities are standard, whatever the cost of the camera – and whether it uses a digital image-recording system or conventional photographic film.

THE PINHOLE CAMERA

The simplest camera is just a box with a small, round, pinhole on one side. This technique of image projection had been used by artists and draughtsmen for centuries to trace pictures of what they saw in front of them, but it was not until the invention of film that this "camera obscura" became capable of producing its own permanent image. A pinhole camera can be made using a box or biscuit tin with a small hole in it, and a sheet of black-and-white photographic paper (as used in the darkroom) to record the image. The shutter speed is controlled by opening and closing the pinhole, usually by raising and lowering a flap. Exposures typically last minutes. The film is loaded, unloaded, and processed in darkness or under a darkroom safelight.

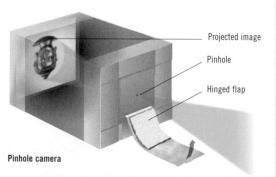

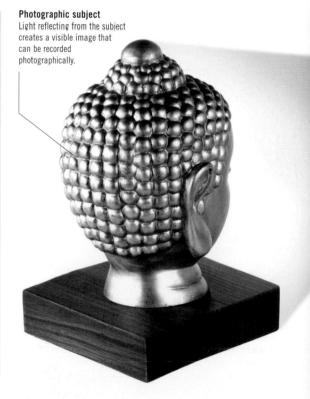

CONTROLLING EXPOSURE

One of the most important features of a camera is its control over how much light reaches the digital sensor or film. The camera regulates the light entering the aperture, the shutter speed, or both. This exposure process is like filling a glass with water. The glass is the digital sensor (or film) and the water is the light. To fill the glass (expose the film), the tap is turned on partially or fully (the aperture) — the amount affects how long the tap needs to run before the glass is full (the shutter speed). Exposure is explained in detail on pp.76–7.

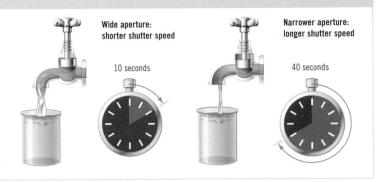

Lens

This gathers light reflecting from the subject, converging each ray so that it forms a point on the focal plane. The image is inverted during the process.

Aperture

Like the iris of the eye, the size of the aperture can usually be varied to alter how much light reaches the film/chip.
The aperture is fixed on basic cameras

Shutter

This controls the amount of time the film or chip is exposed to the light. Usually it opens for a fraction of a second, but exposures can last hours.

Focal plane

This is the flat surface where the image is either recorded on film or is turned into an electrical signal by a digital chip.

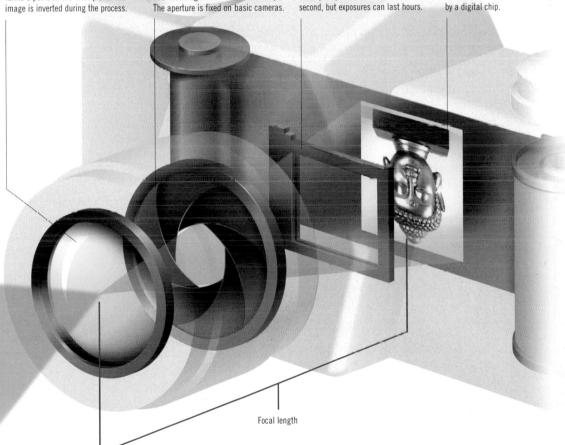

Understanding focal length

The "focal length" is a measure of the magnification and the angle of view of a lens. The longer the focal length, the narrower the view, with the lens recording a smaller section of the scene in front of it. This produces a bigger image of a subject than if a shorter lens is used. The focal length for a simple lens is practically the same as its actual length; many lenses, however, are "zooms", where the focal length can be varied.

Image taken with a short focal-length lens

Image taken with a long focal-length lens

Choosing a camera

There are so many different types of camera on the market that it can be difficult to choose a new one. Do you choose one that slips easily into your pocket for snapshots, or should you opt for a bulkier model that can use interchangeable lenses? Do you stick to digital, or do you go traditional and choose film? Every camera has advantages and disadvantages, and these will vary depending on the type of pictures you want to take, and the quality of results you expect.

Deciding your priorities

In essence, there are four main factors to consider when choosing a camera: resolution, convenience, creative control, and cost. You need to decide what you want to achieve with your pictures, and the subjects you want to tackle, then choose which of these factors are priorities.

Resolution

The ability to reproduce an image in fine detail is called resolution. For enlargements or intricate work, choose the highest resolution available. For pictures for use on web pages or for miniature prints, resolution is less important.

On digital cameras, the resolution of shots is primarily determined by the number of picture elements (or pixels) used by the imaging sensor. A very low-resolution camera may offer just one million pixels, which is suitable for onscreen shots. Cameras with more than 10 million pixels are commonplace, while professional digital systems effectively offer many times this. The processing power of the camera has a powerful influence on how efficiently this resolution is used. When using film cameras, more resolution is gained by choosing cameras that use a larger area of film for each shot. The most popular film format is 35mm, with a film area that measures 24×36 mm $(1 \times 1\frac{1}{2}$ in), but cameras are available that use a film area that measures 25×20 cm $(10 \times 8$ in).

Convenience

Do not choose a camera that will be too complicated for you to use – your chosen camera must be user-friendly if

TYPES OF DIGITAL CAMERA

Basic compact camera

Types: Digital or film (35mm)

Resolution: Low to medium

Convenience: High

Creative control: Very low to low

Cost: Very low

The appeal of the simplest cameras is their cost and convenience. Some models come pre-loaded with film and are thrown away after processing. Typically, the shutter speed and aperture are fixed, and there is no zoom feature. Digital models are often sold as "web cams" — cameras to use for web page pictures — or are built into mobile phones.

Zoom compact camera

Types: Digital or film (35mm)

Resolution: Medium

Convenience: High

Creative control: Low to medium

Cost: Low to medium

Zoom compacts offer much better creative control than basic compacts. The focal length of the lens can be changed to suit the size and distance of the subject. Shutter speed and aperture are variable too, although the user often has no direct control over these. Digital models tend to offer more creative options than their film counterparts.

Luxury compact camera

Types: Digital or film (35mm)

Resolution: Medium

Convenience: High

Creative control: Low to medium

Cost: Medium to high

This type of camera is generally designed either as a pocket camera for those who usually use SLR cameras, or as a stylish gadget. It may have a higher-quality lens than other compacts, but may not have a zoom lens. It may well, however, offer direct control over aperture, shutter speed, and focusing. Design and looks are of crucial importance.

you are going to make good use of it and get the shots you require. A small camera may be easy to carry around, but the buttons may be fiddly to use. Bigger cameras may simply be too unwieldy for some subjects.

Creative control

The single most important factor determining whether a picture is good, bad, or merely average is the amount of creative control that the photographer has been able to exercise over it. With most cameras you can point and shoot, and the camera will do the rest. However, to improve results you need, at least occasionally, to make your own decisions about the zoom setting, and which parts of the scene should appear sharp or blurred. Ideally, you need to be able to see what you are shooting as accurately as possible, and know what you are focused on.

Cost

You tend to get what you pay for when buying a camera. If you want more resolution, you will have to buy a more expensive camera, while the cheapest cameras are those with the least creative control. There are exceptions. Some point-and-shoot cameras cost as much as a basic digital SLR but offer only a fraction of the creative control. Similarly, a basic large-format camera offers considerably more raw resolution than a more expensive top-of-the-range digital SLR. Secondhand models offer you the chance to get a better camera than you might otherwise be able to afford.

FILM OR DIGITAL CAMERA?

Few people nowadays choose film cameras over digital ones. The convenience and low running costs are persuasive arguments for the digital route. Furthermore, digital imaging allows you to share, correct, and customize your pictures far more easily. But film still has its fans, and the cheaper cost of film cameras, particularly secondhand, affords you more resolution and creative control than going digital.

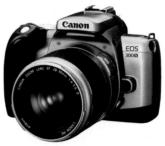

35mm film SLR Film cameras provide a low-cost route to highquality professional equipment, particularly when bought secondhand. Some people also favour their simpler, less electronic, construction.

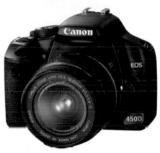

Digital SLR

A digital SLR is the most popular type of camera that allows serious, creative photography. The instant feedback provided by the screen arguably makes it easier to learn from your mistakes than with a film SLR.

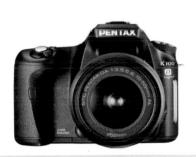

Basic SLR

Types: Digital or film (35mm)

Resolution: Medium

Convenience: Medium

Creative control: Medium to high

Cost: Low to high

Single lens reflex (SLR) cameras typically have interchangeable lenses, allowing you to change focal length. There is almost always complete control over shutter speed and aperture, and the viewfinder design allows you to see exactly what you are shooting. Basic film models may not offer autofocus or motorized film winding so can be less expensive than more popular digital ones.

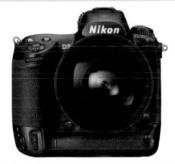

Professional SLR

Types: Digital or film (35mm)

Resolution: Medium to high

Convenience: Medium

Creative control: High

Cost: High

A professional SLR offers all the creative advantages of the basic SLR, but adds many options and features to cover the different needs of working photographers. True professional SLRs can be very expensive (especially high-resolution digital types) due to their robust construction; mid-range SLRs may offer as many features for less money.

Medium-format camera

Types: Digital or film (roll film) or optional back

Resolution: High

Convenience: Low

Creative control: High

Cost: High

The key advantage of the medium-format camera is the size of the image produced, as it allows detailed enlargements that are not possible with smaller camera types. Many different sorts are available, but labour-saving facilities cannot be taken for granted, and they are large and heavy. Some film models can be converted to record images digitally.

Lens coverage

All cameras are capable of shooting most subjects, but some subjects can realistically be shot only by particular types of camera – and with particular accessories. Most significantly, the range of lens options offered by the camera can be critical. While a simple built-in zoom lens

might cope adequately with most family snapshot subjects, it may not cope with photographing ball games, wild birds, butterflies, and many more subjects. Working out which subjects you want to shoot, or may want to shoot in the future, is critical to making the correct camera choice.

Selecting a lens

Many cameras come with built-in zoom lenses – but the range of focal lengths that these offer vary significantly from model to model. The greater the range of focal lengths a camera has, the more subjects that it will be able to tackle easily. For the greatest range of focal lengths, choose a camera that offers interchangeable lenses, which means that the camera can be upgraded to be able to cope with any new subjects you might want to photograph in the future.

Sports and wildlife

Most sports photographers would consider a 400mm lens to be a basic tool of the trade. But this focal length is not available on zoom compacts or medium-format cameras, making the digital SLR, digital hybrid camera, or 35mm SLR the most obvious choices. When shooting some sports, such as major league baseball, surfing, or horse racing, an even longer focal length may be needed – although for other sports, such as skateboarding, a shorter lens can be used.

Shooting wildlife also often demands focal lengths of 300mm or above. This applies particularly if you are shooting timid creatures, such as birds, or dangerous mammals.

Landscapes and architecture

For some subject matter, the wide-angle lenses available with a camera system are important. Many compact cameras offer a 35mm lens as the widest zoom setting, and this may be inadequate when shooting interiors or large buildings from close range, or when trying to capture a panorama in a single frame.

CROP FACTORS

Comparing focal lengths on digital cameras can cause confusion, because the magnification and angle of view that a particular focal length actually provides depend on the size of the sensor used. Interchangeable lenses are often designed to work with digital SLRs with differing-sized sensors, as well as with 35mm film SLRs. The smaller the lens, the smaller the proportion of the scene that is seen by the lens that is actually captured, leading to a cropped view that narrows the effective angle of view of the lens. Popular digital SLRs provide a "crop factor" of around 1.5x, where the actual focal length of the lens needs to be multiplied by 1.5 so that the visual effect can be compared to that of a 35mm film SLR. This crop factor varies from 1.3x to 2x depending on the model. Some pro models have "full frame" sensors that are the same size as a 35mm film frame, so no crop factor is needed.

 Lens projects circular, upside-down image

The sensor is often smaller than 35mm film, so the angle of view is smaller

MATCHING THE SUBJECT TO THE FOCAL LENGTH

This table shows typical uses for different focal lengths of lenses and indicates the approximate lens range available for particular camera types; some models, however, will provide a more restrictive range. The

focal lengths are given as equivalents for the 35mm film format, as the actual focal length will depend on the actual image area of the particular camera being used (*see pp.38*–9).

FOCAL LENGTH (35mm-FORMAT Equivalent)	KEY USES	35mm Zoom Compact	DIGITAL Zoom Compact	HYBRID Digital Camera	35mm SLR	BASIC Digital SLR	PRO Digital SLR	MEDIUM- FORMAT CAMERA
20mm	Architecture, landscapes, interiors	No	No	No	Yes	Yes	Yes	Yes
28mm	Architecture, landscapes, interiors	Yes	Yes	Yes	Yes	Yes	Yes	Yes
35mm	Group portraits, general views	Yes	Yes	Yes	Yes	Yes	Yes	Yes
100mm	Head-and-shoulder portraits, landscape details	Yes	Yes	Yes	Yes	Yes	Yes	Yes
200mm	Candid portraits, architectural details	Yes	Yes	Yes	Yes	Yes	Yes	Yes
300mm	Wildlife, sport	No	Yes	Yes	Yes	Yes	Yes	No
400mm	Wildlife, sport	No	No	Yes	Yes	Yes	Yes	No
600mm	Wildlife, sport	No	No	No	Yes	Yes	Yes	No

▲ Interior photography

By using a 20mm lens, nearly all the room is in shot. Interior photography requires the use of creative camera angles, as few lenses offer a wide enough setting to fit a whole room in a single frame.

20mm lens, 1/15 sec at f/11 with tripod. ISO 100.

■ Wildlife photography

How long a lens you need to photograph animals and birds will depend on the subject's size and how close you can get to it. For creatures in a zoo, or for tame animals, a 200mm focal setting is a reasonable option.

■ 200mm lens, 1/250 sec at f/4. ISO 100.

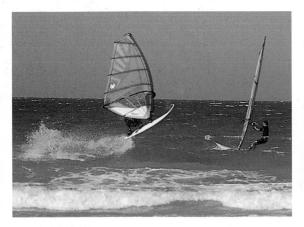

▲ Distant subjects

Some subjects demand the use of a truly powerful lens. For this windsurfing scene, the sea prevented a closer shot, so a 600mm lens was essential to capture the desired detail.

■ 600mm lens, 1/1000 sec at f/8 with tripod. ISO 200.

▲ Portraiture

The ideal focal length for pictures of people is a short telephoto lens. This focal length is found on many, but not all, zoom compacts; about 100mm is ideal for a 35mm-film camera.

■ 100mm lens, 1/60 sec at f/11 with flash. ISO 50.

▲ Sports photography

A good vantage point is essential for close-ups of sport, but a long telephoto lens is also necessary for most events. The lens coverage of an SLR camera is required for successful sports photography.

■ 300mm lens, 1/2000 sec at f/5.6. ISO 100.

▲ Close-ups

When shooting miniature subjects, or close-up details, the minimum focusing distance of the lens is as important as its focal length. Macro lenses and accessories are designed for this type of work.

 $_{\mbox{\scriptsize MI}}$ 100mm macro lens, 1/125 sec at f/16 with flash. ISO 100.

See also How digital cameras work p.26 The digital SLR system p.30 What is a lens? p.38

Single lens reflex cameras

The single lens reflex (or SLR) camera is the most versatile camera on the market. Digital models and those using 35mm film, in particular, provide an enormous degree of creative control without being either overly large or overly expensive. The SLR's characteristics make it by far the most popular type of camera used by serious photographers, whether beginner, enthusiast, or professional.

The key to the SLR's versatility is that it is a system that can be built upon and altered to suit different subject matters. Most SLRs offer interchangeable lenses, allowing you to change the angle of view and magnification of what you see in front of you.

The SLR derives its name from its viewing system. Although the viewfinder is not in a direct line with the lens, a mirror and a prism are used to let you view the image through the lens (and so it is the right way around and the right way up). The mirror, which is angled at 45 degrees, flips up out of the way when the picture is taken, allowing light to reach the digital sensor or film (*see below*). The advantage of this system is that you can compose the shot accurately whatever lens you use, but the disadvantage is that you lose sight of the subject in the viewfinder as the shot is taken.

The simplest SLRs use 35mm film and offer fewer labour-saving and electronic functions than digital models. However, all SLRs provide a variety of ways of manipulating both shutter speed and aperture, allowing a huge degree of creative control over the image.

THE LIGHT PATH THROUGH AN SLR CAMERA

The SLR camera's unique viewing system allows the user to see through the lens, but corrects the image that the photographer sees so that it is the right way up and correctly oriented left to right. This allows the photographer to compose a shot accurately. When the image is photographed, it is recorded upside down.

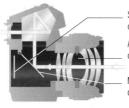

Shutters closed Aperture

Aperture open

Mirror in down position ■ When you are composing the shot, the shutters are closed, the mirror is down, and the aperture fully open, so that the image is as bright as possible.

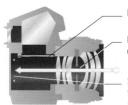

Mirror raised

Diaphragm closes down

Shutters open to expose sensor or film As you press the shutter button, the diaphragm closes to the aperture chosen for the shot, and the mirror rises, causing the viewfinder to go blank. The first shutter curtain opens, so that the sensor or film is exposed to the light.

Mirror dropped down Aperture open

Shutters closed

■ The second shutter closes off the sensor or film, the mirror drops back, and the aperture again opens fully, so the next shot can be viewed clearly through the viewfinder. The shutters are reset.

▼ The basic SLR

The illustration below shows the main features of a typical low-cost, manual-focus, 35mm-format SLR. Most of the facilities shown are shared by all SLRs, whether they are digital or film, and whatever the format.

Shutter release

As well as being used for taking a shot, this button activates the meter and the viewfinder display when pressed lightly.

Information screen

Gives the frame number, exposure mode, shutter/ aperture setting, and other indicators.

Shutter control dial

Manually sets exposure times from 1/2000 second to two seconds.

Focusing screen

Used when adjusting the lens, as it lets the photographer see when the image is focused correctly.

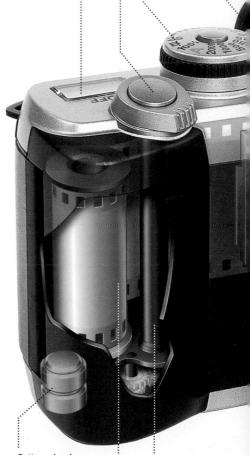

Battery chamber Power for motors and

electronics comes from battery cells.

Recording medium

35mm SLRs use non-reusable rolls of light-sensitive film, typically allowing 24 or 36 exposures per roll. Digital SLRs use a single sensor, which is used to create every exposure.

Film transport

On 35mm SLRs, the film is wound on after each exposure by a built-in motor, and is respooled when the film is finished. On some cameras, the film must be advanced manually.

▼ Through the viewfinder

The exposure details are usually indicated at the side or below the viewfinder on a miniature LCD display. The central area is used for fine focusing.

▼ The viewfinder and film chamber

At the back of a 35mm SLR is the viewfinder, through which the shot is composed, and a light-tight chamber where the film is housed. The film is wound from one spool to another as each frame is taken. Light reaches the film only when the focal-plane shutter is fired; this consists of two curtains, the first opens the light path from the lens, while the second closes it.

Viewfinder

Gives a view through the lens and provides an LCD readout of exposure details.

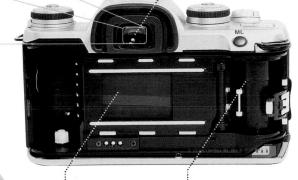

Focal-plane shutter

Found immediately in front of the film, it consists of a pair of cloth or metallic blinds — one opens to expose the film, the other follows to shut out the light. Both are then reset for the next exposure.

Film transport mechanism

Film is loaded into the cassette chamber, where it is taken up by the film spool, moved across the shutter, and wound on to the film take-up spool.

..... Exposure compensation dial

Used to adjust exposure when overriding the auto exposure system. Used when deliberately under- or overexposing, or in difficult lighting conditions that may fool the camera's light meter.

Aperture control ring

Allows manual adjustment of the diameter of the lens aperture.

Manual focusing ring

Rotated until the main subject appears sharp in the viewfinder.

Zoom ring

Rotated manually to give the angle of view desired.

Mirror Reflects the image formed on the focusing screen, so

focusing screen, so that it can be seen in the viewfinder.

Pentaprism

A five-sided block of glass that reverses and flips the image on the mirror, so that it appears correctly in the viewfinder.

Diaphragm

Opens and closes to determine the size of the aperture, which dictates the brightness of the image reaching the film plane.

Internal lens elements

The lens is, in fact, a series of different lens elements set in groups that can be moved back and forth to focus or zoom the lens.

.... Light path

The yellow line indicates the route taken by the light from the subject through the lens.

Medium-format cameras

Medium-format cameras offer a much larger image area than most digital and 35mm film cameras, and give higher-definition results. Traditionally they use roll film, which is wound from one spool to another after each exposure, and is protected from the light during loading and unloading by a thick opaque paper backing. But many medium-format models now record digitally – and some can switch between film and digital backs, giving the best of both worlds.

The term "medium format" represents a range of cameras producing a number of different image formats. The film commonly used by these cameras is known as 120 film ($see\ pp.116-17$), which measures 6cm (2%in) across. Depending on the dimension of the image produced by the model of camera – common ones are 6 x 4.5cm, 6 x 6cm, and 6 x 7cm – a roll of 120 film would typically provide 15, 12, or 10 exposures. Cameras using wider, panoramic, aspect ratios can also be bought – providing even fewer exposures per roll. Some models can use 220 film – a double-length roll of 120 film.

Medium-format cameras come in many different shapes, though all are large. Most are system cameras, but the range of accessories, including lenses, is often restricted. Interchangeable backs, and viewfinders, are common, however – allowing them to be used in ways not possible with smaller digital SLRs.

TYPES OF MEDIUM-FORMAT CAMERA

While many medium-format cameras are system cameras that are primarily designed for studio use, there are many other types. These might offer fewer interchangeable parts, be designed for particular types of photography, or be ideally suited to location use. These are some of the different types of roll-film camera available:

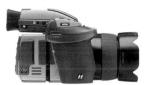

Hasselblad medium-format digital camera
Many medium-format cameras appear rudimentary,
offering few of the electronic features we take for
granted. However, there are exceptions, such as
this all-digital Hasselblad, with features such as
autofocus, built-in flash, and advanced metering.

Panoramic medium-format camera

Some medium-format cameras are primarily designed for landscape photographers. The Fuji panoramic camera (*right*) produces extremely wide panoramic images — with negatives or slides that measure approximately 60 x 170mm.

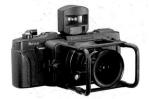

Monorail medium-format camera

This unique medium-format camera by Rollei, modelled on a large-format monorail camera (*see pp.350–3*), can record digitally or on film. The independent movement of the image and lens planes allows for a degree of creative control not possible with other cameras.

Twin lens reflex (TLR) medium-format camera

Few TLRs are now produced, but there are advantages to the design. Rather than seeing through the lens that exposes the film, you view the image through an identical lens, placed above the first. This means that you see the image as you take the picture, as there is no mirror. The Rolleiflex (right) does not have interchangeable lenses or backs.

▼ Medium-format SLR

The main features of a typical medium-format system camera are shown here, including the waistlevel viewfinder and interchangeable back. This classic Hasselblad design uses the 6 x 6cm (2½in square) film format, but can be adapted to shoot digitally.

Removable back

This is where the image sensor is housed. Unlike 35mm film cameras, the film back (shown here) on many medium-format SLRs can be changed mid-way through a roll.

Pressure plate

This uses a spring mechanism, which gently pushes the film from behind so that the area currently in use is as flat as possible.

The viewfinder can be removed, providing a direct view of the focusing screen, or so that another viewing system can be used.

Advance crank handle

This camera advances the film between exposures, and resets the shutter curtains for action. If the film back is temporarily removed as the handle is advanced (with the dark slide in place), the shutter is cocked, without the film being advanced, allowing you to superimpose two or more images on the same piece of film (see pp.84–5).

Waistlevel viewfinder

The standard viewfinder on this sort of camera folds flat when not in use, and is designed to be used with the camera at chest or waist height. Other viewfinders can often be used.

Pop-up magnifier

A magnifying glass can be sprung into place for critical focusing with the waistlevel viewfinder, allowing you to see the central part of the image on the focusing screen in more detail.

Focusing screen

This is where the image is projected on to by the lens and mirror when the shot is being composed. The ground-glass surface is designed to aid focusing. Different types of screen may be available.

Mirror

This reflects the image formed by the lens on to the focusing screen. The image will be the right way up with a waiotlovol viewfinder, but will be laterally reversed, which can make composition awkward.

Exposure control

On this model, both aperture and shutter speeds are set using dials on the lens

Digital back

▲ Interchangeable backs

A key advantage of removable backs is that films can be changed extremely quickly (as long as spare film backs are available). The fiddly process of unloading, and reloading, the backs can then be left until later. It also means that you can change the film type, and even the format, during a shoot. A 6 x 7cm camera system, for example, may also offer 6 x4.5cm and 35mm backs for its bodies. Digital backs are available for many medium-format cameras.

INTERCHANGEABLE VIEWFINDERS

Although they are found rarely on 35mm SLR cameras, interchangeable viewtinders are a common teature of many medium-format cameras.

Many are supplied, for example, with a waistlevel finder, which allows you to look downwards directly on to the focusing screen of the camera. A pop-up magnifier can be used for critical focusing, while the whole box-like structure

can be collapsed flat when not in use. The viewfinder image is an uncorrected mirror image, though, so it appears the wrong way round

Those preferring to use the camera at eyelevel, rather than at stomach height, can opt for a prism finder. This uses a fivesided prism, as with an SLR, which ensures that the camera is not only the right way up but also the right way around. Prism finders also often add metering systems and exposure modes that the basic camera does not

Waistlevel finder in use on a tripod

Interchangeable lens

Only some roll-film cameras

have interchangeable lenses, and

even then the range may be limited.

Shutter release

This is pressed so that the shot is taken. The threaded socket in the centre is for use with a cable release.

See also Types of digital camera p.24 Film format p.116 Instant film p.128

Compact cameras

By far the most popular type of camera available is the compact camera. It is small, straightforward to use, and easy to carry.

Over the years, the distinction between SLRs and compacts has become blurred. Point-and-shoot models now frequently have built-in zoom lenses, limited exposure controls, and special effects. Although these controls provide some creative options for the snapshot photographer, they still fall short of the depth of field and shutter speed options available on the average SLR. Moreover, the viewfinder gives only a representation of the shot you are about to take; it cannot show you what is in focus, and at close distances will actually frame the shot differently from the lens.

Not all compact cameras are point-and-shoot models; this wide catch-all term is often applied to cameras that offer a wide range of exposure and focusing control. The famous Leica rangefinder camera (*see p.34*–5), for example, is sometimes classed as a compact.

Most compact cameras today use a digital sensor to record the image, but film models are still produced. The advantage of the digital type is that you can see your results almost instantaneously using the TV-like monitor at the rear. This gives you assurance that you have taken a successful picture – and allows you to share your results with others without the delay of the film being processed. As memory cards are reusable, digital cameras can have very low running costs compared with film alternatives.

Nearly all film compact cameras made today use the 35mm film format, creating images on film that measure 36 x 24mm.

WHAT IS PARALLAX ERROR?

Many compacts use a simple direct-vision viewfinder, which is above and to the side of the lens. Although this viewfinder will zoom to mimic the various focal lengths that the compact may offer, the fact that you are looking at the subject from a slightly different viewpoint means that you are seeing a slightly different image from that which will be recorded. This is known as "parallax error". This difference between the two viewpoints is of no significance with distant subjects, but the closer you get to the subject, the more inaccurate the viewfinder will become.

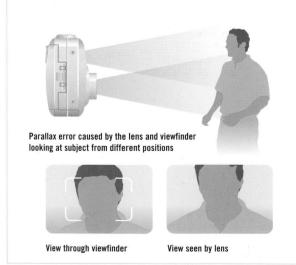

▼ Zoom compact

This illustration highlights the key features and controls found on a typical mid-priced 35mm-format zoom compact, including limited control over focusing and flash systems.

Remote control receiver

This camera can be used with an infrared remote control to simplify taking self-portraits and candid shots.

Zoom control

This rocker switch controls the focal length of the builtin zoom lens; this is altered using a motorized system.

Film

Film is extended from the 35mm cassette to a take-up spool on the other side of the rear light-proof chamber.

Battery

As with most modern cameras, this camera is totally reliant on battery power, and no pictures can be taken when the battery runs down.

Self-timer

Adds a delay between pressing the shutter button, and the picture actually being taken. This can be used for self-portraits, or when using slow shutter speeds (see pp.102–3).

Viewfinder light path

Reflected light from subject seen in the viewfinder is different to that seen by the lens. The parallax error this creates is minimized on this model by using prisms.

Light path to film plane

Reflected light from the subject passes straight through the lens when the picture is taken. It is not diverted to the viewfinder (which has a separate, direct view of the subject). The shutter is situated in the lens itself.

200

Auto lens cover Protective lens cap

opens automatically when the camera is switched on.

Zooming lens mechanism

The built-in zoom retracts right into the camera body when switched off. The focal length range of compacts varies widely. This model has a 28–120mm range; longer focal lengths can be found.

AF button

This allows you to override the autofocus system. This model offers a single manual focus setting for very distant subjects (those that are at "infinity"). This is useful when shooting through glass (see pp.72–3).

Flash mode

Flash can be switched on, turned off, or set to automatic activation. Also provides access to creative flash effects.

Viewfinder

The viewfinder has a motorized zooming mechanism, which works in tandem with that used by the lens itself, so the image can be previewed with some accuracy.

Dioptric setting

Allows the lens in the viewfinder to be adjusted to suit the user's eyesight.

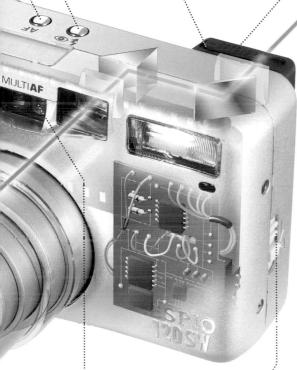

Autofocus window

On nearly all compacts, the lens is automatically focused through a separate window, rather than through the lens. Some use infrared measuring systems, but many use a passive contrast-detection system.

Back opening button

This opens the film chamber for unloading and loading. It must not be opened mid-roll, otherwise the film will be fogged by the light.

TYPES OF COMPACT CAMERA

Although all compact cameras share their pocketable size, they are available at a wide range of prices. Most are designed for point-and-shoot use, but creative control and features vary significantly.

Disposable compact camera

Some of the simplest cameras are designed to be used once. The body is preloaded with colour-print film and, when used, the whole camera is given or sent to the processing laboratory.

Digital zoom compact camera

Most zoom compacts are designed with ease of use and portability in mind. This digital model offers an impressive 10x zoom range and a resolution of 10 million pixels.

Creative compact camera

This luxury digital model offers much more creative control over camera settings than most compacts, and it will even record in RAW. It is designed as a style statement, as well as a pocket camera for serious photographers.

▶ Behind the camera

The majority of film compacts have a motorized film transport system, which automatically advances the film as each shot is taken, and which rewinds the film into the cassette when it is used up (or the mid-roll rewind control is used). Digital models avoid you having to load up the film carefully – but you must check memory is available.

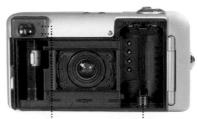

Indicator lights
Green and red LEDs at
the side of the viewfinder
provide visual warnings
or confirmations.

Film chamber

The film's sensitivity to light is automatically measured using contacts, which read a code printed on the cassette.

LCD screen

The colour screen on some digital models must be used for framing shots, as well as reviewing images.

Menu button

One touch of this button brings up a menu on the LCD screen, giving extra choices without extra buttons.

Types of digital camera

In the same way that there are two main types of film cameras, there are two main types of digital camera – the compact and the SLR.

Digital models using a reflex design and offering interchangeable lenses tend to offer the best creative control, but the advantages of the SLR over the compact are not as marked as they are with film cameras.

As most digital compacts have an LCD screen, it is possible to see exactly what is being recorded without the need to see directly through the lens. Furthermore, as digital cameras often offer extensive creative control, it is possible to see the effect that changing shutter speed and aperture has on the picture without having to wait for the film to be processed.

Hybrid, or "prosumer", models offer a half-way house between SLR and compact. They do not have interchangeable lenses, but they do have a long zoom lens built in, the range of which can often be increased with add-on optical converters. A secondary LCD screen provides an eye-level viewfinder that allows the camera to be handled in much the same way as a traditional SLR.

Digital cameras are also frequently built into other electronic and optical devices, such as video camcorders, binoculars, and mobile phones (*see pp.34*–5).

HOW MANY PIXELS?

The number of pixels (measured in millions of pixels, or megapixels) needed on a camera will depend on what the pictures are going to be used for. There are two main uses for digital pictures:

- Those used for web pages, email, and on-screen presentations need only to be low resolution.
- Those printed out by a desktop printer, a processing laboratory, or a publisher need to be high resolution.

Generally it is best to get the highest resolution that you can afford. This will give you the flexibility to have top-quality results when required, and you will be able to limit the resolution before or after shooting for on-screen use. High-resolution cameras also tend to be those with the best creative control over the results.

USE	UNDER 2M Pixels	4M PIXELS	8M PIXELS	12M PIXELS	
Web pages	Yes	Yes	Yes	Yes	
Email	Yes	Yes	Yes	Yes	
Presentations	Yes	Yes	Yes	Yes	
4 x 6in prints	No	Yes	Yes	Yes	
5 x 7in prints	No	Yes	Yes	Yes	
A4 prints	No	No	Yes	Yes	
A3 prints	No	No	No	Yes	

TYPES OF SENSOR

Two types of imaging sensor are commonly used on digital cameras — CCD or CMOS. Both are made up of a grid of microscopic, light-sensitive picture elements, and both essentially work in the same way. The CCD (charge coupled device) is a relatively simple design, in which the information recorded by the pixels is read off by the camera one line at a time. With CMOS (complementary metal oxide semiconductor) arrays, each pixel has its own circuitry, so that the camera can read out

the value registered by each element separately. The main advantage is that the pixels can be used to help with other camera systems, such as exposure metering and autofocusing. With CCD and CMOS chips, individual pixels measure the intensity of just one of the three primary colours of light (red, green, or blue). A less popular design, however, uses X3 (or triple-well) technology, where each sensor is capable of measuring all three primary colours simultaneously.

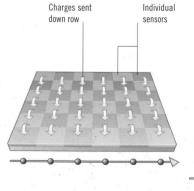

CCD sensor array

The image is scanned over its whole area to retrieve data. This process must be complete before another picture is taken.

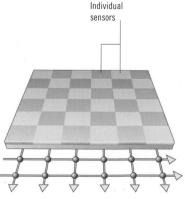

CMOS sensor array

Each of the sensors has its own circuitry and is read independently of the others, which gives a high degree of versatility.

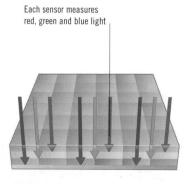

X3 CMOS sensors

Each pixel can measure all three colours of light, with layers that are sensitive to red, green, or blue light.

Digital designs

As with film cameras, the most popular type of digital camera uses the compact design. Nearly all of these have built-in zoom lenses, which often have greater focal length ranges than their film counterparts. Many digital compacts are very small, but some are deliberately designed to have the handling characteristics of a traditional reflex camera.

▲ Pocket model

Digital compact models can be much smaller than their traditional film counterparts. This budget Fuji model is just 2cm (less than 1in) deep but still squeezes in a 3x zoom lens and a 6.3cm (2½in) LCD screen.

▲ Zoom compact design

Looking much like a 35mm zoom compact, this Canon is identifiable as a digital camera by the colour monitor on the back. Despite being designed for point-and-shoot use, the camera offers a decent 7-million-pixel (7-megapixel) resolution and a number of creative overrides.

▲ Hybrid design

Although this Olympus model has a non-interchangeable zoom lens, it is designed to look like and handle in much the same way as a digital SLR. There is no focal plane shutter or reflex mirror, but you can see exactly what you are shooting through either of the two LCD screens. This model has a built-in 20x zoom and a full range of creative controls.

A wide range of professional digital solutions are available, from the 35mm-style SLR system camera through to optional bolt-on backs for larger-format cameras. One of the main features that distinguishes serious models from snapshot cameras is the speed at which the camera processes the digital data at the end of each shot.

► Digital SLR

Digital SLRs are designed to both look like and handlo like their 35mm SLR equivalents. They can often use the same interchangeable lenses, but because the digital imaging chip may be smaller than the 35mm frame, the effective focal length may not be exactly the same with both models ($see\ p.16$).

On-screen menu
Rear screen can be used
to display images, or to
change camera settings.

Resolution

Image files can be saved in a range of formats.

Fine control

White balance can be set to a precise level.

Digital SLR LCD screen

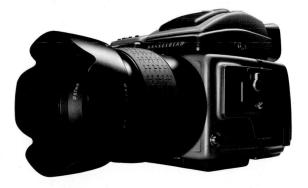

▲ Digital medium-format camera

Many medium-format SLR cameras are designed to work with a digital back, rather than their usual interchangeable film back. These units are often used to record direct to a linked computer, rather than to a memory card. Some models are digital only, such as this Hasselblad, and are custom designed for the modern studio photographer.

How digital cameras work

In many ways, digital cameras are just like film cameras. They are available in a wide variety of designs, and at a wide range of prices. Some offer superb resolution and creative photographic controls, while others are sold simply to provide low-quality snapshots.

The main difference, of course, is that rather than using film, the picture is recorded in digital form, using the same simple binary code that is used by all computer files.

While many components are shared by digital and film cameras, there are some that are unique to the digital camera, the most important of which is the imaging chip. This chip is made up of millions of miniature picture elements, or "pixels". These pixels individually measure the intensity of light falling on them, and create an electrical signal. Different pixels are responsible for registering the three main primary colours, so they collectively build-up a detailed dot-by-dot picture of the image.

The more pixels that a camera has in its imaging chip, the more detailed the resulting picture can be. This increased resolution can be used to create bigger, and better-quality, enlargements. However, the disadvantage of increased resolution is that the amount of memory required to store each image increases (*see pp.24*–5).

FROM LIGHT TO DIGITAL FILE

The route to creating a permanent image in a digital camera is very different to that in a film-based camera. The light-sensitive sensor takes the place of the film at the camera's focal plane. Each pixel in this chip creates an electrical signal, which is processed electronically and then converted into a digital signal. It is this that is recorded on to the camera's memory (usually a removable card, *see right*).

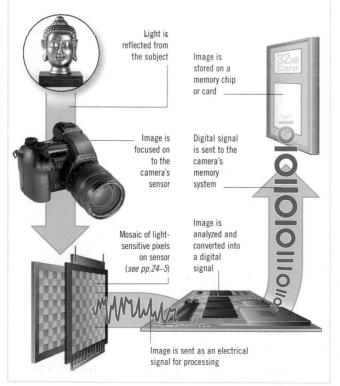

▼ Hybrid digital camera

This cutaway diagram shows the main features and controls on a typical middle-of-the-range digital camera. This model uses a so-called "hybrid" construction, which combines design elements from both traditional SLRs and zoom compacts.

This overrides the automatic colour correction system (*see pp.138–9*). (This control is out of view)

Record mode button

A rotating wheel is used on its own or in conjunction with other buttons to change a wide range of camera settings.

Zoon

Manual focus

A ring around the lens allows the user to adjust the focus manually in situations where autofocus is inappropriate. . . .

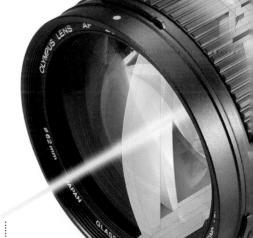

Light path

The arrow indicates the route taken by the light reflected from the subject; a beam-splitting prism supplies identical images to both the imaging chip and the optical viewfinder.

Filter thread

A screw-thread mount allows the camera to use a wide range of accessories, including lens converters that can extend the rand of the built-in zoom lens to include longer and shorter focal lengths.

Exposure modes

Used to set programme. manual, and shutter/aperture priority operation. It also sets the camera to playback or download mode.

Hot shoe

This is an electrical contact and mounting system for attaching accessory flashguns. A low-powered flash unit is also built in.

Viewfinder

Use the viewfinder to see the image. Some digital cameras have an LCD monitor. Here, an optical system gives a direct view through the lens.

▼ Controls on the back of the camera

Digital cameras have an LCD screen as a second viewfinder. This is particularly useful for reviewing shots already taken, and for setting up the camera using on-screen menus.

Screen menu

Computer-like menus can be displayed to customize camera

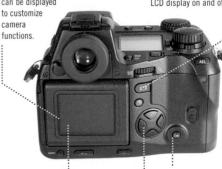

Monitor ...

Colour LCD can be angled to aid viewing.

4-way cursor !

Up-down, left-right controls, for use with screen menus.

UK command

Input key for actioning selection made on screen.

Flash synchro socket

Power cord socket for connection to a wide range of flach accoccorioc and ctudio lighting unitc.

..... CCD imaging chip

Found at the focal plane, this is the light-sensitive concor that convorts the image formed by the lone into an electrical pulse. Several types of sensor are commonly used (see pp.24-5).

Socket to computer

Beneath this flap is the connector used to wire the camera to a computer for downloading images.

Video out socket

Many digital cameras can be linked to a TV using a cable, so recorded shots can be shown on a big screen.

Number of pixels

The main factor affecting resolution is the number of pixels used by the image sensor. These are measured in millions of pixels, or "megapixels".

Memory chip

The image is recorded on to a removable memory card, typically capable of recording between 256 megabytes and 16 gigabytes of digital data.

Mains input DC

Digital cameras can use up battery power quickly. Some can be run off the mains when convenient; some have a rechargeable battery that can be topped up with power as required.

STORING IMAGES

Most digital cameras store picture files on a removable memory chip or card. Several different types are in use, and the ones your camera takes will depend on the make and model that you buy. Other removable memory stores include miniature hard drives, CDs, and diskettes. Some basic models have a fixed internal memory. Unlike film, you do not need to keep buying more memory; you can delete, and re-record over, unwanted shots. When the pictures you want to keep have been copied to your computer or another device (see pp.32-3), the whole memory can be reused.

Micro SD card

vD card

SDHC card

CompactFlash card

Digital SLRs

Digital SLRs are by far the most popular type of camera among creative and hobby photographers. While they include many of the design elements and controls of a 35mm film SLR, they also provide the convenience and economy of digital shooting. Whether you are a seasoned photographer or just starting out, immediately seeing your results allows you to experiment and learn from your mistakes in a way that was impossible with film.

Digital SLRs, by their very nature, are sophisticated pieces of electronics, but the on-board circuitry can make these cameras easy to use – thanks to features such as intelligent metering and high-speed automatic focusing. However, while these cameras may be used in a point-and-shoot fashion, you also have the option to override settings and bring your own interpretation to a scene. Furthermore, such manual controls on the best models are designed to be easy to access.

Digital SLRs are available at a wide range of prices. More money may buy you better features – such as faster continuous shooting speeds, a higher resolution, and more manual settings – but it will not guarantee you better pictures. One of the reasons some SLRs are more expensive than others is that they are built with stronger materials, designed to withstand heavy everyday use by professionals. Such solid construction is not worth paying extra for if your living does not depend on the camera.

EXPOSURE MODES

The wide range of exposure modes typical on an SLR enable it to be used in different ways — to suit a preferred way of working, or to suit the subject (see pp.78—9). The mode affects whether the camera decides which shutter speed and aperture is used (program), whether the user chooses these (manual), or whether you share responsibility (aperture/shutter priority). To use the modes effectively, the camera must display the aperture and speed chosen, so adjustments can be made appropriately. This data needs to be shown clearly outside of the camera (as in the LCD below) and prominently in the viewfinder.

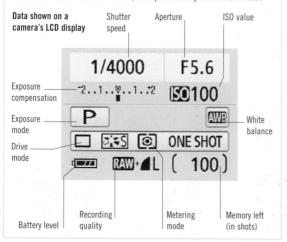

RAW FILE FORMAT

While digital compact cameras usually record images using the JPEG file format, digital SLRs provide an alternative RAW option. The RAW quality setting records the image at the top available resolution, but saves the information in a semi-processed state. It remembers the amount of exposure compensation and white balance you have set, for instance, but allows you to change these at the processing stage — without any detrimental effect on the image quality. Many serious photographers shoot only in the RAW format, because of the extra creative latitude that this provides. The disadvantage is that the image files are larger than the best-quality JPEG. This means memory cards fill up quicker, and the camera takes longer to process the shots. RAW files also require more computer processing than JPEGs.

▶ Mid-range digital SLR camera

The main features and controls found on a mid-range digital autofocus SLR can be seen in this illustration. Many of the core features are the same as those on the basic SLR (see pp.18–19). This model provides a greater degree of automation and far more user modes.

Front control dial

This rotating wheel is used on its own, or in conjunction with other buttons, to change a range of camera settings. It is used while looking at one of the LCD displays, so that the user can see what is being set.

Shutter release

A full press on this button fires the shutter and takes the picture. A light press activates the autofocus and brings the image in the viewfinder into focus.

Autofocus zoom lens

AF SLRs use lenses with electrical or mechanical links with the main body, so that the lens elements can be adjusted by motors to bring the image into focus.

Light path

The yellow line indicates the route taken by the light reflected from the subject, through the lens, off the mirror, and around the pentaprism to the viewfinder. When the mirror is raised, the light travels to the digital sensor.

Manual focus ring

Although the lens can be focused automatically, the lens and camera provide easy-access controls for manually adjusting which parts of the scene are tack-sharp.

Built-in flash

Although nearly all compact cameras have an integral flash, not all SLRs do. As the power is low, and its position fixed, it has only limited use. But it is handy in daylight, as well as after dark, when no accessory flashgun is to hand.

Eye sensor

Diopter dial

Dioptric correction adjusts the viewfinder image and display to suit your eyesight....

Mode dial

This provides options for selecting the combination of shutter , speed and aperture.

This offers access to setup options, and is used in conjunction with the cursor buttons to the right of the LCD screen...

Playback button

Use this to display the pictures you have just taken or other images stored on the card.

The LCD on a digital SLR is used to replay your shots and to access menu items. On some models, however, it can also be used as a viewfinder, showing you the shot you are about to take as the sensor sees it. This Live View option necessitates swinging the SLR mirror out of the way. It is a particularly useful facility when shooting portraits or still-life shots in the studio, but it can also be handy outdoors, aldling accurate composition — when holding the camera above your head to shoot over an obstacle, for example.

Image sensor

This is where the image is focused by the lens — it is the electronic chip that turns the light into an electrical signal. This signal is then processed and converted into digital form and saved to the camera's memory card.

Sub-mirror

The main mirror is semi-silvered, so that some light passes through it. This bounces off a second sub-mirror, providing an image that is used by the autofocus sensor to control the lens.

Computer connector

This socket is used to connect the camera to a computer to download images. It may also be used to control the camera remotely. It is usually a USB socket.

HISTOGRAMS

You can judge roughly whether you have set the right exposure by reviewing the shot you have taken. However, the small LCD image can be misleading or hard to see clearly. Most digital SLRs provide a more graph-like representation of the exposure. By

450D

displaying this histogram (*see p.388*), you can see the range of tones in a picture, from dark black to bright white. The shape and position of the graph provide clues to exposure, so you can see whether you need to reshoot with exposure compensation.

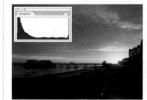

Too dark

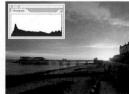

Ideal exposure

Too bright

Image stabilization

Many digital SLR systems use technology that aims to counteract the natural movement of the camera when it is held by the human hand. Either elements within the lens, or the sensor itself, are moved to minimize the effects of camera shake.

The digital SLR system

Buying an SLR is only the beginning. The beauty of the digital SLR is that it is a system camera, which can be adapted to cope with many different situations.

The first choice is the lens. Although many SLRs are sold in a package with a particular zoom lens, it is quite possible to buy most models in "body only" form, and then choose the lens, or lenses, best suited to the range of subjects that you want to cover. Not only is there a range of lenses made by the manufacturer of the SLR itself – but independent manufacturers provide additional choice, and these are often more affordable.

The brand and model of SLR you choose will also define the number of different accessories that can be bolted on or plugged into your camera. Some brands, and some budget models, will offer a much more restricted choice than the usually more expensive models that are produced for the demanding professional photographer. However, specialist accessory manufacturers again improve the choice available for your make and model of camera.

After buying your various lenses, you may also want to invest in filters, focusing screens, viewfinder modifications, battery packs, flash units, extension rings, and remote controls. Many of these add-ons will contribute greatly to the creative control allowed with SLRs. The diagram on the right shows examples of some of the many system accessories – some common, and some obscure – that can be found for many SLR cameras, though not all of these are made for all models of SLR.

FILTERS

Nearly all SLR lenses have a screw-threaded attachment ring at the front, which allows a wide range of accessories to be attached to the camera. The most popular of these are filters (see pp.62–7). Hundreds of types are available. Many modify the image in a subtle way, making small changes to the colour balance of the picture, for example. Others have a more spectacular effect – including diffracting the light, creating multiple images, and eliminating reflections.

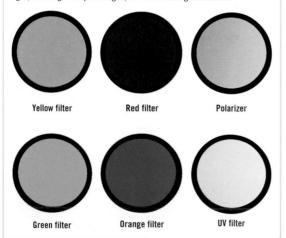

■ Eyepiece options

Most SLRs offer dioptric correction, to adjust the viewfinder to suit your eyesight, but some provide more powerful correction, allowing the use of the viewfinder without glasses. Other viewing accessories

can also be attached.

► Right-angle finder
A right-angle finder allows you
to see the image through the
viewfinder from above the
camera. This is particularly useful
when using the camera at low
level, such as when shooting a
toadstool on the forest floor.

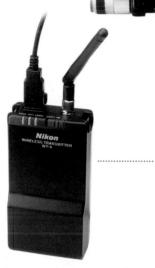

▲ Wireless transmitter

Some professional digital SLRs have optional WiFi transmitters that allow you to control the camera from a distance, without a cable. The camera settings are then adjusted, and the shutter subsequently fired, using a standard computer. The resulting images can be seen, and even stored, on this remote PC.

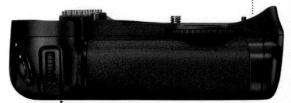

▲ Battery grip

Many SLRs have optional bolt-on grips. These typically increase the amount of onboard battery power available, but also change the shape of the camera to alter the handling characteristics. Often additional control buttons are supplied to aid when shooting in the vertical format.

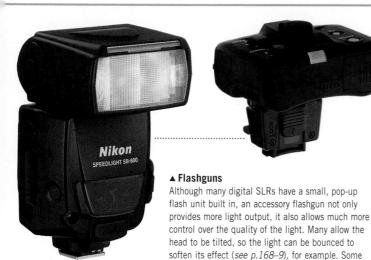

TETHERED OPERATION

Some digital SLRs allow you to control and fire the camera from a remote computer. While this is possible wirelessly (*see left*), with many models the only piece of hardware you need is a simple USB lead.

The remote-control software necessary may have to be bought separately, but it is sometimes supplied with the camera.

▲ Specialist lenses

offer wireless operation, allowing you to place the flash away from the camera without the need for a cumbersome cable to ensure correct synchronization.

Some lenses are designed not just to provide a certain angle of view, but to perform a specific task. Fast lenses are better at blurring backgrounds (see p.50); macro lenses get in close to small subjects (p.56); and shift lenses allow you to manipulate perspective (p.54).

▲ Extension ring

This fits between the lens and the camera body, allowing you to focus closer than normal and providing high-magnification images.

▲ Close-up lens

This magnifying glass fits over the lens, allowing you to get closer to the subject than would otherwise be possible (see pp.58–9).

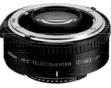

▲ Teleconverter

Fitting between the lens and camera body, this increases the effective focal length, for a more magnified view of a distant subject (see p.48).

▶ Lenses

Being able to change the lens on an SLR allows its user to alter its angle of view to suit the size and distance of the subject being photographed. Lenses are available in different focal lengths, with the shortest offering an extreme wide-angle view, and the longest telephotos offering a very narrow angle of view that provides a high magnification of distant subjects. Many lenses are zooms, providing a range of focal lengths in just one lens; others are prime lenses, with just one fixed angle of view.

The digital system

One of the main differences between digital and film cameras is that even the simplest and cheapest digital models are already part of an elaborate system. After all, digital cameras can be seen as just another computer peripheral that can be plugged into a computer in much the same way as a printer, disk drive, or scanner. However, a computer is not an essential requirement for the digital camera user. Many high-street processing laboratories, or digital bureaux, can print your pictures direct from your memory card.

The importance of computers

The computer opens up a world of possibilities for the digital camera user. It acts as a convenient place in which to store images. Downloading the digital images on to a computer also means that they can be used by other programs. They can be turned into greeting cards with a desktop publishing package. They can be sent to friends around the world via email, at practically no cost. They can be exhibited to a global audience using the internet. They can be used as sales aids using a software program, such as Powerpoint.

Most significantly, the computer allows you to manipulate your pictures at little cost and with only a little practice. You can recreate all the tricks of the skilled darkroom worker, and explore many new ones, too, from minor corrective tweaks to a composition to projects that completely transform the original image. Unlike with darkroom techniques, you can easily go back a step on the computer, and you can make extra copies of the final masterpiece just by pressing the print button.

Once an image has been turned into a digital file by the camera, it can be stored and used in a wide variety of different ways, as this flow chart of digital pathways shows.

▲ Portable storage

With most cameras you can increase the number of shots you take between downloads to the computer by buying additional cards. The card bought with the camera may store only a handful of images at the highest resolution, so a high-capacity card is a sensible purchase.

▲ Card reader

The camera can be plugged directly into the computer using the supplied USB lead, but it can often be more convenient to use a card reader. These usually have slots for various card types and are available with differing computer connectors (such as Firewire).

PORTABLE STORAGE DEVICE

When you are on a long trip, it is advisable to have the capacity to download and store images from your digital camera, without the need to take a laptop. You can use a small, portable hard disk drive. These can have capacities of many gigabytes — some can hold 30GB or more of data — and may even have built-in LCD viewing screens.

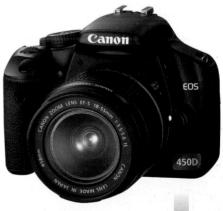

▲ Digital camera

A computer is not essential in order to use a digital camera. Prints can be made direct from the card or camera by commercial laboratories. Some cameras can be linked directly to a portable printer without the need for a computer (although this does limit the amount of control you have over the result).

► Back-up and archiving

As with all computer data, it is easy to lose digital images. It is therefore sensible to keep copies of your pictures where they can be stored safely. Since a hard drive can soon reach capacity, and is itself prone to data loss, it is sensible to have a back-up system. There are many types of storage media available, including recordable CDs and DVDs.

Most modern computers can be used with most digital cameras. However, the software and hardware requirements differ significantly. It is sometimes possible to get around incompatibilities using a card reader and choosing your own software. The type of connector available on your computer will also dictate the speed at which files can be downloaded.

■ Printer

Most computers are sold with a standard inkjet printer, which is more than capable of making acceptable colour prints up to A4 or US letter in size on a variety of special paper. Printers specifically designed for high-quality and larger-sized photographic printing are also available, using inkjet, laser, and dye sublimation technologies.

Other types of camera

Although the vast majority of cameras on the market today belong either to the compact or SLR categories, there are plenty of other types of camera available that refuse to be so easily classified.

The examples on this page represent just some of the most noteworthy specialist cameras that are available today. Some, such as the panoramic camera, have been specially designed and produced to tackle a particular photographic subject – in this case, panoramic views of beautiful scenery, both for private enjoyment and for travel publications. Others, such as the video camcorder or mobile phone, are purchased primarily to fulfil a function other than recording still images – however, they are becoming increasingly adept at taking decent-quality digital photographs. The stereo camera and spy camera are almost as old as photography itself but are still going strong in the 21st century.

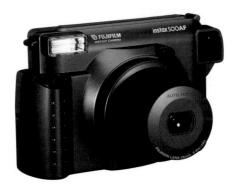

▲ Instant camera

Each print produced by an instant camera contains its own processing chemicals, and begins to develop as soon as it emerges. Instant cameras were pioneered by Polaroid, but the film is no longer in production (*see p.128*). The concept of the self-produced print lives on through Fuji Instax novelty cameras and compatible 10-shot packs of Instax film.

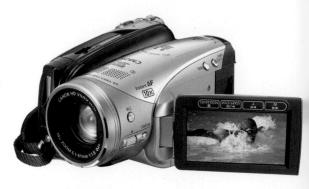

▲ Digital camcorder

Most video cameras can record digital stills images as well as movies. Stills are recorded on to tape, memory card, hard drive, or DVD, depending on the camera; some have separate memories for movies and stills. Picture quality is limited (a good model might give a resolution of 4 megapixels), but you get good control over focus, shutter speed, aperture, and white balance. The zoom range is very often greater than on a digital camera.

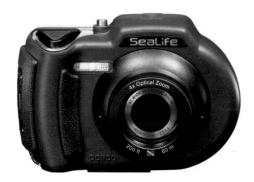

▲ Underwater camera

A wide range of waterproof digital and film cameras is available to meet the needs of the snorkeller and diver. Features are often limited, and primarily concerned with what depth of water pressure they can withstand. Custom-made sub-aqua housings are available for many popular digital SLRs and digital zoom compacts.

TYPES OF PANORAMIC CAMERA

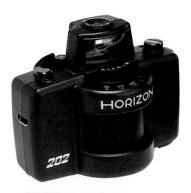

Swing-lens panoramic camera with 120-degree field of view

Designed to provide images that are significantly wider than normal formats allow, panoramic cameras traditionally use either 35mm or 120 roll film. Some simply use a wide-angle lens but do not offer a genuinely panoramic image. On true panoramic cameras (such as the Zenit Horizon and Noblex ranges), the lens rotates during exposure, offering an angle of between 120 and a full 360 degrees. In the shot on the right, the central area indicates the normal view that a 35mm wide-angle lens would have produced with 35mm film; with a panoramic camera, the print, and the angle of view, is twice as wide.

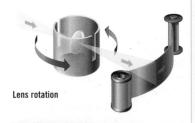

Panoramic image

▲ Stereoscopic camera

The stereo camera is a Victorian concept. It takes two shots at the same time, which must then be viewed so that each eye sees a different image. Some subjects produce better three-dimensional effects than others. Stereo attachments (as above) are available for many digital and film cameras.

▲ Spy camera

Miniature cameras have been the stuff of fiction and real-life espionage since the early days of photography. The Minox range, in production since 1938, has film cartridges that produce slides or negatives measuring just 8 x 11mm ($\frac{1}{2}$ x $\frac{1}{2}$ in). There is no zoom, and a flash has to be bought separately, but you do get control over shutter speed and aperture.

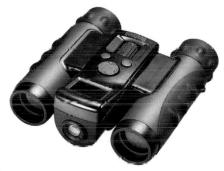

▲ Binocular camera

Using this combination of binoculars and digital camera makes sense if you are looking at wildlife. For example, you can spot and later correctly identify birds or other animals when they are moving quickly. However, because binocular cameras tend to produce low-resolution images, its main use is as an *aide memoire*.

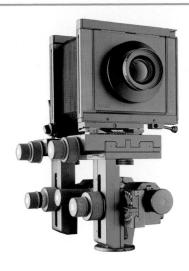

▲ Large-format camera

These cameras offer the ultimate in image quality, using either individual sheets of film that measure $12.5 \times 10 \text{cm}$ (5 x 4in) or 25 x 20 cm (10 x 8in), or digital backs. As well as providing very high-resolution images, large-format cameras offer a degree of control over picture perspective that is not usually available with smaller-format cameras (see pp.352–3).

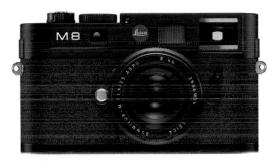

▲ Rangefinder camera

Some 35mm and medium-formal cameras use a rangefinder system made famous by Leica. Rather than looking at the image through the lens, you look through a separate viewfinder window, and focus the lens by bringing two superimposed images into alignment. Rangefinders are much quieter than SLRs, and can be manually focused more easily in low light.

MOBILE PHONE CAMERAS

The most popular type of digital camera was never conceived as a camera. Most mobile phones now have either a camera built in, or the facility for one to be clipped on. Compared with normal digital cameras, mobile phone cameras usually offer low-resolution results, no optical zoom, and few creative photographic controls. They enable the user to send simple snapshots to other mobile phone users as a multimedia message (MMS). However, these images can be downloaded on to a computer using email, a data lead, or an infrared or Bluetooth wireless connection.

▼ What is Bluetooth?

This is a radio link that allows data to be sent from one digital gadget to another without the need for cables. It has a range of around 10m (30ft) and can be used by a mobile phone to send pictures to a laptop, printer, or another mobile.

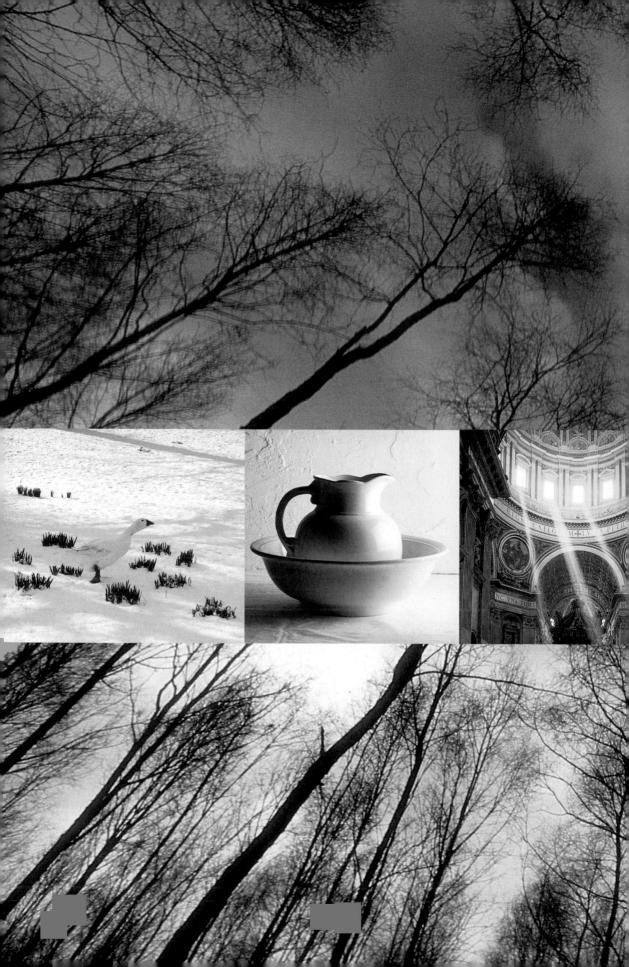

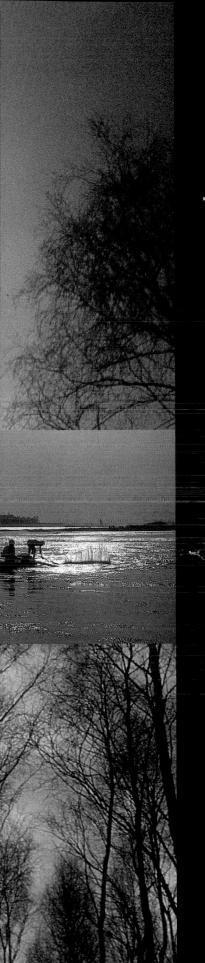

The elements of photography

Photography is both a science and an art, and an understanding of the basic techniques will contribute to successful creative compositions. Lenses, focus, exposure, shutter speed, film, and lighting all work together when creating top-quality photographs.

Lenses

Understanding how to use a lens is fundamental to the creative photographer, since, along with the aperture and the shutter speed, it is one of the key controls on the camera.

A lens's primary function is to ensure that the subject appears sharp in the picture, and it may do this automatically or manually, depending on the type of camera. The lens also has other roles to play. The focal length of a lens (*see below*) will

influence the apparent perspective and the relative sizes of subjects within a scene. By changing the type of lens used (or altering the lens setting, in the case of a zoom lens), the photographer can affect the size at which an image is recorded. Finally, the lens type or setting has a major affect on depth of field (*see pp.86–91*), which dictates how much of a scene is in focus, and which parts appear blurred.

What is a lens?

The lens is essentially the eye of the camera, and it has several important functions in photography. It is vital that the main subject of a picture (or at least a key element of it) is completely in focus. The lens controls precisely which part of the image appears perfectly sharp — although a certain distance in front of and behind the subject will look acceptably sharp in the final picture.

Another major function of a lens is its angle of view — this decides just how much of the world in front of the photographer is in the shot. A long telephoto lens isolates a distant detail and allows it to fill the frame, while a short, wide-angle lens takes in a much wider view.

Most lenses in use today are zoom lenses, which offer a range of different focal lengths (*see right*) without the need to swap lenses. However, cameras with interchangeable lenses may still use lenses with a single focal length (prime lenses), which are used as alternatives to zoom lenses.

Anatomy of a lens

A photographic lens is not a single lens but a number of different lenses, or elements, that are arranged into groups. One of the groups is moved to focus the lens. Groups are also moved on zoom lenses to change the focal length.

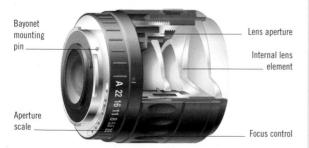

Using a lens

An interchangeable lens fits to the camera body using a bayonet mount, which provides mechanical or electrical contacts so that the aperture can be controlled from the camera. The focus control dial is turned – which moves the internal lens elements – until the image appears sharp.

FOCAL LENGTH

The focal length of a camera is defined as the distance in millimetres from the lens's nodal point (the point from which rays of light passing through the lens appear to come) to the focal plane (the film) when the lens is focused on the distant horizon (referred to as infinity); the bigger the image area, the longer the focal length needs to be. The focal length is therefore dependent on the size of the film or digital chip used (*see p.16*). A lens that gives a particular angle of view on medium-format film is going to be longer and bigger than a lens giving a similar angle of view on 35mm film.

This means that it is difficult to compare focal lengths on different types of camera lens. A 70mm lens could be either a telephoto or a wide-angle, depending on the camera for which it was designed.

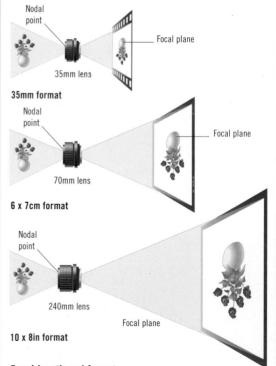

Focal length and format

A 35mm lens on a 35mm SLR gives the same angle of view as a 70mm lens on a 6×7 cm camera. To get the same size image on a 10×8 in large-format camera, a 240mm lens would be needed.

Angle of view

Different lenses are divided into three main categories – depending on their angle of view. A standard lens produces an image that is similar to that seen with the human eye. Telephoto lenses have a narrow angle of view and a long focal

length when compared to a standard lens. A wide-angle lens has a wider angle of view, and a shorter focal length, than a standard lens. These categories are often further sub-divided, the main examples of which are given in the chart below.

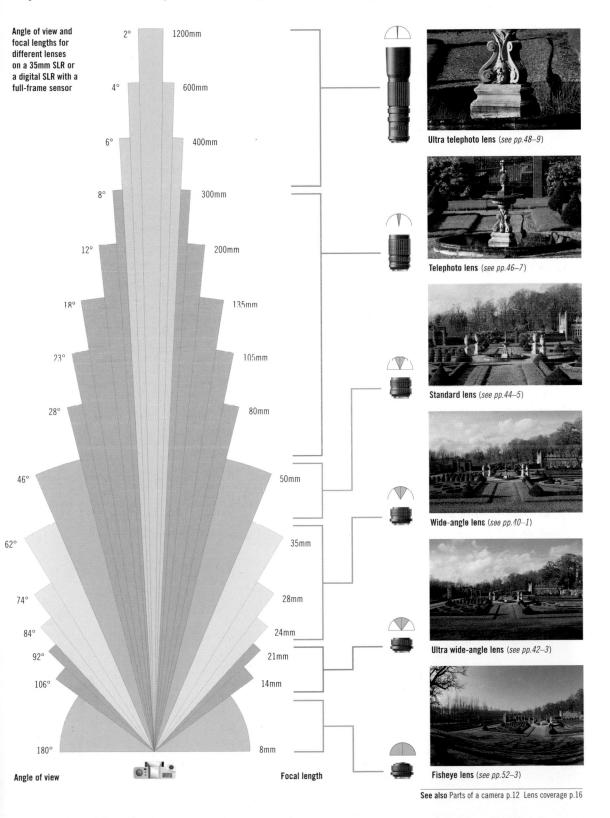

Standard lenses

The significance of standard lenses has diminished in recent years. At one time, almost every SLR came fitted with a standard lens. Now, SLRs are bought with zoom lenses, and, although many of these include standard focal lengths, those focal lengths are often only used as you zoom from wide-angle to telephoto.

However, standard lenses have a special place in photography because they offer focal lengths that most closely approximate to the central field of view of our own eyes (if peripheral vision is ignored) – so a standard lens will tend to give a far more natural view of a subject than any other focal length.

The standard focal length for a particular format is about equal to the diagonal distance across the image area. For 6 x 6cm medium-format cameras, the standard lens is considered to be an 80mm (the diagonal distance from corner to corner is 85mm); for the 35mm-format camera, it is a 50mm lens (the diagonal distance being 43mm).

Lenses with standard focal lengths are widely available for almost all camera types. Short standard zooms, which include both telephoto and wide-angle lens settings, are built into many zoom compacts – these are often provided as part of the standard equipment when purchasing an SLR. Superzooms, with their wide range of focal lengths, also include standard settings.

▲ 50mm (with full-frame digital SLR)

A standard lens provides the most natural looking pictures of all the focal lengths. Its perspective closely approximates to that offered by human vision — so that the various elements in this garden landscape look the same distance away from each other, and are at the same magnification as if you were actually looking at this view.

50mm lens, 1/125 sec at f/8. ISO 100.

STANDARD FOCAL LENGTHS COMPARED

The table shows the approximate focal length needed with each format to give a particular standard angle of view. Digital camera lenses are usually quoted with focal lengths that have already been converted to 35mm-format equivalents.

35mm format	APS-C sensor	6 x 4.5cm format	6 x 6cm format	6 x 7cm format	5 x 4in format	10 x 8in format	Angle of view
45mm	30mm	72mm	80mm	90mm	150mm	300mm	55°
50mm	35mm	80mm	90mm	105mm	180mm	360mm	47°

TYPES OF STANDARD LENS

35mm and digital SLRs

Although standard focal lengths are found on many zoom lenses, prime lenses are still useful. They are used in low light, as they have much wider maximum apertures than zooms, and are relatively inexpensive. At this widest aperture, the very limited depth of field can also isolate the background from the subject.

Canon 50mm f/1.4 standard lens

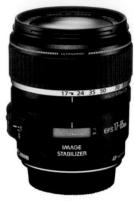

Canon 17-85mm IS standard zoom

Medium format

Most medium-format cameras are normally sold in kits that include a standard, prime lens. The actual focal length of this will vary depending on the film format or digital back used.

Pentax 645 75mm f/2.8 standard lens

Pentax 67 105mm f/2.4 standard lens

▲ Creating a tight composition

A wide-angle lens could have been used for this landscape shot, but the narrower angle of view afforded by the standard lens allowed concentration on the pattern created by the tree trunks and their reflections.

■ 50mm lens, 1/250 sec at f/11. ISO 100.

▲ Fading light

A 50mm prime lens is a more useful companion at sunset than a zoom lens – as the light dims, its wider maximum aperture means that the photographer can keep shooting with a handheld camera for longer.

■ 50mm lens, 1/60 sec at f/4. ISO 100.

▲ Close to the subject

A lens with a standard focal length is a very good choice for portraits – particularly when shooting full-figure shots, as it allows you to keep reasonably close to the subject.

50mm lens, 1/125 sec at f/4 with flash. ISO 200.

■ Selective focus

The large maximum aperture of a prime standard lens allows you to restrict depth of field in ways that are not possible with most zoom lenses. In this shot of an Indonesian actor, the use of a wide aperture ensures that the background appears well out of focus.

■ 50mm lens, 1/500 sec at f/2. ISO 100.

PROFESSIONAL HINT

A low-cost 50mm prime lens typically has a maximum aperture of f/1.8 — letting in almost four times more light than a 28–70mm zoom with a maximum aperture of f/3.5. This could mean using a shutter speed of 1/30 sec. rather than 1/8 sec.

Wide-angle lenses

Lenses with wide-angle focal lengths are found on more cameras and zooms than any other type of lens. Even the simplest disposable camera, with its fixed plastic lens, is a moderate wide-angle.

The most popular wide-angle focal lengths are the 35mm and the 28mm (for the 35mm format, see the table below for rough comparisons with other film/sensor sizes). Although both are available as prime lenses, the 35mm and 28mm are incorporated into the ranges of a huge number of interchangeable zoom lenses. One of these focal lengths is also usually the widest setting for compacts and digital cameras with built-in non-interchangeable zoom lenses.

While a 35mm introduces no noticeable distortion in most cases, the 28mm must be used with a little more care, since it is capable of producing noticeable changes in perspective.

With a 24mm lens, the effect is yet more extreme. This was once a favourite prime lens of architectural and landscape photographers, but is now found in the range of many specialist wide-angle zoom lenses, such as the 17–35mm (*see pp.44*–5). Sometimes the distortions are welcome, and maximizing them can enhance the picture – but it is also worth remembering that the effect of vertical, parallel lines converging can be minimized by making sure the back of the camera is not tilted.

▲ 28mm (with full-frame digital SLR)

Shorter focal lengths tend to give the appearance of stretching perspective – making objects in the foreground seem bigger than in reality, while those in the distance are made to appear smaller. However, the wide angle of view means that more of the scene in front of you can be captured than with longer lenses.

■ 28mm lens, 1/125 sec at f/8. ISO 100.

WIDE-ANGLE FOCAL LENGTHS COMPARED

The table shows the approximate focal length needed with each format to give a particular angle of view. Digital camera lenses are usually quoted with focal lengths that have already been converted to 35mm-format equivalents.

35mm format	APS-C sensor	6 x 4.5cm format	6 x 6cm format	6 x 7cm format	5 x 4in format	10 x 8in format	Angle of view
24mm	16mm	40mm	46mm	50mm	75mm	155mm	84°
28mm	19mm	45mm	50mm	55mm	100mm	200mm	75°
35mm	23mm	55mm	65mm	70mm	120mm	240mm	63°

TYPES OF WIDE-ANGLE LENS

Moderate wide-angle focal lengths are incorporated into the ranges of many zooms for the SLR – including standard zooms (with typical ranges of 28–80mm), superzooms (with typical ranges of 28–200mm), and ultra wide-angle zooms (with typical ranges of 17–35mm). For wider wide-angle focal lengths, such as the 24mm, consider the lighter, faster, non-zoom alternatives. These prime lenses are not only available new for most SLR systems, but can be more affordable secondhand (as many photographers have traded them in for zooms).

Nikon 28mm f/2.8 wide-angle lens

Nikon 35mm f/2 wide-angle lens

Nikon 24–85mm f/3.5–4.5 wide-angle lens

Wide-angle converter

Cameras with built-in zooms often have a limited wide-angle range, as the manufacturer concentrates on maximizing the telephoto end of the zoom. With some models, particularly digital cameras, the wide-angle capabilities of the lens can be increased by using a wide-angle converter. This screws into the front of, or over, the zoom. A magnification ratio of 0.8x would change the focal length of a 35mm into a 28mm lens. A 0.5x converter would change a 35mm setting into an 18mm ultra wide-angle.

▲ Depth of field

Wide-angle lenses are favoured by landscape photographers because of their angle of view, but mainly because they give good depth of field, keeping foreground details in focus, as well as distant hills and skies.

28mm lens. 1/125 sec at f/11. ISO 50.

Focusing on the middle and foreground

Focusing on the middle and background

Focusing on the foreground

▲ Group portraits

A wide-angle lens is almost essential for taking pictures of three or more people – and not just because of its wide angle of view. It makes foreground subjects look bigger than similarly sized subjects further away. This allows emphasis to be given to one or more people in the frame, while the others occupy supporting roles. Altering the arrangement of people provides a range of different compositions.

m 28mm lens, 1/125 sec at f/5.6. ISO 200.

▲ Converging lines

Wide-angle lenses can be used to help exaggerate linear perspective. Using a 24mm lens, both the girl and the top of the steps are very close to the camera — making the bars of the rails appear to converge.

24mm lens, 1/125 sec at 1/11. ISO 100.

▲ Interior sho

Wide-angle lenses work well in confined spaces, allowing more of the scene to be framed without having to move further back. This is essential for interior shots, where walls severely limit the position from which the picture can be taken.

■ 28mm lens, 1/4 sec at f/11 with tripod. ISO 100.

Ultra wide-angle lenses

Ultra wide-angle lenses are useful in confined spaces because they do not cause straight lines to bow excessively in comparison to fisheye lenses. Typical focal lengths for a 35mm SLR range from around 14mm to 21mm – and because the focal lengths are often the same as those provided by some fisheye lenses (*see pp.52–3*), it is important not to get the two lens types confused. The ultra wide-angle lenses are designed to provide a relatively normal view of the world – where the inherent distortions of such wide angles of view have been corrected for, whereas the fisheye lens provides a more extreme angle of view.

Such ultra wide-angle lenses were once found only in prime lenses but are now seen in specialist wide-angle zooms for 35mm and digital SLRs. These ultra wide-angle zooms have a limited range of focal length, such as 10–20mm for APS-C sensor digital SLRs, but several wide-angle lengths can be combined in one lens. Ultra wide-angle lenses are available for large-format and some medium-format models.

One of the reasons for using an extreme wide-angle lens is to manipulate perspective – the lens enlarges anything that is close to the camera, and creates emphasis in the foreground. The distortions this produces can be used to good creative effect. However, for a more natural-looking result, it is best to plan a symmetrical composition, where the main subject is not too close to the lens and lies in the centre of the viewfinder.

▲ 18mm (with full-frame digital SLR)

Ultra wide-angle shots may show little signs of distortion if, as with this shot, the main elements are some distance from the camera. The drawback with all wide-angle lenses, and especially those with shorter focal lengths, is that the photographer has to find ways of not leaving vast areas of empty space at the bottom of the composition.

■ 18mm lens. 1/125 sec at f/8. ISO 100.

ULTRA WIDE-ANGLE FOCAL LENGTHS COMPARED

The table shows the approximate focal length needed with each format to give a typical ultra-wide angle of view. Digital camera lenses are usually quoted with focal lengths that have already been converted to 35mm-format equivalents.

35mm	APS-C	6 x 4.5cm	6 x 6cm	6 x 7cm	5 x 4in	10 x 8in	Angle of view
format	sensor	format	format	format	format	format	
20mm	13mm	32mm	38mm	40mm	65mm	120mm	95°

TYPES OF ULTRA WIDE-ANGLE LENS

While ultra wide-angle focal lengths are available only as prime lenses for most formats, it has become increasingly common for lens manufacturers to design specialist wide-angle zoom lenses for digital SLRs and 35mm SLRs (*below*). Cameras with built-in zoom lenses, including digital models, rarely have focal lengths that are especially wide. However, more extreme focal lengths can often be achieved through the use of wide-angle converters, which screw into the existing lens in a similar way to fisheye converters (*see pp.52–3*). A 0.5x wide-angle converter, for instance, will double the angle of view — turning a 35mm lens setting into a 18mm ultra wide-angle lens.

Canon 10-22mm ultra wide-angle zoom

Pentax 12-24mm ultra wide-angle zoom

Nikon 14-24mm ultra wide-angle zoom

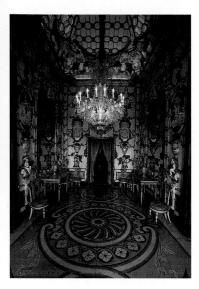

▲ Indoor use

Ultra wide-angle lenses allow you to include a whole room in a shot without extreme distortion. Here, the symmetrical composition hides the exaggerated perspective – although the pattern on the floor appears stretched.

■ 18mm lens, 1 sec at f/11 with tripod. ISO 100.

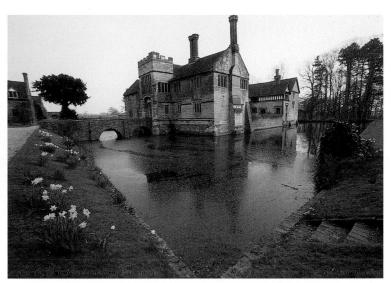

▲ Creating depth

The ultra wide-angle lens can be used to increase the feeling of depth and distance. In this shot, the moat around the castle has been made to appear much wider and more dominant in the picture than it would have been with a more conventional wide-angle lens.

20mm lens, 1/125 sec at f/11. ISO 100.

▼ Caricatures

Both ultra wide-angle and fisheye lenses can create amusing caricatures of people's faces. Here the girl's eyes, forehead, and nose appear much larger than in reality – as these features are closer to the lens than other parts of her face and body.

m 20mm lens, 1/60 sec at f/2.8. ISO 100.

◄ Stretching reality

Since foreground subjects are enlarged, this can have an interesting effect when parts of the subject are at different distances from the camera. Here the model's arms appear to be twice their normal length, while her head is the same size in the frame as each of her hands.

■ 17mm lens, 1/125 sec at f/8 with studio flash. ISO 200.

Telephoto lenses

Telephoto lenses allow you to see into the distance, magnifying the scene in front of you and cropping into just a small part of it. A telephoto lens is any focal length that is appreciably longer than the standard for the format. For 35mm users, the 70mm is considered the shortest telephoto, but this group of lenses offers by far the largest range of focal lengths, with the longest lens being restricted only by economics and practicality (*see pp.48–9*).

The telephoto lens allows you to take tightly composed pictures of subjects where it is impractical to get any closer and use a wider lens. But it also has an apparent effect on perspective. The unnatural, nonstandard, view makes objects at different distances appear closer together than they are in reality. It is for this reason that short telephoto focal lengths are widely used in portraiture. Using a wideangle lens for head-and-shoulder close-ups makes people's noses and other facial features more prominent – while a slight telephoto focal length flattens the facial features a touch, to give a more flattering result. A focal length of 80–150mm for the 35mm format is generally considered to be ideal for such portraits.

▲ 150mm (with full-frame digital SLR)

Taking this shot with a medium telephoto lens setting crops in on the garden view – virtually filling the frame with the fountain. However, the narrow angle of view also has a noticeable effect on perspective, making the gate in the background appear much closer to the pond than it would do in reality.

■ 150mm lens, 1/125 sec at f/8. ISO 100.

TELEPHOTO FOCAL LENGTHS COMPARED

The table shows the approximate focal length needed with each format to give various telephoto angles of view. Digital camera lenses are usually quoted with focal lengths that have already been converted to 35mm-format equivalents.

35mm format	APS-C sensor	6 x 4.5cm format	6 x 6cm format	6 x 7cm format	5 x 4in format	10 x 8in format	Angle of view
70mm	47mm	115mm	125mm	140mm	210mm	420mm	34°
80mm	53mm	128mm	150mm	160mm	300mm	600mm	30°
100mm	66mm	160mm	180mm	210mm	360mm	720mm	24°
135mm	90mm	210mm	250mm	270mm	450mm	900mm	18°
200mm	135mm	320mm	360mm	400mm	720mm	_	12°

TYPES OF TELEPHOTO LENS

Short and medium telephoto focal lengths are widely tound on both interchangeable SLR zooms — and on the zooms that are built into compact cameras. Short prime telephoto lenses can be found for most cameras using larger formats. Specialist short telephoto prime lenses are specifically designed for portrait photographers — and have a variable soft-focus control for producing artistically defocused romantic portraits.

Canon 55-250mm IS telephoto zoom

Nikon 70-300mm VR telephoto zoom

Nikon 135mm f/2 soft focus telephoto lens

◄ Compressed planes

A telephoto compresses perspective, making planes at different distances appear closer to each other than they really are. Here, only the boy in the foreground is sharp, but the two other figures are still noticeable in the frame. ■ 135mm lens, 1/250 sec at f/8. ISO 100.

▲ Softening the background

Telephotos are useful in portraiture because, when used with largish apertures, it is easy to throw a background out of focus. The carvings behind this subject are exquisite, but they would have detracted from the portrait.

■ 85mm lens, 1/125 sec at f/5.6. ISO 50.

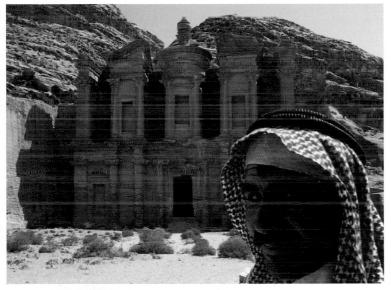

▲ A question of scale

A telephoto lens can give a distorted view of scale. Both these shots of the ancient city of Petra were taken with the same 135mm lens. In the shot above, we have no real idea of the size of the carved building, despite the presence of the person in the foreground. It is only in the shot on the left, which shows a detail of the urn on top of the building, that we get a clear idea that this is a massive structure. These two shots demonstrate that scale objects work effectively only if they are at the same distance from the camera as the subject for which they are providing scale.

■ 135mm lens, 1/1000 sec at f/16. ISO 50.

PROFESSIONAL HINTS

■ 100mm lens, 1 sec at f/32 with tripod.

▲ Showing details

ISO 50.

■ The longer the telephoto focal length, the harder it is to hold it steady. Compensate with faster shutter speeds (see pp.92-3), though some long telephoto lenses will need a tripod or monopod.

A telephoto lens is essential for many subjects,

including architecture and landscapes, allowing

you to isolate interesting details. This abstract shows patterned rock formations in a Petra cave.

■ Telephoto lenses demand that you focus more accurately, as they provide only limited depth of field (see pp.86-91).

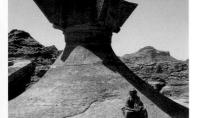

Ultra telephoto lenses

Longer telephoto lenses come into their own when photographing subjects that need to be seen from a distance. Sports and wildlife are classic examples of when long telephoto lenses are most often used. To get a good close-up of a football match, you need a long telephoto lens: with a shorter lens, you would have to stand on the field of play. When shooting animals or birds, a short focal length risks scaring away the subject or endangering your own safety.

The maximum focal length available varies radically, depending on the type of camera you use. The bigger the format, however, the less likely it is to be used for subjects such as sport, and the bigger and more impractical long lenses become.

It is the 35mm or digital SLR user, however, who has the biggest range of telephoto lenses to choose from. Focal lengths of up to 400mm are commonly found on zooms. More powerful lengths can be found on specialist zooms but are often bought as prime lenses, as this helps to keep the overall weight down and means the maximum aperture can be larger (*see p.50*).

▲ 320mm (with full-frame digital SLR)

A long telephoto lens crops in so close to objects in the middle distance that it reveals detail that is not seen even with a wide-angle lens. Depth of field is so limited, though, that only the subject that has been focused on is completely sharp. Without a tripod, or other camera support, the range of shutter speeds that can safely be used is limited.

320mm lens, 1/125 sec at f/8 with monopod. ISO 100.

ULTRA TELEPHOTO FOCAL LENGTHS COMPARED

The table shows the focal length needed with each format to give various telephoto angles of view. Dashes indicate where a lens is not generally available for this format. Longer focal lengths can sometimes be achieved, however, by using a teleconverter.

35mm format	APS-C sensor	6 x 4.5cm format	6 x 6cm format	6 x 7cm format	5 x 4in format	10 x 8in format	Angle of view
300mm	200mm	500mm	540mm	600mm	1100mm	_	8°
400mm	265mm	640mm	720mm	800mm	_		6°
500mm	335mm	_		1000mm		_	5°
600mm	400mm	_		_	. —	-	4°
800mm		_	-	_	_	_	3°
1000mm	_	_	_	_	_		2.5°

TYPES OF ULTRA TELEPHOTO LENS

Long telephoto focal lengths can be found on a number of zoom designs — either built into digital hybrid cameras or as interchangeable lenses for 35mm SLRs. For the more extreme focal lengths, however, many photographers opt for prime lenses. The maximum length for a telephoto lens is limited only by weight and by economics — the longest lens ever made for the Pentax 35mm SLR, for example, is a 2000mm mirror lens. Longer telephotos often have a tripod/monopod attachment — which is built into a rotatable collar.

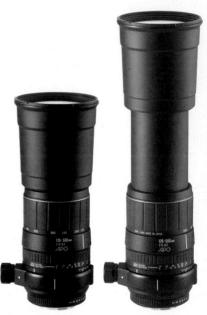

Sigma 170–500mm uitra telephoto lens set at 170mm

Sigma 1/U-500mm zoom lens set at 500mm

Teleconverters

Teleconverters allow you to increase your focal length range without the expense of a new lens, and are available in different magnifications. A typical 2x converter, also known as a doubler, would convert a 70–210mm zoom into a 140–420mm. With SLRs, the teleconverter fits between the lens and the camera body – reducing the effective aperture size. On cameras with built-in zooms, the teleconverter screws into the front of the lens.

2x converter for digital SLR

1.5x converter for digital compact

MIRROR LENSES

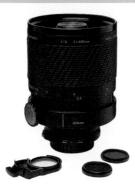

Sigma 600mm f/8 mirror lens with filter drawer and filters

Some of the longest telephoto lenses that have ever been made use a mirror design. This can be the least expensive way of getting a lens with a focal length of over 400mm for a digital camera or 35mm SLR. Also known as catadioptropic, or reflex, lenses, these lenses use mirrors in their design to reduce the size and weight of the lens. The focal length is increased by bouncing the light back and forth within the lens itself.

- Mirror lenses must be handled with care, as it is relatively easy to misalign the mirrors.
- Filters fit into a drawer, rather than on the end of the lens. This is typical of lenses with large or peculiarly shaped front elements.

► Highlight shapes

Out-of-focus highlights do not appear circular, as with other lenses: they have a characteristic doughnut shape.

500mm lens, 1/125 sec at f/8 with tripod. ISO 100.

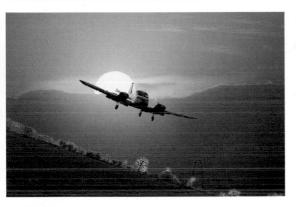

▲ Magnifying the sun

Shooting the sun can damage your eyesight irrevocably – but when it is low in the sky you can photograph it safely and without producing flare. A long lens is necessary, however, to make the sun appear large in the vicwfinder and on the photo.

■ 500mm lens, 1/125 sec at f/5.6 with monopod. ISO 100.

▲ Isolating a view

People assume that wide-angle lenses are needed for landscapes or panoramas, but sometimes long lenses work better, though their effectiveness over long distances depends on atmospheric conditions. A long lens here cut out the foreground and isolated the mountain top.

m 300mm lens, 1/1000 sec at f/8. ISO 100.

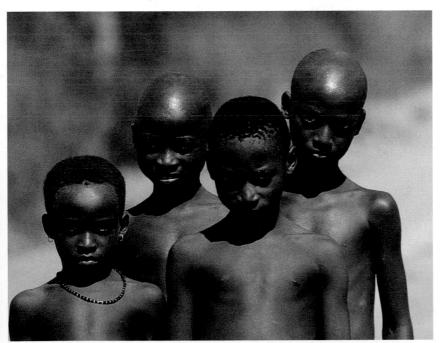

\blacktriangleleft Controlling composition

The longer the lens, the more it compresses perspective, and the more that depth of field is reduced. Both these factors have combined to produce a tight group portrait with no background distractions.

300mm lens, 1/4000 sec at f/5.6.
 ISO 100.

PROFESSIONAL HINT

Long telephoto lenses are particularly prone to chromatic (colour) aberration, where different wavelengths of light are focused slightly differently. This can lead to a slight softening of the image and colour fringing. The most expensive telephoto models use apochromatic (Apo) or extra-low dispersion glass to minimize this distortion.

Fast lenses

Although the focal length is probably the first consideration when choosing a lens, it is not the only factor. For the serious photographer, the maximum aperture of the lens (its "speed") is also of crucial importance. Some otherwise similar lenses are "faster" (have wider apertures that are capable of letting in more light) than others. A larger maximum aperture can be particularly useful in low light – allowing you to carry on taking pictures until later in the day without the need to use a faster ISO or a tripod, and allowing you to keep the shutter speed fast enough to freeze action and avoid camera shake.

Fast-aperture lenses are available in most of the popular focal lengths for the digital and 35mm SLR. They are more expensive, heavier, and larger than normal lenses. Many are primes; zooms usually have smaller maximum apertures than fixed focal length lenses, though this is not always the case. A 70–200mm telephoto zoom might have a maximum aperture of f/4–5.6 (f/4 when used at the 70mm end, and f/5.6 at the 200mm end). A fast version of this lens (a 70–200mm f/2.8) allows you to use a maximum aperture of f/2.8 at all focal lengths.

Key lenses for the professional sports photographer are the 300mm f/2.8 and 400mm f/2.8 – these allow you to use a shutter speed that is perhaps four times faster than with a more ordinary lens or zoom.

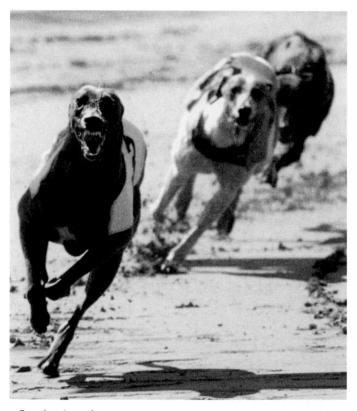

▲ Freezing the action

Fast, prime, telephoto lenses are the tools of the trade for the professional sports photographer. Here the maximum aperture of a 300mm f/2.8 lens serves a double of purpose. It ensures a fast enough shutter speed to freeze the sprinting greyhound, and also means that depth of field is restricted to focus the viewer's attention on the dog in the foreground that is winning the race.

300mm lens, 1/4000 sec at f/2.8. ISO 100.

TYPES OF FAST LENS

The fastest lens for most digital and 35mm SLRs is the 50mm lens. It typically has a maximum aperture of f/1.2—f/1.8, ideal for using handheld in low light. Once sold with every SLR, they are inexpensive to buy new, and can also be a secondhand bargain.

Canon 28mm f/1.8

Fast lens with a tripod mount

The faster a lens, the bigger it gets. Large-aperture lenses often have a tripod mount fitted to a rotating collar (protruding from this lens). This keeps the SLR steady without feeling front-heavy.

Nikon 70–210mm f/2.8 fast telephoto zoom lens with image stabilization

Professional-style ultra-fast lens

Sports photographers use fast telephoto lenses, such as the 400mm f/2.8 and 300mm f/2.8. These lenses enable them to use fast shutter speeds in low light, and the wide apertures allow them to throw hoardings and spectators out of focus.

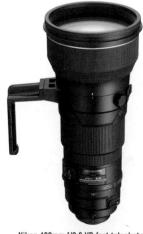

Nikon 400mm f/2.8 VR fast telephoto lens

▲ Keeping it natural

Using a fast standard lens can often mean that it is possible to avoid using flash in lowlight situations, so that you do not kill the atmosphere that has been created by the ambient illumination.

■ 50mm lens, 1/60 sec at f/1.7. ISO 100.

▲ Fast wide-angle and portrait lenses

Wide-aperture lenses are available not just in standard and long telephoto focal lengths. Some ranges offer faster-than-usual wide-angle and portrait lenses too. This picture of designer Erté was taken with an 85mm f/1.4.

m 85mm lens, 1/125 sec at f/2. ISO 100.

▲ Out-of-focus background

The large aperture of the standard lens ensures that just the hand is in focus – leaving the rest an artistic blur. A shot such as this would not work with flash, since the glass would reflect the light.

m 50mm lens, 1/30 sec at f/1.4. ISO 100.

The faster the lens you have with you, the longer you can carry on taking pictures at twilight without having to resort to using a tripod. This shot of London's Tower Bridge was taken with an ordinary fixed-focal-length standard lens. With a fast f/1.7 maximum aperture, it allows you to take handheld pictures of bright city lights well after dark.

■ 50mm lens, 1/15 sec at f/1.7, ISO 200.

◆ Freezing movement at dusk

As the light dims at the end of the day, it becomes harder to maintain the shutter speeds necessary to freeze moving subjects crisply in the frame (see pp.98–9). For this shot of a speedboat at dusk, a fast lens and a faster than usual ISO were necessary to provide a suitable action-stopping shutter speed.

200mm lens, 1/250 sec at f/2.8. ISO 400.

PROFESSIONAL HINT

Although a 50mm standard lens is already fast, you can buy faster models. These are more expensive but have maximum apertures of f/1.2 or f/1.4. The fastest ever made is a 50mm f/1.0 — capable of letting in 16 times more light than a zoom with a maximum aperture of f/4.

Fisheye lenses

Most lenses are designed to achieve an image that is as distortion-free as possible, although they do not always succeed. The fisheye lens is a notable exception: the whole point is that it produces contorted images where both vertical and horizontal lines curve outwards.

There are two types of fisheye lens: circular and full-frame. All lenses create a circular field of light, but usually only a central rectangular area is captured. With a circular fisheye, however, the image itself becomes round – with only the central part of the film or imaging chip actually being used. The corners of the image, therefore, are black. Circular fisheyes are usually made only for digital and 35mm SLRs; typically they have a focal length of 8mm with an angle of view of 180 degrees.

Full-frame fisheyes, too, typically provide an angle of view of up to 180 degrees – but they fill the whole image area. These have a longer focal length than some wide-angle lenses – typically 15mm for full-frame digital SLRs – but the barrel distortion created by the oversized front element of the lens gives an unmistakably warped image.

The bulbous glass at the front of the lens also means that filters, or other accessories, cannot usually be attached to the front of the lens. Some fisheyes have built-in filters, while others allow you to slot in cut-to-shape gelatin filters (usually used over studio lights). Extreme care must be taken not to scratch the front of the lens, since it is all too easy to touch the subject with the glass.

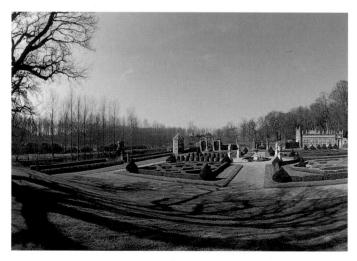

▲ 16mm fisheye (with full-frame digital SLR)

The full-frame fisheye lens used for this shot fills the whole image area – but the extreme wide-angle view has not been corrected, providing an image that is noticeably distorted. Here, we can see the horizontal lines of the formal parterre garden bowing downwards.

16mm fisheye lens, 1/125 sec at f/8. ISO 100.

FISHEYE FOCAL LENGTHS COMPARED

Strict comparison between the formats is not possible with fisheye lenses, as the angle of view is deliberately distorted. Only full-frame fisheyes are usually made for medium-format lenses. Dashes indicate where a lens is not available for this format.

35mm format	APS-C sensor	6 x 4.5cm format	6 x 6cm format	6 x 7cm format	5 x 4in format	10 x 8in format	Angle of view
8mm	4.5mm	_	_	_	_	-	180°
15mm	10mm	24mm	27mm	30mm	_	_	180°

TYPES OF FISHEYE LENS

Fisheye lenses are not made by all manufacturers.

Many SLR users have little choice as to what fits their cameras, and may have to buy out-of-production models secondhand. Fisheye zooms are uncommon.

Full-frame fisheye lenses have been made for some medium-format cameras — including some Mamiyas, Pentaxes, Bronicas, Rolleis, and Hasselblads — but their high cost means photographers tend to hire them.

Sigma 4.5mm f/2.8 circular fisheve lens

Pentax 10-17mm f/3.5-4.5 full-frame fisheye zoom

Fisheye converters

A low-cost alternative to a true fisheye lens is to use a converter, which radically increases the angle of view of the existing lens. These screw into the filter thread, and come in a range of magnifications. For example, a 0.42x converter turns a 28mm lens into a 12mm lens. Those with less-marked increases in angles of view are known as semi-fisheye converters, and these give a full-frame effect. The more powerful models produce a circular image. These converters bring fisheye photography to a variety of formats — including many digital cameras. They should be used with small apertures to maximize image quality.

Ohnar semi-fisheye converter

▲ ► Alternative shot

Above is a straightforward picture of a castle, taken from a distance to fit it all in. The less orthodox strategy (*right*) is to move in close and frame the whole image using the same lens but with a 0.3x semi-fisheye converter.

(t) 50mm lens and (r) 16mm lens, 1/60 sec at f/8. ISO 200.

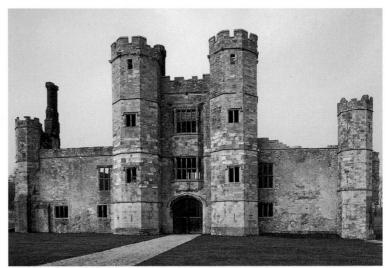

▲ Central subject

By placing the main subject in the centre of the frame, he appears relatively normal – but surrounded by a bizarre spherical world.

• 6mm fisheye lens, 1/15 sec at f/8 on tripod. ISO 400.

◄ Distorted self-image

In this self-portrait, taken with a circular fisheye lens, the hand and the lens are so close that they are practically touching. Both this shot and the one above show a round image surrounded by darkness.

m 6mm fisheye lens, 1/4 sec at f/8 on tripod. ISO 400.

PROFESSIONAL HINTS

- Take particular care that your feet, tripod, or camera bag do not appear in the shot.
- The most extreme fisheye lens was the Nikon 6mm. No longer made, it offered a circular image with a 220-degree angle of view. The mirror of the SLR had to be locked up to accommodate the rear elements necessitating the use of a custom direct-view viewfinder.

Shift lenses

For the serious architectural photographer, the shift lens, also known as a perspective control (or PC) lens, is an essential piece of equipment. Unlike ordinary lenses, it allows you to shoot a tall building without parallel lines appearing to converge, as the lens design means that the camera does not have to be tilted upwards to get the top in. Not only can elements of the lens be moved upwards out of central alignment, but also the shift mechanism can be rotated – allowing you to move the lens down and to either side, providing a range of useful effects.

How a shift lens works

A shift lens works by providing a much larger image than that of a normal lens. Only part of this circular image is recorded, however. The lens is shifted up, down, or sideways, to select which part of the image appears in the photograph. The apparent viewpoint is moved, without moving the camera. Shifting the lens upwards is known as "rising front", shifting downwards as "drop front", and moving sideways as "cross front".

With cross-front shift (not square on)

▲ Cross-front shift

By shifting the lens sideways, you can shoot slightly from the side of a subject, but still get a "square-on" image. This trick can be used when there is an obstruction immediately in front of the subject - or when the scene includes a mirror but you do not want the camera to appear in the shot (above left).

28mm shift lens, 1/60 sec at f/11 with bounce flash, ISO 100,

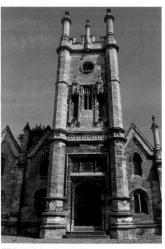

With rising-front shift

▲ Shift lens problems

There are drawbacks to using a shift lens, as these two pictures highlight. The areas of the shot at the extremes of the lens's coverage receive less light, and when the lens is fully shifted, parts of the image appear darker than others. The shot taken with the shifted lens (above right) has much darker top corners than the tilted shot (above left).

28mm shift lens, 1/125 sec at f/8. ISO 100.

USING A SHIFT LENS

- Mark Shift lenses are available for some, but not all, SLRs, and some medium-format cameras.
- Most models force you to focus manually, to stop down the aperture manually before shooting, and to lose some metering options.
- Most shift lenses have a wide angle of view with a typical shift lens for a digital SLR having a focal length of 24mm.
- The amount that you can shift the lens in each direction is limited. A far greater range of camera movements is possible with large-format cameras (see pp.350-1).
- A teleconverter used with a shift lens, though, will increase the amount of shift available (although the focal length also increases).
- A few shift lenses have a separate tilt control that allows you to swing the angle of the lens independently of the image plane (see pp.352-3).

Variable control

A typical shift lens has two controls. The front rotates. so that the lens can be orientated in the direction the shift is needed. A screw-like device refines the shift movement until the required effect is achieved.

A shift lens locked in central alignment

A shift lens with the front shifted to the side

Avoiding converging verticals

It is often necessary to tilt a camera with a normal lens backwards in order to fit the top of the structure in the frame. But by doing this, the lens is also tipped at an angle to the building, so vertical lines in the composition tend to run into each other. With a shift lens, however, you can keep the camera perfectly level, and raise the lens independently from the camera so that the top of the building is included in the frame without any distortion.

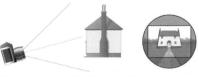

Normal lens: camera tipped at an angle

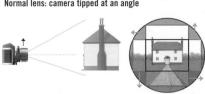

Shift lens: lens shifted to change composition

PHOTOGRAPHING PEOPLE AND BUILDINGS

Holidaymakers are fond of taking shots of friends or family standing in front of famous buildings, but this approach rarely gives a quality shot of either the person or the architecture. A good tip is to place the person to the side of the frame, and in the foreground, so the two subjects are visually distinct. The lens may need to be tilted, which will produce converging verticals; but these can be avoided by using a shift lens.

▶ Parallel verticals

Using a normal lens setting, the sides of the building converge (*right*). With a shift lens, the sides of the building appear more naturally parallel (*far right*).

28mm shift lens, 1/250 sec at f/11. ISO 50.

Without shift

With shift

▲ Rising front

Here the aim was to shoot the basketball hoop without the lines on the far wall appearing to converge. This was possible only by keeping the back of the camera parallel with the wall and using the rising-front movement to bring the backboard into shot.

28mm shift lens, 1/15 sec at f/11. ISO 200.

◄ Drop front

This photograph was taken from a bridge, and use of a shift lens with drop front avoided the need to tilt the camera down. This made it possible to include more of the railway track in the shot, which therefore provided a stronger feeling of linear perspective.

28mm shift lens, 1/60 sec at f/8. ISO 200.

Macro lenses

An important part of the specification of any lens is how close it can focus. The closer a lens can get to the subject, the bigger the magnification. Macro lenses are primarily designed to be used at very close focusing distances, so that even small objects can appear large in the frame. The actual magnification of a lens is dependent on focal length as well as focusing distance. Shorter focal length lenses tend to focus closer than telephoto lenses, though this advantage is usually cancelled out by the wider angle of view. However, the degree of enlargement varies significantly from lens to lens.

Some camera lenses may offer a maximum magnification ratio of only 1:12 (the image being only a twelfth of the subject's real size), but the image can be enlarged at a later stage.

True macro lenses can give an image on the sensor (or film) that is life-size, with a magnification ratio of 1:1. However, they still have a full focusing range, so can also be used for distant subjects. The stepless progression of magnification makes them far more versatile than other types of close-up equipment (*see pp.58*–9). A macro lens is invaluable not just for photographing miniature objects, such as insects and coins, but also for isolating details in all manner of subjects.

DEGREES OF MAGNIFICATION

This sequence of pictures shows the vast range of magnifications that are possible with a true macro lens. The first two shots show the maximum magnifications possible with most zoom lenses. The following shots were taken with a macro lens. The beauty of a macro lens is that it gives a stepless range of magnifications, from those possible using a normal lens through to ones that produce an image of the subject that is the same size as it is in real life.

m 100mm macro lens. 1/60 sec at f/11 with flash. ISO 100.

0.1x magnification with zoom lens

0.2x magnification with zoom lens

0.35x magnification with macro lens

0.5x magnification with macro lens

0.7x magnification with macro lens

1.0x magnification with macro lens

TYPES OF MACRO LENS

The most versatile macro lens for digital or film SLRs has an effective focal length of around 100mm. Some manufacturers also make 50mm or 200mm macro lenses. A 200mm might be better for timid insects, for example, while a 50mm might be convenient for small-scale rostrum work (*see pp.348*–9).

Canon 50mm f/2.8 macro lens

Nikon 105mm f/2.8 VR macro lens

Nikon 200mm f/4 macro lens

▲ Close focus

Focus accuracy is critical at close subject distance, as depth of field is limited. It took a tripod and a small aperture to get this snail looking sharp. Macro lenses often have a minimum aperture of just f/32 or f/45.

100mm macro lens, 1/125 sec at f/16 with tripod. ISO 100.

▲ Filling the frame

A macro lens allows you variable magnification. To ensure that this water lily filled the frame, the distance between it and the camera had to be adjusted only until it appeared neatly framed in the viewfinder.

100mm macro lens, 1/250 sec at f/8. ISO 100.

▲ Hidden world

Close-ups can reveal patterns and shapes that are not usually seen; this is a yacht's winch.

100mm macro lens, 1/60 sec at f/11 with flash. ISO 100.

■ Moving the lens

For fine focusing, it is often best to move the lens back and forth, rather than adjust the lens itself.

100mm macro lens, 1/125 sec at f/8 with monopod.

◄ Studio still-life

A macro lens is not just useful in the field – it can be invaluable for still-life shots in the studio.

100mm macro lens, 1/60 sec at f/16 with flash. ISO 100.

PROFESSIONAL HINTS

A 100mm macro lens
 enables you to be far enough away from the subject to
 avoid blocking out the light.
 "Macro" settings on zoom

lenses vary from an eighth life-size (1:8) to half life-size reproduction (1:2).

Macro accessories

While a macro lens is probably the most versatile option for those wanting to take close-up pictures, there are plenty of other ways to increase the magnification of the image, although the convenience, cost, quality, and magnification offered by each varies significantly. A much less expensive solution, and one that can be used even on cameras with built-in lenses, is an add-on lens. Extension tubes, which fit between the lens and the camera body, can also be less expensive than a specialist macro lens – and can be used with any focal length of lens, although the number of different magnifications is limited. For larger-than-life magnifications, a bellows unit can be used.

ACCESSORY MAGNIFICATION

Different close-up accessories offer differing magnification ranges and minimum focusing distances. The maximum magnification shows how large the recorded image will be, compared with the subject's real size (described using a magnification ratio).

Max magnification	Magnif.	
0.25x	1:4	
0.4x	1:2.5	
1x	1:1	
1x	1:1	
20x	20:1	
	magnification 0.25x 0.4x 1x	magnification ratio 0.25x 1:4 0.4x 1:2.5 1x 1:1 1x 1:1

Close-up lenses

Close-up lenses are used in much the same way as filters, screwing into the front of the lens. They are inexpensive and can also be used on many non-SLR cameras, including many digital compacts. They work like magnifying glasses, and come in a variety of strengths, measured in diopters (usually from +1 through to +4). A +1 diopter attachment will focus at 1m (3ft), a +2 will focus at 0.5m (20in), and a +4 at 0.25m (10in) – with any focal length of lens itself focused at infinity. They will focus even closer if the lens on the camera is focused at a closer distance than infinity. Close-up lenses can be combined: a +2 and +4 together give a +6 diopter effect (focusing at 0.17m/7in or less).

► Pentax S33

This close-up lens is specifically designed for use with the standard 75mm lens for Pentax 645 medium-format cameras – offering 0.42x maximum magnification.

▲ Magnifying the image

A supplementary close-up lens is essentially a magnifying glass that screws into the front of an existing photographic lens. The optical quality is not as good as with a true macro lens – but the result is acceptable if the aperture used is kept small.

 ${\tt m}$ 50mm with +2 close-up lens, 1/125 sec at f/11 with tripod. ISO 200.

DIGITAL CLOSE-UPS

Compact digital cameras often seem to have powerful close-up abilities. Even budget-priced compact models can be capable of focusing down to a few centimetres. This is because the lenses are generally smaller than on film cameras, and it is therefore much easier to build in extra extension as standard to position the lens elements that much further from the camera's focal plane. This comes into play when a special macro button is pressed.

On the LCD screen at the back of the digital camera, the image is shown larger than lifesize. This image has already been enlarged inside the camera, and is larger than that recorded by the CCD or CMOS chip. With many digital cameras, you can zoom in on images even further, before downloading them to a computer.

◆ Close focus

Unlike film cameras, the image from a digital camera is usually enlarged when you see the scene through the camera's viewing system, exaggerating its size. However, many digital models have excellent close-up capabilities, as can be seen in this shot of a rock pool.

35-140mm zoom lens, 1/60 sec at f/8.

Extension tubes

An extension tube fits between the lens and the SLR body, and allows you to focus closer than is possible with an ordinary lens, by extending the distance between sensor (or film) and lens. The tubes are often sold in sets of three, each with a slightly different length. They can be used singly, in pairs, or all together to give different magnifications. They can be used with prime or zoom lenses, but are normally designed to provide lifesize image magnification when all three tubes are used together with a standard lens.

▲ Extension tube

Pentax produced its own set of extension tubes for use with its 645 range of medium-format cameras.

► Single extension tube

This studio shot of a courgette flower was taken using a standard lens, with the smallest extension tube available for the camera.

80mm lens with extension tube, 1/00 sec at f/16 with tripod and flash. ISO 50.

PHOTOMICROGRAPHY

For really large image magnifications, you need to use a microscope, which will allow you to see subjects that are invisible to the naked eye at hundreds of times their normal size. Most microscope manufacturers make adaptors so that digital cameras and SLRs can be attached to their instruments. With some digital models, it is possible to shoot reasonable pictures simply by aiming the lens through the microscope's eyepiece. This can reveal information about the subject's structure that is otherwise invisible. Lighting must be carefully set up to suit the subject: while translucent subjects need to be backlit, solid ones should be lit from the viewing direction.

▲ Cross-polarization

This psychodolic shot was taken using an effect called cross-polarization, where polarizing filters are placed on both the light source and the viewfinder.

■ SLR with microscope, 1/15 sec. ISO 400.

Bellows

The bellows unit is a variable extension tube that allows you to change the distance between lens and camera. It can be expanded or collapsed using a rack-and-pinion system. The maximum magnification offers images up to 4x life size with a standard lens. Specialist bellows lenses offer even greater magnifications of up to 20x. The unit is attached to a focusing rail, which screws into a tripod that can be racked back and forth to focus the image.

▲ Novoflex Balpro 1

This universal bellows is designed to work with a wide range of cameras and lenses – including 35mm autofocus models and the Pentax 67 medium-format camera it is pictured with here.

◄ Bellows in the studio

A bellows unit is cumbersome to use, and is best confined to the studio, but it makes possible such novel shots as this view of a tube of toothpaste. Although the amount of extension is variable, the minimum amount of magnification may be too great for some applications.

50mm lens with bellows unit on tripod, 1/60 sec at f/22 with flash. ISO 100.

Lens attachments

A wide variety of accessories can be used to change the way in which a particular lens sees the world. Teleconverters and wide-angle adaptors change the angle of view, for example, while close-up adaptors increase its magnification. Filters can be used to change colours, to change the characteristics of the light, and to provide special effects. Other lens attachments provide a variety of other unusual effects.

Masks

A mask in front of the lens can be attached before the shot is taken to create a frame for your picture. Popular but somewhat overfamiliar choices include hearts, keyholes, and binoculars. To make these, simply cut out the required shape from a sheet of black card or plastic, or buy

them precut for square filter systems. In order to get a sharp outline, use a wideangle lens and a small aperture. The effect is easier to achieve in image-editing software.

Binocular mask

▼ ► Binocular effect

A mask of two overlapping circles is traditionally used to suggest looking through a pair of binoculars.

35mm lens, 1/30 sec at f/16, ISO 100.

Candid angle converter

The candid angle converter is designed more for harmless fun than for serious photography. The candid attachment fits to the front of the camera, and contains a 45-degree mirror that allows you to shoot pictures at right angles to the way the lens appears to be pointing. You can therefore take pictures of camera-shy subjects — who cannot see what is happening.

▲ Candid camera

A candid angle lens adaptor lets you shoot pictures at 90 degrees to the direction the camera is pointing, making it useful for shooting pictures of friends and family unawares.

85mm lens. 1/125 sec at f/5.6. ISO 100.

Anamorphic lens

Designed to allow you to shoot panoramic pictures with a film camera, anamorphic lenses shrink the image in just one dimension, fitting a wider than normal image into the usual picture area. After the shot is taken, the lens can be fitted to the enlarger or projector, which "stretches" the recorded image back to form a panoramic image. Many movies use anamorphic lenses to create a widescreen effect. The distortions that these attachments create, however, can be appealing (or amusing) in their own right.

Anamorphic lens with camera adaptor

▲ Without anamorphic lens

In this unmanipulated view of a glass-roofed building, note the shape of the windows in the immediate foreground. These will act as a demonstration of the effects of an anamorphic lens.

■ 50mm lens, 1/125 sec at f/11. ISO 100.

Split-field adaptor

Also known as a half-lens, the split-field adaptor is a semi-circular close-up lens that magnifies just half of the image area.

It is mounted like a filter – so that while one half of the lens is focused on the horizon, the other half can focus on something in the immediate foreground. The effect of using a split-field adaptor is similar to maximizing depth of field, but with a greater choice as to the lens and aperture that you use. A visible line between the two halves of the lens can be noticeable in the image, so it should be placed in order to make it as inconspicuous as possible. These adaptor lenses are available with different strengths of magnification, just as with close-up lenses (*see pp.58–9*).

Split-field adaptor

▲ Without split-field adaptor

With the snowdrops immediately in front of the camera, it is impossible to keep them in focus, even with a small aperture, if the building in the distance is to be sharply focused.

 $\,$ $\,$ 50mm lens, 1/30 sec at f/16 with tripod. ISO 100.

▲ With split-field adaptor

With the half-lens in place, both foreground and background can appear sharp at the same time. Notice the out-of-focus band just above the snowdrops, however, which is where the two halves of the lens meet.

 $\,$ 50mm lens, 1/30 sec at f/16 with tripod. ISO 100.

▲ Stretching the shot vertically

Used at a certain angle, the anamorphic lens squeezes the building inwards from the sides. The windows now appear narrow and taller.

m 50mm lens. 1/125 sec at f/11, ISO 100.

▲ Stretching the shot horizontally

The anamorphic attachment has now been rotated through 90 degrees, so that the image of the building is now squeezed from both the top and bottom. Notice that the windows have each become wider than they are tall – the reverse of their original shape.

m 50mm lens. 1/125 sec at f/11, ISO 100.

Filters

There are hundreds of different types of filters available to the photographer, and these filters change the image in a wide variety of different ways. Some create dazzling and psychedelic effects, some are essential with certain types of photography (*see pp.66–7*), while others are so subtle that it is hard to see what they are actually doing.

A filter can also be used to protect the vulnerable front element of a lens from knocks and scratches. Many

photographers permanently use a UV or skylight filter for this reason. UV filters are designed to reduce the amount of ultraviolet light reaching the film; these are particularly useful at high altitudes or in coastal locations, as they help to reduce the blue colour cast seen with distant vistas in such places. They also help to reduce haze. A 1A skylight filter is similar to a UV filter, but is amber-coloured – which warms up the tone of the picture slightly.

Filter systems

Filters, in comparison with other photographic equipment, can be inexpensive – but as your collection builds up, the total amount spent can soon mount up. For this reason, it is worth considering carefully which of the three filter

systems you are going to use. The square and round systems are the most popular. Confusingly, some filters for the square system are actually round, as polarizers and starburst filters need to be able to rotate freely.

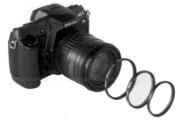

Round filter system

Round filters are mounted on a metal thread and screw into the front of the lens. The size (and the cost) of each filter will depend on the filter thread of the lens being used. If two or more lenses are being used, each may need differently sized filters. However, if the size differences are small, they can be overcome using adaptors (which are known as step-up and step-down rings).

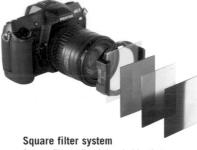

Square filters slide into a holder that screws into the front of the lens. A filter can be used on different sized lenses with the same holder, simply by changing an adaptor ring. Several sizes of square filters are commonly sold, so as to cater for all the different camera types and lens diameters available. Square filters are more cumbersome than round ones, especially for filters that are used semi-permanently.

A third filter type of filter system uses thin sheets of gelatin. These can be supported in front of the camera using a clamp and frame, or simply held in position. They are of less practical use outside the studio than the alternative systems, and are mainly used for colour correction (see pp.136–7). An advantage is that the sheets can be large enough to filter the light source.

Neutral density filter

This filter simply decreases the amount of light reaching the digital sensor or film. It is used when you want to use longer shutter speeds or wider apertures than you could otherwise use in the lighting conditions. It can be useful, therefore, for creative blur effects or when you need to minimize depth of field. An ND filter can be used when an exposure of many seconds is needed in daytime – for example, to make crowds disappear from a busy railway station.

► Slow shutter speed

A neutral density filter was used for this shot of a waterfall. This reduced the light reaching the film, allowing a shutter speed of four seconds. This long exposure, which would not otherwise have been possible, turned the waterfall into cloudy, white froth.

Filters for black-and-white film

By using filters with a single, uniform colour it is possible to change the tonal balance of black-and-white film. When using a green filter, for example, the grey tones created by green objects in the image are made to look lighter. At the same time, a green filter has the opposite effect on red-coloured objects, making them appear blacker in tone on film.

Strongly coloured filters are useful in black-and-white landscape photography, because they help to improve the contrast between the clouds and the sky. A red filter is particularly impressive, turning blue skies black – this happens in part because the film reacts to UV light that we cannot see, but the film can. An orange filter produces a slightly less dramatic result, while a yellow filter may be needed to record the sky as we actually remember it.

Some filters can be used in the same way with blackand-white film as they are for colour film. Other filters, such as those for correcting colour casts, are redundant. However, there is a full range of filters that are almost exclusively designed for use with black-and-white emulsions.

With green filter

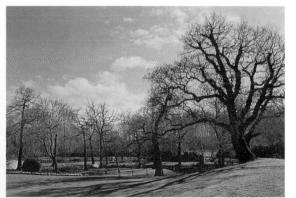

With orange filter

▼ Changing the tonal range

As with all coloured filters, those used for tonal adjustment with mono film reduce the light reaching the film, necessitating longer exposure. This is corrected for automatically if the SLR's built-in meter is used.

35mm lens, various shutter speeds at f/11. ISO 100.

Without filter

With red filter

With vellow filter

BLACK AND WHI	TE FILTERS			
FILTER COLOUR	WRATTEN NO.	TONES MADE LIGHTER	TONES MADE DARKER	PRIMARY USES
Red	25	Red, orange, yellow	Blue, green	For dark, dramatic skies
Orange	16	Red, orange, yellow	Blue, green	For contrasting skies. Hides freckles.
Yellow	8	Red, orange, yellow	Blue	For natural skies, lighter skin tones. Hides spots.
Yellow green	11	Green	Blue, purple	Gives foliage lighter, more natural, tone.
Green	58	Green	Blue, orange, red	Lightens foliage.
Blue	47	Blue	Yellow, orange, red	Lightens skies. Enhances haze.

Creative filters

There is a huge range of weird and extraordinary effects that can be produced by these lens attachments. You can add rainbows or mirages to your shots, or turn the scene in front of you into a dream-like blur. However, although it is fun to play with the more extreme creative filters,

and appealing though some of these effects are when used occasionally, they can quickly become tiresome if over-used. There are certain creative filters, such as soft focus, graduates, and starbursts, however, that some photographers use time and again.

Coloured filters

Filters with a uniform colour tend to be used with blackand-white film to change the tonal balance of the picture (see pp.62–3). However, there are occasions when these can be used with colour films. The effect is best suited for strong graphic compositions and for silhouettes - where the overall colour cast may help to add atmosphere.

Without filter

With orange filter

With yellow filter

With blue filter

Graduated filters

Graduated filters are very useful for digital or film landscape photography. The filter is coloured over one half, fading to transparent in the middle. This allows you to add colour to the sky and simultaneously reduce the contrast of the shot.

Graduates are available in many colours. A grey graduate (or neutral density graduate) darkens the existing colour of the sky. For a more marked division between the two halves, and stronger colours, use a wider lens or a smaller aperture.

Without filter

With blue graduated filter

With grey graduated filter

With tobacco graduated filter

Special effects filters

The usefulness of many filters has, to some extent, been diminished by the popularization of digital manipulation. Many of the effects provided by traditional filters can now be added easily, and with more precise control, using computer software (*see pp.392*–3). However, for many photographers, it feels more convenient and familiar to use the old-fashioned method to achieve popular effects, such as centre spots, prisms, starbursts, and soft focus.

► Prism filter

This filter allows you to multiply the number of times that a subject appears in the picture. The number and the arrangement of repetitions varies. In this shot, Battersea Power Station in the UK, is multiplied fivefold.

■ 50mm lens, 1/30 sec at f/2.8, ISO 200,

▲ Centre spot filter

These filters are clear in the middle and diffused or coloured around tho odgo. This allows you to keep a central subject sharp, while blurring everything around it.

■ 50mm lens, 1/8 sec at f/1.7 with tripod. ISO 100.

▲ Diffraction filter

A diffractor is similar in effect to a starburst filter, but priomotic grooved on the lone ercete rainbow-like patterns across the image. The radial patterns and amount of diffraction vary.

85mm lens, 1/60 sec at f/16 with flash. ISO 100.

▲ Soft focus filter

This softens the overall definition of the picture, giving a dream like quality particularly suited to romantic portraits. An alternative is to smear petroleum jelly over a clear piece of glass.

150mm lens, 1/60 sec at f/8 with flash. ISO 100.

A starburst, or cross-screen, filter has a grid-like pattern etched on it. This turns any highlight into a pointed star, with tails that can stretch across the whole image. They are particularly useful when shooting city lights after dark, candles, or shiny objects. Different types provide stars with varying numbers of points.

■ 35mm lens, 1/15 sec at f/5.6. ISO 100.

PROFESSIONAL HINTS

■ The most useful creative filters for digital photographers are the graduate ($see\ p.64$), the polarizer (p.66), and the ND (p.62).

■ Circular filters can be used together. Check that they are protruding so far that they are stopping light reaching the corners of the frame (which causes an effect known as vignetting).

Polarizers

Polarizers are among the most useful filters, particularly for those photographers using digital cameras or colour film. A polarizer is most often used to cut out reflections from glass or water, allowing the photographer to see through a window, or below a pond surface, more clearly. To get the maximum possible effect, a polarizer must be rotated. The effect is judged visually, turning the filter until the reflections are reduced as much as possible.

With many objects that are photographed, it is not obvious how much any polarized reflections spoil the shot. When polarized reflections are removed, objects such as glossy doors, glazed pottery, or shiny plastic have much richer, striking colours. Polarizers do not eliminate all reflections, though. A light source is polarized to varying degrees, depending on the angle of the light to the surface. Light must be reflected off a surface at around 30 degrees for the filter to have maximum effect. The choice of viewing angle, therefore, has an effect on the result. But even when the lighting angle is not ideal, a polarizer, rotated to the correct position, still has a useful effect.

Polarizers can also be used to deepen sky colour when shooting landscapes. The effect can turn featureless skies dark blue, and boost the contrast of the horizon so that cloud formations are more visible. The polarizer may need orientating so the effect is not overpowering.

WHAT IS POLARIZED LIGHT?

Although some insects can see polarized light, humans cannot. This is why the polarizer seems to us to have a miraculous effect on pictures. In simple terms, normal, unpolarized, light is a wave. It vibrates at right angles to the light wave's direction of travel, and in every direction that is at right angles to this direction of travel, while polarized light vibrates in just a single plane.

Light becomes polarized when it reflects off a surface — a glass window, water, a shiny object or even the atmosphere. Polarizing filters are made out of specially stressed plastic, and act a in a similar way to a set of railings — a barrier with thin slits in it. By rotating the filter, the slits can be positioned so that polarized light is blocked, as it is not vibrating in the right direction to get through. Normal light can partially get through, as some of it vibrates in the right plane.

Polarized light travelling through a filter

▶ Filtered reflections

In the shot on the far right, a polarizing filter has not only removed the reflections of the clouds from the car windscreen, but it has also reduced the reflections of the sky in the paintwork on the bonnet of the car. The filter was rotated until the best effect was achieved.

28mm lens, 1/125 sec at f/8. ISO 100.

Without polarizer

With polarizer

Without polarizer

▲ ► Intense skies

A polarizer has been used here to beef up the intensity of the blue sky in the background of this statue of a man holding a rearing horse. The effect is variable – the saturation level can be adjusted to suit the image.

m 28mm lens, 1/250 sec at f/11. ISO 100.

With polarizer

▼ ► Removing distractions

The bright reflections in the window behind the model were in danger of ruining this portrait. Careful use of a polarizer makes the problem completely disappear, creating a less distracting background.

■ 80mm lens, 1/125 sec at f/5.6 with tripod. ISO 100.

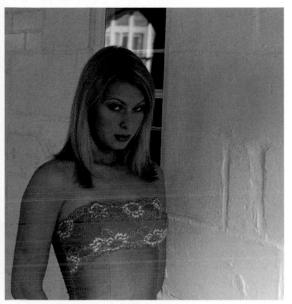

Without polarizer

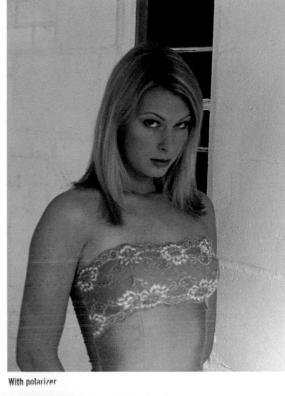

◄ Darkening the sky

The sky reflects polarized light when it is at 90 degrees to the angle of the sun. Using a polarizer to darken the sky, therefore, works best when the sun is overhead – as it will have an effect whichever way you turn your camera. But even when the sun is nearer the horizon, the filter works best with the sun behind you.

35mm lens, 1/250 sec at f/11. ISO 50.

PROFESSIONAL HINTS

- A polarizing filter can also be used as a variable neutral density filter (see pp.62–3), cutting down the light entering the lens by up to two stops, so that the photographer can set a wider aperture or slower shutter speed.
- Polarizers can help to reduce haze in mountainous landscapes, since this is caused by reflections from dust particles. The greatest reduction in the effects of haze will be achieved with sidelighting.
- There are two types of polarizing filter. The less-expensive linear polarizers work with basic cameras, and larger-format models however, they can have an adverse effect on modern metering and autofocus systems. Circular polarizers, which avoid these difficulties, are therefore the safest choice for most users.

Focusing

The success of most photographs hangs or falls by whether the image is in focus or not. The composition and other creative input count for little if the main parts of the picture appear fuzzy because the lens is not adjusted properly. On many cameras, the focus is adjusted automatically. However, it is still worth learning how autofocus works, so that you can understand its limitations – and can anticipate and correct for its mistakes. Whether using autofocus or manual controls, there are techniques for ensuring that the subject is as sharp as possible.

Understanding focusing

A lens can actually focus accurately at only one distance at a time – so just a single plane is sharp. Everything in front of, or behind, this plane is technically out of focus – and becomes progressively more out of focus the further away it is from this plane of focus. Fortunately, focusing is not quite as critical as this. In practice, there is a range of distances around the plane of focus that look acceptably sharp – a concept known as depth of field (*see pp.86–91*).

On the most basic compact cameras (such as disposable models), focusing is fixed at around 3m (10ft) – with depth of field being exploited to ensure that everything from 1.5m (5ft) to the horizon is sharp. With such fixed focus cameras the focal length and aperture are highly restricted.

When using other more complex cameras, it is essential that the focus is adjusted for every picture taken. On some cameras this is done manually, and on others it is automatic – while many cameras give you the option of both systems.

▲ Focusing on the eyes

It is not essential to have all of a subject in focus for it to appear sharp. When shooting portraits, for example, you should ensure that you focus on the eyes, so that these are as sharp as possible – whether using manual or automatic focus. If the eyes are sharp, it is not important if the tip of the nose or the back of the head is not completely in focus.

■ 120mm lens, 1/60 sec at 1/4 with diffuse flash. ISO 50.

Focus of attention

One of the beauties of photography is the way in which you can set up the camera and lens so that only some parts of the picture are in focus. This forces the viewer's attention on some parts of the scene, while blurring others.

Plane of focus

These three pictures clearly demonstrate that a lens can focus precisely on only one plane at a time. In the first shot, the lens is focused on the front of the table; in the second, it is focused on the statue; and in the third, it is focused on the painted background.

85mm lens, 1/15 sec at f/2.8 with tripod. ISO 200.

Focused on the foreground

Focused on the statue

Focused on the background

Manual focusing

Some digital and film compact cameras provide a manual override where you have to guess the distance to the subject. However, the advantage of all SLRs (and TLRs and large-format monorail cameras) is that you can actually see when you have focused the camera correctly. The image seen is the one formed on the focusing screen. This has a textured "matte" surface, designed to accentuate whether the image is sharp or not.

Manual-focus SLRs

Film SLRs without autofocus have focusing screen features that help to ensure precise lens adjustment, although these require reasonable light levels. A split-field prism, found in many manual-focus SLRs, uses two wedges of glass. When a line in the image is placed across the two halves of this split field, it appears broken if this part of the picture is not in focus. A microprism is found in addition to, or in place of, a split field on non-autofocus SLRs. This exaggerates inexact focusing by dispersing the image unless it is completely sharp, and it can be used in lower light than the split-field prism. An alternative manual-focus system is the rangefinder, found on some 35mm, digital, and medium-format cameras, which works in a similar way to the split-image prism. The lens is focused until the two images in the centre of the viewfinder are superimposed.

▲ Out of focus

Occasionally, you may not want anything in the picture to appear in focus. This effect can be achieved with manual focusing. Here, the unfocused silhouette and sun create a successful abstract picture.

300mm lens with yellow filter, 1/2000 sec at f/4, ISO 50.

DIOPTRIC ADJUSTMENT

To be able to judge whether or not an image is focused properly, the viewfinder needs to be adjusted to your eyesight.

Many SLR cameras offer built-in dioptric adjustment — allowing the viewfinder to be adjusted to your eyesight so that spectacles are not necessary. Usually this involves turning a knob or sliding a control while looking in the viewfinder, until the LCD or LED read-out (not the image) is in focus.

▶ Standard focusing screen

The basic focusing screen found on most manual-focus SLRs features both split-prism and microprism focusing aids. You adjust the lens while looking through the viewfinder, so that the microprism appears as clear as possible over the kcy subject area, and the split prism shows unbroken lines. Some models offer interchangeable focusing screens to boost image brightness, or for special applications (see pp.30–1).

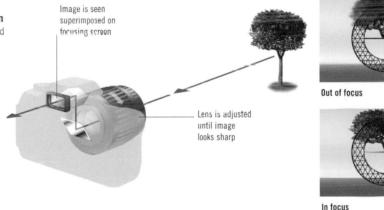

► Rangefinder system

This system superimposes two different views of the same subject – a direct view, and one reflected from a slightly different viewpoint. By angling the reflecting mirror, which is directly linked to the lens's focusing control, these images can be made to coincide so that the lens becomes focused.

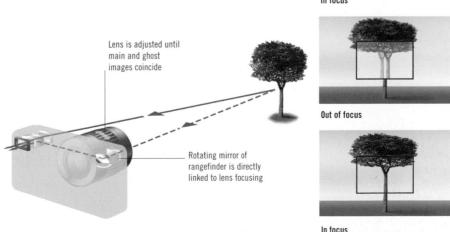

How does autofocus work?

There are two types of autofocus system used by cameras. Active autofocus, also known as infrared autofocus, is commonly used on film compact cameras, while passive autofocus is used on practically all types of digital camera (and on autofocus 35mm SLRs).

Active autofocus uses a beam of infrared (IR) light to measure the distance between the film and the object at which you are pointing the camera. Passive autofocus does not actively measure the distance to the subject – instead it adjusts the focus by looking at the image, using a similar approach to the way that we do when we manually focus an SLR camera on a subject.

The main assumption of the passive autofocus system is that an in-focus image has a higher contrast than an out-of-focus one – if it is in focus, it is blacker with hard edges; if it is unsharp, it is greyer and softer-edged. It continually adjusts the lens until it finds the maximum contrast in the area that you are focusing on.

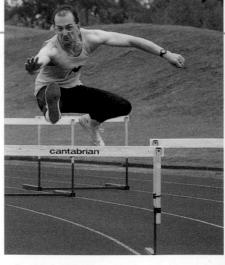

▲ Focusing at speed

Success in getting a sharp picture of a fast-moving target depends on the type and sophistication of the autofocus system used – not all will be able to focus fast enough.

200mm lens, 1/500 sec at f/5.6, ISO 100.

Active (infrared) autofocus

Infrared autofocus is fast and will work in total darkness. Its downfall is that it is effective only over distances of around 6m (20ft). This is fine for compacts with a fixed wide-angle lens, or for those with short built-in zooms, because, when the lens is focused at 6m (20ft), depth of field can be used to ensure that everything is sharp from that distance to the horizon (infinity).

The sophistication of infrared autofocus systems varies considerably. Some are capable of focusing at only two different distances – while others offer many hundreds of "focusing steps". The more sophisticated the IR AF system, the closer the minimum distance at which the camera will be able to focus.

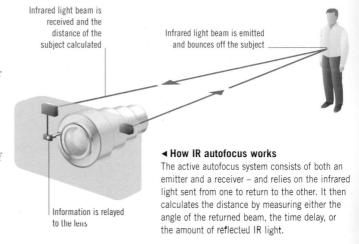

▲ Limited range

This yacht is far enough away that a camera using infrared autofocus can successfully set the lens for the middle distance – and know that depth of field will ensure that the subject is sharp.

Zoom compact, 135mm lens. ISO 200.

► Low-light shot

One of the strengths of infrared autofocus is that is can measure the subject distance with no difficulty in low light or even total darkness, making it the ideal partner for flash photography.

m Zoom compact, 35mm lens. ISO 200.

Passive autofocus

The passive system, or phase-detection autofocus, uses a small imaging chip (CCD or CMOS). This may be the same sensor that records the image, or a chip solely for focusing. This sensor analyzes whether the subject is in focus. The disadvantage of this system is that it needs reasonable light and contrast to work efficiently. There is also a tendency for the system never to be satisfied – still hunting for better focus, even when the image is perfectly sharp.

Although passive AF cannot focus in total darkness, some SLRs have a built-in lamp that shines a high-contrast pattern of light at the subject, giving the autofocus system something to lock on to in very low light situations. Most add-on flashguns for AF SLRs also have a built-in AF illuminator. The effective range of an AF illuminator, however, is only a few metres.

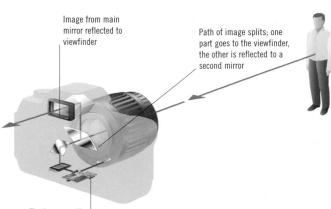

The image on the second mirror is sent to the CCD or CMOS chip, where it is analyzed. The data is then used to adjust the lens

▲ How passive autofocus works

On a 35mm SLR, some of the light from the image is directed through the semi-silvered section of the main mirror, via a secondary mirror below, to one or more CCD or CMOS sensors. On some digital cameras, the sensors used to form the image are also used to control the focus.

▲ Continuous adjustment

Passive autofocus systems often have a continuous mode, where focus constantly adjusts, making it useful for moving targets.

200mm lens, 1/500 sec at f/5.6. ISO 100.

▼ Long-distance photography

Passive autofocus excels with long lenses, as it just looks at the image rather than measuring the distance.

m 300mm lens, 1/500 sec at f/4. ISO 100.

FACE DETECTION

All digital zoom compacts use passive AF, but many use computing power to identify the main subject so they know which part of the scene to focus on. With face-detection autofocus, the camera analyzes the picture for human facial features within the frame. Some will even tweak exposure and colour balance to suit these parts of the picture. As with all intelligent autofocus systems (see pp.74–5), this system works best if you get a visual confirmation of what the camera is focusing on — and if you can switch to other focusing options when this mode is not appropriate.

Using autofocus

It would be wrong to assume that autofocus does everything for you. In fact, this facility would be better described as semi-automatic focus, because although it adjusts the lens for you, you still need to show the camera what to focus on initially. Autofocus is not perfect in all situations: you need to know when to give it a guiding hand, and when you will need to switch to manual.

The basic assumption made by autofocus cameras is that the subject is in the centre of the frame. Even multipoint focus cameras (*see pp.74*–5) assume that the nearest part of the subject is where you want to focus. Yet in many situations these assumptions are incorrect – especially when you start composing your pictures more creatively and wish to position your subject away from the centre.

Focus lock

Fortunately, even the most basic autofocus cameras have a facility that allows you to focus on a subject even when it is well away from the centre of the image. Called the focus lock, this is often incorporated into the shutter release button. Press the trigger halfway down to focus the lens. The camera then shows the focus is locked via an LED (light-emitting diode) indicator, which usually appears as a green blob in the viewfinder. The focus remains locked for as long as the button is pressed halfway down — or until the picture is taken. Use this system to focus on something at the side of the frame by placing it temporarily in the centre of the viewfinder, locking focus, and then recomposing the shot.

Focus lock set on key part of subject

Lens zoomed out and shot

▲ Focusing accurately

An effective method to get the camera to focus more accurately, whether using autofocus or manual focus, is to zoom in on a key part of the picture and focus on this using the focus lock (or manual focus). The camera can be focused more precisely using the telephoto end of the zoom, where focusing is more critical. Once set, the focus is locked, and the lens is zoomed out as required for the composition.

 $\,$ 35–80mm zoom lens, 1/500 sec at f/4. ISO 50.

Focus lock set to the side of off-centre subject

Focus lock set on off-centre subject

Image reframed and shot

▲ Focusing on an off-centre subject

In this shot of an oriental dancer, the main figure needed to be placed at the side of the frame. However, with most autofocus systems, the AF would lock on to the unwanted background of the shot, leaving the subject out of focus. A simple solution is to point the lens so that the dancer is in the centre of the frame, lock the focus, then recompose the shot so that the dancer is at the side of the frame.

■ 200mm lens, 1/500 sec at f/5.6. ISO 200.

▼ Autofocus through glass

Infrared and passive AF systems can have problems focusing through glass. A contrast system may focus on the surface of the glass, while infrared beams will be reflected. To be safe, it is wise to focus the shot manually, so that you can ensure that it is the subject beyond the window that appears sharp, and not the dirty marks on the surface.

■ 135mm lens, 1/125 sec at f/3.5. ISO 100.

Avoiding autofocus problems

Although the focus lock will work well on some occasions, there are other times when it is simpler to switch to manual. Manual focus will avoid unnecessary hunting by the AF system in challenging conditions – so that you can take the picture quicker, and with less chance of you missing the shot.

◆ Picking the right point

There are times when you cannot be sure that the AF system will focus on the right place. Here, the lens needed to be focused on the subject's eyes, and not the brim of the hat, so the distance was set manually.

135mm lens, 1/250 sec at 1/4. ISO 100.

▲ Very low light

Passive autofocus systems struggle in low light or in darkness, particularly if the subject is in the distance. For this shot of fireworks, autofocus was unnecessary anyway – as the lens could simply be set to infinity.

■ 50mm lens, B setting at t/8 with tripod. ISO 100.

PROFESSIONAL HINTS

■ Cameras with passive autofocus often have at least two AF modes. With "one-shot AF", the camera starts focusing as the shutter button is pressed, and locks focus when the relevant part of the image is sharp. This is best used with stationary or off-centre subjects. With "continuous AF", the camera continues focusing up until the moment that the shutter is fired. This is used with moving subjects (although predictive autofocus is better, see pp.74–5).

■ Even when switched to manual focus, passive AF cameras often provide a facility called "AF assist", which provides an in-viewfinder confirmation when it thinks the image is focused correctly.

Intelligent autofocus

The sophistication, speed, and accuracy of autofocus varies significantly from camera to camera. But it is when it comes to tackling moving subjects that the difference between models becomes particularly apparent. Some can compensate for high-speed subjects in a way that would be impossible with hand and eye alone.

While continuous autofocus (*see pp.70–1*) just adjusts the focus of the lens until the trigger is pressed, most digital SLRs and some other cameras have predictive AF systems – where the focus is adjusted right up until the point that the shutter is opened. The delay between firing and exposure (during which an SLR's mirror is moved) can be as much as a quarter of a second. A moving subject – particularly one moving towards or away from the camera – may therefore have moved out of focus during this time.

▶ The challenges of autofocus

Some subjects are easier for autofocus systems to cope with than others. If the subject is static, and in the centre of the frame, most will cope well. It is with fast-moving subjects that fill the frame that the difference between autofocus systems becomes noticeable. A good digital SLR would easily keep this challenging subject in focus.

300mm lens. 1/500 sec at f/4 with monopod. ISO 200.

Predictive autofocus

A predictive system uses the readings it takes before the camera's mirror moves to work out the direction, speed, and possibly even the acceleration of the subject – and adjusts the focus continually to suit. The longer the lens being used, the more the subject is moving and the more reduced the distance between camera and subject is, the harder predictive autofocus has to work – particularly when the subject is moving towards the camera.

► Approaching subject

This series was shot with a digital SLR, whose makers claim it can focus on an approaching subject moving at 40km/h (25mph) with a 300mm lens to within 8m (25ft). The closest shot of our less-demanding test was taken at 10m (30ft) – and the camera coped easily.

210mm lens, 1/90 sec at f/5.6 with tripod at 4.5fps. ISO 100.

Subject at 15m (50ft)

Subject at 24m (80ft)

Subject at 12m (40ft)

Multipoint autofocus

A fundamental weakness of autofocus cameras is that they assume that the subject is in the middle of the picture (see pp.72–3). Many autofocus systems are now capable of focusing over a wide area of the frame – and do not use just a small area in the centre of the image on which to base their calculations. Many AF SLRs, and some compacts, now take readings from several (or even several dozen) different parts of the frame. Normally the system then assumes that it is the focus area that gives the closest distance reading that is the one you want to focus on.

However, some cameras allow you to override the system – letting you select the sensor that you want to use for a particular shot. Some cameras can even set the focus area used by carefully monitoring which part of the frame you are looking at. Ideally, a multipoint autofocus system should tell you, in the viewfinder, which focusing area it is using at any time, so you can monitor its assumptions more accurately.

PROFESSIONAL HINTS

- When shooting moving subjects that you want to frame off-centre, override the multipoint autofocus system on the camera, and select the sensor you want to use.
- when using predictive autofocus, do not expect to see the subject in focus in the viewfinder. The image needs to be sharp only when the picture is taken at the point when you cannot see it. The effectiveness of the system can be judged only by the results themselves.

■ Identifying the subject

Here, the SLR marks the focusing sensors. As the boy's leg is covered by a diagonal sensor, the shot is focused accurately.

200mm lens, 1/1000 sec at f/5.6. ISO 100

Subject at 21m (70ft)

Subject at 11m (35ft)

Subject at 18m (60ft)

Subject at 9m (30ft)

Exposure

Whether you work with a digital chip or with photographic film, you will need a reasonable amount of light to take a good photograph. The exact amount that is needed or used to record an image is known as the exposure. Some scenes that are photographed are brighter than others – so the camera needs to control how much light reaches the film or imaging device. If there is too little light, the image will be too dark; too much, and it will appear washed out. The camera controls the amount the image is exposed with the aperture and the shutter speed.

Understanding exposure

For the camera to control and limit the amount of light reaching the image plane, the aperture and the shutter speed work in combination in a similar way to filling a tumbler. If you were to turn the tap so that a trickle of water came out (using a small aperture), it would take a long time to fill the tumbler (a long shutter speed). Turn the tap on full until it is wide open, and the tumbler fills much more quickly (a short shutter speed). How far you choose to open the tap will directly affect the rate at

which the tumbler is filled. In the same way, aperture and shutter speed cannot be chosen independently.

One other key factor is the sensitivity of the sensor or film. On digital cameras this sensitivity can often be increased or decreased, while some films require less light than others. This sensitivity is measured on the ISO scale (*see pp.112–13*); the higher the value, the "faster" the film or sensor sensitivity, and the better it is suited to low light (or where you need particular shutter speeds or apertures).

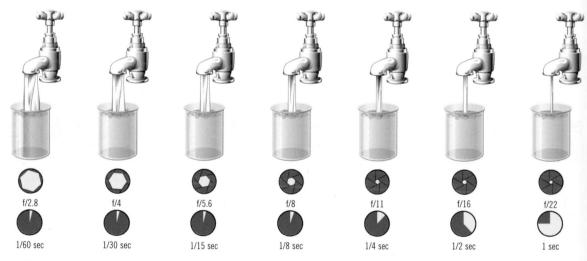

▲ Choosing the right combination

The tap analogy illustrated above is designed to demonstrate that the digital sensor (or tumbler) will receive the same amount of light (water) if each change of aperture (how much the tap is opened up) is matched

by a corresponding shutter speed change (the time the water is allowed to enter the tumbler). While the sequence of shutter speeds is self-explanatory, the aperture values need to be learnt (see opposite).

EXPOSURE VALUES

For any subject you wish to shoot, there is a wide range of shutter speed and aperture combinations that will allow exactly the same amount of light to reach the sensor or film, and so produce the same result. If 1/30 sec at f/11 will provide enough light for your photograph, then so will a combination of a 1/125 sec shutter speed and an aperture of f/5.6. So will 1/500 sec at f/2.8, and so will 1/1000 sec at f/2.

All these settings have the same exposure value (usually abbreviated to EV); in the example given above, it is EV12. Some cameras have EV scales marked on them, as do some handheld exposure meters, helping

you to select the right shutter speed/aperture combination for each photograph you take.

An EV value, when quoted in combination with a film speed, defines the amount of light in the scene. Therefore, EVs are often quoted by manufacturers to show the operational range of the meter or autofocus system of a camera.

Exposure values can be negative as well as positive numbers. For example, one stop below EV1 is EV0, and one stop below this is EV-1, and so on. EV0 is equivalent to a one second exposure at f/1.0.

Selecting aperture

The range of apertures available to choose from depends on the lens you are using – some open wider than others, while others have especially small settings. The aperture size is measured in f/numbers, or stops, corresponding to fractions of the focal length of the lens. So f/2 means the diameter of the aperture is half the focal length, and at f/4 it is a quarter of the focal length. Confusingly, therefore, f/4 is a smaller aperture than f/2. An f/4 opening on a 200mm lens is 50mm, and on a 28mm lens is 7mm; but each lets the same

amount of light reach the image plane, because brightness reduces as focal length increases.

It is the area of the aperture opening, not its diameter, that dictates how much light is let through – as the f/number is halved, the amount of light is quartered. Thus f/2 is four times the size of f/4. On the main f/stop scale, each stop lets in half as much light as the one before it. So f/2.8 is midway between f/2 and f/4. Many cameras and lenses also allow you to set half-stop or third-of-a-stop values.

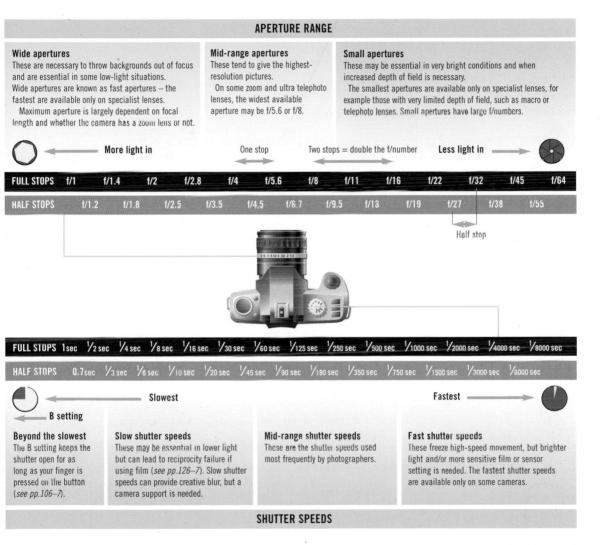

Measuring shutter speed

Shutter speed values are quoted in fractions of a second (sec): a 1/125 sec exposure is twice as long as one lasting 1/250 sec. A cause of confusion is the abbreviation of these values to 125 and 250, found on many cameras. Each halving or doubling of shutter speed represents a difference of a stop on the f/stop scale. The range of shutter speeds available will depend on the camera but is usually more extensive than the range of apertures. An exposure can be as short as 1/12,000 sec on top SLRs, but can also be set to last for several minutes (or even hours).

PROFESSIONAL HINTS

- Exposure can be open to interpretation. Just as some people prefer to fill a jug to the brim, while others might be more cautious, it is not always possible to say when a shot is perfectly exposed.
- With many subjects, you have to decide which part of the composition you want to expose for, as it may be impossible to choose a shutter speed/aperture combination where all parts are successively exposed.
- The reciprocal relationship between aperture and shutter speed should hold true for all shutter speeds. If using film, however, at very slow speeds reciprocity failure will occur (see pp.126–7).

Measuring and setting exposure

In order to produce an image with a good range of tones, it is necessary to select the correct exposure. This ensures that details appear neither too dark nor too light. A camera enables you to select exposure simply, since it measures the brightness of the scene for you, using a photo-sensitive cell that converts light to electricity – the more electricity generated, the brighter the image.

The problem for the photographer is that the brightness can vary significantly from one part of the image to the next. For example, the sky in a summer landscape is far brighter than the area of shade under a tree. If you were to set the exposure manually, the area you should set the exposure for depends on the result you want; normally you would set the exposure for somewhere between the two extremes. The way that a camera arrives at this compromise depends on the type of metering system it uses. Many SLR cameras provide a choice between three or more light metering systems.

How the camera measures light

The exact method that different cameras use to measure exposure varies from model to model – but essentially there are four types of metering system commonly found on modern cameras. The matrix system, in particular, varies enormously in its sophistication, depending on the camera.

On some autofocus cameras, the exposure mode and the autofocus system can be linked (*see pp.74*–5), so that the camera can work out which segment of the frame the subject is in. It then biases the exposure towards the light reading that was taken from this area.

▲ Average metering

This basic system, still used on the simplest compact cameras, takes light readings from across the whole image and calculates a mean value. Its main drawback is that it can easily be misled, most obviously when shooting a backlit landscape, where the sky is significantly brighter than the foreground. The lower part of the shot would end up underexposed.

200mm lens, 1/250 sec at 1/5.6. ISO 200.

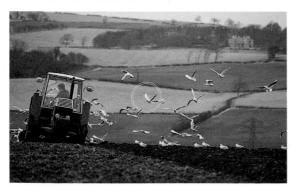

▲ Spot metering

Like a handheld spot meter (see opposite), this system takes its reading from a tiny area of the frame. By pointing the camera at different areas of a composition, the photographer can take a number of readings and calculate a representative average reading. It requires practice to identify suitable areas from which to take readings, and how to interpret them.

200mm lens, 1/250 sec at f/5.6. ISO 200.

▲ Centre-weighted average metering

This system works in a similar way to average metering, but its readings are biased to pay more attention to the brightness in the centre of the frame. The theory is that the subject of the picture is most likely to be in the middle. Of course, not all compositions are like this, but it is easy to anticipate when this system will fail and to compensate accordingly.

200mm lens, 1/250 sec at 1/5.6. ISO 200.

▲ Matrix metering

Also known as multi-zone and evaluative metering, this system is found on most top-end cameras. Essentially, it divides the image area into different zones, then compares the brightness values of each, using its computerized memory to estimate what type of picture is being taken. It then compensates for elements such as a bright sky or dark foreground.

200mm lens, 1/250 sec at f/5.6. ISO 200.

How exposure is set

Once the camera's meter has decided on a brightness reading for the scene, it uses this information to suggest, or to set, suitable aperture and shutter speeds. The choice that you have at this point will depend on the exposure mode used. Many cameras offer a range of exposure modes, giving you control over aperture opening and shutter speed.

Programme mode

Found on most modern cameras, including basic compacts, this system allows the camera to set both the aperture and the shutter speed automatically to suit the meter reading. In many cases, the shutter speed chosen will reflect the zoom setting or lens used. Some "picture programme" modes are designed for tackling particular subjects. For example, a sports programme may try to give you the fastest shutter speed possible to freeze the action.

The programme shift system is a clever compromise between the point-and-shoot programme mode and other, more creative, exposure modes. It is quick to use but allows some flexibility when required. The camera sets the aperture and shutter speed automatically, but, if you wish, you can change settings to get a particular shutter speed or aperture without affecting the overall exposure value.

Metered manual

This mode is useful for subtle exposure corrections. It allows you to set both your own aperture and shutter speed. The in-built meter then tells you how far it thinks you have got it wrong, based on its own exposure calculations (*see pp.80–1*).

Aperture priority and shutter priority

Aperture priority is a semi-automatic mode. You set the aperture and the camera sets the shutter speed to match the metered reading. With shutter priority, another semi-automatic mode, you set the shutter speed you want to use, and the camera sets the aperture needed to match the metered reading. Aperture priority mode is useful when you need to maximize or minimize the depth of field. Shutter priority is useful for freezing or blurring movement.

Off-camera meters

A separate, handheld meter is seemingly inconvenient, as any setting suggested by it has to be transferred to the camera. However, its advantage is that it takes incident light readings as well as the reflected light readings that a camera's built-in meter takes. Incident light is the amount of light falling on the subject, rather than that which is reflected from it, and as such is not affected by the subject's reflective or tonal properties.

▲ Using a handheld meter

With its white subject and white background, this scene would confuse a built-in meter, which measures light reflecting from the scene. A handheld incident meter, however, can measure the light falling on the scene, and so is not fooled by the highly reflective subject matter.

■ 135mm lens. 1/250 sec at f/5.6, ISO 100.

CHOOSING A HANDHELD METER

Handheld melers are available at a wide range of prices. Choose one that allows you to take normal reflective readings, and incident readings (through a slot-in white cone). Most meters take an average reading, but spot-metering models are also available. Special light meters are needed to measure flash exposures accurately (see pp.336–7).

▲ Aperture priority

A wide aperture throws a background out of focus. If this effect is required, aperture priority is the ideal exposure mode to use.

■ 135mm lens, 1/250 sec at f/4.

▲ Shutter priority

To shoot birds in flight you need to use a fast shutter speed to ensure that they appear in the frame. Depth of field and aperture were relatively unimportant for this shot of a seagull set against a background of vapour trails, so shutter priority mode was chosen in order to guarantee a shutter speed of 1/2000sec.

m 200mm lens, 1/2000 sec at f/4. ISO 100.

PROFESSIONAL HINTS

Top-end SLRs and digital cameras usually offer several built-in metering systems. With digital SLRs, you can check whether the meter is setting the right exposure by looking at your shots on the LCD screen. Most have clipping warnings to show which areas are overexposed. A histogram (see p.29) gives a graph-like representation of the exposure; this will help you judge when to use exposure compensation (see p.80). ■ The metering mode you use

is mostly a matter of taste.

Manual exposure

However sophisticated the metering system, a camera will occasionally suggest exposure settings that are wrong. Some scenes refuse to conform to the mathematical algorithms that intelligent cameras use. Problems also arise when the brightness range within the picture – the difference between the darkest and lightest spots – exceeds

the range the film or imaging chip can cope with. Areas of the picture will turn white or black, whatever exposure you set. The human eye, unlike the meter, can see what elements within a scene are important, so you can manually set the exposure to suit the compositional focal point. You can make these adjustments in a variety of ways.

Exposure compensation dial

The exposure compensation dial allows you to use the built-in meter to set aperture and shutter speed, and then adjust the overall exposure value (*see pp.76–7*). With a typical SLR, you can increase or decrease overall exposure by up to three stops. Experimentation will teach you where your built-in meter will fail and what the appropriate correction should be.

▲ Avoiding underexposure

Bright, reflective snow frequently leads to an underexposed picture. Use exposure compensation to get the camera to "overexpose" the shot. A setting of +1 is a typical starting point for such scenes.

28mm lens, 1/60 sec at f/5.6. ISO 100.

▲ All white

A light-coloured background can fool most types of exposure meter. For this shot, the exposure compensation dial was set to give half a stop more exposure than the built-in meter suggested.

200mm lens, 1/500 sec at f/5.6. ISO 100.

Grey card

Most meters assume that a picture has an equal distribution of dark, light, and grey tones. But what about those that are meant to be very white or very black? The built-in meter may try to turn both a uniform grey. A way around this is to use a special grey card; this is placed in the same place as a subject, and a reflective meter reading is taken from it.

▲ Built-in meter reading

A camera's built-in meter sees this predominantly white scene and sets the exposure to produce an average range of tones. But this means that the white water lily becomes darker than it is in reality.

■ 100mm macro lens, 1/125 sec at f/11 with tripod. ISO 100.

▲ Meter reading with grey card

For this shot, the camera took a meter reading from an 18 per cent grey card, which was held over the lily. The camera then had an "average" scene to work with, and produced a more natural exposure.

 $\,$ $\,$ $\,$ 100mm macro lens, 1/125 sec at f/8 with tripod. ISO 100.

Exposure lock

A common exposure compensation tool is the automatic exposure lock (AEL). This turns your camera into a basic handheld meter. The facility is found on some compact cameras, as well as many SLRs. To use it, point the centre of the viewfinder frame at the subject or area you want to take the meter reading from, press the lock, then compose the picture. Usually, you have to keep the lock button pressed down until the picture is actually taken.

Exposure lock can be used when shooting a picture of someone standing in front of a window. An exposure reading is taken by pointing the camera to the side of the window, and locking the exposure before recomposing the shot. On some cameras, the focus lock and exposure lock are combined, so care must be taken to avoid an out-of-focus picture.

Dark subject produces an incorrect exposure reading

Camera pointed at midtones, exposure locked

▲ Using the exposure lock

Choose a part of the scene that looks as if it is a mid-grey, or contains an average mixture of tones. Point the camera at this area and set the exposure lock.

▲ Keeping the elephant as a black silhouette

For this shot, the black silhouette in the centre of the frame would have affected the camera's motor reading. An exposure reading was taken from a grey area of water (one without for many bright highlights). The exposure lock was used to save this reading, while the shot was recomposed with the elephant in the centre of the frame.

135mm lens, 1/500 sec at 1/5.6, ISO 50.

Using manual exposure

A traditional way of compensating for exposure is to use the SLR's metered manual mode. The viewfinder information screen allows you to set shutter speed and

▲ Exposure suggested by built-in meter

With metered manual mode, it is relatively straightforward to choose aperture and shutter speed to get the exposure so that it is "correct" according to the readings taken by the built-in meter.

m 50mm lens, 1/125 sec at f/4. ISO 100.

aperture values that suit the built-in meter's evaluation of the scene. From this point, it is easy to turn the aperture or speed dial to increase or decrease the overall exposure.

▲ Deliberate underexposure

For this shot, a high-contrast version of the shot was wanted, so the exposure was set for the highlights of the scene. The result is a dramatic interpretation of the same portrait.

50mm lens, 1/125 sec at f/5.6. ISO 100.

Creative exposure

How accurate you must be with your exposure will depend on the recording medium you are using. Colour print film is very forgiving and gives printable pictures even if the image is overexposed by three stops or more, or underexposed by one stop. Digital images can also tolerate a surprising amount of exposure inaccuracy, which can easily be corrected in image-manipulation programs. But with digital it is safer to underexpose than to overexpose, as it is impossible to recover detail from areas that are significantly burnt out. There is much more latitude for correcting for exposure mistakes, without unwanted side-effects, if you shoot in the RAW format rather than JPEGs. Colour slide film needs to be exposed to within half a stop of the ideal, otherwise the image will look over- or underexposed.

Experimenting with exposure

For the best tonal range, your exposure setting should be reasonably exact. But it can sometimes pay to get the exposure "wrong" for artistic effect. Colour slides often give more saturated colours if they are underexposed by half a stop. Similarly, overexposing colour print film by a full stop can give more natural colours and contrast. Extreme overexposure can be used artistically to suggest bright sunlight or to give an abstract image. Underexposed shots can have a moody appearance.

► Creative underexposure

To take advantage of the dark background and the subject's black clothing, this shot was composed as a moody portrait. An ambient flash meter reading was taken from in front of the woman's face, and then the shot was underexposed by a full stop.

■ 120mm lens, 1/60 sec at f/16. ISO 100.

"Correct" exposure - 1/60 sec at f/16

+2 stops - 1/60 sec at f/8

+4 stops - 1/60 sec at f/4

▲ Ignoring the meter

There are occasions when using the incorrect exposure can lead to interesting pictures. These three shots of the same scene were taken with slide film. Each picture was given two more stops of exposure than the last. The final shot in the sequence is 16-times overexposed (+4 stops), but this still provides a good abstract image.

m 100mm lens, 1/60 sec at f/16, f/8, and f/4. ISO 100.

◄ Creative overexposure

At first sight, this composition looks like it might be two separate shots. In fact, the effect was created because the film was overexposed by three stops, causing the arms of the dancer in front to merge into the white background. This created a semi-abstract image that is more reminiscent of a painting than a photograph.

m 100mm lens, 1/125 sec at f/8 with flash. ISO 200.

BRACKETING

Setting the right exposure can be difficult in some situations, even with years of practice and the best metering systems. Occasionally, the consequences of not getting a successful shot are too great to risk leaving exposure to chance. It is for this reason that photographers will sometimes "bracket" important exposures, shooting a sequence of almost identical shots of the same subject — each at slightly different exposure values (*see pp.76–7*). How many shots are taken, and how much the exposure is compensated each time, will depend on the situation and the lighting.

Bracketing is particularly important when using slide film because it is so unforgiving of over- or underexposure. However, it is also a useful tool in digital photography. Typically, a user may shoot one shot at the

metered reading, then use the exposure compensation dial to take shots that give half a stop more, and half a stop less, exposure. Some cameras have an auto-exposure bracketing (AEB) facility, which automatically controls the adjustments necessary to create a bracketed sequence.

▼ Bracketed sequence

This sequence of shots shows how intolerant to incorrect exposure slide film is. For precise, high-quality results, the exposure needs to be within half a stop of the ideal settings. The amount of latitude available depends not only on the digital camera or film type but also on how much contrast there is in the scene being photographed.

■ 80mm lens, 1/60 sec at various apertures. ISO 100.

-2 stops - 1/60 sec at f/16

-1½ stops - 1/60 sec at f/13

-1 stop - 1/60 sec at f/11

-½ stop - 1/60 sec at f/9.5

"Correct" exposure - 1/60 sec at f/8

 $+\frac{1}{2}$ stop $-\frac{1}{60}$ sec at f/6.7

+1 stop - 1/60 sec at f/5.6

+1½ stops - 1/60 sec at f/4.5

+2 stops - 1/60 sec at f/4

Multiple exposure

When working digitally, it is easy to superimpose or merge two or more images into one frame, simply by using image-manipulation software. But with film, multiple exposures are more tricky. After each shot is taken, the film is often automatically advanced to the next unexposed part of the roll. To re-expose the same frame, this action has to be overriden. If a multiple-exposure facility is not available, it may be necessary to rerun the whole film (*see below*). With older manual-wind cameras, it may be possible to reset the shutter without advancing the film.

Creating a multiple composition

The simplest way to approach a double composition is to shoot the subject against a dark background, then shoot the second and subsequent exposures so that they coincide with unused areas of the dark background. Double-exposure masks – available from filter manufacturers but very easy to make at home – allow you to shoot multiple images that will be perfectly aligned, provided the camera is in the same position for each shot. For this reason, they work best when used with a tripod.

DOUBLE EXPOSURE MASK

Double exposure masks are designed to expose just half of an image area. After the first shot is taken, the mask is turned and the other half of the frame exposed, giving a dual image on the same exposure without the need for a black backdrop.

RERUNNING FILM

It is possible to take multiple exposures with some non-motorized 35mm SLRs by holding down the rewind clutch while cocking the shutter. But it is difficult to get well-aligned double images in this way. To gain more control, many photographers prefer to take an initial sequence of shots and then rerun the film.

To do this, start by lining up the film carefully when loading, marking it with a chinagraph pencil to show how far it was extended. Now shoot your series of first exposures. Carefully rewind the film so that the leader does not wind right into the canister (or use a special leader-retrieval tool). Reload the film, making sure that the pencil mark is in the same position as when the film was first loaded, and shoot your series of second exposures.

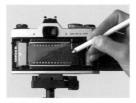

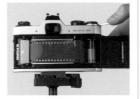

Marks matched up after reloading

▲ Black backdrops

Multiple exposures in the studio can be achieved by taking each shot against a backdrop of black velvet, ensuring that the different elements do not overlap. To create the blue coloration, tungsten film was used.

50mm lens, 1/60 sec at f/11 (twice). ISO 64T.

▼ Using an exposure mask

For this picture, the camera was locked on a tripod, with a double exposure mask obscuring one half of the scene. The shutter was then reset without winding on the film, the mask rotated through 180 degrees, and a picture taken of the woodpile without the model.

• 80mm lens, 1/125 sec at f/5.6 (twice) with tripod, ISO 100.

DIGITAL SOLUTIONS

Some digital cameras have multiple exposure facilities, allowing you to compare different effects before the shot is exposed. In this way, you can carry on reshooting until you are sure all the elements in the composition are perfectly aligned. Use a digital manipulation package to overlay several images in a simple process. Each layer can be modified separately, and there is a range of options to choose from when deciding on the final combination.

■ Triple exposure

Three separate exposures were used for this studio portrait. A black backdrop means that the joins cannot be seen between the different exposures.

80mm lens, 1/60 sec at f/11 (throo timos), ISO 100.

▲ Combining transparencies for double exposure

A low-tech route for double exposure is to combine two slides in the same mount. Patterns work well together with landscapes or portraits.

- m 100mm lens, 1/250 sec at f/4. ISO 100.
- 28mm lens, 1/250 sec at f/11. ISO 100.

▲ Projected images

One way to superimpose one image on another, without resorting to double exposure masks or other camera trickery, is to use two slides projected on to the same screen from two separate projectors. By adjusting the position of each projector, you can manipulate the elements.

50mm lens, 1/8 sec at 1/5.6 with tripod. ISO 100.

◄ Exposure compensation

If the light-toned elements in a double exposure overlap, there is a danger that the resulting image will be overexposed. The solution here was to underexpose both images by a full stop. This was done by setting the film speed on the camera to twice that of the film being used.

- **28mm lens, 1/250 sec at f/11. ISO 100.**
- m 50mm lens, 1/60 sec at f/4. ISO 100.

Depth of field

Without a doubt, depth of field is one of the most important controls in photography, and it is essential to understand how it works in order to manipulate it fully for your own needs.

Depth of field can be used to disguise or soften objects within the frame, or to make a photograph look so sharp that it almost comes alive. Depth of field is also a reason why it is easier to get an in-focus picture with some subjects than with others. As a general rule, photographers usually try to maximize their depth of field – making the image as pinsharp as it can be. But there are plenty of occasions when depth of field is deliberately minimized so that only a small part of the image is in focus, and the rest of the frame becomes unrecognizable.

What is depth of field?

A lens can focus precisely at only one distance at a time. To be completely sharp, the image must record points of light reflecting from the subject as points of light on the film (or image chip). Away from this plane of focus, points are recorded as minute circles, known as "circles of confusion". The larger these circles, the more out-of-focus the shot appears. For a certain range of distances, the circles are small enough to look like points, so the image appears sharp. This in-focus range is known as the depth of field.

The amount of depth of field is not constant – it depends on three main factors: the aperture, the focused distance, and the actual focal length of the lens (not the effective focal length). You can alter the effect by changing just one of these, but for the most extreme effects of depth of field, two or more are changed in combination.

CIRCLES OF CONFUSION

Depth of field depends on the size of so-called circles of confusion, which need to be small enough to look like points of light, rather than circles, if the image is to look sharp. The size of this "least circle of confusion" depends on the sensor size or film format, the distance the results are viewed from, and the enlarged image size. These last two factors usually cancel themselves out, as big blow-up pictures are looked at from farther away than small prints. For 35mm, the least circle of confusion is usually considered to be 0.036mm (0.0015in).

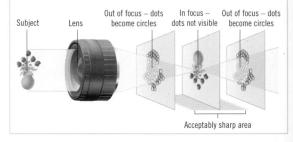

THREE WAYS TO AFFECT DEPTH OF FIELD

- The size of the aperture used is the most important factor in the control of depth of field as it is the one the photographer can usually do most about. (The other two factors are inter-related, and decided on by the composition.) Making the aperture smaller increases depth of field, while opening it up restricts it.
- The distance to the subject also has an effect. At close distances, all lenses offer less depth of field than when they are focused further away.
- The focal length of the lens, or zoom setting, affects the range of distances that appear sharp. The amount of depth of field reduces dramatically as focal length lengthens.

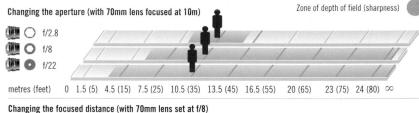

Ondinging the recused distance (with reliminations set at 176)

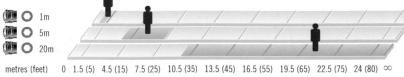

Changing the focal length (with aperture set at f/8 and focused at 10m)

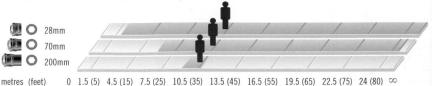

Changing the aperture

In these three shots, only the aperture was changed. Focusing on the model, who was 1m (3ft) away, it was possible to have the buildings in the distance pinsharp, or

significantly out of focus, depending on the size of the lens opening. The aperture that can be used for a shot also depends on exposure and sensible shutter speed selection.

▲ Taken at f/22

With the smallest aperture on a wide-angle lens, everything in the shot appears in focus.

28mm lens, 1/15 sec at f/22 with tripod. ISO 200.

▲ Taken at f/11

Opening the aperture two stops, the building in the background now appears out of focus.

28mm lens, 1/60 sec at f/11 with tripod. ISO 200.

▲ Taken at f/5.6

With a wider aperture, the statue is now out of focus, and the far background is more blurred.

28mm lens, 1/250 sec at f/5.6 with tripod. ISO 200.

Changing the focused distance

It is not the distance of the subject from the camera that is crucial for depth of field – but the distance at which the lens is focused (although the two are often the same). In this

sequence, three people are placed in a line 1m (3ft) away from each other. Focusing on each of the faces in turn produces three very different pictures.

▲ Focused at 1.5m (5ft)

Focusing on the first person in the line ensures only she appears sharp, although the second, unsharp, person is recognizable.

■ 80mm lens, 1/250 sec at f/2.8. ISO 100.

▲ Focused at 2.5m (8ft)

Focusing on the middle figure ensures he appears in focus. Notice that the person behind looks less blurred than the one in front.

■ 80mm lens, 1/250 sec at f/2.8. ISO 100.

▲ Focused at 3.5m (11ft)

Focusing on the furthest figure ensures she is sharp. Notice that the girl in the foreground looks more out of focus than the man.

m 80mm lens, 1/250 sec at f/2.8. ISO 100.

Changing the focal length

This statue was photographed from 3m (10ft) away. Despite using a small aperture of f/22, changing the focal length alone still had a significant and noticeable effect on the

depth of field. With a 28mm wide-angle lens, everything in the shot is in focus; but with a moderate telephoto lens, it is the statue alone that appears sharp in the photograph.

▲ Using a 28mm lens

Everything looks sharp – with depth of field extending from just under 1m (3ft) from the camera to the horizon (infinity).

m 28mm lens, 1/125 sec at f/22. ISO 200.

▲ Using a 70mm lens

Depth of field has been restricted using a longer lens. Sharpness extends from around 2m (6½ft) to 5m (16½ft) from the camera.

■ 70mm lens, 1/125 sec at f/22. ISO 200.

▲ Using a 135mm lens

Now the wall in the background looks out of focus. The depth of field extends from around 2.5m (8ft) to 3m (10ft) from the camera.

m 135mm lens, 1/125 sec at f/22. ISO 200.

Maximizing depth of field

Obtaining sharp pictures is a crucial part of photography, and for this you need to know how to extend depth of field. The general rule for doing this is to set a small aperture, use a wide lens setting, and position the subject far away, so that the focused distance can be increased. But although this can help on most occasions, there are times when it is necessary to be absolutely sure that the flower in the foreground is as sharp as the trees on the distant hilltop. There are a number of different ways in which the dilemma can be resolved.

If you are using a digital camera, the simplest solution is to take a shot then review the result, zooming into the recorded shot to see if your aperture or focusing point need to change to get more of the image in focus. To aid focusing and to make the viewfinder bright, all SLRs show the image with the lens aperture wide open. To get an accurate indication as to depth of field, some SLRs have a control that allows you to stop down the aperture to the value you want to use for the exposure, so you can preview which parts of the scene will be sharp. However, the smaller the aperture, the darker the viewfinder becomes, making this "depth of field preview" harder to use.

▼ Quick solution

Obtaining a maximum depth of field when there is a large object in the foreground can cause problems, as the foreground subject is likely to look out of focus. For this grabbed shot, I focused on the far arm of the statue and set the smallest aperture that the light would allow to get both the foreground and background successfully in focus.

m Pentax, 50mm, 1/30 sec at f/16. Agfachrome 100.

Focusing on the background (50m/160ft)

Focusing on the foreground (0.7m/28in)

Focusing on the middle distance (2m/61/ft)

▲ Using depth of field preview

Both the pier and gull needed to be in focus but, using the depth of field preview, this was not possible simply by focusing on either subject and using the smallest aperture. The answer was to focus just beyond the gull.

35mm lens, 1/30 sec at f/22 with tripod. ISO 100.

DIGITAL SOLUTION

Many digital SLRs have a Live View facility (*see p.29*) that allows you to preview and frame the image using the camera's large LCD screen. Because this image is created using the actual aperture set, it allows you to assess depth of field accurately — and you can often zoom into this preview to check the image sharpness carefully.

DEPTH OF FIELD SCALE

Some SLR lenses have a calculating device on them that allows you to read off the maximum and minimum distances that will appear sharp for a particular aperture and focused distance. On either side of the mark that is used to show the distance the lens is focused at, you will find a set of aperture values on a scale. Using the two marks for a particular aperture, you read off exactly how far depth of field extends behind and in front of a subject. You can check the distance of a subject within the frame by focusing on it, and reading the measurement off the scale.

Maximum depth of field can be quickly set by manually focusing the lens so that the infinity mark on the distance scale lines up with the appropriate aperture mark on the depth of field scale.

▶ Using the depth of field scale

Focusing on the sunbather, it was impossible to get the shoes in focus even with a small aperture (*far right*). I therefore used the depth of field scale on the lens to refocus the lens so that both elements were acceptably sharp (*right*).

■ 24mm lens, 1/30 sec at f/22, ISO 200.

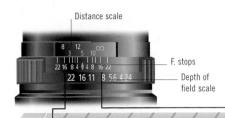

■ Using the scale

With the aperture set to f/16, the depth of field can be set to maximize how much of the picture is sharp. By focusing at 5m (16½ft), everything from 2.5m (8ft) to infinity will be sharp.

0 2.5m (8ft)

Without using depth of field scale

■ Where to focus?

Depth of field usually extends further behind a focused subject than it does in front of it. The depth of field behind the focused point is approximately twice that III (1011t. 10 Maximize the depth of field in this shot, the camera was focused a third of the way along the bike.

50mm lens, 1/60 sec at f/32 with flash. ISO 100.

PROFESSIONAL HINTS

Maximizing depth of field in landscape shots is to focus at the "hyperfocal distance". When the lens is focused at infinity, the minimum distance that appears sharp for a particular aperture is known as the hyperfocal distance. If you focus on the hyperfocal distance, depth of field at that same aperture will then extend from half the focal distance to infinity. ■ Some cameras use their autofocus systems to ensure that the elements that you want sharp are within the depth of field range. SLRs with multi-point autofocus (see pp.74-5) can access the closest and furthest points in the scene and adjust the lens and iris to keep these sharp. On other SLRs, you can manually input the two points you want to be covered by the depth of field range.

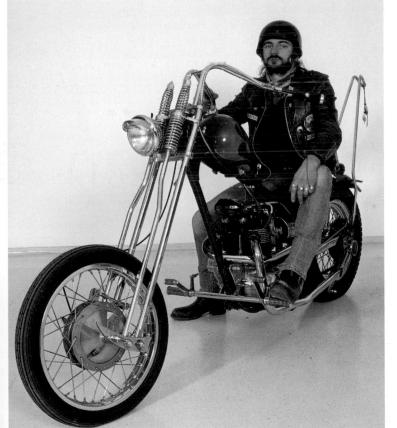

Minimizing depth of field

Even though every photographer needs to know how to create sharp, focused photographs, there are many occasions when the opposite effect is desired. By limiting depth of field, you can control the emphasis within your composition. You can disguise unattractive elements by softening their outlines, muting their colours, and throwing them out of focus, while at the same time drawing attention to the elements that are left in focus.

There are three simple ways to restrict depth of field. First, you can use a wider aperture. Second, use a longer lens setting – if you zoom in, for instance, you not only crop out part of the background, but you also increase the chances that the remaining background will appear out of focus. Third, you can get closer to your subject.

It is important to realize, though, that there are degrees to being out of focus, from a blurry but recognizable image to an abstract, anonymous backdrop. To achieve the latter, you need to use all three of the ways to restrict depth of field, and you also need to extend the difference between subject and background.

▲ Macro control

Although shots taken with a macro lens are usually taken with a small aperture, the subject is so near to the lens that any background more than a few millimetres behind the point of focus appears blurred.

■ 100mm macro lens, 1/250 sec at f/16.

▼ Losing the cage

Differential focus becomes essential when shooting caged animals. The secret is not just to use a telephoto lens and a wide aperture, but to push the lens as close as possible to the wire.

200mm lens, 1/250 sec at f/4.5. ISO 100

▲ Telephoto limits

With telephoto lenses, depth of field is extremely limited when focusing on subjects that are in the middle distance. The bust in this shot is 6m (20ft) from the camera, and the aperture is set at f/16. However, depth of field extends only from 5.3 to 6.9m (17.3 to 22.6ft). With this set-up, the window looks out of focus.

■ 150mm lens, 1/30 sec at f/16 with tripod. ISO 50.

▲ Instant backdrop

One of the reasons why medium-length telephoto lenses are so suitable for informal portraits is the ease with which they allow you to throw any background out of focus – even a busy beach.

■ 135mm lens, 1/125 sec at f/2.8. ISO 100.

▲ Losing the foreground

Use depth of field to make foregrounds practically disappear. The grass in front of the lens obscures the view of this male-voice choir – but it is far enough out of focus that it is not a distraction to the portrält.

■ 50mm lens, 1/250 at f/8. ISO 100.

◆ Providing emphasis

A difference in sharpness between the background and the subject is essential for this studio portrait – otherwise the model's top would be in danger of merging into the similarly coloured background.

■ 135mm lens, 1/30 sec at f/4 with flash. ISO 100.

PROFESSIONAL HINTS

- The closer the lens is focused, the more evenly distributed the depth of field is, both behind and in front of the lens.
- With backgrounds that are particularly distracting, try focusing the lens slightly in front of the main subject.
- Restricting or minimizing depth of field is often also referred to as differential focusing, or selective focusing.
- Lens definition varies with aperture size. Lenses give their worst performance when the aperture is wide open. The best quality is usually obtained when the lens is shut down by a couple of stops typically at around f/5.6 or f/8. Quality then deteriorates again slightly when the lens is shut down to the smallest apertures.

Shutter speeds

How long the shutter remains open determines the amount of light reaching the sensor or film. When selecting a shutter speed, consider whether the camera is supported securely. The steadier it is, the longer the shutter speed that can be used. Even tiny movements during exposure may mean the whole image is blurred. Using a tripod is the only way to guarantee success with pictures that require long exposure times. With a telephoto lens, camera shake is far more noticeable than with a wide-angle, so the longer the lens, the faster the shutter speed needed. As well as freezing action, shutter speed plays a role in suggesting movement, panning, and zoom bursts.

Holding a camera by hand

Most people use nothing more than their hands to keep the camera steady while taking a photograph. Unfortunately, the human body is not a steady platform. The beating of our hearts and the involuntary movement of our muscles make it impossible to hold a camera completely still.

The slowest shutter speed possible when holding the camera by hand will depend on a number of factors, including how steadily the camera is held, the type of camera and focal length of the lens that is being used (*see* Minimum Shutter Speeds *opposite*), and the atmospheric conditions on the day. It is much harder to prevent the camera shaking when you are taking photographs in a high wind or on a cold winter's day, and you may achieve better results at such times with a faster shutter speed than you would normally use for the subject and the lighting conditions. There are several ways to hold the camera securely, depending on what type of shot you are taking.

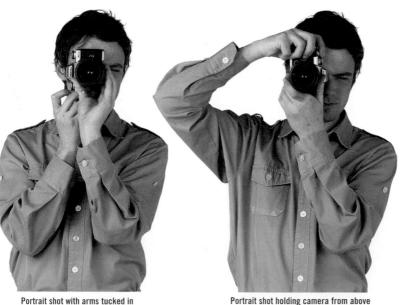

Holding the camera

When taking your photograph, stand with your feet slightly apart and always use two hands to hold the camera. Keep your elbows tucked into your sides, relax, and squeeze the trigger gently to minimize shake (*right*). To turn the camera for a portrait shot, either hold it with your arms tucked in to your side again (*above left*), or grip the camera from above, with your elbow pointing outwards, cradling the lens for support with your left hand (*above right*).

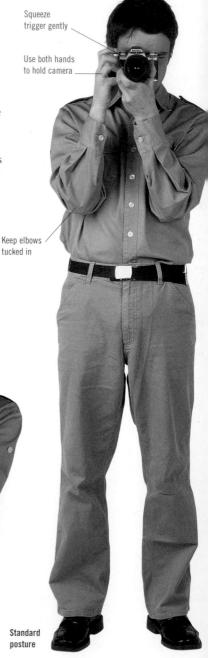

Keeping the image sharp

The unintentional movement of the camera during exposure – resulting in camera shake – is usually to be avoided, although there may be certain occasions when a blurred special effect is desired (*see pp.100–1*).

Usually, though, eliminating shake and keeping the picture sharp is a major aim when holding a camera. This is achieved by setting a fast enough shutter speed so that any movement of the camera is not noticeable in the finished picture. The exact shutter speed is not constant – and is largely dependent on the lens setting used.

Imagine the camera is moved no more than a fraction of a degree during an exposure. When using a wide-angle lens with an angle of view of 75 degrees, this is of little significance; but with an ultra-telephoto lens with an angle of view of eight degrees, the picture could be ruined (*see pp.38*–9). It is the angle of view, more than length of lens, that is important when choosing shutter speed, so the minimum speed for a zoom lens depends on the focal length at which it is used. For a 28–200mm lens, the minimum handheld shutter speed varies from 1/30 to 1/250 sec.

Allowing for camera make

Different types of camera will have subtle differences in how steady they can be held for certain shutter speeds, so it is important to experiment. SLRs require slightly faster shutter speeds than compacts, as the movement of the mirror contributes to vibration.

Non-reflex digital cameras with full exposure control can be used at shutter speeds around two stops slower than those recommended for an SLR, as the camera itself creates less vibration.

Large-format cameras are too heavy to use effectively without a tripod.

MINIMUM HANDHELD SHUTTER SPEEDS

As a rule, SLR users should use a shutter speed faster than, or equal to, one over the effective focal length of the lens in use (once crop factor is accounted for; $see \ p.16$). So with a focal length of 18mm and crop factor of 1.5x, the shutter speed should be 1/30 sec or faster.

LENGTH OF LENS USED		HANDHELD 35mm SLR	
	20mm	1/30 sec	
	28mm	1/30 sec	
	35mm	1/30 sec	
	50mm	1/60 sec	
	80mm	1/90 sec	
	135mm	1/125 sec	
	200mm	1/250 sec	
	400mm	1/500 sec	

▼ Minimum shutter speeds

These three shots of a seaside pier were taken using different lenses. With a 28mm lens, a shutter speed of 1/30 sec was needed to ensure there was no camera shake. For a 50mm standard lens, the speed was increased to 1/60 sec. For a handheld 135mm lens, a shutter speed of 1/125 or faster was essential.

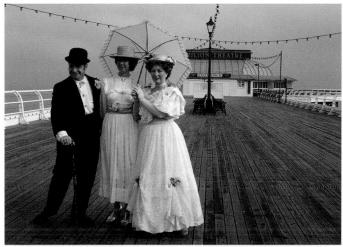

■ 28mm lens, 1/30 sec at f/16. ISO 200.

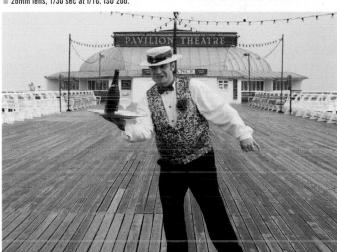

■ 50mm lens, 1/60 sec at f/11. ISO 200.

m 135mm lens, 1/125 sec at f/8. ISO 200.

Handheld camera support

To use the slowest shutter speeds, and to avoid camera shake at the same time, the camera needs to be steadily supported. However, there are times when you want to use exposures that are longer than those recommended for handheld users – and do not have a tripod to hand.

For longer exposures, you need to find a place to rest your camera where it can still have a good view of your subject. Placing it on a car roof, wall, window ledge, or table will provide support that is almost as sturdy as a tripod. It is useful to carry a small beanbag on which to prop the camera, which will cushion it and allow you to adjust its angle easily.

Leaning against a wall

Steadying the camera

There are a variety of ways in which you can increase the range of shutter speeds you can use, without the need for a support. If you just want to shoot at one or two shutter speeds slower than you would normally use, it is worth trying to find a way to brace your body as you shoot. Leaning your shoulder on a doorway, sitting on a chair, or even lying on the ground will all give your camera more stability than standing.

Some lenses and cameras have built-in systems that compensate for camera shake. They use an image stabilization system, which has detectors that measure the amount of camera movement. This information then controls a floating lens element or sensor, which can be moved continuously so the image remains static.

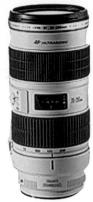

Canon image stabilization zoom

Sitting down

One of the most obvious ways of steadying the camera when you need to use a slower shutter speed than normal is to kneel or sit down. Whether there is a chair available, or if you simply sit down with your back against a convenient wall, you will immediately reduce the amount of movement in your body. Furthermore, as you relax, your heart and breathing rate will slow down, making it even easier to use slow shutter speeds.

◆ Finding support

Tripods are often frowned upon or banned in many public places – and in crowded venues they can be awkward to use, even if you do have approval for their use. This shot involved kneeling in an aisle, resting the lens on a railing to give it extra support. It was then necessary to wait for the right moment in the skaters' act, in order to get away with a slower-than-usual shutter speed.

200mm lens, 1/60 sec at f/4. ISO 400.

◄ Sitting still

Despite the stage lighting, this scene was not quite bright enough for handheld photography. By remaining seated, and using a wide-angle lens, however, it was possible to get a successful shot with very little movement.

■ 35mm lens, 1/15 sec at f/4. ISO 100.

CABLE RELEASES

For long exposures, do not use the shutter button, since this adds to the vibration of the camera; a cable release or remote control are better solutions, since you do not have to physically touch the camera. A low-tech alternative is to use the self-timer facility. This is designed for self-portraits, but the typical 10-second delay between pressing the shutter button and the shutter firing means that the exposure will be much steadier than otherwise.

- Use longer shutter speeds in obvious lowlight situations they are also often necessary when you want to achieve maximum depth of field.
- When resting the camera on a surface, prop it up with a beanbag, which can be made by filling a sock with dry rice or pulses.

Complete stability

While there are plenty of ways in which you can brace the camera so that your pictures are slightly less prone to camera shake, such techniques allow only a slight increase in the time the shutter can be opened before the risk of a blurred picture becomes likely. The only guaranteed route to a shake-free picture is to use a support that firmly anchors your camera and lens in position.

Supports such as clamps and spikes can be bought, but it is the tripod that is the most widely used device.

A tripod provides a solid platform on to which you can firmly screw the camera. Although all tripods have three legs, it is wrong to assume that they are all identical.

The main dilemma with tripods is that those that are most stable – and those that offer the best range of shooting positions – are the largest and the most difficult to transport. It is often necessary to compromise between rigidity, versatility, and portability. Budget is also a factor: a good tripod can cost more than your camera.

Quick-release platform allows Choosing a tripod instant removal of the camera from the tripod A heavy, stable tripod is capable of allowing exposures that are minutes, Standard pan-and-tilt or even hours, long, without any sign head allows precise control of the camera angle of camera shake, and so is invaluable when slow shutter speeds, smaller apertures, or excellent picture quality are sought after. One of the key factors to take into account when choosing a tripod is the range of different heights at which the camera can be used. Extendable legs and an elevating central column mean that the ▲ Ball-and-socket head platform may be raised and lowered The pan-and-tilt head can to accommodate different subjects. be exchanged for a balland-socket head. This allows quick and more varied movement of the camera, but is less precise than the pan-and-tilt head. ▲ Adjustable feet Many tripods come with a choice of rubber feet or spikes. Rubber ▲ Foldaway design is better suited to The legs of a tripod can be smooth surfaces, such shuttered in a telescope as floorboards, while fashion, and will fold inwards spikes are better for when not in use. use on dry grass. Geared centre column raises and Brace gives adjusts the overall the camera height of the more stability Legs made up of a number of camera. A crank sections. The number handle is turned to determines how small the tripod lift and lower the becomes when not in use, and platform will also have a bearing on the tripod's stability ▲ Typical tripod Tripods vary in price, the main difference being size and weight. The heaver it is, the more stable it is; the bigger it is, the higher the camera can be used above the ground. This tripod has a pan-

and-tilt head, which allows independent swivel-and-tilt movement.

PORTABLE SUPPORTS

Tripods are available in all sizes. Small models that fit inconspicuously into your camera bag are tempting — and have some use when you unexpectedly find yourself wanting to use a slow shutter speed.

Miniature tripods need to be placed on top of a raised surface, such as a table, so may have limited use. Also, there is a smaller range of shutter speeds available when using a mini tripod, compared to a tripod of a more solid design. Other portable supports, such as spikes, clamps, and pistol grips, can also be bought — and may prove useful for some applications.

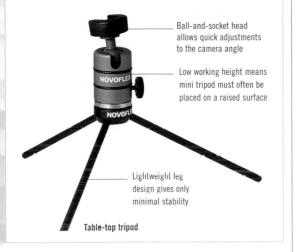

▼ Tripods for nature photography

Specialist tripods have legs that can be angled independently, and have a camera column that can be swung around – allowing you to take shots of a low flower, or of an insect resting on a tree trunk.

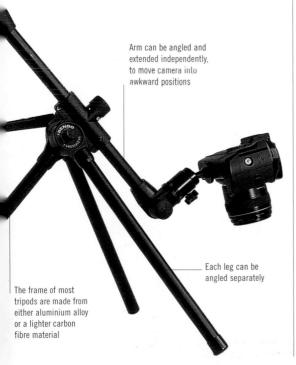

Monopods

For some subjects, a tripod is completely inappropriate. Its bulk and unwieldy shape means that it cannot be manoeuvred quickly – and it can provide a hazard to other spectators at popular destinations or events. The use of tripods is often banned in public buildings.

A monopod does not offer the same level of stability as a tripod. Its one leg is designed to give a little more support to the camera and lens than would be obtained by handholding. It is particularly useful with long telephoto settings, allowing you to use a shutter speed that is one or two stops slower than recommended for a handheld camera. Monopods are frequently used for subjects where very slow shutter speeds are inappropriate, such as sport.

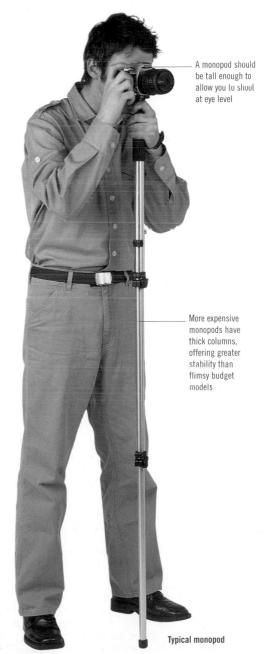

Freezing movement

Shutter speed plays an important part in translating moving subjects into a still image. The less time the shutter is open, the less the subject will move within the frame and the sharper it will appear. So it makes sense to use a fast shutter speed when shooting a fast-moving subject, such as a speeding motorbike or a galloping horse.

There are other factors to consider, too. First, the actual speed of the subject does not necessarily indicate how fast the image will change in the viewfinder. If a subject is heading directly towards or away from the camera, the image will change more slowly than if it is moving across the frame, and a slower shutter speed will be required to freeze it. Diagonal movement across the frame needs a shutter speed in between.

The size of the image is also important: a train seen as a blob on the horizon will not seem to move as fast as a poppy swaying in a gentle breeze right in front of the lens. The longer the lens setting and the closer you are to the subject, the faster the shutter speed you will need.

▼ Diagonal movement

In this display of horsemanship, these riders are galloping diagonally across the frame. To ensure the movement was caught crisply, a shutter speed of 1/1000 sec was required.

■ 300mm lens, 1/1000 sec at f/8. ISO 100.

SHUTTER SPEEDS TO FREEZE MOVEMENT

SUBJECT	DIRECTION OF SUBJECT MOVEMENT		
	Towards camera	Across frame (90° to camera)	Diagonally (45° to camera)
Pedestrian	1/30 sec	1/125 sec	1/60 sec
Jogger	1/60 sec	1/250 sec	1/125 sec
Sprinter	1/250 sec	1/1000 sec	1/500 sec
Cyclist	1/250 sec	1/1000 sec	1/500 sec
Horse at gallop	1/500 sec	1/2000 sec	1/1000 sec
Car at 50km/h (30mph)	1/250 sec	1/1000 sec	1/500 sec
Car at 160km/h (100mph)	1/1000 sec	1/4000 sec	1/2000 sec

▲ Panning

It is not always necessary to use quite as fast a shutter speed as the rules suggest. Often you can track the subject as you shoot to compensate for movement, using a technique known as "panning" (see pp.100–1).

135mm lens, 1/250 sec at f/5.6. ISO 200.

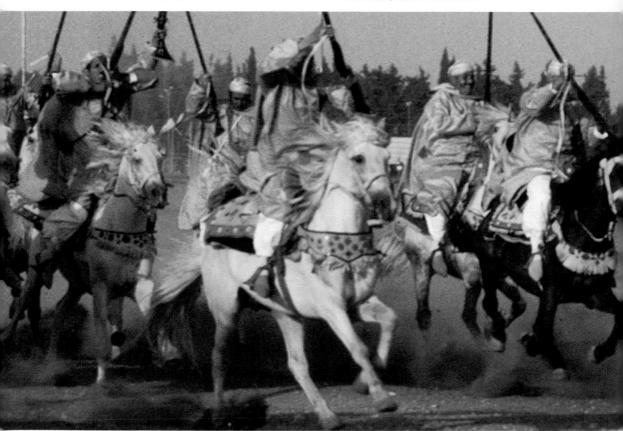

■ Keeping the image sharp

Moving across the frame at high speed, the speedboat in this shot demanded that one of the fastest shutter speeds available on the camera was used to ensure it appeared sharp in the picture.

200mm lens, 1/2000 sec at f/8. ISO 100.

◆ Frozen water

In this backlit shot, the water being thrown from the bucket has been captured in mid-air – as if it had been caught with stop-frame techniques.

28mm lens, 1/4000 sec at f/4. ISO 200

▼ Using a slower speed

In this family shot, the intention was not to freeze the water but to capture the three subjects sharply – so, compared with the shot above, a slower shutter speed was used.

■ 35mm lens, 1/250 sec at f/5.6. ISO 100.

PROFESSIONAL HINTS

- If you are going to blow your picture up to poster size, any subject movement will be far more noticeable than if you are going to use it as a thumbnail representation on a web page.
- Remember that there is movement in many scenes that at first glance appear static. People walk in front of your architectural shots, birds fly across your landscapes, and trees bend in the wind. You may need to increase the shutter speed to allow for this.
- A shutter speed that freezes the movement completely may not give the best results. There is often artistic merit in suggesting speed by allowing a moving subject to create a blurred image (see *pp.102*–3).

SHUTTER SPEEDS AND RELATIVE DISTANCE

Which shutter speed do you require to freeze a train crossing the landscape at 160km/h (100mph) when using a 50mm lens on a fixed 35mm SLR? The answer depends on how far it is away from you. The closer it is, the faster the shutter you will need to capture it clearly.

15m (50ft) away: 1/4000 sec

100m (330ft) away: 1/500 sec

500m (1/2 mile) away: 1/125 sec

1km (% mile) away: 1/60 sec

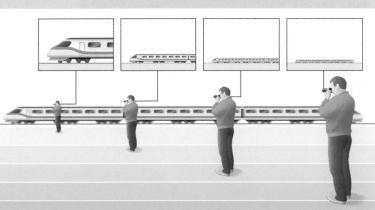

Panning and zoom bursts

As a photographer, you will sometimes want to take shots while in transit – in a car, for example. Since the camera is moving, use a faster shutter speed than you would from a stationary position to avoid a blurred image. There may also be times when you want to move the camera during an exposure. By moving your body around to follow the action, you compensate for the movement of the subject across the frame. "Panning" does not require as fast a shutter speed as when the camera is stationary. It also blurs the background, creating a feeling of movement.

A picture of a stationary subject can be manipulated to give a feeling of movement and drama, using a technique known as the zoom burst. Working with a zoom lens, the photographer changes the focal length during a slower than usual shutter speed. This results in an image with blurred radial lines appearing from its centre.

▲ Taking pictures from a moving car

It was relatively straightforward to pan smoothly with this shot, as it was taken from a car that was being driven alongside the two cars seen in the shot. Note that although the cars are in sharp focus, the camera movement has blurred the trees at the edge of the road.

m 50mm lens, 1/30 sec at f/16. ISO 100.

PANNING SUCCESSFULLY

- Hold the camera with two hands (*see pp.92*—3), with your elbows firmly tucked into your body and your feet slightly apart.
- Practise swinging around from the waist, keeping your upper body rigid and your feet firmly rooted to the ground.
- Keep your movements as smooth and steady as possible to avoid losing the fluidity of the shot. Do not rotate more than 90 degrees.
- If possible, pre-focus the lens at the correct distance for the subject.
- Set a shutter speed that is between two to four stops slower than you would normally use to capture this particular type of movement. For example, the standard minimum shutter speed for a sprinter running across the frame would be $1/1000 \sec{(see pp.98-9)}$; but for a pan, you should use a setting of $1/60-1/250 \sec{}$
- Start panning before your final composition comes into view, then gently squeeze the shutter when the subject is in the desired position. Continue the panning movement after the picture has been taken.
- Successful panning shots need a little luck and lots of practice.
- For smoother pans, use a tripod with a fluid pan-and-tilt head.

Panning action

▼ Action shots

Panning is useful in sports photography, enabling you to capture subjects moving at speed across the frame with slower shutter speeds than would normally be advisable – letting you continue shooting in lower light. It allows you to blur the background even if you are not using a fast lens.

200mm lens, 1/250 sec at 1/5.6. ISO 200.

▲ Abstraction

Zoom bursts allow you to create abstract patterns from all manner of objects. Here, a sunset behind a silhouetted tree has been turned into a radial design.

80-200mm zoom lens, 1/15 sec at f/11, ISO 50.

■ Twisting effect

For this shot, the camera was twisted around during exposure to create circular blurred images in the background. The subject itself was caught crisply by combining a 1-second exposure with flash.

35mm lens, 1 sec at f/11 with flash. ISO 50.

PERFORMING A ZOOM BURST

- Hold the camera as steadily as possible (see pp.92—3). Practise zooming at a moderately fast speed with the minimal camera movement possible. You can zoom in or out. Zooming out will mean you will be able to focus more accurately, as you will set up the shot using a more telephoto setting.
- Set a shutter speed of 1/2–1/30 sec. Start zooming the lens and then fire the shutter. Continue the zooming action until after the picture is taken. Try different shutter speeds, to give more or less blur.
- Use a tripod for sharper zoom bursts with straighter radial lines.
- Zoom bursts are most impressive with colourful or high-contrast subjects.
- Zooms with a separate manual zoom ring are best. With one-touch zooms (designed for manual-focus SLRs), the trombone action can cause the focus to be changed accidentally during the exposure.

▲ Creating movement

Although the boy on his bike was standing still, zoom burst gives an impression of speed to this shot. This sequence was taken at 1/4 sec, 1/8 sec, 1/15 sec, and 1/30 sec shutter speeds in order to experiment with different amounts of zoom blur.

■ 35-80mm zoom lens, 1/8 sec at f/22. ISO 50.

Suggesting movement

When using a fast shutter speed to freeze movement, it sometimes does the job so well that when you look at the picture, you have no idea that the subject was moving in the first place. A more artistic approach to moving subjects is to set a slower shutter speed. The resulting blurred image suggests movement and action. However, the effect works best if static parts of the image are blurfree. This gives a juxtaposition between subject and setting and also ensures that the effect looks as though it has been planned. The best way to achieve this is to use a tripod.

The exact shutter speed used will depend on the image speed and how blurred you want the subject to be. The shutter speed needs to be significantly less than the speed you would use to arrest movement (*see pp.98–9*); two or three stops slower would be a good starting point, so if you might conventionally use a shutter speed of 1/60 sec, try using 1/8 sec with the tripod.

▲ Selective blur

A slow shutter speed here has successfully captured a lively children's game in a single static image. The blindfolded girl keeps still, while the other children rush around her.

■ 35mm lens, 1/8 sec at f/16 with tripod, ISO 100.

▲ Conveying movement

The blurred figures in this portrait help to convey the energy and movement of the children's game. A handheld camera creates a more abstract shot than using a tripod would have produced.

m 135mm lens, 1/30 sec at f/8. ISO 100.

▲ Adding background interest

This set-up contrasts two types of transport. The bike is used as a prop for the portrait; the tractor adds interest to the background, and is blurred so as not to dominate the scene.

m 135mm lens, 1/15 sec at f/11. ISO 200.

▲ Ghost image

When combining a slow shutter speed with flash, the effect will depend on the amount of ambient light. Here, a strong ghost image is created as the woman turns around 90 degrees during the exposure.

 $\,$ 50mm lens, 1/4 sec at f/16 with flash and tripod. ISO 100.

▲ Static focal point

Shot with theatrical lighting and a tungsten white-balance setting, the cast become blurred as they move around the static central tigure — making him the main focal point for the shot.

100mm lens, 1/15 sec at f/4. ISO 320.

For this fashion shot, two assistants were asked to move quickly across the frame during the exposure. Their brightly coloured coats add streaks of red and yellow to the picture. The single black boot, captured crisply as the assistant swirled her coat, adds a surreal note.

50mm lens, 1/4 sec at f/16. ISO 100.

PROFESSIONAL HINT

Using longer shutter speeds will effectively banish anything that is moving from the scene. If a shutter speed of approximately 30 seconds or more is used, even a busy railway station at rush hour can look almost deserted, with only a ghostly blur to signify a human presence. To achieve such slow shutter speeds in daylight, you may have to use a neutral density filter to cut down the amount of light reaching the digital sensor or film (see pp.64-5).

Streaks of light

They say that the camera never lies, but there are many occasions when the photographer can capture images not visible to the human eye. Slow shutter speeds in particular transform moving subjects into images that are so blurred that they are unrecognizable – but the effect still creates a convincing artistic impression.

Slow shutter speeds are useful for capturing moving lights after dark. For example, the lights of passing cars can be turned into picturesque shots with snaking red and white lines by keeping the shutter open for several seconds at night. Other subjects that benefit from an even longer shutter speed than you might otherwise use in low light include fireworks and carbon-arc welding.

► Combining bursts of light

For aerial fireworks, it is easiest to keep the shutter open using the B setting (see pp.106–7), so that you can make the exposure last as long as the rocket. Frame the shot loosely, as you cannot be sure how high each firework will go. Several bursts can be combined on one frame by covering the lens with a piece of black card or cloth between each explosion.

50mm lens, B setting at f/5.6 with tripod. ISO 50.

▼ Adding fill-in light

Steelworks are notoriously difficult places in which to take photographs, due to the intense heat and ultra-bright furnaces. The challenge for this shot was to get enough fill-in light into the dark, steamy shadows, so old-fashioned flash bulbs were used, with a slow shutter speed.

 $_{\mbox{\scriptsize m}}$ 50mm lens, 1/15 sec at f/8 with tripod. ISO 50.

■ Optical tricks

Sparklers provide a spectacular photographic subject, but must be held at arm's length. For the flame to appear near to a person's face, a helper should hold the sparkler on one side of the subject, while the camera is on the other.

70mm lens, 1/15 sec at f/8 with monopod. ISO 200.

■ Reflected light

Welding provides an intense light that lights up the user's face. However, to ensure more even illumination for this shot, a mirror was used in front of the camera to reflect light back into the shot.

■ 00mm lens, 1/8 ser: at f/6.7 with tripod. ISO 50.

▼ Safe viewpoint

With large public fireworks displays, you need to find a safe place to set up your tripod where others will not trip over it – and where there are not too many heads blocking the view. A good tip is to stand behind a car, so that you get some protection from the crowds. Alternatively, persuade some friends to act as a shield.

35mm lens, D setting at f/8 with tripod, ISO 100.

PROFESSIONAL HINTS

- Do not use flash, as this will kill the atmosphere.
- Do not use a high ISO setting or film. A lower ISO, such as ISO 100, will let you use slower shutter speeds to maximize the streaks of light.
- \blacksquare Keep the camera on a tripod and use a flashlight to fill in shadows.
- Exposure can be hit-and-miss because of the contrast between the intense light of the subject and the dark shadows. However, when taking a reading, do not point the camera at the centre of the light, as this will create an underexposed shot in which the trails of light are weak. It is better to have the centres of the light source slightly burnt out. Experiment with a range of shutter speeds, and, if possible, bracket the exposure.
- For car headlights on a busy road, try 20 secs at f/16 (ISO 100).
- For aerial fireworks, try 4 secs at f/5.6 (ISO 100).
- For fairground rides at night, try 8 secs at f/16 (ISO 100).

Timing technique

While appropriate shutter speeds can normally be selected on the basis of subject and camera movement, there are subjects for which the usual rules do not apply. Lightning, for instance, is a subject that needs careful shutter speed selection. This natural phenomenon can produce impressive photographs, but it is not possible to capture lightning simply by firing the shutter at the right time – as the exact timing of the flashes cannot be predicted accurately. Instead, use the B (bulb) setting. This is found on most advanced cameras, and it allows you to keep the shutter open for as long as the camera trigger is pressed down. It is used when you want exposures lasting a number of seconds.

A tripod should be employed when using the B setting, but it should not be used in the open during an electrical storm. Instead, find a window with a wide panorama, which, if feasible, should be open to avoid reflections in the glass. Use a slow ISO and a small aperture. When the storm starts, keep the shutter open using the B setting. You can close the shutter when lightning strikes – or you can try to capture two or more forks in the same exposure.

Another occasion when the usual rules do not apply is when photographing the stars. The earth's movement will have an effect on the exposure (*see pp.346*–7). When using flash with an SLR, the shutter speed must be selected to ensure that the flash synchronizes correctly with the shutter firing (*see pp.166*–7).

TV MOMENTS

Particular care must be taken with the shutter speed when shooting images from a TV screen or computer monitor. Although the image appears constant to the human eye, it is actually made up of fine horizontal lines of light that are written one by one. If you use too fast a shutter speed, you will see only part of the image, or there will be a dark band across the picture. The whole image takes either 1/25 sec or 1/30 sec to be displayed on screen (depending on the TV standard used in your part of the world).

For lens-shutter compact cameras, a shutter speed that is the same or slower than this frame-refresh rate is perfect. With focal plane shutters, where there is the added difficulty of two moving curtains, the fastest safe shutter speed to use becomes 1/8 sec.

To ensure good screen shots:

- Clean dust and dirt from the screen.
- Never be tempted to try flash.
- Set up the screen so that colour, contrast, and brightness are not too extreme.
- Use a tripod and cable release.
- Darken the room completely, to eliminate reflections from the screen.
- The colour temperature of a TV screen is slightly blue, so use a CC20R warmup filter for accurate coloration if using slide film.
- Try to lock the image using the freeze frame control, if it is from a tape or disk.

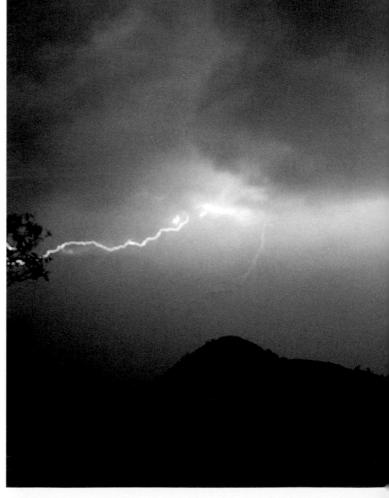

▲ Stop-motion shot

Capturing the moment when a balloon full of water explodes after a bullet hits it takes a brief exposure and split-second timing. Although a special triggering device can be used for such stopmotion events, a studio flash was used here and a plentiful supply of balloons. The camera shutter and the air pistol were fired together. These four attempts catch four different results.

■ 100mm moore lone, 1/60 sec at f/11 with studio flash and tripod. ISO 100.

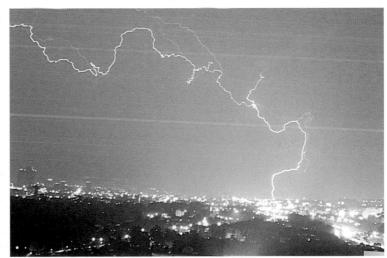

▲ Assessing shutter speed

How long you can keep the shutter open (using the B setting and a tripod) while you wait for lightning to strike will depend on how dark the scene is. The lights of the city (above) mean that even with a slow ISO and the smallest aperture, the maximum exposure was limited. In the countryside (left), a longer shutter speed could be used, with the silhouette of a tree providing the only foreground interest.

- (a) 28mm lens, 30 secs at f/11. ISO 100.
- (I) 35mm lens, 2 mins at f/11. ISO 100.

PROFESSIONAL HINTS

- Some cameras have a T (time) setting instead of a B (bulb) setting. To use this, press the trigger once to open the shutter, which then stays open until the trigger is pressed once again.
- For both T and B exposures, it is advisable to use a cable release or remote control to release the shutter (see pp.94–5).

Motordrives and continuous shooting

A continuous shooting mode allows you to take a series of pictures in rapid succession by keeping your finger on the shutter trigger. Most digital cameras have an option that allows this, while many film cameras have a built-in motor to wind on the film. On some film cameras, this feature is only available when a special accessory is used.

There are normally two or more drive settings. In continuous (C) mode, exposures are taken until you release the trigger. In single-frame (S) mode, just one shot is taken every time the trigger is pressed. Models with high-speed "motordrives" often have two continuous settings, which varies the intervals between shots.

Although handy for action subjects or for once-in-a-lifetime events, a motorwind does not guarantee that you will get a picture at exactly the moment that you want. If, for example, you are using a shutter speed of 1/1000 sec, and a motordrive of five frames per second (5fps), you will be taking pictures for only 0.5 per cent of the time; 99.5 per cent of the event, therefore, is not covered by the camera.

The faster the motorwind speed, the faster the memory or film is used up. At 5fps, a 36-exposure film can be used up in just over seven seconds. Bulk film backs are available for some cameras. A professional photographer will have several camera bodies and swap between them.

▲ Continuous shooting

Setting the camera to continuous drive means that you can shoot a series of similar pictures in a short period of time – so that you can check for the best expression and pose later on. This sequence was shot at 2fps.

■ 50mm lens, 1/125 sec at f/8. ISO 100.

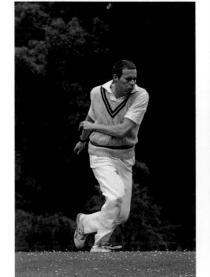

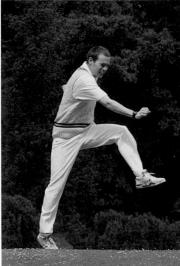

► High-speed motordrive

A fast motordrive is a useful tool for analyzing movement, or for when you want a sequence of shots of a moving subject with slightly different compositions. This sequence was taken with the continuous shooting drive mode set at 3.5fps.

m 200mm lens, 1/500 sec at f/5.6. ISO 200.

MOTORWIND SPEEDS

The maximum continuous shooting speed varies widely from model to model. Some cameras with built-in winders take over a second between exposures — and are of little use for continuous shooting. Others can shoot at up to ten frames per second (10fps). The maximum rate is often available only when the camera is used with a particular high-power battery pack. (In the SLR pictured, the top speed rises from 6fps to 8fps when the optional grip is used.) Film SLRs without built-in motors may have two or more accessory winders — a slower motorwind and a faster motordrive.

Nikon digital SLR

Battery grip for Nikon

BURST RATES AND BUFFERS

The maximum shooting speed for a digital camera depends not on the speed and quality of the film wind mechanism, but on the size of its internal "buffer" memory. It takes time to write the digital files to the permanent memory, so they are stored temporarily after the pictures are taken. In continuous shooting modes, it is not just the speed of the motorwind that is limited by the buffer size — so too is the number of exposures that can be taken at this speed. For the longest continuous "burst" rates, you must record using the JPEG format rather than RAW.

Film

The magic of film is its ability to record an image projected on to it. This happens because silver salts in the film change their chemical composition when they are exposed to light, with microscopic areas of the silver salts becoming metallic silver. This process, in itself, is not particularly sensitive or stable. After exposure, the film still does not have a visible image – it is at the processing stage that the chemical change in the silver salts is amplified and turned into a stable, visible form.

How film works

All film consists of several layers. The backbone of the film is the base – a thin sheet or strip of flexible plastic on to which the other chemical layers of the film are coated.

This transparent base is traditionally made of celluloid (cellulose triacetate) and may be just 0.1mm (0.004in) thick. The back of the base (the shiny side of the film) is coated with one or more layers. These include an anti-halation layer, which prevents light reflecting back through the base of the film and fogging the image. A coating is also usually added that prevents the film from curling when wetted and dried during processing. On top of the film are the emulsion layers, the duller side of the film, which typically measure just 0.015mm (0.0006in) in thickness – but it is here that the image is formed.

The emulsion layers

The emulsion is where chemical reactions occur and the image is actually made. The layer of emulsion contains the silver halides, a group of light-sensitive salts that include three chemicals: silver bromide, silver iodide, and silver chloride. It is these chemicals that react with light when the film is exposed.

The silver halides are microscopic crystals of various shapes and sizes, which need to be modified, since, in their raw state, they are sensitive only to blue light. They are mixed with chemicals known as spectral sensitizers, so that the crystals, even in normal black-and-white film, are sensitive to all the visible colours of the spectrum. Colour is produced in colour films by couplers, which release dye during processing in areas where the silver halides have been sensitized.

The glue that holds the light-sensitive silver crystals, dye couplers, and spectral sensitizers together to form the emulsion layer is gelatin. As well as acting as a binder, the soft gelatin has a vital role to play in the development process. Gelatin is highly absorbent, allowing the processing chemicals to reach the silver crystals without the emulsion falling apart.

How black-and-white film works

For black-and-white film, the negative image is traditionally created from the silver in the sensitized silver salts. However, chromogenic black-and-white films ($see\ p.119$) use colour dyes to create the negative image, and have a structure and development process that is closer to that used for colour negative film ($see\ below$).

How colour negative film works

Colour film has three separate emulsion layers, each of which is sensitive to a different primary colour of light. The latent, unprocessed, image in each layer is effectively black and white; it is converted into colour by the use of different dye couplers in each light-sensitive layer. The strength and distribution of colour depends on how well the silver salts were sensitized during exposure. These salts are washed away during processing to leave the three-layer dye-based negative image.

How colour slide film works

Colour slide film uses a similar process to colour print film, but the development of the image is in two stages. First, the silver halides are developed in a similar way to black-and-white film, then the negative images are turned into positive ones. These are redeveloped so that the dye couplers are activated. This produces the final, transparent, positive full-colour image. A blue colour in the subject creates a final positive image not in the blue-sensitive layer but in both the other emulsion layers, which create the blue image with cyan and magenta dyes.

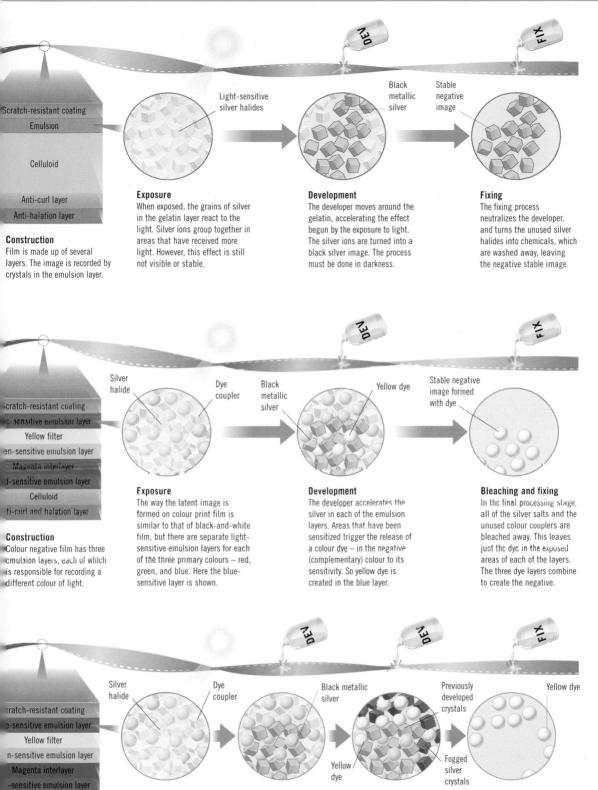

Construction

Celluloid

ti-curl and halation layer

Slide film is similar to print film – the differences are produced through the chemical process.

Exposure

The latent image is formed as with colour print film, with minute reactions in the silver crystals in each of the three light-sensitive layers. Here the bluesensitive layer is shown.

Mono development

The latent image is developed in the same way as in a black-and-white film — creating negative images in each of the three emulsion layers.

Reversal and development

The unused silver halides are then fogged (as if exposed to light) — creating a reversed image in each layer. The colour developer triggers the couplers to produce dye.

Bleaching and fixing

The silver material and unused dyes are removed with bleach, to leave a positive image, formed from the three colour-dye layers. Blue is created by the cyan and magenta layers together.

Film speed

Some films require much more light than others in order to produce a visible image during the processing stage. These variations in sensitivity to light are known as film speed. The less light a film needs to produce an adequate exposure, the "faster" it is said to be. A "slow" film, by contrast, is one that needs significantly more exposure than most other films.

In the analogy used to explain exposure, where water running into a glass is the light reaching the film (see pp.76–7), the film speed would be the size of the glass. Some films need more exposure, or "water", than others (so need longer shutter speeds or larger apertures) to get a similar result in the same lighting conditions.

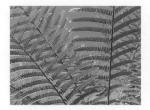

▲ ► Slow film

Slow film is used when there is full control over the lighting and it is possible to use a tripod, allowing as much subject detail to be captured as possible. Enlarged by 1,500 per cent (right), the fine grain quality is apparent.

■ 100mm macro lens, 1/60 sec at f/11 with tripod. ISO 50.

Grain quality produced on ISO 50 film

Choosing film speed

The availability of films with different speeds means that a photographer can choose one with an ISO rating that provides the range of shutter speeds or apertures that is suited to the subject matter in the prevailing lighting conditions (see opposite, above).

Film speed is usually measured on the ISO scale (see far right). By doubling the ISO speed, the film effectively only needs as much light to produce the same exposure with a one stop difference. So if an ISO 100 film needs an exposure of 1/30 sec at f/8, you could use a setting of 1/60 sec at f/8 with ISO 200 film, and 1/125 sec at f/8 with ISO 400 film. The slowest speed films available on the market have a speed of ISO 25, while the fastest are rated at ISO 3200.

It is not just a matter of choosing the fastest film whenever possible, however, as the disadvantage of a more sensitive film is that the grain structure is larger, with the larger silver crystals clumping together more visibly in processing. So the best-quality results, with the finest detail and best colouration, are achieved with the slowest films.

When to use fast film

It is generally better to choose a faster film, rather than risk your pictures suffering from unwanted camera shake, blurred movement, or inadequate depth of field. Although fast films are generally considered most useful in low light situations, this is not always the case. If you are using flash, or it is convenient to use a camera support and long shutter speed, then it is often perfectly possible, and even preferable, to use a slower film speed.

DIGITAL SOLUTION

The sensitivity of the imaging chip on a digital camera is typically equivalent to that of an ISO 100 film. On most models, it is possible to increase the sensitivity of the sensor manually by amplifying the signal from the chip before it is recorded. Although this means that less light is necessary to produce a well-exposed result, electronic noise is also boosted by the gain circuitry, producing a grainy picture similar to the effect gained when using a faster film in a film camera.

▲ ► Medium-speed film

A general-purpose film speed of ISO 100-200 can be used for the majority of shots. It should provide fast enough shutter speeds and sufficient control of depth of field for most subjects. Enlarged by 1,500 per cent (right), the medium grain quality is apparent.

■ 28mm lens, 1/60 sec at f/18. 150 200

Grain quality produced on ISO 200 film

▲ ► Fast film

A fast film ensures that it is possible to carry on shooting with a handheld camera even in bad lighting, making it perfect for lowlight action photography, or in situations where flash would be inappropriate. It also adds a grainy texture to photographs, which can be seen in the enlargement at 1,500 per cent (right).

m 50mm lens, 1/15 sec at f/1.4 ISD 800/3200

Grain quality produced on ISO 1600 file

Speed	ISO rating	Grain	Typical uses
Slow	25–64	Fine grain	Where fine detail is essential: copying work, still life and studio photography, tripod work
Medium	100–400	Medium grain	Handheld cameras in most situations where average daylight is available. General flash shots. Night photography where tripods and slow shutter speeds are required.
Fast	640–3200	Noticeable grain	Handheld photography in low light (<i>see pp.122—3</i>). When grainy quality is required.

THE ISO SCALE

The International Standards Organization (ISO) scale for film speed should be made up of two different numbers, but usually only the first is used. The ISO rating is a merger of two earlier systems — the ASA (American Standards Association) and DIN (Deutsche Industrie Normen) scales.

The ISO put the two different ratings together, so a film rated at 100 ASA, equivalent to 21°DIN, hecame ISO 100/21°. The full designation is usually given on film boxes, but only the ASA part of the number is used in common parlance — hence ISO 100.

Lyuiva	UIIIL	 ratings

=dantarent inni i anni B-			
ISO	ASA	DIN	
25/15°	25	15	
100/21°	100	21	
200/24°	200	24	
400/27°	400	27	
1600/33°	1600	33	

DX coding

In order for a camera's built-in meter to suggest suitable shutter speed and aperture combinations, it must know the sensitivity of the film you are using. With some cameras (and handheld meters), this information needs to be set manually, but other cameras can set it automatically.

On 35mm film, a silver pattern is painted on the side of the cartridge. The pattern is made up of 12 squares, which are painted either silver or black. The silver ones interface with electrical sensors inside the camera, and communicate the film speed. Some cameras have only a limited range of sensors, so can differentiate between only the most popular speeds of film.

A similar system used to be found on APS film. The film speed was recorded on a data chip in the film cartridge, and formed part of the information exchange (IX) facilities of the format (*see pp.116–7*).

Silver squares interface with electrical sensors in camera

▲ Coded information

The metallic pattern on the side of the 35mm film canister is used to relay its film speed automatically to the camera.

Types of film

There are three main types of film commonly used by most photographers. Although colour print film is by far the most popular film type in use by the majority of photographers, serious photographers are still keen users of black-and-white print film and colour transparency film.

While black-and-white film has its own aesthetic and creative advantages (see pp.118-21), colour transparency film gives results that match the original camera settings more closely than colour print film.

Transparencies and prints

Transparency film (also known as slide or chrome film) is essentially a two-stage film. The picture is shot, and the film is processed. The result of processing can be mounted in the form of a slide and viewed through a projector. Print, or negative, film is a three-stage film. It is shot, processed, and then it is printed on photographic paper to be viewed. The latter is popular because it provides the image in a form that is easy to hold and to display. Slides can also be turned into prints, but this is relatively expensive.

Serious non-digital photographers prefer slide film because the third stage that colour print film goes through allows room for change and error. When the negative is transferred to paper, the exposure and the colour balance are analyzed, and a decision made about how long the paper is printed for and the filtration that is used. If you have spent time adjusting the exposure and colour balance, you will not want a machine or a stranger to change these adjustments. A slide gives you the results as you set the camera. With colour print film, a third-party has been involved.

Slide film, however, has two major drawbacks: it has a much more limited exposure latitude than colour print film (see pp.82-3), and it can realistically be used only with more advanced cameras.

Film camera

print film, but slide

versions are available.

Colour print film This is the most

popular type of film in photography.

There are three different types of film in common use - each of which has different benefits and disadvantages. The route that each has to take from film to final form may affect the type that is chosen.

Colour slide film

Colour film is preferred by many serious photographers, who believe it gives better colour.

Brand differences

Some brands are better suited to some types of photography than others. One film may boost colours, making it ideal for general photography. Another may give more natural hues, making it better for scientific record taking. Some will enhance suntans in a portrait, others will make foliage more lush than in reality. The four pictures here show the subtle differences between four makes of ISO 200 film.

Agfa

This German manufacturer's film produced a wellbalanced palette of colours with the test subject.

Fuji

This Japanese manufacturer's film produced a less warm. perhaps slightly weaker, print than the Agfa film.

Processing

Processing Processing for colour

This can be developed by professional laboratories. and is also the easiest type of film to process at home (see pp.358-9).

Black-and-white negative

The processed film shows a reversed, negative, black-andwhite image.

Printing

of the colour process,

although negatives can be

digitally scanned straight to

a computer (see pp.368-9).

Home printing of black-andwhite negatives gives tremendous control over the resulting print. Commercial prints can also be made.

Black-and-white print

Black-and-white photography has aesthetic qualities and a simplicity that are not possible with colour films.

Colour negative

Not only does the processed film show a reversed colour image - but a strong orange dve in the film base also makes it hard to see the result.

Colour print

One of the reasons why colour print film is so popular is that it is so easy to see, store, and display the results.

prints is usually undertaken

by a professional laboratory

or high-street mini-labs with

a quick turnaround.

Processing

Processing for slide film involves an additional stage to that for colour negatives, as the image is turned into a positive using a reversal process.

Colour transparency

Once processed, there is no need for an additional printing stage. However, prints can be made from the positive.

Mounted transparency

Slides are more difficult to display than prints. They are viewed on a light box or projected with a slide projector.

Kodak

This American giant's film produced results similar to those of the other ISO 200 films, although slightly more saturated than the Fuji film.

Proprietary brand

Film is made in just a few factories in the world; most own brands are made by well-known manufacturers. This one arguably gave the best colours of all.

PROFESSIONAL HINTS

For high-quality commercial printing, such as magazines, brochures, and books, you will get better results using slides than with colour print film. In nearly all commercial printing applications, slides and prints will be turned into digital files before use. This process often loses some of the quality of the film medium. Although picture libraries used to accept only transparencies, nowadays nearly all will only accept new submissions in digital form.

Film format

The film format that a camera uses dictates both the size and the shape of the image produced. The key advantage of size is in the image quality. The bigger the film area that a camera and lens has to work with, the better quality the result should be. A big negative has to be enlarged less than a smaller one to produce a print of a given size.

With this increase in film size, there is a corresponding increase in the size of the camera itself, and of any lenses and accessories that are used with it. Professional photographers, therefore, work with the largest format feasible for the type of subjects they cover, or the smallest that their clients will readily accept.

Aspect ratio

The film format dictates the aspect ratio of the image area (the relationship between the height and width of the film area used to record the picture). Most cameras use a rectangular film area, but the relative dimensions of the shorter and longer side vary significantly. Panoramic models, for example, produce images where one dimension is generally two or more times longer than the other. The 6 x 6cm format is unique among commonly used film

formats in that the picture area is square. The aspect ratio can be important, as with some formats it may be necessary to crop the image in order to print it on a favourite size of paper.

Some cameras offer a choice of different aspect ratios. Some 35mm cameras have offered panoramic modes, where the image area can be masked for a single frame, or for a whole roll of film. The Advanced Photo System (*see right*) is designed to allow easy switching between three aspect ratios.

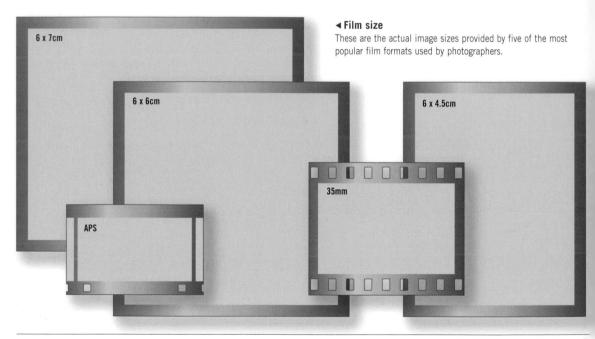

Format and image size

The key advantage of larger formats is that the bigger image area allows more picture detail. However, the quality of larger formats is slightly poorer than their size suggests because lenses for smaller formats often provide higher-resolution optics.

The table on the right shows the image area recorded for various popular film formats – and the amount of enlargement needed with each to produce a standard 10 x 8in print. Note that the image (negative) areas for medium and large formats are slightly smaller than their names actually suggest.

FORMAT Name	ALTERNATIVE NAME	ACTUAL Image size		ENLARGEMENT
8mm	Sub-miniature	11 x 8mm	(0.43 x 0.31in)	25.3x
APS	IX240	30.2 x 16.7mm	(1.18 x 0.65in)	12.2x
35mm	Miniature or 135	36 x 24mm	(1.41 x 0.94in)	8.5x
6 x 4.5cm	Medium format, 120/220	56 x 42mm	(2.20 x 1.65in)	4.8x
6 x 6cm	Medium format, 120/220	56 x 56mm	(2.20 x 2.20in)	4.5x
6 x 7cm	Medium format, 120/220	69.5 x 56mm	(2.73 x 2.20in)	3.7x
5 x 4in	Large format or sheet film	120 x 90mm	(4.72 x 3.54in)	2.3x
10 x 8in	Large format or sheet film	240 x 180mm	(9.44 x 7.08in)	1.1x

Types of film

The casing in which film is sold varies significantly with format. Smaller formats, such as 8mm and APS, are sold in easy-to-handle, lightproof, drop-in cassettes. Large formats use sheets of film that must be handled with extreme care if they are not to be fogged.

Medium-format film

▶ Boxed sheet film

Large-format film comes in sheets that must be carefully loaded into special film holders, one sheet at a time, before it can be used.

◆ Formats of film

Medium-format film comes in rolls without an outer cassette. The film is protected from the light by thick backing paper. 35mm film comes in a light-proof cassette.

Advanced Photo System (APS)

Once widely used for point-andshoot compact film cameras and some SLRs, the Advanced Photo System was designed to be easy to use. Ito oprocketless cassette is designed to avoid the loading problems that can be experienced with 35mm film. Human error is eliminated as the film is never seen by the user, being advanced from the cassette by the camera itself, and rewound after use. A unique indicator shows whether or not the film has been used and processed. The film area is around 40 per cent smaller than that used by 35mm cameras. Due to the popularization of digital cameras, APS cameras are no longer made, but film is available for older models.

Most APS cameras allow you to choose between three different aspect ratios. The "H" (HDTV) format uses the full film area, while the other two effectively crop the image. However, the film area is not masked, just tagged using a recordable magnetic layer used by the film. This cropping information is then passed automatically to the processing lab, but it is possible to override this and print the full area. The magnetic layer can also be used to store a wide range of information about the exposure, which the processing lab can use to help maximize the print quality. Date and caption information can also be stored, and printed on the picture at the lab.

APS Panoramic format - 3:1 ratio

▲► APS formats

APS film's magnetic coating allows a user to instruct the photo lab to print each frame in one of three formats:

HDTV - 4 x 7in (10 x 18cm)

Classic - 4 x 6in (10 x 15cm)

Panorama 4 x 12in (10 x 30cm)

Panorama – 4 x 12in (10 x 30cr prints

APS HDTV format - 9:5 ratio

▼ APS canisters

Each APS film cartridge has a unique serial number. A window at one end reveals one of four symbols: Circle = film unexposed; Half circle = some of frames exposed; X = all frames exposed; Square = film developed. The magnetic coating of APS films allows the user to instruct the photo lab to print each frame in one of the three formats shown right and above.

APS Classic format - 3:2 ratio

Film identification number stamped on back of prints

Indicators show if film is exposed or not

APS film cartridge back

Using black-and-white film

Black-and-white film not only gives an aesthetic, craftsman-like quality that is hard to produce in colour, it also allows you to do things that simply are not possible with colour film.

Black-and-white pictures often have a moody or timeless feel. In compositional terms, the lack of colour allows you to concentrate on form, texture, and pattern. There are practical advantages, too. In portraits, skin blemishes are much less noticeable than in colour. There are no problems with colour temperature and mixed lighting, making black and white ideal for many types of lowlight photography.

But the greatest appeal, perhaps, is the ease with which you can print your own pictures (see *pp.356–67*). In the black-and-white darkroom it is possible to experiment with contrast and exposure, and enjoy far more creative control than with conventional colour photography.

▼ Texture

Black-and-white film makes it possible to accentuate qualities that are often lost in colour photography. In this picture, the texture of this old man's back has been enhanced by increasing the contrast of the print in the darkroom (see pp.364–5).

100mm lens, 1/60 sec at f/16 with flash. ISO 100.

▲ Skin tone

Spots and skin blemishes are not as noticeable on blackand-white film as they are on colour, making it an ideal medium for photographing people. Blemishes can also be erased in the darkroom by shading these areas during exposure under an enlarger (see pp.364–5).

m 100mm lens, 1/60 sec at f/16 with flash. ISO 100.

▲ Exploiting grain

Deliberately using fast film, and then cropping or developing so as to exploit the grain, works particularly well in black and white. Here, the clumps of silver crystals in the film add an intriguing rough lexture to the skin of the model.

50mm lens. 1/30 sec at 1/16 with flash. ISO 400.

▼ Leaf detail

As black-and-white film portrays the world in a different way than we actually see it, it gives subjects an artistic quality that is much harder to capture in colour

■ 100mm lens, 1/30 sec at t/16 with flash. ISO 100.

CHROMOGENIC FILM

On traditional black-and-white print film, the image on the negative is made out of silver crystals. An alternative type of black-and-white film is known as chromogenic or dye image. This type of film works in a similar way to a layer of colour print film, creating the image by converting the silver to dye during processing.

An advantage of chromogenic film is that it has a greater exposure latitude. This means different ISO ratings can be set on the same roll of film to be used at speeds from, say, ISO 50 to ISO 800 without any need for change in the development procedure. The film can be processed at a colour laboratory, although best results are obtained using hespoke developers.

Many photographers prefer the distinct, gritty grain structure that the traditional films produce, although grain structure can vary significantly from brand to brand.

See also How film works p.110 Seeing in black and white p.120 The darkroom p.356

Seeing in black and white

Although black-and-white film simplifies the image, it can be more more difficult to use than colour film because it is hard to visualize how the picture will appear when stripped of all its colour. Instead of a colourful rainbow, you need to be able to see nothing but blacks, whites, and shades of grey.

Part of the problem is that when a subject is reduced to tone alone, areas that look distinct can start to merge together. A bright red, for instance, can end up looking the same shade of grey as a dark green. Learning to be able to visualize this can take a lot of practice. One successful way to exploit black-and-white film is to think carefully about the contrast between light and dark. Look at the way in which these are used to create pattern, form, shape, and texture.

Black-and-white film records certain wavelengths of light better than others. There is a bias towards blue sensitivity, which means that skies frequently look duller and more washed out than they do in reality. This problem can be overcome simply by using a colour filter over the lens (*see pp.62–3*); this changes the contrast between sky and clouds to look normal, or to look much more dramatic than it did in real life.

SEEING COLOUR IN GREY

One of the problems with black-and-white photography is that colours that appear completely different to the human eye can be recorded in the same shade of grey on film. Red and dark green, for instance, can tend to merge in a way that it is difficult to previsualize. The photographer must learn to see subjects as light or dark — as different shades of grey.

► Adding contrast

Filters create dramatic landscape and architectural shots, simply by accentuating the contrast between sky and clouds. An orange (Wratten 16) filter creates a stormy atmosphere over Ely Cathedral in the UK, from a perfect summer's day.

80mm lens, 1/60 sec at f/5.6 with tripod. ISO 100.

▼ Light tones

It is the lightest areas that attract the eye in most compositions, as they stand out so well against the greyer tones of an average composition – as in this portrait of composer Sir Malcolm Arnold.

85mm lens, 1/125 sec at f/8. ISO 100.

▲ Shades of grey

The three main elements in this composition are portrayed in significantly different shades of grey. The dark would forms a background, and the deep grey pitcher forms a centrepiece, while the light-toned leaves create a contrast and focal point.

80mm lens, 1/8 sec at f/16 with tripod. ISO 100.

◆ Strong areas of tone

Subjects that offer strong, contrasting areas of tone will provide a successful black and-white shot. Here, the main subject of the picture is the pair of crows – not only are they the only real black areas in the frame, but they are also far darker than their surroundings.

200mm lens, 1/250 sec at f/5.6. I\$0 400.

DIGITAL SOLUTION

Many digital cameras allow you to switch off the colour, and shoot a scene in black and white or sepia. Although this allows you to visualize how the scene will appear, it is better to shoot in colour then convert to black and white using manipulation software. This not only gives you the option of using the shot in colour too, but also colour channel data can be used to change the tonal balance more effectively.

High-speed film

Most serious photographers use the slowest speed film they can get away with, as this provides them with the best colours and the finest grain. Even in lowlight situations, few use films with an ISO rating higher than 400. However, more sensitive films are now available that can be used in situations where photography would have been virtually impossible a few years ago.

The maximum speed for a film depends on its type. For colour print film, the usual maximum is ISO 1600. For black-and-white print film, the most light-sensitive material has a rating of ISO 3200. Slide film usually has a maximum nominal rating of ISO 400, but this can be effectively increased to ISO 3200 by increasing the subsequent film development (*see below*). High-speed films come into their own in situations where flash cannot be used and where a tripod or a very slow shutter speed is unfeasible. They were traditionally used by sports and news photographers, and also useful in museums and zoos, where perspex or glass reflect the flash. Black-and-white versions work best in such cases, as they are not affected by the differing colour temperatures of artificial light.

PUSH PROCESSING

Pushing, or uprating, is a technique that allows you to use a film at a higher ISO rating than that written on the box. The film is effectively underexposed, allowing you to use faster shutter speeds or smaller apertures than would otherwise have been possible in such lowlight conditions. The underexposure is then compensated for at the processing stage by giving the latent image more time to develop than usual.

Many black-and-white and colour slide films with nominal ratings of ISO 400 or greater are designed to be push processed. Typically, it

may be possible to use an ISO 400 emulsion at ISO 1600 or even ISO 3200. The process increases the grain in the resulting images. There is also an increase in image contrast.

Push processing is not usually recommended for colour print films.

▼ Lowlight portrait

For this portrait of the architect Basil Spence, the available light from the lamp was used and ISO 400 black-and-white print film was pushed to ISO 1600 to increase the grain.

■ 150mm lens, 1/30 sec at f/4. ISO 400.

▲ ▲ Moving subjects

A high-speed film was vital for this sequence taken in a Romanian church. Flash was forbidden, and slower shutter speeds were not possible because the subjects were moving. Using a fast slide film that was push processed to give a rating of ISO 1600 made it possible to use reasonable shutter speeds.

50mm lens, 1/15 sec at f/1.4. ISO 800/3200.

Black-and-white infrared film

Black-and-white infrared films are available from a number of different manufacturers, and for a range of formats. However, the final image will vary greatly, and some are far more difficult to handle than others. Monochrome infrared films are best known for the ghostly images that they produce – with jet-black skies, snowy-toned foliage, and grainy images. But just how dramatic these effects are depends on how sensitive the film is to infrared (IR) light. The key to using all these films is to accentuate the infrared, or near infrared, sensitivity with filters. A red filter is usually the minimum required, while dark red filters (such as Wratten 89B) are often recommended (*see pp.136–7*). Filters that are opaque to anything but IR light can be used with real infrared films.

While some films can record true infrared light, some black-and-white infrared films are better described as "extended-red" films, as their sensitivity is only 750–800nm (*see below*). Used with a red filter, the effect obtained is somewhere in between that of a true infrared film and a normal black-and-white film. They can be easier to handle than true infrared film – it may be possible to load the film in low light, for example, rather than in total darkness.

▲ Adding texture

Infrared film is often used because its marked grain structure brings an intriguing textural quality to any portrait or landscape. A red filter (or special infrared filter) is used to accentuate the film's sensitivity to invisible parts of the spectrum.

35mm lens with red (Wratten 25) filter, 1/125 sec at f/11. Infrared film.

Measuring infrared light

Different types of light have different wavelengths. Visible light is measured in nanometres (nm) and has a wavelength range of 400–700nm. Normal films have a sensitivity to wavelengths from around 300–650nm (they have some sensitivity to invisible ultraviolet light). The true infrared part of the spectrum starts at around 800nm – but only some films can record these wavelengths.

INFRARED FILM SPEED	AND SENSITIVITY	
INFRARED FILM Type	APPROXIMATE Film speed	MAXIMUM INFRARED SENSITIVITY
Adox IR820	ISO 100	820nm
Efke IR820	ISO 100	820nm
Ilford SFX	ISO 200	750nm
Rollei Infrared 400	ISO 400	820nm

■ Black sky

Even on a perfectly clear day, infrared film can produce the effect of a deep black sky, which immediately adds dramatic impact to most landscape and architectural scenes.

28mm lens with deep red (Wratten 29) filter, 1/125 sec at f/11. Infrared film.

▼ Ghostly glow

The ghostly white appearance of black-and-white infrared prints is unmistakable. Focusing or depth of field should be adjusted so that both infrared and visible light are acceptably sharp.

28mm lens with red (Wratten 25) filter, 1/125 sec at f/11. Infrared film.

◄ Ilford SFX

This film is a so-called "extended red" film. It is not actually sensitive to the infrared part of the spectrum, but it gives similar results to infrared black-and-white film.

Uses for infrared film

The ability to record the invisible, infrared part of the spectrum can have a range of practical, and artistic, applications. Infrared film is widely used in aerial photography, where it can be used by foresters to show early signs of disease, or by the military to tell living foliage from camouflage. It is used in microscopy and forensics – and in the art world it can be used to help reveal forgeries and alterations to paintings.

▲ Tonal transformation

It is worth experimenting with all manner of subjects for black-and-white infrared film, because it gives such a different tonal balance to normal monchrome film. The radiant glow of these sunlit trees is typical.

35mm lens with red (Wratten 25) filter, 1/125 sec at f/11. Infrared film.

PROFESSIONAL HINTS

- For best results, use infrared film on a sunny day (when there is more infrared light), and when there are white clouds in the sky.
- Dark filters reduce the light reaching the film. If using a built-in meter, remove the filter to take a reading using the guide film speed (see Infrared Film Speed and Sensitivity, opposite); set the aperture and shutter speed manually then replace the filter. Bracket exposure, as meters are not calibrated for infrared.
- Some, but not all, digital cameras are sensitive to infrared light. Use a special IR filter on the lens; pictures are recorded in tones of red but can be converted to give a traditional black-and-white infrared effect using image-editing software.

Tungsten film

Most colour film is manufactured only to provide accurate colours under average noon-day sun – and when used with electronic flash. But for some applications this is not a good choice. While flash is the most popular form of artificial photographic lighting, some photographers prefer using high-power, often 500-watt plus, tungsten bulbs (known as photofloods) instead. With these, the lighting is constant, so you can see what you are doing. But as well as being hot to work with, they create orange pictures with normal colour film. Tungsten-balanced film is designed to give accurate colours under tungsten light.

Tungsten film is most usually available for photographers using transparencies. Tungsten colour print film has been produced in the past (for use by portrait photographer's using photoflood), but is rarely necessary as the orange cast created with normal daylight film can be removed during the printing stage – an option that is not so readily available to the slide user.

Tungsten film is occasionally used deliberately to give the wrong colour balance to the subject, imparting a blue wash to daylight and flashlight scenes.

▲ Tungsten projection

In this shot, a slide projector was used to create a multiple exposure effect. Slide projectors typically use halogen lamps, which have a colour balance nearer to tungsten bulbs than daylight ones.

m 100mm lens, 1/60 sec at f/5.6. ISO 64T.

Experimenting with tungsten film

Tungsten film can also be used with light sources that are similar in colour to photofloods – such as domestic bulb lighting. It will give a more natural result than with daylight film, while precise colour matching can be achieved by

adding an appropriate colour correction filter (*see pp.136*–7). For example, to use tungsten-balanced film with 40-watt bulb lighting, you would require an 80D colour-conversion filter.

▲ Warm glow

The oil lamp is not perfectly matched to tungsten film, but this gives a pleasing result. With daylight film it would look too orange.

35mm lens, 1/15 sec at f/8 with tripod. ISO 160T.

▲ Blue tinge

The use of daylight-balanced flash with tungsten-balanced film gives the picture a characteristic blue tint.

35mm lens, 1/15 sec at f/8 with flash. ISO 160T.

▲ Lacking colour

Perfect colour balance is achieved with tungsten lighting and tungsten film, but the final effect is rather colourless and neutral. It lacks the warmth of the oil lamp shot.

■ 35mm lens, 1/30 sec at f/8. ISO 160T.

Mixed lighting

Film cannot be chosen to suit two different light sources simultaneously. In many situations, the photographer is confronted by a scene that is lit by different types of lighting, for example, when a room is partially lit by window light and bulb lighting. Should you use tungsten or daylight film? Normally the answer is to use the one that matches the lighting that has the major influence on the main subject of the image. Interior photographers sometimes put gels over lights or windows to correct the colour of one of the light sources (*see pp.136–7*).

Daylight-balanced film

Tungsten-balanced film

▲ Mixed lighting

Here, the inside of the stable is lit with a photoflood lamp, while the outside is lit by daylight. Daylight-balanced film (top) provides natural colours outside but an orange glow indoors. With tungsten film (below), the interior scene looks better but the exterior is blue.

80mm lens, 1/30 sec at f/8 with tripod. ISO 64 and 64T.

RECIPROCITY FAILURE

Tungsten film can be useful for avoiding reciprocity failure when using long exposures. Reciprocity failure is what happens when the reciprocal relationship between the aperture and shutter speed fails. On most occasions, if you double the shutter speed you can close the aperture a stop to get the same overall exposure as before (see pp.76–7). However, films are manufactured to be sensitive only to light within a certain brightness range. If you use a longer shutter speed than the film is designed for, then the reciprocal relationship fails. The result is that, with shutter speeds of a certain length, pictures can be underexposed, and manual compensation must be used.

At which point reciprocity fails depends on the film. With many colour print films no compensation is necessary until you have an exposure of ten seconds or more. Colour slide film has less exposure latitude, and compensation may even be recommended for exposures that are as short as 1/10 sec. Most slide films domand exposure compensation with shutter speeds of 1 sec or longer. As well as additional exposure, filtration is trequently needed, as reciprocity failure affects the different emulsion layers at different rates.

Some tungsten slide films, however, are specially designed to provide accurate metering at slow shutter speeds. With such films, reciprocity failure does not become a problem until the exposure is a minute long, or more

▲ Tungsten film

Tungsten film is usually found only in slide film ranges, as it is essential that the processed film has the colour balance you want. With print film, the cast produced by bulb lighting can be compensated for by filtration at the printing stage. Tungsten-balanced colour print film is produced, however, for specialist studio use.

PROFESSIONAL HINTS

- Tungsten-balanced slide film is now usually only found with an ISO speed of 64.
- If you are unsure of the colour temperature of a light source, or want to avoid problems with mixed lighting, use black-and-white film.
- Digital cameras can adapt automatically to different colour temperatures, giving them a significant advantage over film in many artificially lit situations (see pp.138–9).

Instant film

There are two types of instant film. One type is used in a camera with interchangeable backs, where Polaroid film can be used to take test exposures during a shoot, and gives a "peel-apart" print; the other is used in a Fuji Instax camera (see p.34) and has no backing to peel off. This instant film enables the photographer to see exactly how the shot has turned out almost immediately it is taken. The main benefit for the serious photographer using a Polaroid back was that, in many instances, the picture could be retaken if necessary. Most people now use digital cameras or backs, but a Polaroid gave similar advantages in allowing checking of depth of field, composition, and shutter speed – and the settings could then be altered until the desired effect was obtained. The checking of pictures as they are taken is not possible with most film cameras. Polaroid ceased making instant film in 2008, so it has become difficult to find material to use in Polaroid backs.

How instant film works

Polaroid film was an instant process where images were produced directly on to prints. Unlike using a digital camera, however, the set-up had to be re-photographed in order to get a high-quality result. Polaroid film was therefore best suited to photography where the result could be repeated – such as still life and architecture. The process was also less instant than it is using a digital camera screen, as the development of the peel-apart print took a couple of minutes. Polaroid film was sold in cassettes holding eight or ten sheets of film. The cassette was loaded into the holder, and each sheet had a tab for removing the print from the cassette and holder once it had been exposed. Once each print was removed, the image began to develop. However, the image was not visible until the development finished, as the print had to be peeled away from the chemical backing layer.

▲ Peeling apart

The amount of time that the image took to develop depended on the type of Polaroid film used and on the temperature of the location. Once the print had been peeled off, the other layers could be discarded, although the negative could prove useful later (see Professional Hints, opposite).

CREATING SPECIAL EFFECTS WITH POLAROID FILM

Burnishing technique

A technique often used with integral Polaroid films (those that did not need to be peeled apart and were used by Polaroid's own cameras) was to manipulate the image while it was still developing. A blunt point, or a custom-made burnisher, was used to move the emulsion around underneath the plastic topsheet before it set. In artistic hands, the result could be similar to that of an oil painting. Many more recent Polaroid films developed too quickly for successful results, but Polaroid made a film especially for this purpose; it was usable in Polaroid SX70 cameras or could be adapted for use in some later instant cameras.

Emulsion lift-off technique

Popular with professional and student photographers was the emulsion lift-off technique. A peel-apart Polaroid print that had dried would be immersed in hot or boiling water (depending on film type) for a few minutes. The film would start to fall apart, and the backing layers could

▲ Textured effect

One of the appeals of the emulsion transfer process was that the Polaroid image could be burnished on to art or handmade paper, providing a textured surface to the picture.

▼ ► Manipulated images

The surface of the film used by Polaroid's own cameras had a plastic covering – which allowed you to manipulate the emulsion underneath as the image developed, without doing any structural damage to the print. This technique was more successful with some film types than others.

Untreated Polaroid

e discarded, leaving a thin layer of emulsion with the image. This could be carefully turned over and removed from the water using a sheet of acetate. The image was placed on a sheet of wet textured paper and tried and pressed until flat. The transfer process allowed distortion, nanipulation, and tearing of the image in countless artistic ways.

Warped and distorted effect

he emulsion was extremely fragile during the lift-off process, and could become twisted or ripped while being transferred. These nperfections could, however, prove pleasing.

Polaroid film backs

Interchangeable film backs holding Polaroid film were available for many medium- and large-format cameras, and a few 35mm SLRs. These were loaded with colour, or black-and-white, peel-apart instant film, which developed automatically as it was squeezed through rollers upon being pulled out of the film back. The image was usually fully developed, and ready for analysis, within a couple of minutes.

A Polaroid back was particularly useful in the studio, as it allowed you to preview the effect of the lighting set-up. In the pre-digital era, a Polaroid proof was often essential in commercial photography, as the client could use the instant print to see the shot and give approval.

► Interchangeable backs

A Polaroid back would fit on to the camera, replacing the normal camera back, or film holder, used by that particular kind of camera.

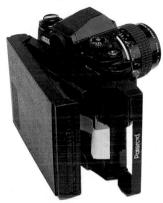

35mm SLR with Polaroid back

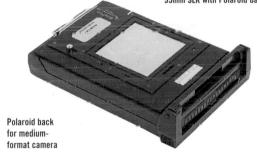

PROFESSIONAL HINTS

- When using Polaroid material, you had to ensure that its speed matched the speed of the film you were using for the final shots. If this was not possible, you had to remember to keep changing exposure to compensate for the different ISO ratings.
- \blacksquare Polaroid backs for 35mm SLRs gave a very small image on the 3% x 4%in film. An alternative was to use Polaroid's now sadly defunct instant 35mm transparency films. These could be used in any 35mm camera but could be processed on location using the supplied all-in-one chemical pack and a special portable processing unit. Not only were these films useful for proofing, and for quick slides, but their peculiar characteristics could also be used for artistic purposes.
- A Polaroid back on a medium-format camera allowed you to shoot an instant print without having to finish the roll of film you were previously using. The interchangeable back system meant you could reload the camera or change film types almost instantaneously (if you had enough reloaded film backs with their own dark slides).
- Some Polaroid films provided a negative that could be sharper than the print and could therefore be better for checking focus.

Splitting images

If the scene or subject that you want to shoot is the wrong shape for the format you are using, the solution is to shoot more than one frame – this "joiner" technique is useful for shooting wide panoramas, for example. Instead of a single image, take a series of shots, turning the camera a few degrees between each one. For realistic results, each shot should slightly overlap the last. The camera height and position must not change between frames – a tripod with a pan-and-tilt head is ideal, but handholding is possible (*see pp.100–1*). Using this technique, all manner of subjects can be shot so that only part of the total image appears in each frame. The result is a mosaic that can be made up of a handful, or hundreds, of different frames.

▼ Contact print

The more pictures that are shot to make a joiner, the less each one needs to be enlarged. This 18-shot joiner (also sometimes called a mosaic) only needed to be contact printed — with the negatives laid on top of the photographic paper — to provide a reasonably sized result.

■ 135mm lens, 1/15 sec at f/2 with tripod. ISO 400.

DIGITAL SOLUTIONS

There are many photo manipulation packages that help combine two or more pictures to make a composite panoramic image. Some digital cameras even help with the lining-up process as you take each shot.
 The "joiner" technique can get over the limited resolution of digital cameras, as it increases the number of pixels, so improving resolution.

▼ Panoramic join

The classic use for joiners is to enable panoramic shots to be taken with a non-panoramic camera. Here, two slides have been butted together to provide a wide landscape format. Each shot was taken with a different lens,

- (I) 50mm lens, 1/250 sec at f/8. ISO 100.
- (r) 80mm lens, 1/250 sec at f/8. ISO 100.

▼ Disjointed portrait

These two pictures were shot accidentally during the loading of a new roll of film. However, butted together, they make an interesting, artistic, and unusual portrait of a young baby. It is not important that they do not line up exactly.

m 135mm lens, 1/60 sec at f/8. ISO 200.

► Capturing detail

A sequence of five exposures facilitated the composition of a long, thin portrait of this tall man lying on the grass. Such pictures are not only fun to do, but also give you more image detail than would be possible with a single straight shot.

m 100mm macro lens, 1/250 sec at f/5.6. ISO 100.

Lighting

Without light, photography is impossible. Whether using film or digital chip, light creates the image. But all light is not the same. Light can be brighter at some times than at others – but this is not of great significance, as dim lighting can be compensated for with longer exposures and wider apertures. However, the quality of the light is crucial to the success of a picture.

Changing light

The effect that the sun has on the way a scene looks depends on a large number of different factors. This gives such a huge number of permutations that the picture you take today may never be recreated exactly.

The position of the sun in the sky varies not only with the time but also with the season and the location. These factors all affect the hue, angle, and brightness of the light – and the effect this has on the shadows is as important as the one it has on the subject.

Just as crucial are the atmospheric conditions, and these may vary by the minute. Clouds, for instance, do not just obscure the sun – they act as filters and diffusers, changing the light's quality – and a shot that is there one second may well be gone the next.

Also, the human brain has a habit of seeing things as it expects them to be, or as it remembers them, rather than as they actually are. There are times when we notice the difference in lighting quality – such as when a spectacular sunset bathes a landscape in golden rays – but for most of the time we see few differences.

The fact is that natural lighting changes constantly in colour, direction, and harshness – and all these things have a significant effect on how something appears in an image. A photographer needs to learn to see again – to know before the shutter is fired which lighting conditions will create better pictures.

▶ From dawn to dusk

All these pictures were taken of the same view on one particular spring day. They show just how much the light can change – and that some conditions produce much more successful shots than others. The first picture of the Cromer seafront in Norfolk, England, was taken just before sunrise, at around 6:45 a.m., and the last picture of the day was taken after sunset, at 8:30 p.m. Taken at various intervals during the day, these shots show just how much the light can change.

35mm lens, with varying shutter speeds at f/8. ISO 200.

Early morning - 6:45 a.m.

Morning - 8:30 a.m.

Afternoon - 3:00 p.m.

Evening - 7:00 p.m.

Early morning - 7:30 a.m.

Morning - 9:00 a.m.

Afternoon - 5:00 p.m.

Evening – 8:00 p.m.

Early morning- 8:00 a.m.

Morning - 10:30 a.m.

Early evening - 6:30 p.m.

Evening -8:30 p.m.

Colour temperature

The human eye has an amazing ability to see objects in the same colours, whatever the lighting conditions. In reality, however, different types of light have different colours, called colour temperature, which is measured on the Kelvin scale. While the brain can adjust for these, photographic film cannot. The slide photographer has to realize that his or her subject is going to appear in a

different range of colours depending on the type of lighting that has been used. One of the ways to adjust for these colour temperatures is by changing the type of film used. Daylight-balanced slide film is designed to cope with sunlight, while tungsten-balanced slide film (*see pp.126–7*) is designed to give natural-looking results with warmer light sources, and photoflood bulbs in particular.

THE KELVIN SCALE

In photography, the mixture of wavelengths in different types of light is described in terms of its colour temperature. Colour temperature is measured on the Kelvin scale, a temperature scale used by scientists based on the amount of light emitted from metals when they are heated.

If a metal bar is heated to 1,000K, it sends out the same light as a candle. At 3,000K, the bar glows visibly, with a light intensity similar to that of a household lightbulb, and at 6,000K, the bar appears to glow white, giving off the same light as an electronic flash.

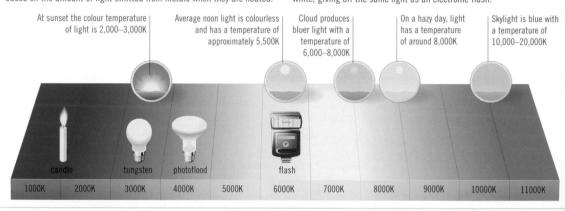

▲ Ghostly appearance

Lighting sources can be deliberately mixed for creative effect. Using tungsten studio lighting with tungsten film, the right side of the face appears normal. However, diffused flash provides blue-tinted fill-in.

35mm lens, 1/60 sec at f/8. ISO 64.

■ Mixture of colours

A view of a city at night shows just how many different colours of artificial light are used in our daily lives. The greenish tinge of the office blocks is characteristic of fluorescent tubes.

135mm lens, 10 secs at f/5.6 with tripod. ISO 100.

PROFESSIONAL HINTS

Remember when choosing film that the colour of sunlight varies during the day. At midday, colour rendition is neutral: towards dusk and just after dawn, light has a warm tone: the more cloud or haze there is, the bluer the light will be. Unlike transparency film, colour print film is rarely made in daylight- and tungstenbalanced varieties because colour casts created by light sources can be removed during the printing process. Use auto white balance with digital cameras (see pp.138-9) to cope with different lighting.

■ Using torchlight

Using daylight film, the bullding in the background appears a natural colour in the setting sun. The model's face has been separately lit with a handheld torch, creating a warm, but unnatural, glow over her face.

120mm lens, 1/4 sec at f/16 with tripod. ISO 100

▲ Blue dawn

Hazy atmospheric conditions produce a noticeably blue tone in photographs, seen in this shot of the Statue of Liberty in the USA. This is due to the high percentage of skylight in the weak illumination of the early New York morning.

m 135mm lens, 1/30 sec at f/4. ISO 100.

WHAT IS SKYLIGHT?

Daylight is made up of two different light sources — sunlight and skylight. Skylight is light that has been reflected by the sky. Variations in the relative intensity of direct sunlight and skylight create different colour temperatures. Skylight is blue in colour, so, the more skylight there is, the bluer the image. Daylight films are produced to handle an average mixture of sunlight and skylight, with a colour temperature of around 5,500K. In sunny conditions, skylight is strong, but sunlight is much stronger, so the blue effect of skylight is seen only in the shadows (which are weakly lit by skylight alone). However, sunlight can be restricted by cloud and haze, so, on overcast days, skylight and sunlight are more evenly mixed, creating an overall blue tone to pictures.

Blue sky opposite the sun reflects light down, which weakly lights shaded areas

Colour correction

Correctly coloured pictures can be produced by using two types of slide film suitable for two types of lighting conditions. Daylight film is fine for shooting pictures under average midday daylight, but it is important to be able to take pictures at other times of the day. Tungsten film is ideal with photofloods, but what if you want to shoot something lit by warmer-coloured household bulbs?

In order to get precise colours from these slide films under different lighting temperatures, filters must be used. Fitted over the lens or the light source, these adjust the lighting so it matches the film being used more closely. There is a wide range to suit most occasions, and these are usually given a number and letter that correspond to Kodak's Wratten series of filters. The number tells you its colour, and the letter its strength. Adding a filter will mean a small increase in exposure (one third of a stop upwards, depending on its strength), although built-in exposure systems will do this for you.

▲▼ Restoring colour balance

These two pictures were both taken with tungsten film and studio flash. The combination would normally provide a picture with a bluish cast (above), which looks wrong (although it might be suitable for a fashion magazine). Using an 85B compensating filter (below) restores the image to a more normal colour balance.

- (a) 120mm lens, 1/60 sec at f/11 with flash, ISO 64T.
- (b) 120mm lens, 1/60 sec at f/8 with flash, ISO 64T.

COLOUR TEMPERATURE METERS

In situations where exact colour rendition is needed, it is necessary to measure the precise colour temperature of the light source — rather than to approximate its value by its type. For this, a colour meter is used. As well as measuring exposure for flash and ambient light, the meter can give a temperature read-out in Kelvin, and suggest the colour correction (CC) filter needed for the film being used.

Gossen ColorMaster 3F

▼ Correcting fluorescent effect

This picture was taken in a bar that was lit mainly with fluorescent strip lighting. This lighting does not fit neatly into the normal colour temperature scale – and if you do not correct it, it will usually look green in your pictures. The solution is to use an FL-D (fluorescent-to-daylight) filter – this is a magenta colour and usually corrects the overall colour balance.

■ 85mm lens, 1/15 sec at f/2. ISO 200,

FILTERS FOR DIFFERENT LIGHT SOURCES FILTER NEEDED WITH FILTER NEEDED WITH LIGHTING USED TEMPERATURE MIRED VALUE IN KELVIN TUNGSTEN FILM DAYLIGHT FILM Candlelight 518 82C + 82CNot recommended 1930K 40w bulb 2600K 385 80D Not recommended 150w bulb 2800K 357 82C 80A + 82BTungsten floodlamp None 80A 3200K 312 3400K 294 82A 80B Tungsten halogen lamp 5800K 172 85B None Average daylight 5800K 172 85B None Electronic flash

▲ Shifting colour balance

A "warm-up" filter is a useful accessory for any portrait session. This just shifts the colour balance of the shot slightly, suggesting that the person has a slightly more golden skin tone than they actually liave. This shot was taken with an 81A filter (giving a mired shift of +18).

85mm lens, 1/30 sec at f/4. ISO 200

PROFESSIONAL HINTS

- Use correction filters when colours need to be reproduced accurately. We are often happy with shots that look blucr or more orange than they did in real life.
- Partial correction is often all that is necessary.
- Some filters measure their effect with a "mired shift" value. A mired value is an alternative way of measuring colour temperature. To convert Kelvin to mired, divide the number one by the value in Kelvin and multiply by a million. The mired value for average daylight is 172, and for tungsten floodlight it is 312. To use tungsten film with daylight lighting, therefore, you need a filter with a mired shift of +140.

White balance

Digital cameras correct for different colour temperatures automatically. There is no special tungsten film, of course, but there is no need to add filters to compensate for different types of lighting either. All digital cameras have a built-in automatic white balance system. This measures the colour temperature of the light being reflected from the subject – and then adjusts the red, green, and blue components of the signal from the imaging chip before it is recorded, so that the picture looks normal. The white balance is usually measured through the lens, often by the same pixels that are used to actually record the image.

Most digital cameras also offer manual white balance settings, allowing you to set the filtration that you want for creative effect or to correct for incorrect assumptions made by the automatic system. These manual settings are usually accessed through the camera's onscreen menu system; the amount of control will depend on the model.

PROFESSIONAL HINTS

- The LCD screen gives a good indication of when the white balance setting needs correcting. However, when absolute colour accuracy is essential, the preview's colours will not be good enough to rely on.

 Colour balance can be corrected, to a large extent, using digital manipulation software, whether the picture was taken with a digital camera or film camera (see p.386—7).
- When using manual white balance, always remember to change the setting before taking your next sequence of pictures.
- with manual white balance, you can point the camera at a coloured surface rather than a neutral surface to shift the colour of the shot. Therefore, you can make shots appear more red, for example, by taking the reading from something blue, such as a piece of blue paper.

Auto white balance

The auto white balance is effective in most situations, but, as with all automatic systems, there are times when it may not give you the exact results you want. For example, in mixed lighting situations, when there are two or more different light sources in the shot (such as in a room lit by both bulb lighting and daylight), the compromise it makes may not give you the effect you were looking for.

On occasion, the auto white balance can overcorrect colour – it may reduce the orange glow of a sunset, for example. At other times, you may deliberately want to alter the colour balance; creating an impression of moonlight by giving shots taken in daylight a strong blue appearance is one such instance.

Sunset with auto balance

Sunset with cloudy white balance setting

▲ Over-correction

The colour of this picture has been over-corrected by the auto white balance. Since this is a picture of a sunset, it should be less blue and more orange.

■ 35-140mm lens, 1/125 sec at f/5.6.

■ Natural result

When shooting sunsets, the aim is usually to exaggerate the red and orange tones. On a digital camera, this is done by using manual white balance, set to cloudy.

35-140mm lens, 1/125 sec at f/5.6.

Manual white balance

A preset manual white balance system allows you to choose from a number of different colour temperature options. These settings are normally represented by symbols, such as a sun icon for daylight, or a bulb icon for tungsten lighting. Sometimes different Kelvin settings (*see pp.134*–5) are offered.

Some digital cameras additionally offer a further manual white balance setting, where you set the white balance specifically for the conditions. With this system, the camera is pointed at a white or grey item, such as small piece of paper or the page of a book. Use the zoom or the macro feature to make sure the colour completely fills the screen – and then press a button.

Display	Name	Description
Α	Auto	Automatic white balance — measures the colour temperature of the scene, and adds correction to provide a natural-looking scene.
<u> </u>	Sunny	Use this manual setting for outdoor shots in fine weather when the main light source for the shot is the sun. Also use for flash.
	Shade	Use this manual setting for shots taken in shade or on cloudy days. It will give warmer results than the sunny setting.
淵	Fluorescent	Use this manual setting for shots taken under strip lighting. Different settings may be provided for different types of tube.
	Tungsten	Use this manual setting for shots when the main light source is normal household light bulbs.
С	Custom	Use to choose the while balance setting manually by taking a colour temperature reading from a white surface.

Tungsten lighting with sunny setting: orange cast

Dull day with sunny setting: blue cast

WHITE DALANCE CETTINGS

Fluorescent lighting with sunny setting: green cast

White balance set for tungsten lighting

▲ Correcting tungsten lighting

Household bulb lighting will tend to give an overall orange colour cast to your digital ohotographs if shot with a daylight manual white balance setting. When the white balance is adjusted for tungsten, or bulb, lighting, this will be corrected, giving a more natural-ooking colour balance.

35-140mm lens, 1/30 sec at f/4.

White balance set for shade

▲ Correcting dull lighting

A high proportion of skylight can make photographs shot in overcast conditions appear slightly blue (see pp.134–5), particularly if the manual white balance is set to the normal sunny-daylight setting. Using a shade manual white balance setting creates a warmer, more pleasing, result.

■ 35-140mm lens, 1/125 sec at f/8.

White balance set for fluorescent lighting

▲ Correcting fluorescent lighting

Strip lighting tends to add a green tinge to digital photographs if shot using a normal daylight white balance setting. In fact, the colour temperature of fluorescent lighting can vary widely, and cameras often have two or three settings to allow for the different types of tubes.

■ 35-140mm lens, 1/15 sec at f/2.8.

Warm glow

In many situations, correcting the colour balance is not necessary, even if the filtration, film, or setting are not those that would ideally be used with that lighting; this is because it is often possible to achieve a better effect with the "wrong" colour balance. It is acceptable in film photography that overcast scenes look slightly blue, or that a floodlit cathedral has an overall yellow tone, even though in reality they do not. Viewers accept them as being normal, because they have seen so many photographs that have looked like this before.

Sometimes the wrong colour balance helps the overall composition. A candlelit scene is a good example of where the correct colour balance would completely drain the orange tones from the picture. It is better to use colour temperature controls to retain the colours of the candlelight. A transparency user similarly uses daylight film for a sunset — even though a Kelvin reading suggests that tungsten film would give a more accurate colour match; warm-up filters could be used to boost the intensity of the sunset still further.

◆ Creating orange tones

When looking at pictures of candles and flames, the viewer expects the fire to have an orangey tone – these are automatically produced when using daylight-balanced film.

100mm lens, 1/8 sec at f/2.8 with tripod. ISO 200.

▶ Night-time warmth

Daylight film gives the "wrong" colour balance for this shot – but it makes little difference to the car headlight trails, and the warmer tone helps to create a more photogenic skyscape.

■ 35mm lens, 30 secs at f/22, using B setting and tripod. ISO 100.

▼ Intensifying light

Nightscapes typically present a mix of light sources. However, it is the different colours of the lights that often make the shot. These can be intensified by using daylight film.

■ 135mm lens, 10 secs at f/8, using B setting and tripod. ISO 100.

▲ Ambient light

It is tempting to use flash at parties, but for more atmospheric shots of the candles on a cake, use the ambient light alone.

100mm lens, 1/30 sec at f/2.8. ISO 200.

■ Golden tones

The warm glow for this picture has been provided by an oil lamp that is just out of shot. The use of daylight-balanced slide film means that the skin tones appear warmer in the picture than they actually are.

■ 85mm lens, 1/30 sec at f/2 with tripod. ISO 200.

DIGITAL SOLUTIONS

Digital cameras will usually automatically correct the colour balance to suit the lighting. In some cases, this means the atmosphere of the shot is lost.

Check the colour LCD screen carefully to assess how orange your results appear.
 If necessary, switch to manual white balance and select a sunny daylight setting.

See also Tungsten film p.126 Colour temperature p.134 Colour correction p.136 White balance p.138

Hard and soft light

Of all the factors that control the quality of light outdoors, it is clouds that have the greatest effect. We often think of clouds as blocking sunlight – but what they actually do is diffuse it. Each water droplet in the cloud changes the direction of the light slightly, so that instead of the light appearing to come from the direction of the sun, it appears to come from lots of different angles.

The extent to which cloud diffuses light depends on the weather conditions. The degree of cloud cover varies enormously, and sometimes the subject is lit by both direct and indirect light. Even with total cloud cover, the thickness of cloud will affect how hard or soft the light is.

A photograph using direct sunlight as a light source is characterized by strong colours and strong shadows. Soft lighting tends to produce a more even illumination, with shadows that are less marked. Both hard and soft light have their different uses.

▼ Moving clouds

As clouds move, the effect on a landscape can change rapidly. In the shot below, the church is lit by direct sunlight. In the next shot, taken a few minutes later, the light reaching the foreground is more diffuse.

■ 135mm lens, 1/125 sec at 1/11. ISO 100.

Hard light

Soft light

Hard sidelighting

Diffused lighting

▲ Softening lighting

In the studio a range of attachments can be used to soften the light (see pp.338–9). Here, a single brolly produces hard sidelighting (top), while a softbox with a reflector creates a more diffuse effect (above).

120mm lens. 1/60 sec at f/11 with flash. ISO 100.

THE SOFTENING EFFECT OF CLOUDS

The more cloud cover there is, the more diffuse the light becomes. Heavy cloud can bounce the light around so much that it becomes so even that there are no visible shadows. Lighter cloud softens the light to a lesser degree, so that it is still evident where the sun is, and creates some shadow detail. Partial cloud cover can create conditions where the subject is lit by a mixture of direct and indirect light.

Partial cloud cover

Heavy cloud cover

▲ Diffused, even lighting

Even in the shadows there is still plenty of light. This is reflected from the sky, ground, and buildings, as well as through the clouds. The light therefore comes from practically all directions.

■ 135mm lens, 1/125 sec at f/4. ISO 100.

▲ Harsh lighting

Direct light through a window creates strong colour and strong shadows in this portrait. Although the shadow areas are lit by some reflected light, the contrast is so great that these parts of the picture appear dark.

namma 135mm lens, 1/125 sec at f/5.6. ISO 100.

▲ Semi-diffused lighting

Here, some of the scene is lit by direct sunlight, while other parts are not. The woman is not in the sunshine, but the thin cloud overhead diffuses the light only slightly, so the lighting still produces noticeable shadows.

■ 35mm lens, 1/60 sec at f/8. ISO 100.

◆ Hard and soft lighting

With direct sunlight above and behind her, this model's face would have been in shadow. However, for this photograph the contrast has been controlled with the use of a large white reflector (see pp.270–1), which has been placed to bounce light back on to her features.

135mm lens, 1/125 sec at f/11. ISO 100.

PROFESSIONAL HINTS

Hard light and soft light are not absolute values – there are infinite variations in light direction and diffusion.

As well as being diffused and reflected by clouds, light is reflected by the ground, the sky, and other objects.

Early morning light

Many photographers prefer to take pictures early in the morning when working outdoors, as some of the best natural lighting is available at this time of day.

When the sun is low in the sky, light has to penetrate a greater depth of atmosphere than at other times of the day. This not only reduces the intensity of the light but also makes it more diffuse. By contrast, general visibility can be excellent, because there is often less atmospheric dust and pollution. There is also a noticeable effect on colour temperature – the atmosphere absorbs some colour wavelengths more efficiently than others, which can give a warm, glowing tone to directly lit subjects. The oblique angle of the early morning sun creates a raking light, which, in turn, creates long shadows that are good for recording the texture of the landscape.

A wide range of effects can be observed within a short period at this time of day. Just before dawn, the light is blue, even, and shadowless, providing conditions that are particularly favoured by professional car photographers. After sunrise, the quality and quantity of light then changes quite rapidly. As the ground heats up, mist and dew often appear – but these are quickly burned off as the sun continues to rise higher in the sky.

TIME OF DAY: DAWN

Direct light just after dawn is characterized by warm tones. These are created by the fact that blue light is scattered more readily by the atmosphere through which the light is travelling. The light is weak, though, so skylight plays more of a role at dawn than at other times of the day — so indirectly lit subjects appear blue. Shadows are long but weak.

▲ Fast-changing light

Morning light changes constantly. In this shot of mountains, fast-moving low clouds create a pattern of light and shade on the ground.

50mm lens, 1/125 sec at f/4.

▼ A clear view

Visiting the ruins of Machu Picchu, Peru, as dawn breaks provides a unique chance to take a dramatically lit picture – with no crowds.

35mm lens, 1/90 sec at f/8. ISO 100.

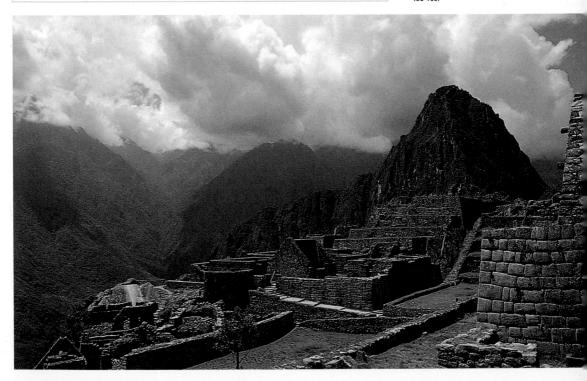

▲ Emphasizing depth

Early morning mist enhances the aerial perspective (see pp.198–9) of this shot of a Welsh valley, adding to the feeling of depth.

85mm lens, 1/15 sec at f/5.6 with tripod. ISO 100.

▲ Overcast weather

The early morning light and overcast weather create a very even illumination in this shot of Tobermory harbour in Scotland's Western Isles. These conditions allow the details in both packground and foreground to be seen clearly.

35mm lens, 1/15 sec at f/16 with tripod. ISO 100.

▲ Clear view

First thing in the morning in the Atlas Mountains in Morocco, and the light is giving a warm glow to the sandy rocks. Later in the day, dust and atmospheric haze will make the same view less clear.

35mm lens, 1/500 sec at f/11. ISO 100.

PROFESSIONAL HINT

How early is early depends on the time of year and also on latitude. The sun rises more rapidly in some places, and lowangled morning light may not last long.

Mid-morning and mid-afternoon light

For much of the year in many parts of the world, the intensity of sunlight does not vary much during the middle hours of the day. Once the sun is at around 45 degrees in the sky, it is almost as bright as it is at noon. However, these morning and afternoon hours are a better time to take pictures because the sunlight is more angular than at midday.

The colour temperature is reasonably neutral at these times, shadows are distinct but not overpowering, and there is strong directionality. Most significantly, when shooting away from the sun, colours appear rich, intense, and saturated, in contrast to the more washed-out tones that are characteristic of photographs taken in harsh midday light.

▲ Bands of colour

At first glance it appears as if the vibrant red in this picture is provided by a field of poppies – in fact, it is a plastic fence, drawn out from the yellow oilseed rape and the white earthworks by the glowing afternoon light.

■ 135mm lens, 1/125 sec at f/11. ISO 100.

TIME OF DAY: MORNING AND AFTERNOON

How quickly the sun climbs depends on the time of year and the latitude. In summer, or near the equator, there is little difference between noon and mid-morning. However, avoiding the sun at its highest produces shadows that show form, texture, and colour. Colour balance is neutral in direct light, and only slightly blue in indirect light. It is bright enough for most handheld photography.

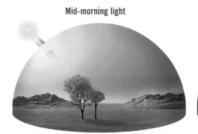

▲ Earthy tones and frontal lighting

The semi-diffuse mid-morning sun, positioned almost directly behind the camera, accentuates the earthy tones of these Moroccan houses.

200mm lens. 1/2000 sec at 1/5.6. ISO 100.

▲ Landscape textures and sidelighting

In this shot, taken in the Egyptian desert on a day with exceptionally good visibility, the sidelighting helps to create a well-defined landscape.

50mm lens, 1/1000 sec at f/11, ISO 50.

▲ Green tones after rain

An afternoon downpour has cleaned the atmosphere, enhancing the quality of light and producing a vivid range of greens in this shot.

28mm lens, 1/60 sec at f/11. ISO 100.

▲ Angular backlighting

Strong, angular light creates interesting effects when exploited either as side- or backlighting. Here, the silhouette of St. Michael's Mount in Cornwall rises from the mirror-like sea, in a shot taken towards the sun. ■ 300mm lens, 1/1000 sec at f/11. ISO 100.

◄ Optimizing reflections

Lake Dal in the Kashmir mountains usually produces atmospheric, misty shots. To achieve clearer results, and make the most of the reflections, avoid taking photographs when the sun is high in the sky.

■ 50mm lens, 1/250 sec at f/11. ISO 100.

▼ Cornfield in Gloucestershire

The directional light of mid-afternoon produces a rich intensity in the orange of the fields and the red of the barn. The acottorod cloud gives this strong light a semi-diffuse quality.

m 135mm lens, 1/250 sec at f/8. ISO 100.

See also Early morning light p.144 Noon light p.148

Noon light

The intensity and angle of the sun at midday are such that many photographers deliberately avoid working in these conditions. With the sun high in the sky, there is less directionality in the light, so that shadows can often become a hindrance. Direct sunlight at midday is very harsh in portraits, creating heavy shadows under the facial features, and in the subject's eye sockets. Noon is when the colour of sunlight is at its most neutral – and the time for which the colour balance of most films is set.

However, some subjects benefit from the effects of midday sun. This type of light works well with strong shapes and forms, where the shadows do not destroy essential detail. It can also be surprisingly useful for revealing texture on vertical surfaces, such as the carving on headstones.

TIME OF DAY: NOON

The sun is directly above at noon only if you are standing on the equator in mid-summer. However, in many places the sun is high enough to ensure the tops of subjects are better lit than the sides. Shadows are short, and can merge with the subject casting them. However, colour film produces natural colours with the mix of skylight and direct light found at temperate latitudes at noon.

▲ Geometric structures

The simple, geometric shape and stark architecture of the Cornish castle of Carn Brea still stand out well in the unflattering overhead sunlight.

m 135mm lens, 1/250 sec at f/11. ISO 100.

▼ Shadows from overhead light

Noon sunlight rarely works well with garden photography because it washes out intense colour, but here it suits the composition. The overhead shadows mirror the symmetrical pattern formed by the avenue of trees, while the water in the fountain is slightly backlit.

m 135mm lens, 1/125 sec at f/11. ISO 100.

▼ Highlighted inscriptions

Overhead sunlight is ideal for accentuating carvings, such as these heroglyphics. Strong, short shadows pick out recesses in the stone, making them intensely dork, without coorificing overall detail

100mm lens, 1/1000 sec at f/11. ISO 50.

▲ Contours in the landscape

The terraces of this prehistoric long barrow would hardly be visible in normal lighting conditions. However, bright overhead sun transforms the steps and ridges into a strong pattern of light and dark.

m 28mm lens, 1/250 sec at f/16. ISO 100.

▲ Accentuated diagonals

Here, the noonday sun actually helped the composition of the shot. The strong diagonal line of the path leading across the garden of this French chateau was accentuated because of the lack of shadows.

m 28mm lens, 1/60 sec at f/22. ISO 100.

PROFESSIONAL HINTS

- \blacksquare Check your latitude in some countries, the sun does not climb very high even at noon, so angular light is still available.
- \blacksquare Clouds will temper and soften the light significantly, even at midday.
- Make the best of it if, on some occasions, you have no choice but to shoot at noon but remember to shoot portraits in a shaded area.

Late afternoon light

Photographers do not always need to be early risers; the light of late afternoon can also produce magical pictures. The sun is low in the sky once again, with long shadows and a marked decrease in intensity. However, of more interest to landscape and architectural photographers is the way the colour temperature shifts to the warmer tones of the spectrum. Direct light at this time of day can turn the humblest scene into a beautiful photograph.

Another advantage for the photographer is that the wind tends to drop as the day wears on, and land and water become still, presenting a good opportunity to shoot reflections. In countries with warm climates, this is the time when the heat of the day has gone, and local people can be seen relaxing after their day's labours; scenes like these can make interesting subject matter for photographs.

TIME OF DAY: LATE AFTERNOON

Late afternoon light may last hours or a matter of minutes, depending on the time of year and the latitude. As the sun falls below a certain angle, the light is softened and coloured by the depth of atmosphere it must pass through. Lengthening shadows emphasize the shapes of subjects, although the contrast between the dark and light areas is less marked than at noon.

▲ Reflected sky

When this shot was taken, the low afternoon sun was obscured by cloud, so the light was soft and even. The wind often drops at this time of day, making it perfect for photographing reflections in still water.

28mm lens, 1/30 sec at f/8. ISO 100.

▶ Break in the clouds

Even in poor weather, the early evening sun can suddenly break through the clouds, bathing the landscape in warm-toned lighting. The warm tones are accentuated when contrasted against a dark sky.

■ 200mm lens, 1/250 sec at f/5.6. ISO 200.

▲ Buildings in a landscape

In this archetypal early evening shot, the red-toned sunlight makes the Tuscan buildings stand out from the surrounding landscape. When taking a photograph such as this, remember to keep the sun behind you so that the full intensity of the light on the buildings is captured.

m 135mm lens, 1/125 sec at 1/5.8. ISO 100.

▼ Timing the shot

Some scenes can be captured only at certain times of day. When taking off, hot-air balloons need calm weather conditions, without too much wind; these are usually found early in the morning or shortly before sunset. In this shot, the late afternoon sun casts dramatic shadows on the ground.

■ 50mm lens, 1/30 sec at f/5.6. ISO 100.

Light at sunset

For most of the time, the photographer should avoid shooting the sun because the intense brightness can cause permanent harm to the eye, as well as damage to the camera. However, there are times when conditions moderate the full intensity of the light, and it is possible to take shots with the sun in the frame.

At sunset, the sun shines at an acute angle to the earth's surface, so the sunlight must penetrate more of the earth's atmosphere than in the day. The dust and water particles in the air significantly weaken its intensity. This diffusing process works more efficiently on some wavelengths of light than others, producing the typical colours of sunsets. At this time of day, the sun's disk also appears larger than usual, and can be framed with an object of known size to maximize the effect.

TIME OF DAY: SUNSET

Contrary to popular opinion, the sun does not always set in the west. It may disappear over the horizon anywhere in a 90-degree arc between southwest and northwest, depending on the time of year and the latitude. Direct light is characterized by its warm temperature, low intensity, and the long shadows it creates.

▲ Illusion of size

Optical illusion makes the sun appear much bigger when low in the sky near objects of known size. To recreate this effect on film, you need to use a long lens.

m 500mm lens, 1/500 sec at f/5.6. ISO 100.

▲ ► Diffused sunlight

The three pictures right and above show the effect of dust and moisture in the atmosphere and how it dictates the colour and visibility of the sun's sphere at sunset. A clear view will still be diffused by dust particles (far right). If covered by weak cloud or smog, the sun's shape can still be seen distinctly (above and right).

- (a) 350mm lens, 1/250 sec at f/6.7. ISO 200.
- (r) 300mm lens, 1/1000 sec at f/4. ISO 200.
- m (fr) 200mm lens, 1/125 sec at f/4. ISO 200.

▲ Adding emphasis

The elegant shape of the dhow against the orango sky is a striking image on its own, but the sun's sphere provides emphasis to the composition.

iii 135mm lens, 1/250 sec at f/4. ISO 200.

The sun appears at a low angle at one corner of the building, and the light spills across the silhouetted structure to create a feeling of drama. This is a favourite way of photographing ruins. The star-like pattern to the sun's rays is created by using a small aperture.

■ 150mm lens, 1/60 sec at f/19. ISO 100.

PROFESSIONAL HINTS

- It is possible to shoot the sun safely during those times of day when it is higher in the sky only if it is obscured or diffused by cloud.
- If the sun is out of focus in the frame, use a large aperture, otherwise it will appear as a polygon (the same shape as the iris), rather than as a circle.

Afterglow

When shooting sunsets, it pays to be patient. The best results are rarely achieved as the sun disappears over the horizon – the most dramatic colours are seen some time later. This afterglow can appear in a very wide range of colours and intensities, from subtle watercolour to surreal poster-paint shades.

The best afterglow effects often occur when there is some cloud in the sky, as this acts as a reflector, helping to maintain the colour long after the sun is out of view. To make the most of the sky after sunset, you need to find suitable structures and shapes to include in the composition. Provided it is relatively calm and smooth, water comes in very useful here, because it can double the amount of colour in a single frame.

This is also the best time of day at which to photograph city lights and floodlit buildings. Later, as darkness falls, a strong contrast is created between highlight and shadows. With the last vestiges of brightness still in the sky, exposures are much more balanced. For this reason, artificial lights and afterglow will both show up well with the same exposure.

TIME OF DAY: DUSK

The sky may not go dark when the sun sets because light may be reflected by clouds and the sky itself. How long the afterglow and the sunset last depends on your location and the time of year. In northern latitudes, the colour in the sky may persist all night. On the equator, spectacular sunsets last just minutes, swiftly followed by total darkness.

▲ The sky as backdrop

The remaining colour in the sky at dusk creates the perfect backdrop for the coloured streetlamps, car lights, and neon signs.

28mm lens, 1/8 sec at f/8 with tripod. ISO 200.

▼ Foreground silhouette

For this shot, a stand of young trees was isolated with a long telephoto lens to make a simple foreground to the Australian sunset.

200mm lens, 1/250 sec at f/5.6. ISO 100.

◆ Light on water

Still water is the perfect foil for the setting sun. Not only does it reflect the light but it also allows the photographer, as in this shot, to fill the frame with colour.

35mm lens, 1/125 sec at f/5.6. ISO 200.

▲ Dramatic light

Sunsets last longer, and are therefore easier to catch on film, the further north or south you are from the equator. This dramatic sky was captured in northern Scotland.

70mm lens, 1/125 sec at f/5.6. ISO 50.

DIGITAL SOLUTIONS

Unlike traditional cameras, digital cameras adjust automatically in response to the colour temperature of the light in the scene (see pp.138–9). Known as auto white balance circuitry, this feature works well most of the time but, when photographing sunsets, you may find that the camera tries its best to filter out the glorious colours.

One solution is to use a manual setting. Set the white balance to its midday setting, which is usually indicated by a "sun" icon. To get even more intense colours, use the white balance set control, and point the camera towards something blue. The camera will then electronically add more orange filtration to the shot, making your sunsets even more intense.

■ Capturing silhouettes

Figures can provide foreground interest when sllhouetted against a colourful sky. Always use a fast shutter speed to keep outlines sharp.

■ 35mm lens, 1/30 sec at f/4. ISO 50.

▼ Reflected colour

A cloudy rather than a clear sky tends to produce the best post-sunset pictures, because clouds reflect colour back into the landscape.

80mm lens, 1/60 sec at 1/5.6. ISO 100.

M SUMM IERS, 1/60 SEC at 1/5.6. ISU IU

Shafts of light

Clouds not only act as diffusers, softening the light of the sun, they also work as masks, creating holes through which the sun can shine directly on a subject. Sometimes the holes are so small that you can see an individual shaft of light. These sunbeams highlight random areas of the landscape, so that they stand out from the surrounding gloom. As the clouds move, sun spots move around the scenery, picking out different sections and providing the photographer with an ever-changing picture.

Such shafts of light transform the most mundane vista into something quite exotic – but it is the light itself that is more important than the landscape, as the play of light is effectively becoming the main subject of the shot.

▲ Momentary light

A shaft of light might last for only a few moments, but in that time it can transform a mundane scene into one full of vitality.

m 200mm lens, 1/125 sec at f/8. ISO 100.

▲ Monochrome landscape

As you invariably have to shoot into the sun to catch sunbeams on film, you create a strong contrast between light and dark. The result is often a monochromatic, semi-abstract shot.

■ 80mm lens, 1/125 sec at f/4. ISO 100.

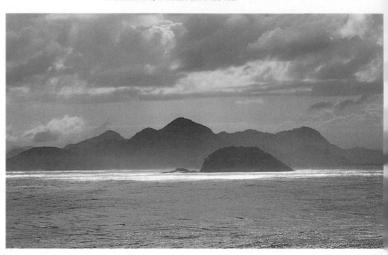

▲ Sunlight through cloud

As the sun breaks through the cloud and sea mist above the Lofoten islands in the far north of Norway, it shines on the water and creates a halo of reflected light around the dark hills.

m 100mm lens, 1/125 sec at f/8. ISO 100.

▼ Beams of light

A dark backdrop is essential to see sun rays clearly, otherwise the effect is lost. Here the spears of light counterpoint the rugged Norwegian cliffs.

■ 80mm lens, 1/250 sec at f/4. ISO 100.

▼ The sky as subject

If the sky is more interesting than the landscape, as in this scene, do not be afraid to let it fill the majority of the shot, composing the picture so that the horizon falls at least two-thirds of the way down.

m 100mm lens, 1/60 sec at f/5.6. ISO 100.

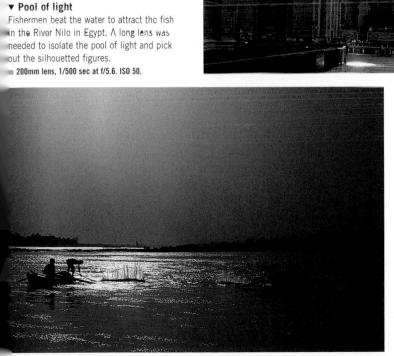

▲ Evocative effect

Shafts of light can also be captured indoors as they break through a window and light up the dust along their path. This evocative shot was taken in St. Peter's Basilica in Rome, Italy.

28mm shift lens, 1/60 sec at f/5.6. ISO 100.

PROFESSIONAL HINTS

■ Capture the effects of sunlight on the landscape by photographing the sun's rays through dust, mist, or smoke and at dawn or dusk. The special quality of light at these times of day will enhance the scene.

■ Rays of light can often be photographed most successfully in landscapes containing water. The water reflects the light, creating

a strong contrast with shaded areas.

Storm lighting

Adverse weather conditions can sometimes provide an opportunity to take unusual and interesting photographs. In fact, stormy weather can often bring with it brief periods of dramatic lighting, which is particularly suitable for creating moody landscape shots in glowing colours.

One of the most magical moments to look out for is when sunlight is juxtaposed with dark, brooding clouds. This effect is normally seen just before or after a heavy shower of rain – and as the resulting conditions may last for only minutes, or even seconds, it pays to be prepared by having photographic equipment to hand and a suitable subject in mind when these lighting conditions occur.

The maximum contrast is achieved with frontal lighting, when the sun is behind you, as this produces strong colours in the landscape. After the rain, colours can be even stronger: the downpour will have washed dust particles from the atmosphere, increasing visibility.

► Dark backdrop

A break in the clouds after heavy rain can result in theatrical lighting effects — with the dark sky creating an unusual backdrop. In this shot, the eye is drawn away from the foreground to the sunlit horizon.

28mm lens, 1/30 sec at f/16 with tripod. ISO 100.

▼ Strong colours and sharp contrasts

Storm lighting creates intense, vivid colours. In this shot of a fishing village, a strong contrast is made between the overpowering dark cloud and the blue summer sky and whitewashed buildings.

■ 35mm lens, 1/250 sec at f/8. ISO 100.

▲ Warm colours and reflected light

Storm lighting does not always create intense colours. Here, the late evening sun is struggling to break through the cloud, but still adds warmth, while the extreme darkness of the cloud contrasts with the car headlights.

35mm lens, 1/60 sec at f/5.6. ISO 100.

▲ Poor lighting conditions

Dull lighting can be a positive element in a composition, This mist in the Scottish Highlands created a low-key shot in which the mountainous landscape and road have been translated into shades of grey.

■ 24mm lens, 1/30 sec at f/5.6. ISO 200.

See also Shafts of light p.156 Direction of lighting p.160 Rain p.304

Direction of lighting

Shadows provide vital information in photography. The way they fall shows us aspects of a subject that could otherwise not be discerned from looking at a flat picture. The angle of light dictates where the shadows will appear, while their strength depends on how much the light is diffused and reflected. These two factors influence how the essential elements of the objects are revealed – their texture, shape, three-dimensional form, and colour.

The sun can be at a number of different positions in relation to the subject – not only anywhere in a 360-degree arc, but also at varying heights. In the studio, there is an even greater range of lighting angles, because the light source can be placed below the subject (although, as this tends to look unnatural, photographers usually restrict themselves to angles that are possible with sunlight).

Natural lighting

The directionality of light outdoors is, of course, dependent on where the sun is in relation to the subject. But the shadow areas are never completely unlit, as they receive light reflected from the sky, buildings, and the ground.

▲ Frontal lighting outdoors

Frontal lighting, with the sun behind the photographer, provides few visible shadows, as these fall behind the subject. This means that there is little information about form and texture, which can make objects look two-dimensional. However, the even illumination creates trouble-free exposure and the deepest colours in both subjects and sky.

85mm lens, 1/500 sec at f/5.6. ISO 100.

LIGHTING SOURCES

There are three main lighting directions: the light source can be behind the subject (backlighting), in front of it (frontal lighting), or to the side (sidelighting). Each category covers a range of angles, and the border between each is blurred. Other directions of light, such as top lighting (light overhead) or rim lighting (see pp.162–3), are also used.

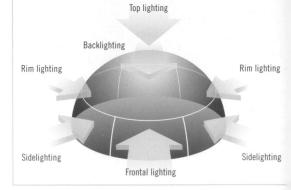

▼ Sidelighting outdoors

Sidelighting often creates the most dramatic pictures, as it casts strong visible shadows that contrast with strong highlights. It is excellent lighting for revealing texture and form. Colours show up well in the lit areas – but are lost in unlit ones.

85mm lens, 1/500 sec at f/5.6. ISO 100.

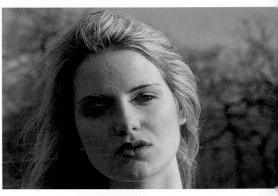

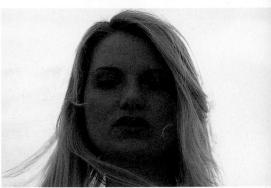

▲ Backlighting outdoors

With the sun behind the subject, detail gets lost in the shadow. Colour are weak or even non-existent. There is no information about form or texture – there is often just an overall shape. The strong contrast can cause exposure difficulties. Outdoors, where reflected light levels are high, you can get a good picture even when the subject is mainly back!

Artificial lighting

The effect of lighting direction is more extreme in the studio than outside. Lights can be set up so that no light reflects into shadow areas. Usually, however, the lighting is set up to look similar to natural sunlight. Studio flash is always diffused, and fill-in flash (*see pp.170–1*) is usually used. This lessens directionality, but also masks the effects of the inverse square law (*see pp.166–7*).

► Sidelighting in the studio

Studio sidelighting allows complete control of the angle of illumination: you can change the height and position of the light, so the exact parts that you want are lit, Here the main light is to the left of the model, and a fill-in light mensures the shadows are not too dark,

■ 120mm lens, 1/60 sec at f/11, ISO 50.

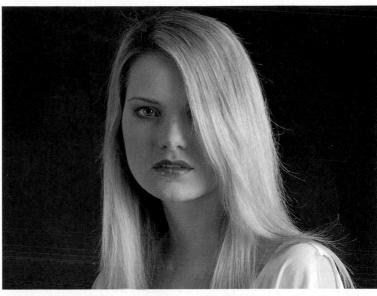

▲ Three-quarter lighting in the studio This form of lighting combines the benefits of frontal lighting and more extreme sidelighting. The main studio light is placed at around 45 degrees to the lens angle. This produces enough shadows to show the form of the face without the shading being too extreme. The colouring of the features also appears more balanced and natural than with the sidelighting. ■ 120mm lens, 1/60 sec at f/11. ISO 50.

◆ Frontal lighting in the studio

Putting the main light in line with the lens provides the simplest lighting for many subjects. If the light source is diffused (with a softbox, for instance, as in this shot) illumination will be even, which helps colour saturation and exposure. Positioning the light above the camera mimics the effect of natural sunlight.

■ 120mm lens, 1/60 sec at f/11. ISO 50.

Rim lighting

Although, for the sake of simplicity, lighting angles can be split up into three broad categories (*see pp.160–1*), there are occasions where lighting refuses to be categorized in this way.

Rim lighting is essentially a type of backlighting. In backlighting, the sun or other light source is behind the subject, so the visible areas of that subject are not lit directly. However, with rim lighting, the light catches the edge of the subject, lighting it up and providing a bright outline to the otherwise dark subject. The light source is normally just out of frame and slightly above the subject. Alternatively, it can be hidden by the subject itself.

The effect of rim lighting depends greatly on the surface of the subject. Dark, shiny materials reflect the light well – and produce an interesting juxtaposition of tones if rim lighting is used against a dark background.

The translucency of hair fibres means that rim lighting also works well with many wildlife subjects, telling us much about an animal's fur and providing a soft edge to the subject. In the studio, rim lighting is often used in conjunction with frontal lighting to reveal the colour and softness of a blonde model's hair.

▲ Bright profile

With true backlighting, all of the face would be in shadow – but the light just out of shot lights up the edges of the nose, mouth, and chin to create an interesting profile portrait.

m 85mm lens, 1/30 sec at f/8, ISO 100,

▲ Rim lighting and backlighting

Sunlight streams in from a high window above the riding school arena. This creates a rim of light on the curves of both horses' backs, while backlighting the tail of one. The dusty atmosphere makes the rays more visible.

200mm lens, 1/500 sec at f/5.6. ISO 100.

▶ Lighting translucent objects

With the sun just in shot, the edge of the dandelion stalk and the seed stem are strongly highlighted. As the subject is translucent, it has not become a silhouette.

100mm macro lens, 1/125 sec at f/5.6. ISO 100.

▲ Emphasizing shape

The high angle of the sun means that the surface of the bales facing the camera is in silhouette, but the tops are in sunlight. This provides a halo effect, which serves to emphasize the shape of the bales.

m 135mm lens, 1/250 sec at f/8. ISO 50.

■ Hair highlight

Rim light is frequently used in the studio with blonde models as a way of drawing attention to their hair. Here, the hacklight is provided by the sun, which was high overhead.

m 135mm lens, 1/250 sec at 1/5.8. ISO 100.

RIM LIGHTING IN THE STUDIO

Outdoors, there is normally enough indirect light for backlighting to be used for softly lit portraits. In the studio, rim lighting is rarely used alone. Here, a spotlight behind the model rim lights the hair, while diffuse frontal light fills in the detail.

■ 85mm lens, 1/15 sec at f/8. ISO 100

Translucent subjects

Many manmade objects and natural subjects have a translucent quality that photographs well – coloured bottles, for instance, make interesting subjects for still-life shots. While most subjects show their colours best when they are lit from the front, such see-through subjects are best photographed with backlighting, otherwise their translucency cannot be properly appreciated.

Among the most photographed translucent subjects are stained-glass windows. Obviously, these are designed with backlighting in mind, which can cause exposure problems. Inside a church, the contrast between dark walls and bright windows is too great for the camera to cope with, and the windows can end up burnt out. The solution is to crop in on the windows tightly – and to photograph them when it is not too bright outside.

▶ Wide aperture

Here, the stained glass occupied the centre of the window, leaving corners where it was possible to see what was beyond. To combat this, a wide aperture was used to throw those areas out of focus.

■ 100mm lens, 1/250 sec at f/2.8. ISO 100.

▼ Exposure choice

For this picture, the exposure was set to ensure that only the light from the window was caught.

A longer exposure would have revealed the interior of the church.

■ 150mm lens, 1/30 sec at f/11. ISO 100.

▲ Shooting in situ

Mask around the area to be shot with black paper to exclude excess light. If you use a ladder to reach the glass, it can also serve as a tripod. Use purposebuilt clamps to attach the camera to the top rung of the ladder.

▶ Up a ladder

After the camera has been clamped to the ladder (see above), fire it, using a long cable release to ensure the ladder does not vibrate.

80mm lens, 1/4 sec at f/16.
 ISO 100.

▲ Shooting in the studio

Flat translucent subjects can be photographed in the studio on a sheet of perspex, with a light beneath. Mask off surrounding areas with black paper or velvet.

80mm lens, 1/60 sec at f/16 with studio flash. ISO 50.

Using flash

On occasion, there is not going to be enough natural lighting to get the picture that you want. Although the photographer can compensate for low light by lengthening the exposure, this solution is suitable only with stationary subjects. Electronic flash, however, not only allows you to carry on taking pictures when ambient illumination is insufficient, but can also be used as a way of controlling the character of lighting.

Most portable flashguns – especially those that are built into cameras – increase the quantity of light only slightly. They tend to give poor-quality illumination in a wide variety of situations. Flash is often an emergency solution, and it is important to realize its strengths and weaknesses, as well as knowing when you can do without it.

One of the main disadvantages of flash is that it is a harsh, low-powered light source. In the studio, flash can be mains-powered to increase its output, and can then be diffused and reflected to change its quality (*see pp.336–9*). However, portable flash is battery-powered, and attempts at diffusion to improve its quality will weaken what is already a weak light source. There are also a limited number of flashes before the batteries are exhausted.

Flash power

The power of a flashgun is normally expressed by its guide number (GN) – the higher the number, the more powerful the flash. The guide number represents the maximum distance over which the flash is effective, using a lens with an aperture of f/1.0. The guide number is usually quoted in metres and (as the range is dependent on sensor or film sensitivity) for an ISO setting of 100. Be aware that some guide numbers are quoted in feet rather than metres.

The guide number can be used to calculate the aperture needed when using the flashgun at full power. To work out the aperture, divide the guide number by the subject distance. So if the strobe has a guide number of 28 (m/ISO 100) and the subject is 7m (20ft) away, the aperture you should use (with an ISO 100 setting) is f/4.

Guide numbers quoted by manufacturers may be optimistic, and you may need to use a wider aperture than the formula would suggest. Buy a flashgun with the biggest guide number you can afford – the more power available, the greater the range of apertures, diffusion, and bounce you can use (the power output can always be reduced).

▲ Low-powered flash

Over short distances, only limited flash power is necessary. The built-in flash of an SLR with a guide number of 12 (m/ISO 100) was more thar adequate for this portrait of a girl standing just 1m (3ft) from the camera 50mm lens, 1/60 sec at f/11. ISO 100.

■ High-powered flash

For this shot, the flash was bounced off the ceiling to make the mural more noticeable. A large hammerhead flash with a guide number of 60 (m/ISO 100) was used to provide enough output.

m 50mm lens, 1/15 sec at f/11 with tripod. ISO 100.

▲ Dark background

Flash pictures characteristically have light foregrounds and dark backgrounds. The effect of the flash lessens rapidly with distance, due to the effect of the liverse square law = 28mm lens, 1/60 sec at 1/5.6 with flash. ISO 100.

Inverse square law

All flash units have a limited range, with their light output dropping off rapidly over distance. This is explained by the inverse square law, which says that the intensity of a light source diminishes with the square of the distance it travels. So if you double the distance between a light source and the subject, the amount of light reaching the subject falls by three quarters. Therefore the distance between subject and flash is crucial. The parts of the picture that are further from the flash will appear darker, while objects that are nearer the flash than the subject will appear lighter, which may make them look overexposed and burnt-out. If a flash used at full power requires an aperture of f/16 at 1m (3ft), it will require 16 times more exposure (four stops) at 4m (12ft) – that is, an aperture of f/4.

SYNCHRONIZATION SPEED

Set to automatic for a subject close to the camera, the burst of light emitted by a flashgun may last only 1/40,000 sec. Set on manual and full power, the flash may last up to 1/1000 sec. With focal plane shutters, the exposure at fast shutter speeds is made through a moving slit, because the second curtain begins closing before the first has finished opening ($see\ pp.18-19$). If the flash is fired at a fast shutter speed, only part of the frame will be illuminated (the rest will appear as a dark band). The fastest shutter speed that can be used with flash is known as the flash synchronization speed (or synch speed for short). The synch speed on $35 \, \text{mm}$ SLRs varies from $1/30 \, \text{sec}$ to $1/300 \, \text{sec}$. There are no synch speed problems for between-the-lens shutters, as found on compact cameras, and used on some accessory leaf-shutter lenses for medium-format cameras, allowing any available shutter speed to be used with flash.

TYPES OF FLASH UNIT

A number of flash unit models are widely available. These vary from those that are suitable for beginners to those more appropriate for professionals.

Built-in flash

These units often have a guide number that can be as low as 5 (m/ISO 100), so they work over only 1 or 2m (3–6ft). Their fixed position often creates strong visible shadows.

Hotshoe flash

An add-on gun provides more power than a built-in flash and increases the angle between lens and flash for better modelling. Often the head can be tilted or rolated for bouncing the flash oft walls or reflectors.

Twin-flash system

This specialized unit is designed for use with macro subjects, where shadows from a normal flash would obscure detail. The two flash tubes attach to the front of the lens to provide even, all-round lighting.

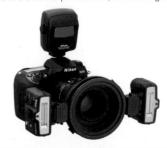

Using portable flash

Flash is an almost essential camera accessory at parties, weddings, and other social gatherings, because many of these events take place indoors. Although a studio flash system gives more control over lighting than a portable flash unit, there are ways in which a portable flash can be adapted to provide better quality illumination.

One of the main improvements you can make is to move the flash some distance away from the lens. Flashguns that are attached to the hotshoe, and built-in strobes in particular, provide rather harsh frontal lighting. By moving the flash so that it is located to the side of the camera, you create more angular lighting, with shadows that provide useful modelling rather than a hard outline.

You can also soften the flashgun's lighting by using a diffuser, weakening its output – and still have enough power to use a reasonable aperture.

▲ Off-camera flash

In the shot above, a hammerhead flash was used on a bracket to the left side of the camera, creating slight modelling on the girl's face. A lead connected the flash to the SLR, ensuring synchronization.

■ 135mm lens, 1/30 sec at 1/5.6 with flash, ISO 100.

Diffusers

Every flashgun has a built-in diffuser, but this is a basic affair that is principally designed to ensure that the illumination is relatively even across the field of view. Some guns have zoom heads, which allow you to alter the amount of diffusion to suit the lens you are using with the flashgun. However, to soften the harsh lighting, it is worth buying an additional diffuser — one that fits over the front of the flash tube. This has the disadvantage of cutting down on both the power and range of the gun, but its advantage is that it will improve the quality of the lighting significantly.

An alternative for a hammerhead strobe is a miniature softbox attachment. The Westcott Micro Apollo, for example, has a frame that fits over the gun. This modifies the light so that it appears to come from a larger, softer source.

ADDITIONAL DIFFUSERS

Accessory diffusers are designed to soften the light source so as to improve the quality of the lighting, particularly for portraits. Some, such as the Sto-Fen Omni-Bounce range (right), are essentially pieces of white perspex that are custom-built to fit over different flashguns.

▼ Extra diffusion

In this candid wedding photograph, the off-camera flash is fitted with a diffuser. This creates a much softer overall lighting effect, providing a more natural result than would be possible with normal direct flash.

135mm lens, 1/60 sec at f/5.6 with flash. ISO 100.

Bouncing flash

Many flashguns have heads that swivel or tilt, allowing you to bounce the flash off walls or ceilings. This works well if the the nearest wall or ceiling is not too far away, but you need to take into account that tilting the flash will reduce flash power and increase flash-to-subject distance.

When bouncing flash, you should also remember that coloured surfaces will tint the light that they reflect. If the walls or ceiling are coloured, use a clip-on reflector, which allows you to provide your own white, silver, or gold surface to bounce the light off.

▲ Flash bracket A bracket connected to the tripod socket means a flash can be placed to the side of the camera.

▶ Pointing flash at the subject

Using the flash at the side of the camera creates better modelling than an on-camera flash - but the lighting is still harsh. The bracket can be angled so the flash points more or less directly at the subject.

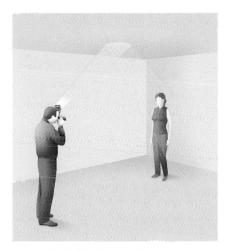

▲ Bouncing flash off the ceiling A tilt head allows you to angle the flash so that it can be bounced off a ceiling. This diffuses the light, creating a softer effect with less-distinct shadows.

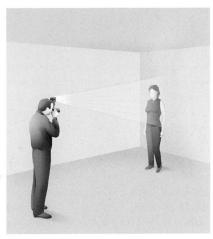

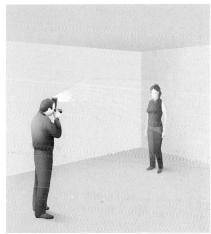

▲ Bouncing flash off the wall An alternative to bouncing the flash off a ceiling is to bounce it off a wall - with a flash head that swivels. This also softens the light.

Dealing with red eye

Of all the problems that portable flash can introduce into your photography, red eye is the most familiar, and is becoming more common because more people are using onger lenses. The effect is particularly marked because flash is isually used in low light, when our pupils are at their most filated. There are several ways to minimize this problem. Many cameras with built-in flash units have an anti red-eye node. This uses a series of flashes to force the subject's pupils o contract immediately before a picture is taken. It works vell, but the disadvantage is that there is a long delay between ressing the trigger and the actual picture being taken – and his tends to kill spontaneity in the pictures.

liminating red eye

To eliminate red eye, increase the angle between the lens xis, flash, and subject. Use an accessory flash rather than he built-in flash to raise the flash tube slightly. You can hen increase the angle between the lens and the flash still urther by using the flash off camera. Alternatively, stand loser to the subject when taking the shot.

■ Red eye

Red eye occurs when the flash bounces off the retina at the back of the eyeball, illuminating the blood vessels in the eye.

▼ Flash distance

The closer the flash is to the lens, the greater the risk of red eye. Using off-camera flash minimizes the problem.

Flash on camera

Flash off camera

Flash exposure

In flash photography, exposure is governed as much by the power setting used by the flash as it is by the shutter and aperture used on the camera. Many flashguns are dedicated - working with your particular camera to make it easier to use and simplify exposure. The flashgun may ensure that the synch speed is set correctly, that you can see in the viewfinder that the flash is ready to fire, and that the output is set automatically for the distance. For most flash photography, the shutter speed used has little effect on the exposure. The flash is so brief that it becomes the effective shutter speed for the exposure. Shutter speed can be used creatively. A slower than usual shutter speed can be used to create a bright background (as this is lit by ambient light, rather than by flash). A slow shutter speed can also be used to effectively superimpose a blurred image of a moving subject with a sharp one frozen by flash.

Ghost images

Flash can be used with slow shutter speeds, to juxtapose a streaked image with a sharp one, but the technique can create problems. The flash fires when the first shutter curtain opens, so the ghost image created by the ambient light seems ahead of the subject. Some SLRs allow "rear-curtain synch", which fires the flash before the second curtain closes; the ghost image then trails the subject. Some SLRs allow speeds of up to 1/12,000 sec with certain flashguns, avoiding a ghost image even in bright light. The flash strobes during exposure, so the film or sensor is evenly lit, even though exposed through a moving slit.

1/60 sec with diffused flash

1/8 sec with diffused flash

▲ Changing background brightness

By changing the aperture, the background of this portrait can be made darker or lighter. Using the synch speed, the wall behind the sitter looks grey. With a slower speed, the wall has a more natural tone.

- m (t) 50mm lens, 1/60 sec at f/8 with flash. ISO 100.
- (a) 50mm lens, 1/8 sec at f/8 with flash. ISO 100.

▼ Slow synch flash

Here the flash creates a sharp, correctly coloured image of the boy, but the slow shutter speed means his waving hand and swaying head have created a blurred after-image, lit by the orange-coloured tungsten lights.

120mm lens. 1 sec at 1/8 with flash and tripod. ISO 100.

FLASH-FREEZING ACTION SHOTS

Flash provides a method of capturing moving objects crisply in lowlight situations where fast enough shutter speeds are not possible. The technique, however, works only if you are within the flashgun's limited effective range — and only if the ambient light is such that the flash has a significant effect on subject lighting.

► Freezing movement

Flash not only boosts the low light for this poolside shot, it also crisply catches the droplets of water thrown up by the swimmer's arms.

135mm lens, 1/125 sec at f/5.6 with flash, ISO 200.

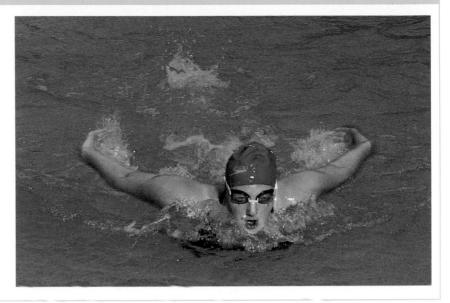

Fill-in flash

Flash is useful not just in lowlight situations but also in daylight. Although only effective over short distances, fill-in flash allows you to change the contrast of the ambient light. In dull weather, fill-in can be used to boost contrast. On a bright sunny day, flash can help to reduce the contrast between the foreground and the background, particularly when you are shooting directly into the light.

Working out the exposure for fill-in manually can be challenging, as you normally want to reduce the intensity of

the flash. The usual method is to set the film speed on the flashgun (not the camera) to two or four times more than the film or ISO setting used. Use the flash ralculator dial to work out a suitable aperture, then set this aperture on the camera with a suitable shutter speed for the ambient light (ensuring that the shutter speed is set slower than the camera's synch speed). Fortunately, built-in (and many dedicated) flash units excel in this area, as they measure flash exposure throughthe-lens, automatically balancing ambient and artificial light,

▲ Without fill-in flash

The wide-brimmed hat means that the girl's face has been thrown into shadow by the sun.

70mm lens, 1/125 sec at f/5.6. ISO 100.

■ With fill-in flash

Flash from the camera's built-in flashgun lights up the immediate foreground of the shot. It reduces contrast, so that the girl's face becomes visible, and adds attractive catchlights to the eyes.

70mm lens, 1/125 sec at f/8 with flash. ISO 100.

Painting with light

Although portable flashguns are designed to work only over relatively short distances, it is possible to increase their fire power so that they can be used with bigger subjects. "Painting with light" involves firing the flash several times while the shutter is locked open. The technique is particularly useful for lighting large rooms, or for illuminating buildings after dark.

A solid tripod is essential for this type of shot. The flash used must also have an open flash or test button, allowing you to fire it without having connected it to the camera. With the camera set to its B or T setting, the flash is then fired at different parts of the room or at the facade of the building. Care must be taken at all times to point the flash away from the camera and to fire from places that are out of frame (for example, from behind pillars). It helps to dress in dark clothes and to keep moving when in front of the lens, so that you minimize the chance of your ghost appearing in the image.

One flash

Two flashes

Four flashes

Ten flashes

▲ Judging the number of flashes required

50mm lens, f/16, using B setting and tripod, ISO 200

This series of shots was an experiment with bursts of flash, using between one and ten flashes to light the interior of the room as well as the model. With one flash lighting the model only, the room is almost lost in darkness. Two separate flashes, in addition to that on the model, help pick out the walls. Four flashes on the wall make a much better balanced picture, while ten flashes make the floor and ceiling much more visible.

LIGHTING CAVES

Speleologists use the paintingwith-light technique to light up large caves. Members of the caving team can each be in the picture discreetly holding their own flashgun pointing at a particular part of the cavern; fitted with a slave unit, each of these then fires simultaneously. As caves are wet places, some cavers use flash bulbs instead of electronic flash. Flash bulbs can be used only once, but produce intense light - and need only a basic electrical circuit to be used.

◄ Lighting the ceiling

The painting-with-light technique is particularly useful for the high ceilings of churches, where it is almost impossible to throw enough artificial light. As you are shooting upwards, there is little danger of the flashgui appearing in the shot. The smallest aperture available was set – giving enough time to fire the hammerhead flash three times.

28mm lens, 2 secs at f/32.ISO 50.

PROFESSIONAL HINT

Fire the flash several times to allow a smaller aperture to be used than would otherwise be possible when shooting stilllife subjects in the studio.

Composition

One of the decisions that the photographer needs to make is where to stand and which way to point the camera. Although technological developments mean that exposure and focusing are often determined automatically, in the end it is always the photographer who makes the decision on exactly how to frame up the picture in the viewfinder.

Whereas a painter can alter reality by leaving out parts of a scene that he or she does not want others to see, the camera will record everything in front of it indiscriminately. Composition, therefore, is essential to simplify the cluttered world around us.

Although some subjects can be physically manoeuvred within the frame, it is not always possible to control totally what is in the scene, especially if the subject is unpredictable. However, by choosing which lens to use and when to press the shutter, the photographer can exert a powerful influence over how the picture ultimately appears.

The selective eye

Rather than just finding what to take a picture of, composition is often about finding ways of emphasizing some parts of the scene, while trying to hide or disguise others. It is about putting things into order – rather like arranging words in a sentence to tell a personal story, or giving a first-hand description of what you have seen.

Although there are plenty of rules that can help guide your compositions, it is important to realize that there is more than one way of framing up a perfect shot. The famous pyramids of Egypt, visited by millions and surrounded by the suburbs of a bustling city, must be among the most photographed sights in the world. However, as these shots show, it is possible to achieve a varied portfolio during a short stay, simply by working hard at the composition.

▲ Balanced approach

In this symmetrical composition, showing the pyramids at sunset, the sun is out of view, and the camel is placed centrally. The horizon is deliberately kept near the bottom of the frame to emphasize the sky.

▲ Minimizing the foreground

Here, the people in the foreground have deliberately been kept small by locating the camera some distance from them. This allows the pyramid and dramatic sky to dominate the frame.

■ 35mm lens, 1/500 sec at f/8. ISO 50.

▲ Bird's-eye view

Always explore a view from different angles. This aerial shot, taken on a sightseeing flight, places the horizon near the top of the picture. Seen from above, the pyramids appear isolated in the landscape.

▲ Long-distance shot

A distant shot of this step pyramid emphasizes its size and solidity by placing the horizon centrally. In the middle distance, the people are barely visible, while in the foreground, the stone blocks look huge.

■ 35mm lens, 1/500 sec at f/8. ISO 50.

▲ Using a backdrop

Including a pyramid in the background of a shot of the sphinx gives context to the subject as well as suggesting the size and grandeur of the statue. The intense blue sky sets off the composition perfectly.

■ 35mm lens, 1/500 sec at f/8. ISO 50.

▲ Losing the crowds

When shooting the pyramids, it is often hard to avoid including the many tourists and coaches. But this angle was worth hunting out as it shows the ancient site as it might have appeared hundreds of years ago.

■ 35mm lens, 1/500 sec at f/8. ISO 50.

▲ Foreground interest

In this shot, the pyramid and mound provide a symmetrical backdrop to the subject. Photogenic and colourful-looking locals can add interest to shots of well-known buildings and sites of historic interest.

■ 35mm lens, 1/500 sec at f/8. ISO 50.

▲ Upright shot

For this silhouette shot, the camera has been turned to give an upright, or portrait, picture. With most formats, switching between upright and horizontal views is the easiest way of adding variety to a set of pictures.

■ 200mm lens, 1/500 sec at f/8. ISO 50.

Can also Calcoting a viewpoint a 196 Vaning the chote a 199

Placing the subject in the frame

Part of the composition process involves deciding where you place the main subject within the frame. Many photographers simplify the composition of their pictures by having just one principal subject and arranging all other elements so that they are subsidiary to it. It is possible to place this main focus in the centre of the frame, which is a useful approach when you want to show the harmony or tranquillity of a scene, or emphasize the symmetry you have seen in the subject. However, this approach may make the resulting composition appear to be too contrived.

With most subjects, it usually pays to place key elements in the scene deliberately and noticeably offcentre. This produces a more dynamic-looking picture, as it creates imbalance within the frame. A number of different rules have been used by artists over the centuries to lay down the exact place in which to put these key elements. Unlike a painter, though, a photographer rarely has time to be precise about such things.

▲ Strong symmetry

Although the children have not been placed centrally in the shot, the composition is still symmetrical. The eye is drawn first to the little girls, and then led along the strong lines created by the church path.

28mm lens, 1/60 sec at f/8. ISO 200.

▲ Using diagonals

In this shot, there are two subjects: the Romanian man and the wooden church behind. Each is placed in diagonal corners of the rectangular 35mm frame.

■ 35mm lens, 1/60 sec at f/8. ISO 200.

Rather than crop in tightly on this shot of Ely Cathedral in the UK, the grass occupies over half the frame. This forces the subject away from the centre and creates a dynamic feel.

250mm lens, 1/125 sec at f/5.6. ISO 200.

THE RULE OF THIRDS

A simple device for getting the balance of a composition right is to use the rule of thirds. This breaks the frame up into a grid of nine equal rectangles. Key points of the shot are placed at one or more of the intersections, while key horizontal or vertical lines relate to the grid lines.

▼ Focal point of colour

Placed to the right and below the centre of the picture, the cyclist's body falls at a key point formed by the rule-of-thirds grid. It provides a perfect focal point of contrasting colour in the landscape.

■ 35mm lens, 1/60 sec at f/8. ISO 100.

▼ Focusing on the eye

This shot exploits the rule of thirds perfectly. Photographers usually focus on eyes when doing portraits. Here, the model's eye falls at the top-right intersection of the grid, intensifying its use as a focal point.

■ 35mm lens, 1/60 sec at f/8. ISO 100.

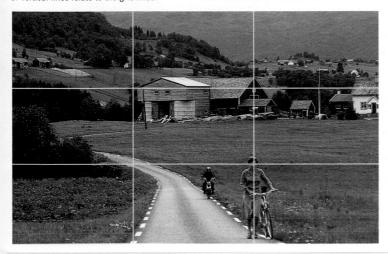

◄ Controd harmony

In this shot, the horizon and church were deliberately placed centrally. This composition emphasizes the reflection in the water, and the peacefulness of the countryside scene.

■ 50mm lens, 1/125 sec at f/8. ISO 100.

PROFESSIONAL HINTS

- In landscape pictures, one of the key focal points is the horizon. To ensure a good balance, place the horizon line so that it falls a third of the way down the frame.
- If you are taking a landscape photograph and the sky looks interesting, you might try placing the horizon line so that the sky occupies two thirds of the picture.
- Key subjects in a picture rarely occupy a single point. In a portrait, the face is the crucial part of the subject, and it can be placed to conform with the rule of thirds, but often the rest of the subject sprawls over the grid. In such situations, ensure that the subject is not too central to achieve the correct balance.

Using diagonals

In the same way that placing your subject dead in the centre of a picture will make your pictures look ordinary and unexciting, you will find that running the lines in the image parallel with the edges of the frame will produce lifeless or ordinary pictures.

Of course, there are occasions where the composition must do just that. For example, when people look at a straight-on shot of a building, they expect to see the uprights run straight up the frame, or the horizontals run perpendicular to the sides of the viewfinder. Similarly, a picture that includes a flat horizon must not be even a degree or two off level, or the image will not work.

However, whenever possible, it pays to try and engineer the shot so that at least some of the lines run diagonally across the frame. The slanted lines create immediate drama in the shot, and create a path that leads the eye across the picture from corner to corner. They can also add a feeling of movement to a scene.

What makes diagonal lines so powerful as a compositional device is the way in which they interact with the rectangular frame created by the photograph. Using them creates a dynamic picture simply because they defy the straight edges of the viewfinder by not running parallel to them.

▲ ► Leading the eye

Here, the outline of the model's hair creates a dramatic diagonal that leads the eye from the corner of the frame at 45 degrees to the direction of the face. This is possible because the model is placed off-centre in the shot.

■ 150mm lens, 1/60 sec at f/5.6 with studio flash. ISO 50.

▲ ► Maximum impact

This dynamic shot combines three different sets of diagonals. The sides of the pyramid create two strong lines across the frame. These diagonals are echoed by those created by the open book and, again, by the shape of the model's arms. The effect is achieved here by placing the model in the centre of the shot.

100mm lens, 1/250 sec at f/8. ISO 50.

▲ ► Aesthetic diagonals

Ballet dancers train for years to be able to produce the powerful and aesthetic diagonals that are such an important part of their art. However, taking this shot was simply a matter of waiting for just the right moment to press the shutter.

35mm lens, 1/60 sec at f/8. ISO 200.

▲ ▲ Capturing action

This scene captures the sheer energy and exuberance of a Spanish schoolyard. The diagonals created by the striding girls help to communicate this feeling, because they contrast so strongly with the girls standing still.

■ 35mm lens, 1/125 sec at f/5.6. ISO 200.

- Look for natural diagonals in every scene they can be used to create structure in the image.
- Get closer to the subject to engineer diagonal lines, using a lower viewpoint and a wider lens. This approach works particularly well with buildings.
- When photographing action subjects, be aware that diagonals impart a sense of movement particularly well.
 A single diagonal creates
- the most dynamic effect when it forms a 45-degree angle with the frame, and when it seems to emerge from a corner.
- When there is more than one diagonal line, the maximum impact is achieved if the lines do not run parallel to each other, but instead each form the greatest angle with the sides of the frame, without any of these angles being equal.

Circles

Subjects come in all shapes and sizes – but it is often the simplest shapes that have the strongest visual appeal in photographic composition. Triangles and diagonal lines are known for their ability to create drama and tension within the frame. Circles and curved lines tend to do the opposite, often creating harmony within a picture.

If you incorporate a dominant round shape within a composition, you will find not only that it attracts immediate attention but also that it is hard for the eye to draw away from it. The perfect symmetry of circles cannot conflict with the angles of the frame itself, so they can be incorporated into practically any part of the frame without causing offence. The composition is often arranged so that the circle becomes a backdrop.

▼ Background interest

A large tractor tyre creates an interesting background for a portrait – drawing the eye into the shot and creating an emphasis. Without it, the picture would not have been so dramatic. Note that a composition is usually arranged so that the main subject breaks across the circle, as the girl does here. The circle then becomes the background element in the picture.

90mm lens, 1/125 sec at f/8. ISO 100.

▲ Playing with shapes

A parasol is used here to create a fun fashion image – which contrasts a circular shape with the strong triangular shape of the pyramid. Circles can create strong frames within a frame, helping to isolate a subject from the background. A plate or bowl can be used in this way for still-life shots, and a hat or umbrella works well with a portrait.

m 35mm lens, 1/60 sec at f/8. ISO 50.

▲ Combining shape and colour

It is the exotic and unusual mix of shape and colour that makes this picture so Interesting. The brightly hued circles are dye baths in Morocco – and a strong sense of perspective has been created by using a wide-angle lens.

28mm lens, 1/60 sec at 1/11, 150 100.

▲ Repeated circular motifs

The circle is a strong motif in architecture and other visual arts. The circular shape of the atrium of this opera house is echoed in the patterns used on the floor and ceiling. A wide-angle lens enabled the ceiling and floor to be included in the shot, so that the overall composition maximizes the sense of symmetry. The circular motif also forms the toreground to the picture, leading the eye to the lighter area in the centre, where a figure can just be seen standing at the top of the stairs.

24mm lens, 1/8 sec at f/11 with tripod. ISO 100.

▲ Strong focus

The rounded form of any circular-shaped building creates a strong and unusual presence in the landscape – regardless of how humble the structure is.

■ 50mm lens, 1/125 sec at f/5.6.

◆ Circles to the centre

The circles used in this painting draw you into the centre of the shot, making an impressive backdrop to a portrait. The subject, the artist Sir Terry Frost, painted the canvas, and has devoted much of his professional life to creating pictures with a circular theme.

■ 150mm lens, 1/60 sec at f/8 with tripod. ISO 100.

Frames within frames

One of the drawbacks of photography as a creative medium is that the canvas you use always has the same shape. This is particularly true with 6 x 6cm medium-format cameras, where every picture is square. With other formats, such as 35mm, you can choose between portrait and landscape format, simply by turning the camera on its side. Some cameras, such as those using APS film, give a choice of different aspect ratios, but still the choice is fairly limited.

While you can always crop your photographs to whatever shape and size you want after they are printed, there are other ways of creating frames while shooting them. The most popular idea is to use a natural frame that is present in the scene, and shoot through this. Archways, columns, trees, door frames, and window frames are commonly used in this way, providing an artistic means of limiting the useful image area of the shot. Once you have started looking, you will find that these natural frames occur everywhere.

Frames within frames also serve other purposes. For instance, the technique can be a way of hiding distracting details in the foreground. It is also a way in which photographers can help to create a feeling of depth in their pictures, because frames add another layer to the image.

▼ Extremes of light and dark

In this scene, the curtains create an ornately edged frame to the nude, while most of the room is thrown into darkness, creating a sharp contrast in degrees of lighting intensity.

80mm lens, 1/60 sec at f/5.6. ISO 100.

◆ Out-of-focus frame

The frame you use does not need to be pinsharp. This thick iron fence around an Indian palace still creates an interesting frame for the imposing building beyond, even though it is out of focus.

■ 35mm lens, 1/250 sec at f/5.6. ISO 100.

▼ Uneven frames

A series of uneven frames within one shot was created by holes in the cave wall. Notice how the horizon line is broken, and the seated figure and person on a donkey are almost incidental.

■ 35mm lens, 1/125 sec at f/8. ISO 50.

▲ Compositional layers

The ironwork entrance to St. John's College, Cambridge, UK, creates a simple frame, leading you nto the photograph. Another layer is added to the composition, helping to accontuate the feeling of lepth provided by the path.

■ 35mm lens, 1/125 sec at f/11. ISO 100.

Accentuating architecture

n this example of the classic frame-within-a-frame echnique, the shape of the Moroccan archway not only provides a border but also helps to show off the raditional Islamic architecture of the courtyard.

m 28mm lens, 1/125 sec at f/16. ISO 100.

▲ Multifunctional frames

Gothic arches fulfil different compositional roles in this shot taken in a Sardinian hotel. One makes a dark background to frame the head and shoulders of the model, while another frames the whole shot.

m 28mm lens, 1/60 sec at f/11, ISO 100.

◆ Creating atmosphere

The simple framing device in this scene – shot in a small Egyptian hotel – evokes a sense of mystery, as we cannot see what is in the passageway beyond. An incident light reading was laken to ensure that the exposure was not upset by the darkness or the white wall.

35mm lens, 1/30 sec at f/8. ISO 50.

- Create an inner frame in a still-life picture by arranging the subjects on a plate or other receptacle, against a significantly lighter (or darker) background.
- Use archways at busy tourist sites to hide fellow visitors, ice cream stalls, and unsightly litter.
- Frames within frames work best when the eye is drawn from the dark area to the light area beyond. So ensure you expose for the subject matter, not the frame.
- Use tree branches and gaps in hedgerows to provide attractive natural framing when shooting landscapes.

Selecting a viewpoint

A good grasp of composition allows you to shoot a variety of different-looking shots of what is essentially the same scene. When photographing a subject, particularly a large subject such as a building, try to look at it from all the accessible angles. This means not only circumnavigating it but also viewing it through a variety of lenses and, if possible, from different heights. In most cases, you will find that there is an almost infinite number of picture possibilities – all you have to decide is which ones you prefer.

By exploring as many camera positions as possible, you will not only be discovering new angles on the subject itself – you will also find that the foreground and background of the picture change with each new viewpoint. Move just a short distance to one side, for instance, and the foreground of your wide-angle shot may be completely transformed. Similarly, moving in closer to the subject, or using an alternative lens, may have radical effects on the backdrop.

As you move around, different elements will come into view, which you may want to use to offset the subject or to frame the shot. The lighting will also change. This gives even greater scope for getting a new angle on a well-known location – without taking into account the different times of the day and seasons of the year, which could provide you with still more ideas.

▼ Diagonal line

Taken from a distance and leaving the expanse of dark hedge and open sky, you create a strong feeling of isolation. Notice the dominant diagonal line leading the eye from one side of the picture to the other.

50mm lens, 1/60 sec at 1/8. ISO 100.

▲ Introducing a new feature

The hedge is again used as the foreground, but a wider lens and a slightly different viewpoint have introduced a strip of grass, which leads the eye through the picture.

28mm lens, 1/125 sec at f/16. ISO 100.

▼ Creating foreground interest

When the subject is seen from the other side of the hedge, the grass becomes the foreground in the shot, its patterns providing additional interest. The strong frontal lighting creates brilliant colour, particularly in the sky.

28mm lens, 1/250 sec at f/11. ISO 100.

▲ Juxtaposing two elements

A gate is now included in the foreground of the picture. The sun has been partially obscured, so the church is no longer strongly lit and colours throughout the shot are darker.

50mm lens, 1/60 sec at f/5.6. ISO 100.

▲ Working with a low horizon

In this shot, the sky is allowed to dominate, with the horizon placed very low in the frame. The horizon is traditionally placed one third of the way down the frame in landscape shots but do not be afraid to vary this.

m 28mm lens, 1/60 sec at f/8. ISO 100.

▼ Framing the subject

The church is shot from between two trees, while the sunlight creates bright colours and distinct highlights on the spire. Notice how the relatively dark foreground adds emphasis to the framing of the subject.

■ 35mm lens, 1/125 sec at f/16. ISO 100.

▲ Reducing the light

With the grass, hedge and trees in halfshadow, the scene takes on a different appearance again. The church itself is only indirectly lit by diffused sunlight.

m 28mm lens, 1/60 sec at f/5.6. ISO 100.

Closing in on the subject

By getting down low, the gravestones can be used as foreground for this vertical shot of the thurch. The flowers introduce vivid colour and he clouds highlight the church tower.

50mm lens, 1/125 sec at f/11. ISO 100.

▲ Interior view

No sequence of shots of this church would have been complete without a look inside. Notice how the horizontal wooden beams draw the eye through the picture and give a long perspective. m 28mm lens, 1/60 sec at f/5.6. ISO 100.

▲ Gate contrast

When using wide-angle lens settings, your angle of view is often dictated by what you can find to flll emply space in the foreground. Here, an ornate gate provides a touch of exuberance and decoration to contrast with the simple church.

■ 35mm lens, 1/125 sec at f/11. ISO 100.

- Move in closer and use a wide-angle lens in order to lose an otherwise distracting background. The subject will instead be framed against the sky.
- You do not always have to walk far from your subject to get different pictures. Look for people or useful objects to use in the foreground, shooting from down low so that they take up a large part of the frame.
- Keep a watch as you approach or leave a new location - some of the best shots are taken from a distance.
- Vary foreground detail it is one of the easiest ways of producing unique pictures of even the most familiar buildings.

Varying the shots

One of the main distinctions between the professional photographer and the snapshooter is the number of pictures taken. While one might fire off hundreds of variations on a particular shoot, the other might take just a single exposure. Although not all subjects are worth a big investment in time and film, plenty of sites are. Many people spend precious time and hard-earned money taking trips to famous landmarks and beauty spots. By comparison, film is relatively cheap, and digital memory reusable. It is worth shooting more pictures than usual – and perhaps spending a little longer composing them.

Rather than just shooting classic holiday-brochure shots of a cathedral, palace, or castle, keep your eyes open for beautiful details, and try a longer zoom setting to pick out interesting ceilings, arches, columns, and other features.

All these pictures are of Durham Cathedral in the UK. Its exterior is better known, but the interiors and details show the range and depth of possible shots.

▼ Showing size

For this shot, a shift lens was used to shoot the cathedral's aisle and to emphasize its vast size. It was not necessary to tilt the camera, so, unlike the shot of the aisle (below far right), the pillars look upright.

28mm shift lens, 1/60 sec at 1/8, ISO 200.

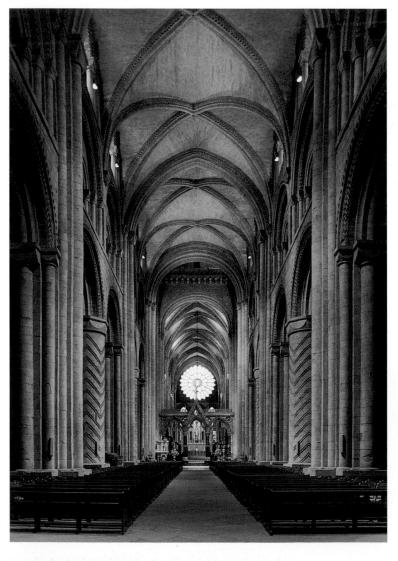

▲ Looking up

Look up as well as straight ahead when you are walking around a building. To take a shot of a ceiling that has good detail like this one, you might even have to lie on your back.

■ 50mm lens, 1/125 sec at f/8. ISO 200.

▲ Focusing on a feature

Prior Castell's wooden clock is an excellent feature to home in on, with its intricate patterns and wealth of detail.

■ 50mm lens, 1/125 sec at f/4. ISO 200.

▲ Zooming in on detail

Look for the detail on otherwise plain features. By zooming in, the camera has isolated the intricate zigzag patterns used in the arches in the cathedral's Galilee chapel - and placing a column in the centre of the shot, with the arches behind in partial shadow, allows the light to pick out the attractive relief patterns of the zigzags.

m 70mm lens, 1/60 soc at f/5.6, ISO 200.

▲ Vertical and diagonal lines

Rather than just showing the stained glass, this shot also shows the surrounding interior, emphasizing adjacent vertical and diagonal lines. 35mm lens, 1/30 sec at f/5.6. ISO 200.

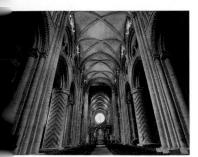

■ Wide-angle view

Jsing an ultra wide-angle lens totally changes he perspective of Durham Cathedral's aisle, howing the magnificent columns at an angle.

15mm lens, 1/60 sec at f/5.6. ISO 200.

▲ Isolated pattern

Architecture often uses repeated pattern and symmetry that people rarely notice, but a zoom lens can isolate it so that it is easy to see.

■ 100mm lens, 1/125 sec at f/5.6. ISO 100.

▲ Spotlit feature

Be aware of how the light is changing during your visit. Here, a shaft of light suddenly lit the pulpit to create an interesting shot.

m 35mm lens, 1/125 sec at f/5.6. ISO 200.

▲ Emphasizing pattern

The sidelighting in this shot shows the different patterns on the main pillars of the church clearly. The contrast of line with the horizontal tomb adds further interest.

m 35mm lens, 1/30 sec at 1/5.0. IEO 200

▲ Contrasting features

This shows the variation of shots gained by a high camera angle, and the contrast that can be obtained by different, but adjacent, features. m 28mm lens, 1/60 sec at f/5.6. ISO 200.

- Guide books, postcard stalls, and tourist leaflets will all help you to find out about a site, and will also show shots that you might otherwise have missed.
- With one-day, once-in-a-lifetime trips to sites, make the most of your time by careful planning. Write a list of the shots you want to take before you arrive.
- With popular destinations, it is worth making that special effort to get there either before or after the crowds.
- Always ensure that you have more film, or memory, than you are likely to need.

Capturing the moment

Composition is not just about framing the picture, it is also about pressing the shutter at exactly the right moment. Get the timing wrong, and the picture may well lose some of its energy.

For some subjects, the key times at which to take pictures are obvious, such as the moment when a winner crosses the finishing line. On such occasions, preparation and practice count as much as good luck. But with other, less predictable, events there can be magical moments – when constantly changing conditions and people suddenly come together to create a strong, beautiful, energetic composition. Such moments might be when two or more elements combine in a certain way. On a stormy day, a beautiful building might suddenly be illuminated by a shaft of light, creating a moody scene that might never be recaptured. To make the most of these decisive moments requires patience – and, above all, the vision to see what might happen, even before it presents itself in the viewfinder.

◆ Fleeting glimpse

During a shoot of pictures of winter berries, these two leaves suddenly blew into the rose bushes. A few moments later they had blown away again.

■ 50mm lens, 1/60 sec at f/4. ISO 200.

▼ One-off chance

This spontaneous shot was snapped as quickly as possible – with the weight of the struggling bird to support, this man was unlikely to pretend to kiss the goose twice.

m 100mm lens, 1/125 sec at f/5.6. ISO 200.

▲ Catching the pose

With the young girl's head nearly touching her feet, this arching pose provided a fleeting opportunity to capture the suppleness needed for gymnastics.

m 50mm lens, 1/125 sec at f/5.6. ISO 400.

▲ Anticipating the conditions

The energy of this shot of the Guggenheim relies on different bands of tone to make an interesting composition. Once the camera was in the right place, it was a question of waiting for the light to intensify.

m 28mm lens, 1/30 sec at f/11. ISO 100.

◄ Perfect timing

This picture involved waiting for two different elements to coincide. The point was to capture the dancer crossing a pool of light – and this brief pose completed the composition perfectly.

■ 50mm lens, 1/125 sec at f/5.6. ISO 200.

- Familiarity with your camera is essential for snatching shots quickly. Keep framing and focusing images without necessarily shooting them all.
- Have your camera ready for action.
- The perfect moment may never come, so make sure you take a few shots, as you wait for conditions to improve.

Influencing a composition

Great pictures are often made, rather than found. Instead of photographing a scene as it is, the photographer usually moves around to find the best angle, actively encouraging the subjects to move into a good composition. When working with inanimate subjects, the photographer can often have a direct influence – the subject can be moved, and pictures set up specifically for the benefit of the camera. For still-life photography, for instance, the objects that are being shot can be rearranged until they look right in the viewfinder. This approach can work just as well when the subjects are people.

In order to improve your shot, it is worth politely asking the subjects to move to a position that best suits the composition. You may even find that, once they are involved, they will suggest other shots that you might take – shots that you had not thought about.

Be aware, however, that the camera's presence can affect people's behaviour. They may play up to the lens – or they may stop what they are doing when they see you, and may need some time to get used to the camera.

▶ Wide-eyed vantage point

It was necessary to get so close to this troupe of five tumblers with an 18mm lens, that it would not have been possible to get the shot without their careful cooperation.

■ 18mm lens, 1/125 sec at f/11. ISO 100.

▼ Gathering the troupe

After the evening show was over, these tired circus performers were persuaded to pose in a group before they sat down for their supper. Many of them were even happy to stay in costume for the shot.

m 50mm lens, 1/30 sec at f/1.8. ISO 100.

► Relaxed pose

You would never expect to chance upon a strongman asleep in a field – so asking him to pose with his comic-book prop was the only way to get this successful shot.

50mm lens, 1/125 sec at f/8. ISO 100.

▲ Pused expression

Lost in thought, this shot looks like a perfectly caught candid – but in fact the clown was asked to sit in this spot so that the trailer could be used as the backdrop, and to ensure that he was in the light.

50mm lens, 1/250 sec at f/2.8. ISO 100.

▲ Creating a trame

Everyone in this family circus had a job to do, and this little girl helped get the balloons ready for the performance. To frame both her and her balloons, she was asked to pose against the doorway of the trailer.

■ 50mm lens, 1/125 sec at f/4. ISO 100.

- Before setting out on a photo assignment, give some thought to what you want to achieve. It is a good idea to make a list of the shots you want to set up.
- Be flexible. As you arrange your set-up shots, you may need to adapt your ideas your subject may also be able to suggest ways in which the pose, props, or setting could be improved.
- Ask for people's help they often appreciate it. It can improve relations between you and the subject and therefore help you get interesting poses, and it may also help with access to vantage points for future shoots.

Linear perspective

Experimenting with perspective – exaggerating distances or diminishing them to suit the composition – is one favoured method by which photographers can create depth in pictures. There are several types of perspective, but the best known is linear perspective. This creates the optical illusion that makes the sides of a straight road appear to converge as we look into the distance.

While an artist has to learn how to draw pictures so that the perspective looks natural, the camera normally achieves the same effect without any help from the photographer. However, changing the focal length used (see pp.16–17) will have a dramatic effect on the way a picture looks. A wide-angle lens will make parallel lines converge steeply, and make subjects in the foreground look bigger and those in the background look smaller. A telephoto lens, on the other hand, cuts out much of the foreground detail that would give clues about distance. In this way, subjects that are far apart can actually appear in the viewfinder as if one is standing on top of the other.

▲ Depth and height

These ancient Egyptian columns appear to tower above the viewer. To emphasize the perspective, a wide-angle lens was used, pointed straight up to the sky. The columns appear to become thinner the further they rise up, which creates a strong feeling of height.

24mm lens, 1/250 sec at 1/16. ISO 50.

▲ Converging lines

When looking at this picture, we assume that the path remains the same width all the way down from the foreground to the church. The fact that it converges tells us that one end is further away from us than the other.

■ 20mm lens, 1/125 sec at f/8. ISO 100.

■ Perfect perspective

In this classic study of linear perspective, not only does the boulevard narrow but so do the lines of the gullies. The houses become smaller as they recede towards the horizon, and even the clouds appear smaller as the viewer gazes into the far distance.

24mm lens, 1/500 sec at f/16. ISO 100.

▲ Curving lines

Lines do not need to be straight to converge. Here, a forest track fades from stretching across the full width of the picture down to nothing as it leads the eye gently through the picture.

■ 35mm lens, 1/125 sec at f/8. ISO 100.

■ VanIshing point

Converging lines appear stronger if the vanishing point can be seen, or if a focal point is included that draws the viewer in. In this shot, the eye is drawn swiftly down the path of this walkway to the doors at the end.

24mm lens, 1/500 sec at f/16. ISO 100.

- Use the widest lens available if you wish to make linear perspective very pronounced, and get down low so that the foreground is as close as possible to the camera.
- Climb up for a good viewpoint if you need to include a long path, such as a garden walkway, without risking the lines converging too steeply.

Diminishing size

As well as apparently making lines converge, linear perspective has another important effect on the way we perceive things. A Cadillac shot from a mile away along a desert road will appear smaller than a picture of the same car seen through the same lens just a few paces away. Therefore, if you have both vehicles framed in one shot, you will be able to make a comparison – and you will notice an obvious contrast in size. This apparent difference in size between objects that we know in reality to be of similar size is what helps our brains make an immediate judgment as to the relative distances of those objects.

This form of perspective is known to artists as diminishing size, and it is one of the most useful forms to use in photography. Although you may be shooting scenes that do not contain a linear perspective – visible lines that are seen to converge – you will often shoot objects whose relative size is known both by you and the viewer. For a landscape photographer, this means that shooting a field full of sheep will produce a picture where the sheep closest to the camera look significantly larger on film than those on the horizon. Similarly, for the architectural photographer, an angular shot of a wall will show some bricks to be larger than others, even though we, the viewers, accept that they came out of the same-sized mould.

▲ Sense of distance

This is a good example of how diminishing size perspective gives a feeling of distance. There is no background to help show which balloons are closer to us, but since we know these objects are similarly sized, we can see immediately which ones are further away.

■ 135mm lens, 1/250 sec f/8. ISO 100.

▲ Combination of clues

In this shot, linear perspective and diminishing size combine to good effect. Not only does the path converge, but the slabs appear to get smaller, giving a strong feeling of distance.

■ 28mm lens, 1/60 sec at f/16. ISO 100.

Here, the windows appear to diminish in size as your eye goes down the corridor. The resulting feeling of depth is reinforced by the strong linear perspective within the scene.

■ 50mm lens, 1/60 sec at f/16. ISO 100.

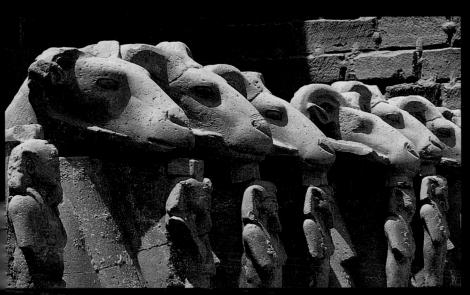

◄ Gradual change

These statues all appear to be of a similar size. A closer look, however, reveals that the statues to the right appear slightly smaller. This is a subtle use of the rule of diminishing size.

■ 70mm lens, 1/125 sec at f/16. ISO 50.

◄ Subtle shrinking

Linear perspective can also be used in a subtle way to aid diminishing size. In this shot, the doorways seem to recede very slightly as they tollow the gently curving path of the driveway.

■ 50mm lens, 1/125 sec at f/8. ISO 200.

◄ Diagonal lines

Here, diminishing size makes strong diagonals in the scene, which lead the eye across the shot.

■ 35mm lens, 1/125 sec at f/8. ISO 200.

PROFESSIONAL HINT

Use only similar, or similarly sized, objects to create a diagonal line across the frame, then exaggerate the effect by using a wide-angle lens, with one of the objects very close to the camera.

Alternative perspectives

Aerial perspective, overlapping forms, and depth of field can all be used to create a feeling of depth in two-dimensional photographs, in the same way as linear perspective (*see pp.194*–5) can. Aerial perspective is especially pertinent to the landscape photographer. When we see objects that are far away, they are less distinct than if they were closer to us. The further away they are, the paler and less colourful they seem. This diffused image is caused by the amount of air between the lens and the subject, and is affected by atmospheric conditions.

When using overlapping forms, the photographer composes the shot so that one object stands in front of another, with the nearer one partly obscuring the more distant one. This provides a visual clue that can be introduced to the shot in cases where other perspectives may not be available. In landscape shots, trees and rocks can be used to create a strong foreground that partially obscures the panorama beyond. In this way, a feeling of depth is suggested.

▼ Aerial perspective

In this classic aerial perspective shot, each successive mountain appears slightly paler, helping to create a feeling of depth as our eyes work back to the horizon from the foreground.

m 135mm lens, 1/250 sec at f/4. ISO 100.

▶ Overlapping forms

This version of overlapping forms features Eilean Donan castle, Scotland. It partly obscures the hillside beyond, which, in its turn, obscures the paler hills behind it.

■ 50mm lens, 1/125 sec at f/4. ISO 100.

MANIPULATING DEPTH OF FIELD

▲ Selective focusing

The photographer can exploit a particular form of perspective that the human eye does not have. The viewer learns to assume that areas that are out of focus in a picture are either further away from the camera or closer to the camera than those that remain in focus. While the poppies in this picture are sharp, the background is blurred, helping to suggest a sense of depth. This technique is known as selective focusing (see pp. 90–1).

■ 50mm lens, 1/125 sec at f/2. ISO 100.

■ Composing a perspective

In this shot of King's College, Cambridge, UK, a three-dimensional feel is conveyed by making the viewer peer through the branches of the tree in the foreground. These not only fill the empty expanse of sky but also overlap the buildings in the background.

28mm lens, 1/125 sec at f/11. ISO 50.

■ Overlap from an elevated position

The elevated camera position used shows the linear perspective of the drive. The pillars in the middle distance overlap the house, helping to show that they are on different planes.

35mm lens, 1/60 sec at f/8. ISO 100.

PROFESSIONAL HINTS

■ Use a telephoto lens to emphasize the effect of aerial perspective when photographing a mountainous landscape. This creates a semi-abstract picture that shows the receding layers of tone.

■ Different types of perspective are rarely found in isolation. Combine two or three types to help control the feeling of depth in the composition successfully.

Creating depth with distance

Perspective does not need to be used directly in order to create a feeling of depth in a picture. There is a much simpler way of providing clues about the missing third dimension simply through the content of the composition.

Depth only becomes apparent in a picture if objects are placed at different distances within a frame. Just as a good story should have a beginning, middle, and an ending, so a good photograph benefits from having a foreground, middle ground, and background. If a photograph is all background, or just includes subjects in the middle distances of your lens's focusing range, then there will be little information about depth. Including elements in at least two, and preferably three, of these distance zones will create a more lifelike representation. So the rule of thumb is: if you want to avoid a flat-looking photograph, arrange the composition so that you include as many elements at as many different distances from the camera as possible.

▲ Triple-layer composition

Three elements combine in this picture, and each is at a different distance from the camera. In the background is the chapel of Kings College, Cambridge, England; in the middle distance are the graphic shapes of two archways; and finally, the main subject in the foreground is the strong silhouette of the university don looking at his pocket watch.

80mm lens, 1/125 sec at f/11.

▲ Emphasizing the background

Although out of focus, the temple in this lowlight portrait has been given a prominent position within the frame, creating a dramatic background.

150mm lens, 1/60 sec at f/5.6 with tripod. ISO 50.

▲ Spontaneous foreground

Usually you can find something that adds a foreground to a distant view. On an empty beach, a friend held a hand on her hip, creating a window through which to shoot.

80mm lens, sepia filter, 1/500 sec at f/11, ISO 100.

■ Adding depth

Often it is unusual, imaginative compositions that succeed best in fashion photography. The male figure here creates a strong foreground, while his outstretched hand creates another layer of depth within the picture.

80mm lens, 1/30 sec at f/11. ISO 50.

▲ Bands of depth

Shot with a specialist panoramic camera, this composition uses six different depth layers to give a feeling of distance. From the sand in the foreground, the eye is led to the figures under the umbrella. The shallow water, the deeper blue of the water beyond, the mountains, and the sky create four further distinct bands.

26mm lens, 1/125 sec at f/11. ISO 100.

■ Cutting across the planes

Intrigue has been added to this sunset shot by introducing a basket of fish. Cutting across the foreground, middle distance, and horizon, the main figure helps to convey a strong sense of space.

135mm lens, 1/60 sec at f/5.6. ISO 100.

- The lighting used for different layers can help to accentuate relative distances. If the foreground is in shadow, and the background brightly lit, this will create a stronger effect than if the whole frame is uniformly illuminated.
- It pays to try to incorporate a complementary element in the foreground, even when the main subject is positioned in the distance.
- The more layers there are at different distances from you, the easier it is to create an impression of depth.

Scale

The size of an object in a picture is often difficult to gauge when the object is framed in isolation. This is because we perceive the dimensions of unfamiliar things in relation to the size of the known objects that surround them.

When shooting particularly large structures, such as rock formations or buildings, the photographer can help to communicate the true size of the structure by including people, cars, or other visual references in the frame. By carefully positioning the "scale" object, it is also possible to exaggerate or minimize the size of other elements.

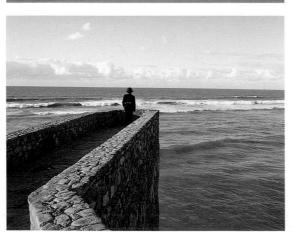

▲ Exaggerating size

The high-angle viewpoint makes this atrium look all the bigger. The addition of the people to the composition was a deliberate attempt to exaggerate this effect.

35mm lens, 1/60 sec at f/8. ISO 100.

◄ Conveying scale

It is the tremendous size of these Egyptian sculptures that is impressive. If you zoom in too closely, the viewer has no idea how tall these monuments are. By using a wider lens setting to fit in the background detail, and including the children going by with their goats, a true sense of the scale was conveyed.

35mm lens, 1/1000 sec at f/11, ISO 50.

These giant binoculars are the entrance to a Californian advertising agency. On first sight, it is difficult to appreciate that they are, in fact, a building. The inclusion of the car in the foreground provides a visual context for the other elements in the composition and also helps viewers to comprehend the sheer size of the binoculars.

35mm lens, 1/500 sec at f/5.6, ISO 50.

◆ Introducing a figure

This shot would be an abstract landscape without the figure. Its inclusion provides a sense of scale.

■ 50mm lens, 1/250 sec at f/11.

► Comparing scale

Only the presence of the human figures in this picture conveys the idea of how large these pillars are. This compositional approach means the viewer can calculate that the pillars must be around 15m (50ft) high.

50mm lens, 1/60 sec at f/8. ISO 50.

Choosing a background

For many photographs, one of the most crucial tasks in the composition process is to choose a suitable background. The most important criterion here is usually simplicity. A good backdrop, almost by definition, is one that fades into the background; if it starts to dominate the scene, the backdrop itself becomes the subject of the picture. If you want to show the subject clearly, therefore, the background should not appear over-complicated or too detailed.

More elaborate backdrops can be used, however – they often work if they add to the story told by the picture. With non-movable subjects, there may be little choice; but for portraits, you can move your subject into a position that allows you to experiment with different backgrounds, such as painted walls, hedges, and curtains. In the studio, the photographer has control over the backdrop: simple rolls of paper in a neutral colour are commonly used for this purpose. More elaborate backdrops can be painted, or bought ready-made. In other settings, hunt out the best background available, using different viewpoints, camera heights, and lens settings.

▲ Home setting

A portrait may say more about its subject if it shows the person's home or place of work as well as their face. In this shot, the homely but highly decorative background also creates strong patterns and colour themes.

■ 35mm lens, 1/125 sec at f/5.6, ISO 200.

◆ Circular pattern

Patterns, either found or manufactured, make pleasing, restful backdrops. Here old tyres, used to weight down a waterproof cover on a farm, make an interesting background. As they are dark, and unsharp, the model is still the obvious focus of attention.

35mm lens, 1/125 sec at f/8. ISO 100.

► Comic juxtaposition

Sometimes, by accident or design, you can discover a link between a subject and its background. Here, a mural containing a black dog complements the black poodle standing in the foreground.

■ 50mm lens, 1/125 sec at f/8. ISO 100.

▲ Theatrical solution

Look out for interesting backdrops that you can borrow, or that you can use for your portrait subjects some time in the future. This hand-painted background was borrowed from Colorama Photodisplay.

m 120mm lens, 1/50 sec at f/8 with flash. ISO 50.

▲ Hat tricks

A spectacular floral hat provides an opportunity to show the same subject in three very different ways. A bright blue background creates an interesting play of light and shade. Shot against an ornate mirror, and at different distances from the wall, the hat can be either half-concealed or brought into sharp relief.

■ 120mm lens, 1/60 sec at f/5.6. ISO 100.

PROFESSIONAL HINTS

■ Ensure that there is as great a distance as possible between subject and backdrop to exercise control over the sharpness of a background.
■ The lenger the lens you use

■ The longer the lens you use, the smaller the area of background that appears in the picture. In some cases, a telephoto lens may simplify the background.

Using shadows

Shadows may sometimes mask important details, or turn an already busy scene into a cluttered one, requiring the photographer to minimize these dark areas in a picture. However, there are times when the shadows themselves become the subject. In fact, they are an essential part of many photographs, suggesting the three-dimensional form and even the surface texture of a subject.

A shadow, of course, provides another way of viewing an image. Like a silhouette, it is a perfect two-dimensional representation of the outline. The size and visibility of the subject's shadow will depend on the angle of the available light. In the harsh, bright midday sun, shadows will be short and the contrast between areas of dark and light will be heightened. Later in the day, as the angle of the sun becomes more oblique, the shadow will become bigger and softer. When photographing shadows, the most obvious approach is to frame the picture so that subject and shadow create a symmetrical composition. A bolder move, though, is to frame the picture in order that the shadow itself is the focus of attention.

▶ Distorted shadow

The clarity of a shadow will be strongly affected by the surface against which it is cast. Here, the wet sand creates a very clear shadow, but this is distorted by the rippling surface – and made more interesting as a result. The surface is also enhanced by the reflected colours of the sky.

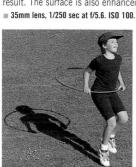

▲ Dark background

A surface does not need to be white or pale for a good shadow to be created. The dark grass in this shot provides a well-defined image, but one that looks more static than the subject.

- 200mm lens, 1/250 sec at f/8. ISO 100.
- ► Shadows as visual guides

Sometimes the shadow gives more information than the view of the subject itself. In this shot, taken from a high window, the passersby are only just visible, but, from the shadows, it is easy to see that there are four separate people.

50mm lens, 1/500 sec at f/8. ISO 100.

Shadow as carlcature

ihadows are not always true to their subjects. In this picture, taken at a ballroom dancing ompetition, the roaming spotlight picks out ne of the pairs — while, at the same time, he shadow cast on the wall creates an almost rotesque caricature of the dancers.

35mm lens, 1/60 sec at f/4. ISO 100.

▼ Symmetrical image

Photographed from a moving car, this motorcycle has cast a shadow that is almost identical in size and shape to itself. The car matched the speed of the bike, providing the opportunity for a perfect panning shot, as the camera was braced against the window

■ 50mm lens, 1/30 sec at f/8. ISO 50.

▼ Shadow as subject

You can make a shadow more prominent than the nominal subject. This shot shows a strong shadow created by the profile of a girl in a bus station. This photograph required focusing on the wall and using the maximum aperture, in order to make her face appear out of focus.

■ 180mm lens, 1/250 sec at f/2.8. ISO 100.

See also Reflections p.208 Shape and silhouettes p.210 Profiles and silhouettes p.262

Reflections

The way in which surfaces both absorb and reflect light is what makes us able to see them in the first place. Reflected light is also an integral part of any outdoor scene, illuminating areas that would otherwise be in shadow. But most of the time we do not see these reflections directly.

Some surfaces, though, are such good reflectors that they create their own images, mirroring the things around them. Water, glass, and polished metal all provide an opportunity to photograph things in an indirect way, resulting in a more oblique view of the world.

■ Glass in urban landscapes

The mirrored glass used in the construction of many modern office blocks can create strong and colourful reflections – as in this shot taken in New York.

300mm lens, 1/250 sec at f/5.6. ISO 100.

▼ Which way up?

If you choose to fill the frame with a reflection, not only do you get a slightly abstracted view of your subject, but you must also decide which way up to display the shot.

85mm lens, 1/250 sec at f/8. ISO 100

◆ Double deal

A symmetrical view suits a tranquil mountain scene, but care was taken not to make the shot exactly balanced. When framing a shot like this, try to crop the shot so that there is as little sky in the frame as possible. This reduces contrast, making exposure much easier to assess.

85mm lens, 1/60 sec at f/5.6. ISO 100.

▲ Rain and neon light

Puddles provide good reflections, particularly when mirroring bright city lights. Here the neon signs of London's West End create coloured pools around a solitary figure.

85mm lens, 1/15 sec at f/5.6. ISO 400.

■ A triple image

In this carefully set-up shot of Château d'O in France, the historic building not only provides the soft background for the still life but also appears again, distorted and inverted, in both carafe and glass.

■ 100mm macro lens, 1/60 sec at f/5.6 with tripod. ISO 50.

- Reflections photograph best when the subject itself is frontally lit.
- Use a polarizing filter to eliminate any unwanted reflections from the shot and also to strengthen reflections in water and glass.

Shape and silhouettes

There are five essential elements in photography – shape, colour, form, texture, and tone. Of these, it is shape that is the most fundamental, and we usually turn to this first to identify a subject. Even when the other elements are not present, we can identify most objects, structures, and people from their outline.

Silhouettes allow the photographer to create an image that identifies the subject by shape alone. Such images are created using strong backlight and a light background. However, the starkness of a silhouette means that it is best not to exclude the other elements entirely when you want to accentuate shape – otherwise you will get an image that is monochromatic and two-dimensional. The shape of a subject usually provides the strongest clue to its identity when it is seen from one particular angle – a bicycle is best seen from side on, and a face when viewed in profile.

▲ Three-dimensional image

Even when the shape predominates in a shot, viewers will use tiny clues to tell them that they are not looking at a two-dimensional cutout or a painted background. In this picture of the Taj Mahal, sunlight on the domes suggests three-dimensional form, while the converging lines of the pond suggest depth through linear perspective (see pp.194–5).

80mm lens, 1/30 sec at 1/8. ISO 50.

▲ Background colour

Sunset is a good time to shoot silhouettes as they provide colour for the background. In this shot of people leaving a Bali beach at the end of the day, a couple on a motorbike and a figure in a straw hat make strong and unusual outlines. The reflections on the wet sand give a further twist to what is already a strong image, and the warm colour of the sandy beach has the effect of softening the silhouette.

m 135mm lens, 1/30 sec at f/5.6. ISO 100.

▲ Backlighting in a landscape

Not everything in the frame needs to appear as a silhouette when a shot is backlit. In this view of Edinburgh Castle, Scotland, the twisted shapes of the trees appear as strong silhouettes in the foreground – buthe slightly angled wall of the castle catches the last of the evening light, and the eye is immediately drawn to its glinting windows.

■ 90mm lens, 1/60 sec at f/5.6. ISO 100.

■ Accentuated shape

With the sun behind the model, but just out of frame, the light catches the outline of her body and accentuates its shape, while she remains mostly bathed in shadow. As swimsuits are designed to show off the shape of the wearer, this type of lighting is ideal for a fashion shot.

80mm lens, 1/500 sec at f/5.6. ISO 50.

▼ Foreground image

The different poses of three men with a hookah pipe create fascinating shapes – providing strong foreground images for this shot of the houseboats on Lake Dal in Kashmir.

■ 135mm lens, 1/500 sec at f/5.6. ISO 50.

See also Direction of lighting p.160 Rim lighting p.162 Profiles and silhouettes p.262

Form

Form is the three-dimensional shape of an object. While an outline may be enough to tell us the identity of a subject, it does nothing to tell us about its solidity. It is form that tells us whether something is a sphere, rather than just a flat disc. It shows us that something can be picked up, it shows the curves of a face, and it shows the recesses of a building.

The reason that we can see form in a two-dimensional photograph is through subtle variations in tone – the shading that an artist would copy if drawing the scene with just paper and pencil. A red apple, for instance, will not be the same colour and tone over the whole of its visible surface. Some parts will be brighter, while others will be in varying degrees of shadow. These darker areas of tone show that these parts are facing in a slightly different direction to the light than those that are better lit. A gradual change in tone suggests a rounded form, whereas a sudden change in form is evidence of a sharp corner on an object.

GRADUATED TONE ON A SPHERE

The reason why we can tell that this is a sphere rather than a disk is the gradual transition of tone from light to shade.

A disk would be the same shade all over.

► Tonal landscape

Form is considered vital in still-life and portrait pictures, but it is also important in landscape scenes. In this shot, it is the subtle differences in the tones of green that show us the rolling hills.

m 50mm lens, 1/125 sec at f/11. ISO 100.

▼ Interpreting shades of grey

Even though at first glance this statue appears to be a single colour, we can tell it is three-dimensional because some parts are a lighter shade of grey than others.

■ 28mm lens, 1/60 sec at f/11. ISO 200.

Emphasizing form

his is a classic shot in which form has ecome the main theme for the photograph.

is the lighting on this castle that provides ne viewer with a sense of its solidity.

35mm lens, 1/250 sec at f/11. ISO 100.

▲ Using shadows

A shaft of light breaking through the window provides just enough shadowing to reveal the rounded form of the man enjoying his siesta. The patterned bedding provides a contrast.

■ 80mm lens, 1/125 sec at f/5.6. ISO 200.

PROFESSIONAL HINT

The human eye rarely looks at form consciously. Try to learn to look at objects, and see how tone changes over surfaces.

Accentuating form

The shadows that help create form in a photograph – often referred to as "modelling" – depend on the angle and quality of the light used. Lighting directly in front of or behind a subject gives either too little or too much shadow. This lack of contrast means form is not revealed. Sidelighting, on the other hand, helps to accentuate form. The light skims across the subject, and so some surfaces are better lit than others, creating stronger shadows in some places and weaker shadows elsewhere. It is this change in tone that reveals the form of the subject.

For maximum effect, consider also the quality of light. It should not be too harsh or direct. Instead, a more diffuse light source gives a gradual change in tone that reveals form in a more detailed way.

▼ ► Soft sidelighting with fill-in

Subtle modelling can give a natural three-dimensional effect with indistinct highlights. In this simple still-life shot, the effect of diffused lighting from a softbox has been softened further with a reflector.

120mm lens, 1/60 sec at f/8. ISO 50.

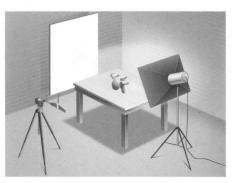

▲ Body contours

Form is the essential element in most portraits and pictures of the human figure. It is the modelling that provides information about the characteristic curves of the face and body.

■ 50mm lens, 1/250 sec at f/8. ISO 400.

▼ Architectural modelling

For architectural shots, waiting for the light to break from the clouds can result in a marked difference in modelling. In the shot below left, the sky is overcast, and the modelling on the beautifully decorated dome is very subtle. However, when the sun breaks through, as in the shot of a different dome, below right, there is a more marked change in tone across the curved surfaces.

- (I) 200mm lens, 1/125 sec at f/8. ISO 100.
- (r) 100mm lens, 1/500 sec at f/11. ISO 100.

Overcast light

Sunlight

▼ Change in contrast

The intensity of sunlight affects the modelling. Compare the hard highlights in one face (below top) with the softer gradation of tone in the other face (below bottom).

- (t) 135mm lens, 1/250 sec at f/5.6, ISO 50.
- (b) 135mm lens, 1/125 sec at f/4. ISO 100.

Harsh light

Soft light

◄ ▼ Strong sidelighting

Straight sidelighting provides a pronounced gradient between light and shade. The lighting for this engraved Roman vessel has been provided by a single studio light placed at 90 degrees to the subject

■ 120mm lens, 1/60 sec at f/11, ISO 50.

PROFESSIONAL HINTS

■ Practise using lighting to emphasize form. Artists learn to master shading by drawing simple still-life subjects, such as bowls of fruit. Still lifes can also be useful for learning about light in photography.

■ Sidelighting encompasses a very wide range of lighting angles. Vary the angle in order to control where the highlights and shadows fall on the subject.

Texture

In many ways, texture can be viewed simply as form on a miniature scale. Form is what tells us that a peach is roughly spherical in shape – but it is the texture, the close-up undulations of the surface, that shows us that the peach is not a nectarine or any other rounded fruit.

Knowing the texture allows us to distinguish polished jade from rough stone, or a furry animal from one with feathers. It shows us when an apple is withered and wrinkly, rather than firm and ripe. Highlighting information about texture is, therefore, a good way to convey a sense of the tactile. It allows us to have a better idea of what the photographed object would feel like in our hands.

Lighting techniques commonly used by photographers to reveal form (*see pp.214–15*) also work well for texture. For example, sidelighting creates shadows and highlights that indicate how smooth or uneven a particular surface is.

▼ Textures in isolation

Texture often photographs well when isolated from its surroundings. In this shot of the seashore, the composition has been cropped in to exclude both sky and sea, bringing out both the textures of the plant- and barnacle-covered rocks and the contrasting colours.

■ 100mm macro lens, 1/30 sec at f/11, ISO 100.

▼ Pattern in nature

A well-weathered plank of wood provides a highly textured and patterned surface, making it an ideal subject for a close-up picture. Direct sunlight to the side of the camera gave the necessary contrast.

■ 100mm macro lens, 1/125 sec at f/11. ISO 100.

▲ Textures in the landscape

Warm afternoon light shows a complex pattern of ravines and caverns in this dramatic aerial shot of clay pits in Cornwall, England. Rain had given the surface of this landscape a luminescent quality.

35mm lens, 1/250 sec at t/8. ISO 100.

▼ Contrasting textures

By cropping in close, the bone-like structure of this tree's root system becomes the abstract focus for the picture. The light accentuates the smooth texture of the roots against the roughness of the fallen leaves.

35mm lens, 1/60 sec at 1/11. ISO 100.

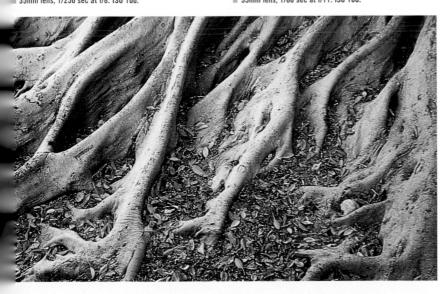

PROFESSIONAL HINTS

Look for a wide variety of textured surfaces - such as the pitted skin of an orange, peeling paint, or rusting metal. Crop in close so that the surface fills the trame. Try contrasting rough texture with something smooth instead of showing it in isolation. For example, a toddler's hand looks smoother when held in the hand of an old person. Similarly, the bumpy surface of a cauliflower looks effective next to a smooth aubergine. Precise focusing and adequate depth of field are essential to show texture clearly. The sharper the image, the more detail you will see in the shot.

Revealing texture

In many ways, texture can be viewed simply as form on a miniature scale: it shows the small dents and undulations that characterize a surface. Texture plays an important part in revealing information – particularly in pictures of people. It provides clues as to a person's age and lifestyle – the furrowed brow of an old farmer has a very different appearance to the smooth skin of a baby. Texture, therefore, is not always a welcome element in portraits – as few sitters wish to have every pockmark and wrinkle emphasized.

To accentuate texture, particularly when viewed in isolation, direct light (without the use of diffusers or reflectors) gives the best results. The light is also placed at a sharply acute angle to the surface of the subject, so that it rakes over the surface.

With more complex scenes, such harsh lighting creates shadows that are too strong so that, while texture is revealed in some places, detail is lost completely in others. Use softer sidelighting, so that texture becomes just one of the elements in the composition.

ACCENTUATED TEXTURE

Texture is shown by the presence, or absence, of shadows on a surface, accentuated by lighting. Hard light at an acute angle creates strong shadows at the bottom and one side of each valley of this textured surface, while everything else becomes a highlight.

Strong angled light emphasizing texture

▼ Contrasting rough and smooth features

There is a fine line between form and texture. Here the smooth skin of the model reveals form and also contrasts in texture with the rippled surface of the water.

■ 35mm lens, 1/125 sec at f/8. ISO 100.

▲ Revealing clues

Texture often plays a minor part. Here, the texture of the model's skin gives a clue to her age.

50mm lens, 1/30 sec at f/11.
 ISO 200.

▲ Creating contrast

A single, undiffused sidelight contrasts the fabric's folds with the smooth skin of the model.

35mm lens, 1/30 sec at f/16. ISO 50.

▲ Using soft lighting

The wrinkled lines of this blacksmith's face tell the story of his life. The shot was framed so that he sat with the furnace as a background, and so that his face was lit from an open doorway to the right-hand side of the camera. His face seems to glow from the warmth of the fire.

■ 105mm lens, 1/60 sec at f/4. ISO 100.

◆ ▼ Creating a hard look

The object of this shot was to produce a very austere shot of this old lady's face. Hard lighting achieved this, while a strong sidelight helped to show the texture of her lace collar and her floral hat.

m 120mm lens, 1/60 sec at f/11. ISO 50.

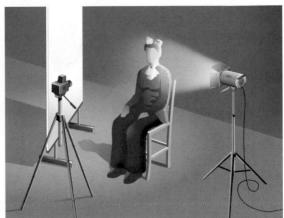

◄ Using natural light

The soft, indirect light that shines through a window is ideal for many portraits – simply because it does not accentuate the texture of the model's face.

150mm lens, 1/80 sec at f/8.
 ISO 100.

- Use sunlight streaming through a window as a source of direct, harsh light.
- Early in the morning and late in the afternoon, the sun is low in the sky. When the light is at such an acute angle, it is ideal for revealing texture in a landscape.
- The best time of day for shooting textured surfaces depends on the angle of the surface. A wall carving, for instance, may be clearest with the sun overhead.
- Increase textural detail in the black-and-white darkroom by printing on a higher grade of paper.
- Achieve similar results in the digital darkroom by increasing the contrast in the image.

Pattern

Pattern is found abundantly in nature – in the repetitive shapes of leaves on a tree, in the hexagonal shapes of a honeycomb, and in the segments of an orange. However, pattern is equally exploited by humans, from the bricks in houses to the fabric of clothes. Once you seek out pattern in order to photograph it, you will see it everywhere.

Pattern is all about repetition of a particular element – usually a shape, but sometimes a form, texture, or colour. The important point about pattern is that it attracts the eye: once you see a pattern, it is hard to take your eyes off

it. This last fact has two important consequences for the photographer. First, if you isolate a pattern in a picture, you can create a powerful image, particularly if you find a motif that is unusual. Second, pattern can be all-pervasive in a composition. The viewer can find it difficult to look at anything else in the frame, and therefore the pattern can obscure the other elements in a picture. It tends to hide information about the subject's form and depth, for instance, so that pictures of pattern can look flat, like a sheet of wallpaper.

▲ Layered patterns

Here the pattern of the steps creates a backdrop for the more elaborate shadowy stripes.

■ 50mm lens, 1/125 sec at f/8.

▲ Fighting for attention

The figure of the sergeant major has trouble competing with the strong stripes of the canvas behind him.

■ 50mm lens, 1/250 sec at f/8. ISO 100.

▶ Pattern and colour

Pattern is found in all buildings, but the bright colours and irregular shapes of this building, typical of the architect Hundertwasser, seem to make it more visible.

■ 28mm lens, 1/250 sec at f/8. ISO 100.

▲ Projected effect

Patterns can be added in the studio with lighting. A gobo (a mask that screens some of the light) was projected on to the image to create an intriguing mix of light and dark lines, with contrasting areas in between.

■ 120mm lens, 1/15 sec at f/5.6. ISO 160.

▼ Juxtaposing patterns

The square tiles of a Victorian floor made an interesting backdrop for this shot showing an unusual hairstyle. To take the shot, it was necessary to stand directly above the model lying on the ground.

■ 80mm lens, 1/60 sec at f/8. ISO 100.

◆ Clashing patterns

For different patterns to work together, they should be on different scales. In this portrait, the strong designs clash so loudly that it is hard even to concentrate on the faces.

■ 35mm lens, 1/250 sec at f/5.6. ISO 50.

PROFESSIONAL HINT

Any repeated object will create a pattern of units, as long as you have enough. Rows of preserves on shelves work well, as do piles of wood screws filling the frame.

Picking out patterns

Patterns are rarely obvious to us, simply because we see them every day. In order to be photographed, therefore, patterns often need to be hunted out and isolated.

A simple straight shot will work well to show pattern if it is a pattern or repetition that we are not accustomed to seeing. Hundreds of one particular species of seabird standing in the low water of an estuary would make a good patterned photo, as would the more unusual choice of a stack of old radiators in a reclamation yard.

With other patterns, it often pays to try to break the pattern up slightly – so that you do not get the impression that you are looking at a new designer fabric. A simple way of doing this it by incorporating an irregularity into the pattern. A pile of red clothes pegs, for example, looks much more interesting if you include a single yellow clothes peg in the frame.

▲ Finding irregularities

The more similar things are in shape and form, the more it is possible to see the individual differences. Graded apples form a precise pattern in their container but, on closer inspection, they are all unique – some have imperfections and some are more red than green.

m 50mm lens, 1/60 sec at f/5.6. ISO 100,

▲ Seeing pattern from above

Pattern is often better revealed from some angles than others. Here, an aerial shot, taken from a bridge, gives a perfect view of the symmetry, and teamwork, needed in this sport.

■ 135mm lens, 1/250 sec at 1/5.6, ISO 100.

▶ Breaking up pattern

The sunbaked mud creates a mosaic of cracks that is reminiscent of a close-up of an elephant's skin. The central tuft of grass breaks up the uniformity of the pattern by adding contrasting colour and form.

m 70mm lens, 1/125 sec at f/5.6. ISO 100.

▲ Pattern as a setting

On its own, the almost sculptured growth of this Canadian swamp grass makes an interesting pattern across the frame. However, it also provides a good setting for a portrait. ■ 50mm lens, 1/60 sec at f/8. ISO 100.

■ Repeated pattern

Leaves create an obvious natural pattern when seen together. Here, the early autumnal colours of this foliage have helped to emphasize the repetition in the leaf shapes.

50mm lone, 1/00 sec at 1/5.6. ISU 200.

▼ Rippling patterns

The distorted reflections found in ponds and puddles create exciting patterns - as long as you choose the lens and vantage point to isolate them from their surroundings. The shot gives no clue as to what is being reflected, but this does not detract from its effect. m 200mm lens, 1/250 sec at f/4. ISO 200.

Tone

Tone is the essential element in every photograph. Ranging from brilliant white at one extreme to jet black at the other, it is the basic building material of an image. Variation in tone enables us to see form and to pick out texture in a subject.

Tone is particularly important in black-and-white photography, where shades of grey must undertake the task otherwise performed by colour. But tone also has its part to play when working in colour. In composition, it is important to know that the eye is often first attracted to the lightest tones in a picture. The number of different tones between light and dark in a picture is known as the tonal range. The exact range is dependent on the lighting, as well as the subject, as this will control the amount of contrast in a scene. On a dull day, the contrast is low with mainly mid-tones, while direct sunlight creates high-contrast pictures.

▲ Drawing the eye

In this shot of a Romanian farmer on the way to market, the viewer is immediately attracted to the goose in the basket on his back, because it is so much lighter in tone than the rest of the picture.

m 35mm lens, 1/125 sec at f/4. ISO 100.

◆ Low-contrast scene

Overcast conditions provide muted colours with few strong shadows or highlights – but there is still a wide range of mid-tones displayed in this garden scene.

■ 50mm lens, 1/30 sec at f/5.6. ISO 100.

▼ High-contrast landscape

Looking directly into the sun provides high-contrast conditions, but the exposure has been set to ensure that there is still tonal detail in the shadows.

■ 135mm lens, 1/125 sec at f/4. ISO 200.

▲ Range of greys

The aim in most black-and-white shots is to obtain a good range of grey tones, as well as visible areas of both black and white. This can be controlled to a great extent in the darkroom, but good exposure is essential to getting the best range of mid-tones possible.

80mm lons, 1/60 sec at 1/8. ISO 100.

◄ Black-and-white impact

This snow-covered landscape creates a high-contrast scene where blacks and whites predominate, with very few greys in between. In this picture, the lack of mid-tones adds to the impact of the scene.

■ 50mm lens, 1/125 sec at f/11. ISO 100.

- Control the tonal range of digital pictures using standard manipulation software. Typically, you can set a black value, white value, and mid-tone value to change the contrast range of the shot.

 Adjust tonal range with black-and white
- Adjust tonal range with black-and-white film by using colour filters.

Using tone creatively

In many situations, it will not be possible to capture the full tonal range of the scene that is being photographed. The human eye can see details in shadows and see tones in bright areas of highlight that the camera will record simply in swathes of black and white. For every picture that is taken, there is a choice of exposures to be used. By altering exposure, the photographer essentially picks where the tonal range for a picture is set. There are times when exposure is used to restrict the range of tonal values in a particular shot. A picture that predominantly uses light tones is known as being "high key", while a picture made up of blacks and dark greys is "low key".

▲ Point of light

This shot is low key in its tonal range. The one thing that attracts the viewer's attention is the solitary light. Notice that the faint diagonal line of the road, and the horizon, both lead to this point.

m 35mm lens, 1/30 sec at f/2.8. ISO 200.

◆ Tonal composition

Even in colour pictures, you can compose shots that rely on tone for their effect. Here, there is little colour, no form, and few distinct shapes – however, the irregular-shaped bands of tone make an interesting shot.

70mm lens, 1/125 sec at f/8. ISO 100.

▼ High-contrast scene

The dark winter sky and area of water on the right create a low-key picture, but high contrast is provided by the bright moon, the highly reflective snow, and the glowing cottage window.

70mm lens, 30 secs at f/5.6. ISO 200.

▲ Spotlit feature

Lit with a single spotlight, the dark hair and dark background turn this portrait into a moody, atmospheric shot. It is the white area of the model's eye, however, that becomes the powerful focus of attention.

70mm lens, 1/60 sec at f/16. ISO 100.

A successful picture does not need a full range of tones. Here, dark colours and shadows fill most of the image area.

50mm lens, 1/60 sec at f/11. ISO 800/3200.

GRFY SCALE

This scale shows a range of tones from black to white. Each tone is 50 per cent brighter or darker than the onc before it. The central one is the 18 per cent grey that many exposure metering systems use as an average tone on which to base its calculations.

▲ Overexposure

The high-key effect in this picture has been achieved by shooting against the light.

100mm lens, 1/1000 sec at f/5.6. ISO 200.

■ Study in white

White clothing, a white drape over the stool, and a white background create a high-key scene.

■ 120mm lens, 1/60 sec at f/11 with studio flash. ISO 50.

PROFESSIONAL HINTS

■ For a high-key picture, shoot a white subject in light-coloured surroundings. The eye is then attracted to the darker tones in the shot.
■ For a low-key shot, shoot a dark-toned subject in a dark setting. Use a shaft of light to create contrast in the scene.

Developing the photographer's eye

One of the skills of a good photographer is to see pictures in everyday objects and scenes. While the beauty of a great cathedral or the drama of a football match presents obvious picture opportunities, the possible shots along a road in your neighbourhood that you have walked along a thousand times are less evident.

To capture these pictures you need to start seeing the everyday world in a new way. One of the best approaches to finding pictures in a familiar environment or in a less-than-photogenic location is to set yourself an assignment.

Try concentrating on a particular compositional approach, or on one of the key elements of photography. If you set out to take pictures that accentuate the form of a subject (see pp.212–15), you will soon start noticing objects that you have never given a second glance to before. The three-dimensional form of rubbish bins, shopping malls, and tree trunks will have new appeal. Experiment with photographing objects close up to create an abstract image, or from an unusual angle so that viewers of the photograph need to pause and consider what they see.

▲ Natural sculpture

Abstract shots can be found everywhere. This rock pool has been framed to create a shot reminiscent of modern sculpture.

50mm lens, 1/60 sec at f/16. ISO 100.

► Creating drama

This shot suggests a threatening atmosphere. An ultra wide-angle lens has created an unusual picture from an ordinary scene.

18mm lens, 1/125 sec at f/11. ISO 100.

▲ Attention to detail

A macro lens can be one of the best tools for discovering interesting views of ordinary sights. Here a close-up of a frozen puddle creates an intriguing abstract.

100mm macro lens, 1/125 sec at f/8. ISO 200.

▲ Glimpse of light

A partly open shutter on a window creates an interesting study of shape and tone. The glimmer of light that can be seen through the crack contrasts well with the shadowy screen.

80mm lens, 1/30 sec at f/5.6. ISO 100.

▼ Elevation

This sculpture is in a park featuring the work of Rumanian artist Brancusi – the elevated camera position helps to reveal the shape of the chairs, hedges, and central pedestal.

■ 35mm lens, 1/250 sec at f/11, ISO 100.

Looking down

his shot was taken from the top if the staircase in one of the pires of Barcelona's Sagrada amilia cathedral. Light from the its in the walls of the spire nine on the stone steps so that heir shape is revealed all the way the bottom of the tower.

28mm lens, 1/125 sec at f/8. ISO 200.

◆ Finding shapes

Circles can be found on the most mundane of objects – but it is the context, composition, and lighting that make the picture. A squashed drinks can on a piece of wasteland is not an unusual sight, but the way the container had been so symmetrically crushed made it interesting.

■ 100mm macro lens, 1/125 sec at f/8. ISO 100.

Colour

Of all the elements of photography, colour is by far the most powerful, and the one that should be used with the greatest care. This is because, unlike the other elements, individual colours provoke strong emotional responses. We all like some colours better than others. Strong colours immediately grab our attention, while muted

ones merge into the background. Some colours have a calming effect; others excite and stimulate us. We often feel even more strongly about colours when they are used in combination, because they complement or clash with one another. It is these reactions to colour that photographers should consider when composing colour pictures.

Seeing in colour

The eye's image sensor is the retina, where three types of cone cells are responsible for colour vision – each responsible for a different primary colour, just like the layers of a colour film. It is important to realize that film records colours in a different way from how we see them and the process used by digital cameras is different again (see pp.26-7). Unlike the eye, which relies on the brain to analyze the signals it receives, film cannot compensate automatically for the varying colour temperature of light, and simply records what it sees. However, most film emulsions are developed so that they boost colour rendition and provide warmer tones than we actually see. The white balance systems on digital cameras (*see pp.138–9*) over-correct for some forms of lighting, so sunsets and candlelight do not look as orange as we remember them.

▲ Strong colours

Whether ordered or random, strong colours attract the attention. But in this composition the kaleidoscopic effect means that you have to look hard to see that the subject is burst balloons.

m 100mm lens, 1/60 sec at f/11 with diffuse flash, ISO 50.

▲ Hot colour

Colours from the red spectrum have a very strong psychological power. Red symbolizes danger and heat - and whether featured as a tiny area or as the main subject in a picture, it is almost guaranteed to draw attention.

m 50mm lens, 1/60 sec at f/8. ISO 100.

▲ Cool colour

Blue-spectrum colours, such as the mauve and greyish blue shown her have a calming psychological effect. While reds dominate a picture, blue tend to recede, creating a cool look that is often linked to sky and watm 28mm lens, 1/500 sec at f/11. ISO 100.

PROFESSIONAL HINTS

■ The difference between the way the eye and the camera sees particular colours is not usually important. But for scientific or industrial work, where precision is important, the film used must be chosen with care - and their characteristics learnt so that the most accurate pictures possible can be taken. ■ The colours of the finished print with colour negative film are largely dependent on the printing process - and the interpretation of the machine or the operator. Unless you are prepared to print your own negatives, you will usually get better colour consistency with slide film.

■ Touch of colour

You do not need a great deal of colour in a scene to make an impact. The translucent red colour of the drink immediately draws the eye in this otherwise monochromatic scene.

■ 135mm lens, 1/250 sec at f/11.

▲ Calm colour

Green has an almost unavoidable association with healthy vegetation. Some films make greens appear more lush than they really are – which can work for or against the photographer, depending on the location.

100mm macro lens, 1/125 sec at f/5.6. ISO 100.

▲ Bright colour

Yellow has a brightness that makes its presence in photographs stand out. It is regarded as a sunny, cheerful colour, and even a small amount can brighten a picture immensely, drawing the eye to it.

■ 180mm lens, 1/125 sec at f/4. ISO 50.

How light affects colour

The reason why some objects look blue and others red is to do with the way that each of them reflects light. A red car looks red because its surface reflects red light, and also because it absorbs green and blue light. Objects that reflect all, or most of, the visible wavelengths of light look white, while those that absorb all, or most of, these wavelengths appear black – as they are reflecting little light.

The exact shade of colour that we perceive will depend on the nature of the light that is shining on the subject. Sunlight has a different colour balance depending on the time of day (*see pp.132–3*), and artificial light, too, comes in a wide range of hues.

The direction and quality of light also have important parts to play in the rendition of colours in the captured image. Direct frontal lighting creates the strongest colours across the frame, as the even illumination creates little contrast. With direct sidelighting, a proportion of colour is lost because of strong shadows created – although it appears strongly in the well-lit areas. With backlighting, colours appear muted or are lost entirely.

COLOUR ABSORPTION Seeing red A red ball appears red because it absorbs most of the wavelengths of light reaching it - reflecting only those from the red part of the spectrum. Red objects absorb green and blue light Seeing white A white ball appears white because most wavelengths of light are reflected (and few are absorbed) - and the colours in combination look white. White objects reflect all wavelengths of light

▲ Sidelighting

With the sun to the side of the camera, some parts of the sunflowers are lit – while others are in shadow. This provides intense areas of yellow in some parts of the photograph – while in others the colour is less obvious as it is either too dark or too light.

200mm lens, 1/250 sec at f/11. ISO 100.

▲ Frontal lighting

Even lighting from behind the camera means that all of the colours in the frame are shown in a more recognizable, and straightforward, form. The colour of the sunflowers is more evenly distributed because the highlights and shadows are less marked.

m 200mm lens, 1/250 sec at f/11. ISO 100.

▲ Backlighting

Shooting into the sun, the principal light reflecting off the sunflowers is reflected skylight. This produces very muted colours. As the lighting on the petals is diffused, however, the colour of the petals is even across the field in the foreground.

m 200mm lens, 1/125 sec at f/8. ISO 100.

Exposed for shadows

Exposed for highlights

▲ Sidelighting

When sidelighting is used, the modelling is extreme. By exposing for the highlights (*left*), many of the colours of the girl's jumper are underexposed. Those that are slightly underexposed appear more intense than they would in reality. Using the same sidelit set-up, but this time with the shot exposed for the shadows (*far left*), the jumper is now overexposed, making the colours appear more inuted.

- (fl) 100mm lens, 1/125 sec at f/8. ISO 100.
- (I) 100mm lens, 1/125 sec at f/16. ISO 100.

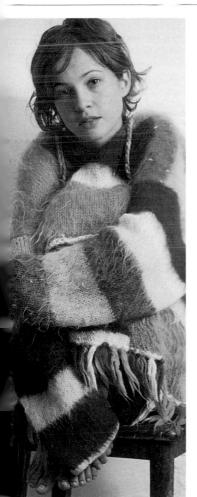

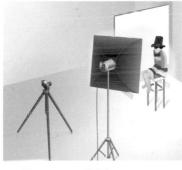

▲ ► Three-quarter lighting

The light source has been moved slightly to the side, creating better modelling. This intensifies some colours in the jumper, but weakens those in the shadows.

m 100mm lens, 1/125 sec at f/11. ISO 100.

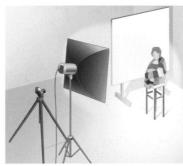

■ Near frontal lighting

With the diffused softbox lighting next to the camera, all the colours of the jumper are well lit, and are recorded clearly.

m 100mm lens, 1/125 sec at f/11. ISO 100.

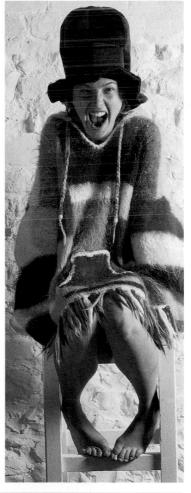

Colour moments

As colour intensity is dependent on lighting, the appearance of colours within a scene can change from minute to minute. Frequently, a shot is successful because the sunlight captures the subject in a particular way—and the combination of elements may never be repeated. Shafts of sunlight can pick out a particular colour within a scene—an effect made more dramatic against a dark background. Other conditions, such as fog or a storm, can provide a fleeting effect that is gone in seconds.

Momentary lighting effects often occur late in the day when the sun is low in the sky. Indoors, light may suddenly break through a window for a few short minutes. Outdoors, the low sun may pick out features in a landscape or a building, transforming an ordinary sight into a perfect, golden-tinged shot.

▲ Streak of light

A shaft of light breaking through a gap in the shutters illuminates the face of the model, although the rest of the room was also well lit. The chosen pose creates an interesting line and spotlights the model's red lips.

180mm lens, 1/125 sec at f/4. ISO 200.

■ Reflected colours

A Norwegian village seen from across a fjord lay in shadow, but a sudden shaft of light that came from a break in the cloud caught the coloured buildings perfectly as well as creating strong reflections in the water.

■ 100mm lens, 1/125 sec at f/16. ISO 100.

▼ Golden glow

When shooting sunsets, it often pays to look away from the sun itself. Here, the light is at just the right angle to catch this row of houses, illuminating the scene in a way that would make any subject look photogenic.

■ 80mm lens, 1/30 sec at f/8 with tripod. ISO 100.

A solitory red ruse on the gravestone of William Shakespeare almost glows as it is lit by a shaft of light breaking through the church window above. The colour of the red flower contrasts well with the grey stone, and the oblique lighting also perfectly highlights the beautiful engraving.

m 50mm lens, 1/50 sec at f/16 with tripod. ISO 100.

▲ Red focus

In an American diner in Amsterdam, a red lampshade is thrown into relief by the descent of fog outside, which has muted the colours in the street.

50mm lens, 1/15 sec at f/16 with tripod. ISO 100.

PROFESSIONAL HINTS

■ When shooting indoors, or in the studio, move still-life arrangements and portrait subjects so as to incorporate shafts of light into the composition if possible. The effect works most dramatically with a dark setting or backdrop.
■ Underexpose slightly with slide film to get the best colour saturation. A half-stop reduction is usually more than sufficient.
■ Slow films generally provide a greater vividness of colour than fast films.

See also Shafts of light p.156 Storm lighting p.158 How light affects colour p.232 Using lighting creatively p.260

Muted colours

Just because colours are not bold and intense, it does not mean that it is always necessary to photograph them with harsh lighting so that they really stand out. Some subjects do not suit this sort of brash treatment. Weak, diffused lighting can give a certain strength and harmony to the scene, simply because the colours are not jumping out of the picture.

The same approach is also often useful for bold colour schemes, as the bright colours may overpower the rest of the composition. Soft lighting, in these circumstances, can cause the colours to fade into the background slightly – which will make the whole composition much easier to view.

▲ Natural combination

Found on a beach, the different coloured layers of stone in this rock would seem bright and artificial if they were photographed in strong light. In diffuse sunlight, the colours are muted, but this makes the combination of colours look more natural.

m 50mm lens, 1/60 sec at f/8. ISO 100.

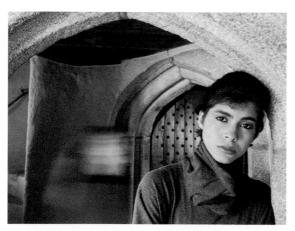

▲ Blurred colour

In this fashion shot, the vivid colour of the red dress worn by the model in the background is muted not only by the soft lighting but also by her movement during the long exposure, which has blurred her image in the composition.

35mm lens, 1/4 sec at f/8 with tripod, ISO 200.

► Muted white

The boards of this Canadian ranch house were painted white. As the light falls away, the gathering shadows create a softer scene than if the shot had been taken with harsher light and bright white paintwork.

28mm lens, 1/15 sec at f/8. ISO 100.

■ Softening strong colours

If strong lighting had been used for this shot, the collection of red fabrics in the frame would have overpowered the portrait. Soft reflected lighting provides just enough form, while keeping the colours under control.

••• 80mm lens. 1/30 sec at f/8. ISO 100.

■ Colour blend

Two Buddhist monks stand in prayer as the sun sets over the Sri Lankan scenery. The soft, warm-coloured light almost makes their hright orange rubes blelld into the background.

■ 135mm lens, 1/60 sec at f/8. ISO 200.

- Clothes and backgrounds that appear too bold in a portrait can detract from the facial features.
- Use a slip-on diffuser to diffuse the lighting of a portable flashgun.
- Severe underexposure will subdue colours by making them into shadow areas.
- Overexposure will make colours appear more pastel in shade.
- Bright colours are less distracting if they are out of focus.

Abstract colour

Like pattern, colour can easily be the dominant element in a composition. By cropping in close, the photographer can isolate small, interesting colour combinations, which may make intriguing pictures on their own, in the manner of an abstract painting. It is not always necessary to give any particular structure to the arrangement of the colours within the frame – the important thing is that they should look pleasing to the eye.

Such photographs work best if you can frame the shot so that the subject is not immediately obvious. Often this can be done by showing the subject from an unusual viewpoint, by using a longer lens, or by shooting patches of colour in close-up using macro techniques.

▲ Abstract appeal

A bin full of tangled, discarded rope and netting, composed of multicoloured fibres, has been shot in close-up, creating the feel of an abstract painting. The soft shades are attractively harmonious.

■ 100mm macro lens, 1/250 sec at f/5.6. ISO 100.

◆ Contrasting combination

Nets and rope piled on the deck of a fishing boat form the subject of this simple yet striking picture in which contrasting colours dominate. Here, again, a close-up shot works as an abstract composition.

■ 100mm macro lens, 1/250 sec at f/8. ISO 100.

▼ Disguising the subject

The bright colours of these flags on display outside a souvenir shop are eyecatching. By zooming in close, the overall shape of the flags is not emphasized, and the patterns fill the frame.

■ 135mm lens, 1/250 sec at f/8. ISO 100.

▲ Mass of colour

An intriguing picture, where the overpowering mass of red dominates the picture. It is only on closer inspection that you see the picture is of thousands of tulips in the Dutch bulb fields.

■ 28mm lens, 1/250 sec at f/11. ISO 100.

■ Powerful hues

Although this is not really an abstract, the mass of bright hues are so powerful that the canoes boome secondary to the pattern and colour they create. An overhead view helped strengthen the composition.

■ 50mm lens, 1/125 sec at f/8.

- The profusion of manmade materials in the modern world means we now spend much of our life surrounded by bright artificial colours. These are perfect for abstract studies.
- Use the longest focal length that you have available (a 300mm lens is ideal) to isolate colour when shooting outdoor subjects such as street signs and shop fronts.
- Use a macro lens to pick out any patches of colour you find around the home.

A touch of colour

All colours do not have equal effect. Some colours have a much stronger presence than others, creating a more powerful visual response from the viewer. Therefore a basic knowledge of colour theory will enhance the impact of your pictures.

Not surprisingly, it is the three colours known as primary colours, or the artists' primaries, that are considered the strongest. These three colours – yellow, blue, and red – are those from which all other hues can be made. Individually, the primary colours are all capable of producing an impact – but even this varies in intensity.

Yellow has a special presence in pictures, simply because it is the brightest and lightest of all the colours. Similarly, a patch of blue can be an irresistible draw to the eye, especially when placed against a pale background. However, for the strongest colour impression possible, red is the first choice. Red is such a strong colour in photographs that even a small patch of it within a frame makes it leap from the page. To maximize its impact, try framing it so that it occupies a relatively small area of the frame against a less vibrant background of black, green, or blue. Used in this way, it gives the impression of advancing towards the viewer.

▲ Catching the eve

In this fashion shot, the minute flashes of red of the women's gloves immediately catch the attention and help link the two models together.

50mm lens, 1/60 sec at f/11 on tripod. ISO 100.

■ Red contrast

This charming portrait is very effective not only because of the bulldog's tired, red-eyed expression but also because of his pink tongue, which shows up well against his black lips.

120mm lens, 1/60 sec at f/11. ISO 50.

▲ Splash of colour

Here, a cockle-gatherer uses traditional fishing methods to bring in his crop. The red-tinged plastic netting is the one touch c colour in this monochromatic seaside scene.

120mm lens, 1/500 sec at f/8. ISO 100.

THE COLOUR WHEEL

The colour wheel is a handy device used by photographers and artists alike for learning about the relationship between different colours. The way that colours react with each other, either in pairs or in groups, depends on their relative positions around the wheel. Laid out clockwise in rainbow order, the three primaries, red, yellow, and blue, are equally spaced apart. The three secondary colours, green, purple, and orange (made by mixing two primaries together) are placed in between, while the intermediate tertiary colours (made by mixing adjacent primary and secondary colours together) are also used. Some colours have different effects on the viewer - for example, vellow is much brighter than the other colours, while red has the greatest intensity.

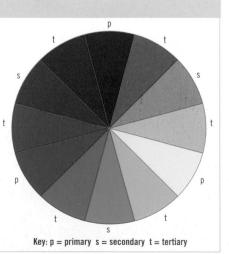

▲ Selective colouring

- n this shot, the bright yellow flowers stand out strongly because they are shown against black backdrop in what is an otherwise nonochromatic scene.
- 300mm lens, 1/250 sec at f/5.6. ISO 200.

Distant colour

Vith pictures of children, it is not always recessary to crop in tight. Loosely framed, the ize of the toddler is made more evident – ithough her pink top and red hat mean that he can immediately be occur in the frame.

250mm lens, 1/250 sec at f/4, ISO 100.

Warning Slyn

'ed is frequently used to catch attention, or to Les a warning. The red roof here was used to elp mark the entrance to the port, and the angle the sun ensures it is brightly lit.

100mm lens, 1/125 sec at f/11. ISO 100.

- m Persuade your subject to dress in red if you want them to stand out against a panoramic background.
- Use red toys, props or clothes for impact in child photography.
- Hunt out red flowers, such as poppies or geraniums, to fill the foreground when using a wide-angle lens to shoot landscapes or architecture.
- Colours other than red can work well in small areas of the frame, particularly if there is a neutral or contrasting background colour.
- Orango, pink, and yellow will also stand out well in a picture, if you saturate the colour Unrough lighting and exposure.
- Do not overdo colour balance a small area of bright colour against a larger area of a more placid colour for the picture to work.

Monochromatic colour

Unlike the artist, photographers may not have direct control over the colours of the objects before them – but, as with all compositions, they choose what does and what does not go into the frame. One way of avoiding clashing colours or difficult colour combinations is to select a scene where the majority of the colours are monochromatic. Whether composing a picture or decorating a room, this means combining different colours from the same family.

When composing such a shot, think of the print swatches or charts produced by paint manufacturers, where colours are arranged in groups from the same area of the colour palette. Using essentially just a single colour in a picture is a way not only of getting a tasteful, safe combination of colours, but also of creating a feeling of tranquillity that suits some subjects particularly well. Through careful cropping and composition, a restricted palette can be found relatively easily in landscape photography.

▲ Monochromatic setting

Fallen leaves on a forest floor were the natural choice for a background for this portrait, as they toned so well with the model's red hair. Her clothing echoes the colours of the trunks.

■ 100mm lens, 1/500 sec at f/2.8, ISO 100.

SHADES OF ONE COLOUR

On the colour wheel, using monochromatic colour is akin to choosing colour from just one segment from the wheel. You are not restricted to a single colour, as each spoke of the wheel can be thought of as representing endless shades of that colour.

▶ Shades of orange

In this classic shot of Mediterranean roofs, the colours of the tiles are intrinsically the same, but their different ages and angles to the light create different shades.

m 50mm lens, 1/1000 sec at f/11. ISO 100.

▲ Ageing colours

Over time, colours begin to fade and merge with their surroundings. This window was once a brilliant blue, but now has rust that is forming tones with the surrounding wood.

m 250mm lens, 1/250 sec at f/4. ISO 100.

▲ Desert colours

This shot was taken on a Moroccan farm during the late afternoon when the sun was starting to cast long shadows. It frames a scene that is essentially made up of just different shades of brown and grey.

200mm lens, 1/1000 sec at f/8. ISO 50.

▲ Earthy tones

The overalls of these men, working in a quarry in the Congo, seem to tone well with the earth and rock that surround them. A scene can include white, black, and shades of another colour and still be considered monochromatic.

■ 85mm lens, 1/125 sec at f/8. ISO 100.

▲ Linking elements with colour

For this portrait of an actress, a tungsten-balanced film was used in daylight to give the frame an overall blue tinge. This helped to link the elements of the wall, window, and figure together, and gave the shot a rather ghostly feel.

■ 100mm lens, 1/500 sec at f/8. ISO 320.

- Remember that whites and blacks are neutral colours, and can be combined with several shades of any other colour without creating a colour clash.
- Fog and mist create monochromatic landscapes because they transform colours into simpler tones.
- For portraits, choose props, clothes, make-up, and a background that complement the colour of the hair or eyes of your sitter.

Harmonic colour

Although traditional colour combinations include colours that complement or contrast one another, colours do not necessarily need to come from different areas of the colour wheel to work together. It is perfectly possible to combine colours in a picture without them intruding on the composition. A simple way of doing this is to choose from neighbouring colours on the wheel. An orangey-yellow will work well next to a plain yellow — especially if neither of the shades is particularly bright.

Another important element to consider when combining colour in a composition is the lighting. If the colours are in shadow, or the lighting is soft, any conflict between the colours may well disappear. With direct lighting, however, colour differences are accentuated.

▲ Green on green

The mower's roller means that the blades of grass are leaning in different ways in alternate stripes of this lawn – providing very pale green alongside dark green.

28mm lens, 1/125 sec at f/16. ISO 100.

▼ Subdued colours

The blues and greens of this thatched cottage have been united by the fading evening light, which has subdued the differences in colour throughout the scene.

■ 135mm lens, 1/60 sec at f/4, ISO 200.

HARMONIOUS COLOURS

The colour wheel theory says that shades of colour taken from adjacent spokes of the wheel will produce a harmonious picture when used together. A deep dark green and a light yellowy-green, for example, will tone well together.

▲ Shades of blue

The different gradations of similar colours make this a much more subtle shot than if a more contrasting-coloured costume had been used. The different depths and the tiles of the pool creat a wide range of blues, and these work well with the silvery-purple costume.

■ 70mm lens, 1/500 sec at f/8. ISO 50.

Gulden brown

n the soft light of the setting sun, the bright gold jewellery of this Jambian woman tones nicely with the glowing, golden brown skin. The dark brown wall behind offers urther harmony.

100mm lens, 1/125 sec at f/4. ISO 100.

· Subtle framing

he rust-coloured roses with their radation of colour go together 'ell with the distressed paintwork f the background.

80mm lens, 1/8 sec at f/11. ISO 100.

- Learn the order of the colours around the colour wheel, as this will help you to remember pairs that will harmonize.
- The main colour order is essentially the same as that of the rainbow: red, orange, yellow, green, blue, indigo, violet. A mnemonic that may help you remember this is "Richard Of York Gave Battle In Vain".
- Remember that each colour has lots of different shades so just because two are next to each other in the colour wheel this does not guarantee that they will work together well in all lighting conditions.

Colour contrast

While subtlety suits some subjects, there are plenty of occasions when a major reason for taking a picture is simply that the image will stand out well. Using bold colour is one of the best ways not only of making a bold statement but also of ensuring that a photograph gets noticed by the viewer.

Although some strong colours can create an impact when used alone, combining two different bold colours can create a more dramatic statement. However, this works at its best only if the force of each colour is equal – if the colours are not balanced, the result may be uncomfortable to the eye.

The best way of picking colours that create a strong but photogenic presence together is to use those that are directly opposite each other on the colour wheel. These are known as complementary colours. Two colours that are opposite each other on the colour spectrum always work well together because when these two colours of light are mixed, they create a white light.

◆ Complementary colours in nature

Flowers often use dramatic colour combinations to attract insects. Here, the purple-pink colour of the petals is complementary to the yellow-orange in the centre of the flower.

100mm macro lens, 1/125 sec at f/5.6. ISO 100.

▶ Red against green

The bold expanse of red dominates this picture, but it works well against the green of the grass that fills the other half of the frame.

24mm lens, 1/125 sec at f/16. ISO 100.

▼ Combining red and blue

While red leaps forwards in a picture, blue, with its associations with the sky, tends to recede. This means that these colours, although not opposite each other on the colour wheel, work as powerful partners.

■ 100mm lens, 1/500 sec at f/5.6, ISO 50.

COMPLEMENTARY COLOURS

Colours opposite each other around the colour wheel are known as complementary colours. The complementary colour of red, for instance, is green. When these two colours are used together in a photograph, the contrast will create immediate impact.

◄ Direct contrast

In this almost perfect example of complementary colours working well together in a picture, the orange-red of the girl's hair and the rusty iron background are found on the opposite side of the colour wheel to the bluegreen of her top.

200mm lens, 1/250 sec at f/3.5. ISO 100.

▲ Double contrast

In this double juxtaposition of colours, the red of the fire engine leaps forwards, while the blue uniform recedes. Meanwhile, the orange of the indicator light is the complementary colour of the blue.

m 50mm lens, 1/250 sec at f/8. ISO 100.

- Remember the complementary colours for all three primaries: green complements red, purple complements yellow, and orange complements blue.
- Placed next to each other, complementary colours make each other seem brighter.
- The shadow of an object will contain some of its complementary colour.

Brilliant colour

The colour wheel provides a simple way of combining two bright colours in a single frame, but combining three or more vivid hues successfully is less straightforward. While a preponderance of a single brilliant colour can work well in a composition, the effect of different combinations of bright colours is determined by personal taste. What is a successful colour medley to one person can look like a clashing disaster to another – and the more colours there are, the greater the scope for a clash.

However, there is a logic when combining vivid colours. The most dynamic combinations are three or more shades that are as distant as possible from each other on the colour wheel. Remember also that the vibrancy of these shades will be affected by the lighting, and by the chosen background.

CONTRASTING COLOURS

Combinations of three or more colours chosen at regular intervals from around the colour wheel create strong contrast in a photographic composition. Getting the exact colours in reality is difficult, and you may often get only two out of three.

▲ Intensifying colour

Artificial lighting will intensify the colours of a room far more than ambient light. The red walls of this room have been made to appear much bolder than they would in daylight through the use of flash units. The red has a vivid quality that is echoed in the red tones of the painting.

50mm lens, 1/125 sec at f/8 with off-camera flash. ISO 50.

▶ Using a dark background

Bright colours against a dark background can enhance the composition of a photograph. The clothes of these Gambian singers, set against the dark background of a bustling street, provide a striking image that might be lost against a pale background.

m 135mm lens, 1/125 sec at f/8. ISO 100.

▲ Combining primaries

The combination of the three primary colours – blue, red, and yellow – creates a potent image, even in dull lighting. The colours of this terraced house were obviously chosen to shock as well as to brighten up the street. Blue is a cold colour, and so it appears to recede into the background, whereas the warmer yellow moves forwards and dominates the picture.

■ 50mm lens, 1/125 sec at 1/5.6. ISO 200.

▲ Primary and secondary colours

This French shop front is exceptionally bright and eyecatching, but because the painter used all the primary and secondary colours, the effect is not too overpowering.

■ 200mm lens, 1/250 sec at f/4. ISO 100.

DIGITAL SOLUTION

Use image-manipulation software to adjust the original colours in a picture by introducing more contrast, increasing brilliance, or changing a colour entirely to improve the composition. When making changes, it is advisable to make them on a copy, or, better still, to use layers (*see p.382*), so that you can revert to the original picture if necessary.

Discordant colour

Colours do not always work together well. Compositions can be engineered so that different hues work in harmony with each other, or contrast them in a dramatic way, but there are times when a scene contains so many different hues that they cannot possibly work together. Such psychedelic scenes can be found frequently, and the kaleidoscopic effect can create powerful pictures, even if they are not always easy to look at.

Sometimes a clashing colour scheme has been put together in order to create an impact, but the arrangement can also come about by accident or necessity. A stall selling brightly coloured souvenirs must show them all in a confined space – even if they were not designed to be seen together. Clashing combinations of clothes may be brought together in a crowd and squeezed into a frame with a distant telephoto lens.

▲ Emphasizing the effect

Some colour combinations are designed to stun – the whole point of this style of body painting is to shock and confuse by destroying the lines of the face and the figure. A wide-angle lens and a tilted camera angle help to reinforce the effect.

■ 35mm lens, 1/125 sec at f/8 with diffused flash, ISO 100.

Colours clash if the hues are not chosen in an even pattern from around the colour wheel. Colours that are close will not work well together, and with too many colours, the combination fails because the selection is not evenly spaced around the wheel.

Poor colour combination

▲ Disorganized and organized colour

The way colours are brought together is important. The picture of the stained glass window (right) uses the same palette as the shot of the clown (left) – but the colours are better organized. In the shot of the clown, the colours combine so poorly that it is hard to look at the portrait for long.

- (I) 35mm lens, 1/60 sec at f/5.6. ISO 200.
- m (r) 90mm macro lens, 1/60 sec at f/5.6. ISO 50.

Successful colour combination

◄ Capturing discord

This sight is typical of many tourist destinations, where bars, hotels, and shops compete for attention via brash signs. The riot of typography and colour is shown best by using a distant viewpoint and a long telephoto lens.

200mm lens, 1/125 sec at f/8. ISO 200.

▲ Filling the frame

Often nature can get away with multiple colour combinations, but the huphazard positioning of these flowers produces a discordant clashing of colours. Filling the frame with colour has increased the riotous effect.

100mm macro lens, 1/30 sec at f/8. ISO 100.

▼ Energy through colour

This composition of Gambian people dancing naturally shows a wide range of colours from different areas of the colour wheel. Although the overall effect is discordant, it provides a powerful effect of movement and life.

35mm lens, 1/125 sec at 1/8 ISO 100.

Still life

Still life is one of the most underrated subjects in photography, probably because it normally involves taking pictures of everyday objects. But this is also its appeal to those who are trying to improve their skills. Still-life subjects are static, usually small, and can easily be set up at home, giving the photographer almost total control of the results. Just as artists often start out by

depicting bottles and bowls of fruit and vegetables, so should the new photographer. These apparently mundane subjects can be used to learn about both lighting and composition. The elements of the still life can be re-arranged to achieve the desired effect. If the pictures still do not come out as expected, the set-up can be adjusted and the still life reshot.

Setting up the shot

For most compositions, photographers move around the scene before them, trying to find the best viewpoint rather than changing the subject itself. When shooting still life, the photographer works more like an artist.

Starting with a blank canvas, add different items to a composition piece by piece, and move them around until the picture looks complete. Often the most simple arrangements create some of the most successful still-life photographs. Correct lighting is crucial for turning the ordinary into the beautiful. Sometimes natural light works; at other times artificial light is needed.

Consider the setting and accessories, too. Backgrounds usually work best when they blend with the main subject. The still-life photographer becomes an avid collector of props, such as bits of slate, rusty metal, weathered wood and other textured material, and containers. An interesting bowl can turn a collection of vegetables from an average shot in to a memorable picture.

▲ Natural lighting

Typical subjects for still life are the everyday items you may see on a shelf or window ledge in anyone's home. Here, richly coloured flowers and fruit have been shot simply by using light from a window.

120mm lens, 1/8 sec at f/11 with tripod. ISO 50.

CHOOSING EQUIPMENT

■ Large-format monorail cameras are ideal for still-life photography. These cameras offer the best possible film quality, using individual sheets of film that measure 5 x 4in or 10 x 8in. As well as improved resolution for showing fine detail, large-format cameras give full control over depth of field, perspective, and macro magnification.

■ Alternatively a medium format or 35mm SLR will suffice Medium.

- Alternatively, a medium-format or 35mm SLR will suffice. Medium-format cameras offer a much larger image area than the 35mm format, but 35mm cameras are capable of giving very respectable results.
- Still-life subjects should be shot using a macro lens or, alternatively, a standard 35—70mm zoom lens with a set of extension tubes.
- A range of backgrounds and props can be used to build up the arrangement and complement the main subject.
- A heavyweight tripod enables you to lock the camera in place and make small alterations to the viewing position.

▼ Colours and textures

In this shot, the aim was to highlight the contorted shapes of homegrown runner beans. Using their flowers added a contrasting colour to the arrangement. Placing the beans against the rough grain of the wood created an interesting mix of natural textures.

■ 100mm macro lens, 1/60 sec at f/8. ISO 100.

▲ The right container

Containers are as important as their contents. This shot of luscious redcurrants would not have worked without the punnet.

120mm lens, 1/60 sec at f/16.
 ISO 50.

▼ Composing the shot

This arrangement of fruit and nuls was created by adding each item individually until the composition resembled an old painting.

210mm lens, 1/8 sec at f/22. ISO 100.

- Take a shot every time you add an element to your still-life arrangement.
- Move the camera nearer and farther away, higher and lower, to create interesting variations without rearranging the set-up.
- Restrict the scale of the still life. It is easier to find interesting backdrops for small objects, and you can work in a modest area.
- Keep an eye out for unusual and aesthetic objects that you can borrow from friends as subjects, props, or backdrops for your still-life shots.

Lighting for still life

Taking still-life pictures is an ideal way to learn about the importance of lighting in photography. A whole range of set-ups can be explored using only basic equipment and without the need for a purpose-built studio. For example, a shot taking colour as its primary theme will demand a different approach to one that concentrates on texture. And, while relatively harsh lighting can be used when shooting single subjects, a large collection of objects will sometimes require softer light.

Still-life photography also raises interesting challenges for the photographer – such as what to do with shiny, reflective surfaces that give away the position of strong light sources through tell-tale highlights. Each new arrangement you come up with can provide a different illustration of how the position and intensity of the illumination affect the photograph.

Soft frontal lighting - little detail

Harsh side lighting - emphasized detail

■ Revealing texture

To show texture on a surface, the lighting has to strike the surface at an oblique angle to create shadows in the indentations and highlights on the raised parts. In the top photograph, frontal lighting has been used, and much of the detail of the carving on the plaque is undefined. In the photograph bottom left, the lighting has been positioned to the side of the moulding. The resulting shadows and highlights emphasize the surface detail.

■ 50mm lens, 1/60 sec at f/8. ISO 100.

CHOOSING EQUIPMENT

- A single studio light is more than sufficient for many still-life set-ups.
- Use barn doors, softboxes, brollies, and other attachments in order to soften the lighting and control its spread (*see pp.338–9*).
- Use a reflector to soften any shadows that require fill-in. Reflectors can be bought from a photographic equipment supplier or improvised using a white sheet or a piece of painted board (*see pp.270–1*).
- A studio flash with a built-in modelling light will allow you to check the lighting in the viewfinder before taking your shot. Experiment with different effects by varying the angle and height of the lighting as well as its distance from the subject.
- If you are working with black-and-white film, it is possible to light your subjects simply using an ordinary desk lamp with homemade diffusers and screens.

▲▼ Shape and tone

When photographing objects such as jugs and bowls, use lighting to emphasize their curvature. Light from the side causes highlights and shadows and provides variations of tone. Here, barn doors were used on the main flash head to prevent light reaching the backdrop.

m 120mm lens, 1/60 sec at f/16. ISO 50.

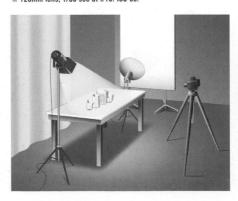

■ Working without studio lights

It is possible to shoot still-life set-ups without using artificial light. A well-lit window is sufficient, particularly if you can use curtains, netting, reflectors, and white card to control the intensity and direction of the light. Under natural lighting, colours are softer and shadows fall realistically in the same direction. There are none of the accidental shadows that can be created by studio lighting.

■ 90mm lens, 1/30 sec at f/5.6. ISO 200.

► Controlling reflections

When photographing bottles and other shiny objects, be aware of the reflections created by the lights and by other objects in the studio. These can be controlled by holding white or black screens just out of shot. For this photograph, a softbox created a pleasant rectangular highlight on the neck of the poison bottle.

■ 80mm lens, 1/60 sec at f/11. ISO 100.

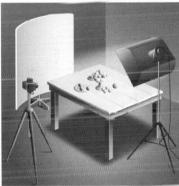

■ Soft lighting

The appeal of this picture comes from the harmony of colour and shape. This has been emphasized by using a main light above and to the side of the set-up. The light was fitted with a softbox to diffuse the lighting slightly, and to create window-like highlights on each piece of fruit. A large reflector, on the other side of the set-up, provides fill-in.

m 120mm lens, 1/60 sec at f/8. ISO 100.

- By directing a lot of harsh light at the subject, overlighting reduces the visual weight of the subject elements, but it may also cause colours to appear weak.
- By restricting the amount of light that reaches the subject, underlighting may make objects appear heavier and more solid, and colours appear darker and stronger.

Portraits and people

Portraiture is by far the most popular of all photographic subjects. For people who do not consider photography a hobby, but merely a method of recording family events, the majority of shots they take will be portraits. For the enthusiast, portraiture allows for far more freedom than other forms of photography, simply because the subject can be moved around and posed with such ease. Much of the composition

can therefore be controlled by instruction – rather than just by viewpoint. A cooperative subject can be asked to turn this way or that, to smile and laugh, and to use props. You can take the person to a particular background you want to use – and persuade them to wear clothes that fit in with the colour scheme or style you want to depict. All this affords the photographer much more control than he or she would otherwise have.

Choosing the setting

When undertaking a portraiture session, the first consideration is whether to use the controlled environment of the studio or the natural lighting of an outdoor setting.

The advantage of the home or studio is that lighting can be put at any angle, at a range of intensities, and with as much diffusion as is required. Backdrops can be changed quickly and lit separately. A studio can also be a more pleasant place to work for photographer and model. Not everyone has room for a studio, but one can always be hired.

Outdoors, less skill is required with the lighting – as, unlike with flash, what you see is what you get. The intensity and direction of the light is mainly determined by where you place your model, or the time you choose for the shoot. But the real appeal of being out of the studio is the huge choice of backdrops – which can be chosen to suit the subject, or to reveal more about them.

◄ Lighting combination

Here, an impromptu studio has been created using the white walls of a garage as a backdrop. Frontal lighting is provided from a window behind the camera, but the main light source is provided by a studio light, bounced into a white brolly, which is placed to the right side of the model. Fillin to the left is provided by a large white reflector.

120mm lens, 1/60 sec at f/11. ISO 100.

▶ Background steps

Stairs are ideal places for portraits, as they create strong diagonal lines that lead the eye through the picture. Try to avoid shooting upwards at the subject, as this will produce an unflattering portrait.

80mm lens, 1/60 sec at f/11. ISO 100.

▲ Lighting control

An advantage of working in the studio is that the lighting can be changed to control the appearance of the subject and background. Sidelighting creates graduated tone from a whitewashed wall.

■ 80mm lens, 1/60 sec at f/11. ISO 100.

► Appealing backdrop

An outdoor shoot provides a wide range of backdrops – and their presence in the picture can be controlled by their distance from the subject, as well as with depth of field. This intricately carved doorway provides a visually appealing backdrop, and sunlight, semi-diffused by light cloud cover, highlights the texture of the carving.

■ 50mm lens, 1/125 sec at f/8. ISO 200.

▼ Outdoor versatility

For this fashion shoot, good weather meant that it was possible to shoot alternative pictures outdoors. Here, the brickwork of a stately garden makes a more complex, but suitable, background for the shot. With more space, full-length poses became possible – and light can be controlled to some extent by the use of reflectors.

m 120mm lens, 1/250 sec at f/8. ISO 100.

▲ Plain backdrop

A simple yet dramatic doorway provides a plain backdrop for this pose. The model was purposely asked to stand close to the door, so that the dark paintwork would fill the entire background.

■ 70mm lens, 1/125 sec at f/8. ISO 200.

CHOOSING EQUIPMENT

- A medium-format SLR camera is ideal for studio shots, with standard and short telephoto lenses, and an extension ring for facial close-ups.
- \blacksquare A 35mm SLR camera makes a good alternative. Use a focal length of around 80–120mm for general portraits.
- \blacksquare Use a wider lens a 28 or 35mm is adequate when you also want to show the setting.
- A 200mm lens, or longer, is useful for candid shots.
- Flash is vital. A separate hammerhead gun on a bracket can be fitted with a diffuser or mini softbox.
- Use a spot meter to take a light reading from skin tones in difficult lighting conditions out of doors.
- Portable reflectors are useful for outdoor shots.

Using lighting creatively

Pools of light make interesting pictures all on their own — but the beauty of some types of photography is that you can move a subject into the light. Photography literally means writing with light, and while light is the basic ingredient of any photograph, it can often become part of the subject itself. How often have you seen a shaft of light breaking across a room late in the day? The sun is at just the height and angle to flood through the glass — creating an intricate pattern that mirrors the leaves of a tree that have partially blocked its path, or the shape of an outside window frame.

This effect is not only true for pictures of sunsets, car headlights, and candles – the light itself can become an integral part of any type of photograph, even portraiture. A person can be manoeuvred into the pattern of light – so that it looks like the spotlight has been set up deliberately to catch the subject.

▲ Divided features

Here, the complex pattern of shadows is created by the combination of a security grille and blinds over a large window. The model was deliberately placed so that a dark line divided her face in two.

m 135mm lens, 1/125 sec at f/5.6. ISO 100.

▲ Using a projector

One way of creating your own spotlight effects is to use a slide projector. In this shot the projector was set up and the model moved so that she was caught in the beam. Different shapes can easily be made using an empty slide mount selectively masked with insulating tape.

■ 50mm lens, 1/60 sec at f/4. ISO 100.

▲ Leaded windows

Not only have the leaded windows created a crisscross pattern across this picture, but the imperfections of the old glass also creates its own rippling pattern across the subject's face.

m 120mm lens, 1/15 sec at f/11. ISO 100.

▲ Warm cast

The colour of the light as it breaks into a room late in the day can add a warm colour cast to the picture, which is particularly pleasing with many subjects, including portraits.

■ 135mm lens, 1/30 sec at f/5.6. ISO 100.

▲ Kaleidoscopic pattern

This photograph was created with the help of the type of kaleidoscopic light often found at night clubs. It was necessary to move the model around until the multicoloured patterns created the best pattern across the frame.

85mm lens, 1/15 sec at f/1.4. ISO 200.

▼ Using light on the floor

To take advantage of even the smallest of spotlights on the floor, try suggesting that the model lies down and moves his or her face into it, so that their face becomes bathed with light.

m 70mm lens, 1/60 sec at f/2.8. ISO 100.

▲ Radiating lines

The warm light of a setting sun shines through the fanlight over a door, making a radial pattern against the backdrop. This creates a pleasant and interesting background for the shot.

m 35mm lens, 1/125 sec at t/2.8. ISO 100.

- Many shots that use light beautifully are found outdoors, where streaks of dappled sun breaking through trees or bushes create patches of light on the ground.
- Ask your models to lie down if this is necessary to take advantage of a small pool of natural light on the ground.
- Recreate the effects on these pages in the studio by using a mask or "gobo" over a spotlight, which creates the appearance of a window with its shadows.

Profiles and silhouettes

In profile shots, the side-on pose can reveal far more about the shape of the face, and therefore someone's identity, than a picture for which the sitter is looking at the camera. In a silhouette portrait, all colour and form are absent from the face – the shape alone identifies the person. For silhouettes, the profile must be backlit and very underexposed.

One of the most famous profiles in the world is that of Queen Elizabeth II. The shot below was approved by the Queen for use on postage stamps in the UK and throughout the Commonwealth. Printed billions of times over the last four decades, it is likely that this is the most reproduced image in history.

◄ Spotlit image

This is one of a sequence of shots of the Queen taken in 1966. It is a partial profile that has been spotlit to the front, leaving the rest in darkness.

120mm lens, 1/125 sec at f/16. ISO 100.

▲ Lighting for a profile

This shot involved using four studio lights. The Queen's features were lit with a softlight, and for fill-in another light was positioned behind her, in line with the Queen's shoulder. Two lights lit the white backdrop.

■ 120mm lens, 1/125 sec at f/11. ISO 100.

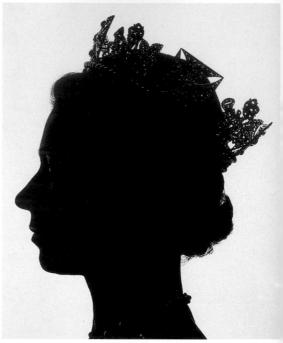

▲ Lighting for a silhouette

For the silhouette, the Queen's profile was photographed framed against a bright window in Buckingham Palace. The shot was composed so that the profile filled most of the frame.

m 120mm lens, 1/250 sec at f/5.6. ISO 100

LIGHTING FOR PROFILES AND SILHOUETTES

- The face is spotlit for cleancut studio profiles — with separate lights for the background. Weak fill-in lighting can be used for the back of the head.
- Using a large, bright window is the simplest way to shoot a silhouette. Use the camera's built-in meter to read the exposure needed to take a shot from the window set this reading using the exposure lock (see pp.80—1).

▲ Unlit background

The white background in this shot looks dark because it is 3m (10ft) behind the model, and not separately lit. A studio flash unit with a softbox lights the subject, while a reflector behind provides fill-in light.

120mm lens, 1/125 sec at f/16. ISO 100.

▼ Combination shot

A profile combines with a silhouette to make an interesting shot lit with a single spotlight.

■ 120mm lens, 1/125 sec at f/16. ISO 50.

▲ Natural silhouette

In silhouettes, the background needs to be significantly lighter than the subject to provide the correct contrast. This shot uses natural sunlight to provide the contrast to the subjects, who are also nicely framed by the arch.

■ 35mm lens, 1/250 sec at f/11. ISO 100.

The sun does not need to be completely behind the subject in order to get an effective silhouette in daylight. Here, the sun is just out of frame, to the right of the picture. This means that some surfaces are lit, while the rest are in strong shadow (see pp.162–3).

■ 35mm lens, 1/250 sec at f/11. ISO 100.

PROFESSIONAL HINTS

■ For a successful profile shot, try using a background that is very light or very dark in tone so that it contrasts well against the hair and skin of the person.

■ In profiles, the outline of key facial features, such as the chin and the nose, stand out, and the overall shape of the skull becomes prominent — if it is not disguised by a hat or hairstyle. Profiles are not, therefore, always the most flattering way to photograph someone — but they give a very good overall impresssion of what the person really looks like.

Life and work

For portraits, the lens of choice is usually the short telephoto. If you want to include more background than usual, however, especially if you want to show where the person works or lives as well as their face, you will need a wider lens.

For shots of of artists, for example, you may want to show their work, and perhaps their studio, in order to provide added insight into their way of life. If you use a wide-angle lens, however, there is a danger that the perspective provided by being so close to the subject's face will distort the features – but this can be minimized if the subject is kept at the centre of the frame. For portraits in which background detail is less important, a focal length of 70–135mm (for a 35mm-format camera) flattens the nose and chin just enough to provide a flattering portrait. If you use a longer telephoto lens, you will be too far away to give the subject instructions.

▲ Wider lens

If you photograph people in front of their work, you can show what they do and what they look like at the same time. Unusually, the artist Anna Mazzotta works in a small living room with no natural light. In order to include her unique paintings, which surrounded the room, it was necessary to use a wider lens than normal.

■ 24mm lens, 1/30 sec at f/5.6 with bounce flash. ISO 100.

▶ Varying the lighting

These two shots are of the painter Sandra Blow – the one on the right was taken with off-camera flash at a gallery, and the far right shot was taken in her studio with ambient light.

- m (r) 35mm lens, 1/125 sec at f/4. ISO 100.
- (fr) 50mm lens, 1/15 sec at f/4. ISO 100.

Off-camera flash

Ambient light

Allow your subject to play to the camera. The animated expression and brightly coloured waistcoat of the painter Terence Frost reveal as much about him as the surrounding paintings.

■ 50mm lens, 1/30 sec at f/8 with bounce flash. ISO 100.

► Natural light conditions

This photograph of the sculptor Eduardo Paolozzi was taken using natural light. The large windows usually found in artists' studios often make flash unnecessary for portraits.

80mm lens, 1/30 sec at f/5.6 with tripod. ISO 125.

▲ Contrasting portraits

In the ohot on the left, one of Philip King's own sculptures has been used as a frame that encloses the head-and-shoulders portrait. Note how the brightly coloured metal has reflected yellow light into the artist's face. In the shot above, the pose is more informal, making it look as if the sculptor is at work in his studio.

- (t) 28mm lens, 1/30 sec at f/2.8. ISO 100.
- (I) 50mm lens, 1/15 sec at f/1.8. ISO 100.

- Do not tidy away all the clutter a sitter may have accumulated. Instead, include it to help reveal more about his or her life.
- Avoid placing the sitter towards the side of the frame, or too close to the camera, if you want to avoid distortion from the wide-angle lens.
- Use natural light whenever possible, so that the scene is evenly lit.
- When using flash, use a low-power setting. This means you can use a wide aperture, so that shadow areas do not appear too dark. You can increase brightness in these spots further by using a slower shutter speed.

Playing to the camera

Although there are plenty of guidelines that you should try to follow in photography, there are times when you need to bend the rules. Sometimes, the only way to create impact – and to develop your own individual style – is to deliberately break with convention. The normal approach to portraits is to catch people looking at their best – to provide a dignified or photogenic picture of the subject. But the photographer does not always succeed: subjects get bored or mischievous – and poses become playful or childish. Rather than keep trying for classic shots, it sometimes pays to ignore the rules and actually encourage outlandish behaviour. These *camera verité* shots show a side to people's characters that traditional portraiture techniques usually miss.

This is an approach that works particularly well with children. They love to mess around, and if you let them have their way, you will find that they will be more cooperative than with any more formal poses that you have in mind.

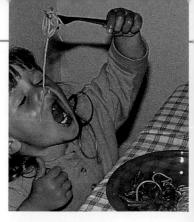

▲ Enjoying the attention

Young children are known for being messy eaters, and this can make interesting photographs. But when some children see the camera, they will deliberately ham it up — as proved by this young spaghetti eater.

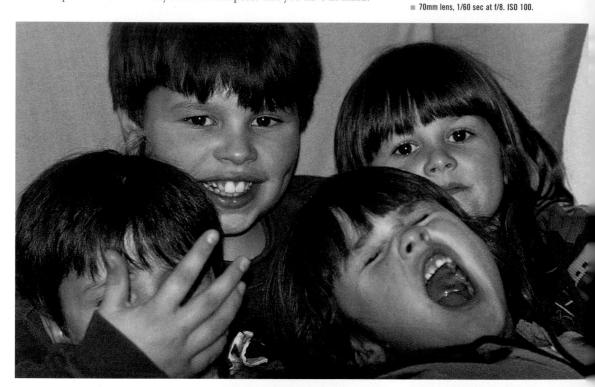

▲ Claiming centre stage

The more children you have in front of the camera at once, the more chance there is that one of them will play up to the camera. The older brother has made himself the centre of attention for the picture by instigating the chaos on the front row.

■ 50mm lens, 1/60 sec at f/5.6. ISO 100.

▶ Wide-angle distortion

It is not just family and children that play to the camera – most people will pull faces if they are in the right mood, irrespective of rank and status. The actor Roger Moore could not resist the temptation to pull faces for the wide-angle lens, providing an amusing sequence of images.

24mm lens, 1/30 sec at f/4. ISO 200.

■ Entering into the spirit

Even complete strangers sometimes relish the opportunity to act the fool. This Chinese dancer saw the camera and decided to get himself into the shot by putting his head into the mouth of the ceremonial dragon.

■ 135mm lens, 1/125 sec at f/4. ISO 200.

▼ Rebellious nature

Children will often make a rude gesture or stick out their tongues when they see you with a camera. Sometimes it is worth taking the shot – as the pose will show the rebellious or cheeky side of the person's character.

m 35mm lens, 1/60 sec at f/2.8. ISO 200.

WIDE-ANGLE PORTRAITS

Another way in which to create portraits with a difference is to use ultra wide-angle lenses. Wide-angle lenses are generally used for portraits only when you want to include as much of the confined setting as you can, but you can get very interesting results by using short focal lengths for their own sake. Ultra wide-angle lenses create a spaced-out perspective – where vertical lines tend to splay outwards, and anything that is fairly close to the camera looks unnaturally big. Used close up to a face, such a lens creates a caricature of that person - which may be amusing. You can minimize these distortions by ensuring that the person appears small in the frame or close to the centre.

▲ Squashed shapes

A wider-than-usual lens makes a room appear bigger. In this portrait there are few tell-tale signs of distortion — unless you know that the table is actually round, rather than oval.

m 21 mm lens, 1/15 sec at f/8, ISO 200.

▲ Minimal distortion

This shot shows minimal signs of distortion. The perspective means that the subject's trailing leg looks longer than it possibly could be, while the pattern of the carpet suggests a close viewpoint.

24mm lens, 1/60 sec at f/8 with diffused flash. ISO 100.

Expressions

In portraiture, the results do not just depend on the skill of the photographer – the subject also has an important part to play in the shot. The human face is capable of a thousand different poses, simply by the way in which the mouth and eye muscles are used. A slight grimace may mean nothing in real life – but caught on camera, it makes a statement. In addition to facial expressions, there is an almost infinite number of ways in which the subject can change posture and position – many of which look much less photogenic than others.

A good, professional model can adopt natural poses and smile on demand, but the photographer can directly influence the results. Ensure the model is comfortable, warm, and at ease, and keep talking to him or her.

Head and shoulder portraits

This sequence of shots shows just some of the varied expressions that can be achieved with a simple head-and-shoulders portrait, shot against a plain background. The lighting is provided by a large softbox, placed above the camera to simulate soft frontal sunlight.

■ 150mm lens, 1/60 sec at f/11. ISO 50.

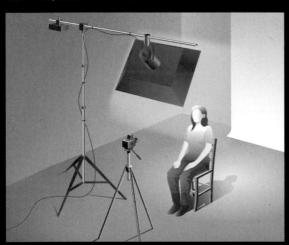

- Ensure that the camera, lighting, and set are all ready for action before the model arrives.
- For face shots, get the model to sit on a stool, so that he or she does not wander out of position.

 Ensure you focus on the eyes.
- Never over-complicate the lighting. Simple lighting gives the most natural results, and does not cause unexpected glare and shadows.
- Keep the make-up basic.

Portraits outdoors

The main advantage to shooting portraits outdoors is that you have much more space; this gives flexibility not only of the backgrounds themselves, but also in the distance between subject and backdrop, and between camera and subject. The main disadvantage is that the photographer is at the mercy of the elements, from a harsh sun to too much cloud cover.

The photographer does, however, have some tools that can help to control the lighting – the reflector and the diffuser (*see pp.338*–9). The reflector bounces back light to soften shadow areas on a subject. Popular versions are circular models that collapse to a third of their maximum diameter when not in use. The diffuser can be used to soften the brightness of the sun. Some white reflectors double as diffusers, and can be bought from professional suppliers in different strengths (measured, usually, by how many f-stops they cut the brightness of the light by).

TYPES OF REFLECTOR

Mirror Extremely reflective. Can be used to simulate a spotlight.

Silver reflector Very reflective; crumpled surface adds some diffusion.

Gold reflector Very reflective; crumpled surface adds diffusion. Adds colour cast to reflected light, which can warm up skin of model.

White reflector Collapsible all-white reflectors are highly portable with average reflectance and good diffusion.

 $\begin{tabular}{ll} \textbf{White sheet} \ Portable \ and \ easily \ available-average \ reflectance \ and \ good \ diffusion. \ Needs \ some \ support. \end{tabular}$

White card or painted MDF Average reflectance and good diffusion – low cost.

Polystyrene Dimpled surface means lower reflectance than other white reflectors and better diffusion. Very light, but easily damaged.

▼ Softening sunlight

Direct sunlight can create strong contrasts. To help control it so that the lighting appears soft and diffused, use a reflector and a diffuser in combination. For the shot below, a diffuser was placed between the model and the sunlight that was coming from the right. A gold reflector provided soft fill-in on the left-hand side.

80mm lens, 1/250 sec at f/4. ISO 50.

◆ ► Matching subject and backdrop

When outdoors, you want the setting to be an adjunct to the image, so it should not be too fussy. Practically any background can be toned down successfully using a large aperture so that it appears well out of focus in the picture (right). However, you might want to include less complex backgrounds more crisply. The grasses in the other portrait (left) make an interesting pattern in the background, which is repeated in the shadow that falls across the model's face.

- m (r) 80mm lens, 1/60 sec at f/5.6. ISO 50.
- (I) 80mm lens, 1/30 sec at f/11. ISO 50.

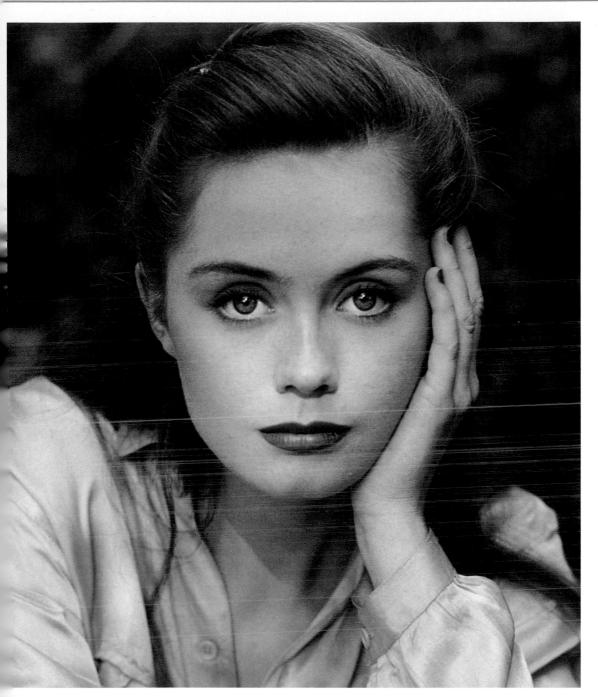

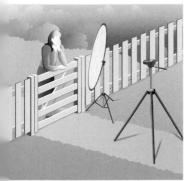

▲ Enhancing natural light

The appearance of natural dappled sunlight is controlled here by the photographer. Illumination is provided by the late afternoon sun, which even when direct is relatively soft. The use of a large white reflector is key – this not only softens the shadows on the face but also adds appealing white catchlights in the model's eyes. If a purpose-built stand is not available, the reflector can be held in position by an assistant or leant against a convenient object, such as a clothes horse.

80mm lens, 1/125 sec at f/5.6. ISO 50.

- Use a piece of white cardboard, a white sheet, or a mirror to reflect the light instead of a bought reflector it can be just as effective. The key is to use as big a reflector as you can and ideally one that is at least the same size as the subject area you want to light up.
- Make a diffuser with a simple wooden frame covered with a diaphanous white material, such as netting or cotton.

Studio backdrops

One of the advantages of having as large a studio as possible is that the distance between the subject and the background is increased. In cramped conditions, it is difficult to light the two separately, and there is a danger of shadows from the subject falling on the backdrop.

If you light your backdrop independently, it can be transformed in hundreds of ways. Graduate it by lighting the top and bottom differently. Alternatively, project patterns or colours on to it by placing masks (known as "gobos") or coloured gels over the lights.

White or black paper rolls are the most popular and the most versatile backdrops. These can be suspended from high on a studio wall, and then extended down in a loop and out over the studio floor, creating a cove so that the join between wall and floor is not visible in the photographs. As the paper becomes tattered or dirty, a length can be cut off and a new section extended.

A vast range of backgrounds can be bought from specialist suppliers – but note that simple backgrounds frequently work best as they do not detract from the subject, and because in smaller studios it is not always possible to throw more elaborate patterns out of focus.

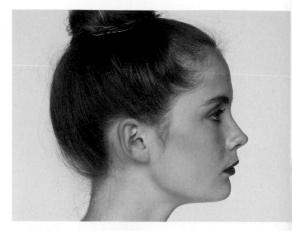

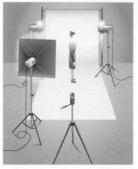

▲ Separate lighting

To ensure that a white background appears white in a picture, it needs to be lit separately, so that it appears one or two stops brighter than the subject. This works well when you want to show the profile or head shape of the subject. It is also a useful technique if the picture is going to be cut out.

120mm lens, 1/125 sec at f/5.6. ISO 50.

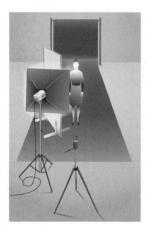

▲ ► Unlit backdrop

This is a similar set-up to that in the portrait above right, but this time the white paper background appears black. To do this you need to ensure that as little light as possible reaches the background. A dark room is essential, and the subject needs to be placed as far forwards and away from the unlit backdrop as the studio allows. A shield is then used (above) so that the subject lighting does not reach the paper.

120mm lens, 1/125 sec at f/5.6. ISO 50.

▲ Reflective background

Sheets of plastic mirror material make an exciting background for use in the studio. The sheets can be gently folded to make a series of ripples across the surface. As the silver material is so reflective, it is possible to add colour to the background (top and left) simply by holding an object of the required hue just out of view, to the side of the backdrop. Alternatively, the material can be left plain silver for a starker effect (above).

■ 120mm lens, 1/125 sec at f/5.6. ISO 50.

Posing groups

As soon as you try to photograph more than one person in a single frame, the composition becomes less straightforward. The more people there are, the harder it is to manoeuvre them effectively – and it is difficult to arrange them so that the picture looks interesting.

With small groups, it is usually best to avoid using a symmetrical composition. Although everyone may want to be the star of the show, the picture will usually look more powerful if some are closer to the camera than others. If people need to be next to each other, have some standing and others sitting – so at least there is a difference in height.

The logistical problems with larger groups make adventurous compositions difficult. As with school and sports team portraits, putting people in lines at least gives some order to the shot – and increases the chances of everyone being seen. Ensure that different rows are at different heights – lying, kneeling, sitting, standing, standing on a chair, and so on. Also try to incorporate a clear focus of attention. At a wedding, this would obviously be the bride; in a football team, it could be the captain or coach holding the ball just in front of the squad.

▼ Large group portrait

Sometimes when working with a large group the composition can look as if it has happened by chance. The truth is, despite the relaxed looks of the many people involved, such a scene can take hours to set up.

65mm lens, 1/125 sec at f/11 with studio flash. ISO 50.

► Creating a link

This series of pictures is of people arriving for a party at a North London nightclub. The groups were asked to pose on the 30s-style sofa that was in the foyer of the building. The portfolio provides a set of semi-formal shots that are linked.

35mm lens, 1/60 sec at f/8. ISO 100.

▲ ► Alternative poses

Not everyone needs to be facing the camera in a group purtrait. In the shot on the right, the two older sistors stand sentry-like at the back. The shot above makes a powerful picture by drawing attention to the girls' beautiful plaits.

■ 80mm lens, 1/30 sec at f/16 with studio flash. ISO 100.

▼ Shared activity

For an informal pose, particularly of a couple, ask the subjects to do something together, such as share a meal, either indoors or out.

■ 125mm lens, 1/250 sec at f/11. ISO 100.

- Always shoot as many pictures as possible when photographing groups. The more people in the picture, the higher the chances that someone will have their eyes closed, will be moving, or will be making an awkward expression.
- Create a series of themed portraits by using the same setting for different subjects. Candidly photograph the different people that sit on a particular park bench on a particular day or photograph different queues at the same bus stop.

Photographing children

The arrival of a child in a family is often the reason why people begin to take up or rediscover photography, when they strive to keep a visual record of the progress and antics of the younger generation.

In many ways, photographing a child is little different from photographing any other person. There are formal approaches and candid styles, there are outdoor poses and studio set pieces. What does make it different, however, is the relative height between a young child and an adult. Using the camera at your own head height works well for photographing adults, but for children the camera will be tilted downwards. You are looking down on the child, literally and metaphorically, and the resulting picture can make the child look smaller and less significant than most parents would like.

It is possible to obtain more natural-looking portraits when the camera shoots from the same level as the child's eyeline. For an eight year old, this might mean sitting down when shooting; for a toddler, it may be necessary to kneel; and for a crawling baby, the best approach may be to lie on the floor.

▲ Creating shapes

Hats help to isolate the face from the background, and create interesting shapes within the composition. They work particularly well on children, as they like to dress up.

m 80mm lens, 1/125 sec at f/4. ISO 100.

▶ Focusing on fingers

People's hands and feet are always fascinating photographic subjects – but this is particularly so with babies and toddlers. Zoom in close to fill the frame with their little fingers or toes.

210mm lens, 1/125 sec at f/8. ISO 50.

▼ Shooting at eye level

When photographing children, shoot the majority of shots from a lower viewpoint, so that your camera lens is level with their eyes. Eye contact with the child will create a much more powerful image.

■ 50mm lens, 1/125 sec at f/8. ISO 100.

► Low-angle shot

Shooting from just below a child's eye-level can make them appear independent and confident. In this shot, the camera angle makes the little girl look on top of the world.

m 135mm lens, 1/250 sec at f/2.8. ISO 200.

▼ View from above

While the general rule is to get down to a child's level when framing a shot, sometimes a different angle works just as well. This high-angle shot enabled the two girls to stand much closer together and fill the frame.

m 50mm lens, 1/60 sec at f/4. ISO 100.

▼ Formal structure

A formal poor particularly suits groups of children when they are in uniform, or similar clotheo, such as these African children on a school bus. Although the atmosphere is relaxed and informal, the symmetrical group pose gives the shot a formal structure.

•• bumm lens, 1/250 sec at 1/8. ISO 50.

PROFESSIONAL HINTS

■ Shoot upwards, from lower than the child's head height, to make him or her look more grown-up and confident. It is an interesting angle from which to portray a child enjoying a new experience, such as riding a bike or skateboarding.
■ Although most shots of children are taken at a low viewpoint, a higher angle can sometimes be useful — use the ground or floor as a background for the portrait, as this may simplify the composition considerably when shooting in a cluttered room or a crowded playground.

Children at play

Children tend to have a very short attention span and soon get bored with any organized portrait session. To a certain extent, they may be persuaded to cooperate, but if youngsters are seriously unwilling to be photographed, they will not be able to hide this, and will be unlikely to produce successful poses.

Often the best way to photograph children is from a distance. This does not mean that you have to take your pictures completely candidly – it just means that the child needs to be so absorbed in what he or she is doing that they have lost interest in what you are doing.

Rather than just waiting and hoping that they will appear relaxed, it is worth setting children up with an enjoyable activity. This allows you to control the setting to a certain extent and the props. With some children a favourite game or toy will provide instant amusement, while others might prefer playing with a favourite pet. If you have chosen a particular setting in the garden or house because of its good lighting or plain background, you should be able to obtain good pictures by ensuring that the children are relaxed and happy there.

▲ Caught in thought

A young girl rests her head thoughtfully on a garden table. The pose creates a symmetrical reflection and a balanced composition that suits the expression well.

135mm lens, 1/125 sec at t/5.6. ISO 100.

■ Anchoring the action

Games that keep children in a fixed area work well for portraits. This lively trio would have been hard to catch in a single frame running around the garden, but once they were on the swing it was simple to pre-focus the lens to catch them sharply.

135mm lens, 1/250 sec at f/8. ISO 200.

▲ Catching the moment

When shooting children in an impromptu home studio, do not confine yourself to formal poses. Use the child's toys, balloons, bubbles, and so on as props to keep the child entertained – and to add extra interest to the shot.

■ 120mm lens with two studio flashes, 1/160 sec at f/11.

■ Unself-conscious play

When concentrating on other things, such as the absorbing business of playing with hula hoops, children lose any self-consciousness in front of the camera.

135mm lens, 1/250 sec at f/11, ISO 100.

▲ Absorbed in play

This little girl was completely absorbed in her game of rearranging small chairs on the beach. The two yellow chairs add colour to this charming study that shows the child's perfect self-assurance.

200mm lens, 1/500 sec at t/5.6. ISO 100.

◆ Informal pose

Children may play to the camera, but their pulled races can make as charming a portrait as any straightlaced formal pose. This photograph was lit using a single flash head to the right of the camera, which was diffused by bouncing the light into a brolly.

80mm lens, 1/60 sec at f/8 with flash. ISO 100.

- Always ask permission of a parent or guardian when photographing children.
- Carry unperfumed wet wipes or have a clean, moist flannel handy to wipe dirty faces and hands.
- Try to keep all photo sessions short, even informal ones. It is very difficult to take good photographs of children once they have lost interest in posing for a shot.

The human form

The naked human body has always fascinated artists, but it can be one of the most difficult subjects to tackle successfully with a camera. Part of the problem is that photography can be so exact with its reproduction that imperfections in skin can stand out – and the subtlety of the body's shape can so easily be lost.

The most important thing to remember is that nudes are an exercise in form. So in the studio you need to use diffused, directional lighting – with fill-in, when required, being provided by a reflector.

The choice of model, male or female, is also crucial. Embarrassment will interfere with natural posing, and it will be almost impossible to make the model look or feel comfortable – so they must be perfectly relaxed without clothes. Additionally, good skin is perhaps even more important than a good figure. To encourage models to relax, whether clothed or not, it may help to have music playing in the studio throughout the shoot.

▲ Using monochrome

Black and white is preferred by many photographers for doing nude work because it allows form and texture to be highlighted, without revealing imperfect tans and skin blemishes.

■ 120mm lens, 1/30 sec at f/11. ISO 1000.

▲ ► Natural lighting

Soft sidelighting is ideal for pictures of the human body, as it helps to show the curves well. Here the light is provided by low afternoon sunlight coming through a mullioned window. Note that nude photography does not need to be too revealing. A photograph can be sensuous and show the model's figure with only a suggestion of complete nakedness.

50mm lens, 1/30 sec at f/8. ISO 1000.

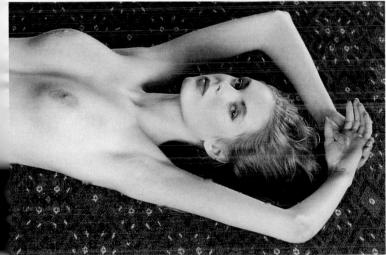

▲ High vantage point

f you work from a high-level camera position, reached with the aid of a stepladder, the model can lie down, and will therefore be relaxed and comfortable and can avoid awkward poses. Use a similarly high, but angled, studio light fitted with a softbox.

120mm lens, 1/60 sec at f/11. ISO 100.

▲ Diffused light

Artificial lighting is not always required. This shot was taken by using strong light from a high window, which was diffused by a net curtain. The high angle was achieved by standing on a chair.

m 50mm lens, 1/30 sec at f/16. ISO 100.

HANDS AND FEFT

Hands and feet always make interesting close-up studies, whatever the subject's age. The hands, in particular, tell you much about a person's age and way of life, and can be very expressive. Bare feet often impart a certain vulnerability to the subject.

120mm lens, 1/30 sec at f/11. ISO 100.

80mm lens with extension tube, 1/30 sec at f/11. ISO 100.

Abstract nudes

One of the most rewarding and easily mastered approaches to nude photography is the abstract nude – where different areas of the body are shown in isolation. This allows the photographer to make compositions in which the curves of the human form can be used to create an almost endless variety of semi-abstract shapes in the viewfinder. The anonymity that this approach provides for the model can be seen as another advantage. For this type of photography, use soft, directional light to obtain the best results.

▶ Softening the effect

For some poses you need to ensure that the lighting is diffuse and relatively even – as otherwise shadows can be too strong and ruin the overall effect.

■ 150mm lens, 1/30 sec at f/16 with flash. ISO 100.

▼ Creating depth

The shorter focal length used below maximizes the three-dimensional form, accentuating the curves of the body.

■ 80mm lens, 1/8 sec at f/16 with flash. ISO 50.

▲ Abstract effect

A single light to the side of the model enhances the abstract effect of the compostion. It provides strong highlights and also illuminates the background.

■ 150mm lens, 1/60 sec at f/8 with flash. ISO 100.

▲ Using shade

Without the use of fill-in lighting, half of the model's figure is thrown into shadow, while the lines of the other side of her body are accentuated by the single light. This results in an almost monochromatic picture.

■ 150mm lens, 1/60 sec at f/8
with flash ISO 100

► Accentuating curves

Even slight changes to a model's pose or to the angle of the lighting can change the look of your shots. Such adjustments will move the highlights and shadows across the frame, and change the prominent curves in the composition.

 150mm lens, 1/60 sec at f/16 with flash. ISO 50.

▲ A Rotating the image

You can vary your shots simply by rotating the camera or the print. These two shots were taken with the same set-up, but in the rotated image (*above*), the model looks as if she is leaning against a wall rather than sitting.

■ 120mm lens, 1/60 sec at f/11 with flash, ISO 50.

Architecture

Since buildings cannot be moved to suit the composition, the skill of the architectural photographer is to find a way that shows the structure in an attractive or innovative way. By making the most of changing natural light, and by altering the viewpoint and camera angle, it is possible to come up with a surprisingly wide range

of interesting pictures of even the best-known and most-visited buildings in the world. Wide-angle lenses are essential, particularly for most interiors. Although they bring with them problems of perspective, these are not insurmountable. Shift lenses (*see pp.54*–5) are also useful as one way of avoiding converging vertical lines.

Using the right lens

The wide-angle lens is closely associated with architectural photography. Because buildings are often large and surrounded by other buildings, they tend to be photographed at close range, and the wide-angle lens ensures that the whole building fits into the frame. However, it is often necessary to lean back to fit in the tops of the buildings. The result is that lines that should be upright appear to slope into each other.

Fortunately, many of the most photogenic buildings are designed to be seen from a distance. Castles, churches, temples, and palaces are not only built on a grand scale – but tend to be strategically placed in the landscape so that they dominate their surroundings.

Rather than using a wide-angle lens from just in front of a building or a telephoto lens from further away, try minimizing the problem of converging vertical lines by finding a higher position, either natural or manmade – a hotel balcony might be perfect. Bear in mind that, if the camera position is some distance away, you will also need to use a longer lens to fill the frame – the advantage then is that the camera does not need to be tilted as much.

CORRECTING CONVERGING LINES AT GROUND LEVEL If you cannot get to a higher viewpoint and you have to shoot a building at ground level, try shooting from further away, using a telephoto lens (below) instead of a wide-angle lens (right). Not only will the image fill the frame, but the camera Wide-angle lens will need to be tilted at less of an angle to get the top of the building in the shot. This will result in vertical lines appearing more upright. Telephoto lens

▼ Filling the foreground

In this shot, a white wall leads the eye towards the typical Greek church beyond, and also helps to fill the foreground. Because the foreground was included, the camera did not have to be tilted too much, so converging verticals were avoided.

35mm lens, 1/125 sec at f/16. ISO 50.

▲ Specialist lens

Here, a specialist shift lens was used to ensure the tall tower appeared upright and square.

28mm shift lens, 1/250 sec at f/11. ISO 100.

▲ Using the space

Make good use of the room that is available to you. Often you can move further back from a building than you think at first, by crossing a road, for example, or by shooting from the other side of a river, thereby minimizing any distortion.

35mm lens, 1/60 sec at f/16. ISO 100.

▲ Lining up the foreground

One way to avoid tilting your lens when photographing buildings is to line up the centre of the viewfinder with part of the structure at the same height as the camera. If the foreground is attractive, this is a perfect solution.

■ 50mm lens, 1/125 sec at f/11.

▲ Undetectable distortion

Vertical lines cause problems with convergence. However, this cathedral in Liverpool, England, has an already converging structure, so the distortion created by a close viewpoint is unnoticeable.

m 28mm lens, 1/60 sec at f/16. ISO 100.

CHOOSING EQUIPMENT

- Large- or medium-format cameras with a full range of movement allow you to avoid converging verticals completely. Alternatively, use a medium-format or 35mm SLR that has a shift or PC lens available for it.
- Special focusing screens, with etched grid patterns to help keep horizons and verticals straight, can be used with some cameras. Some digital cameras have electronic grids that can be superimposed over the viewfinder when required.
- A range of lenses enables you to shoot buildings from a range of distances. Fisheyes and ultra wide-angles are useful for interiors. Telephotos with a focal length of up to 300mm (35mm format) can be used when a building is photographed from a distance.
- A computer with an image-manipulation program lets you correct for converging verticals whatever camera and lens are used.

Abstract architecture

When shooting any type of architecture, it is often worthwhile to home in on the detail, including just a small part of the structure in your composition, rather than trying to get the whole structure into the frame. This approach works well with modern architecture, in particular, as the strong lines and geometric designs lend themselves to abstract treatments.

By using longer lens settings you can pick out patterns, shapes, and interesting arrangements of tone and colour that are hard to see in panoramic shots. Not only does this make well-known buildings less instantly recognizable, it also enables tourists and traffic to be easily hidden.

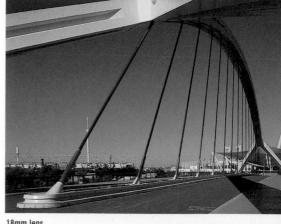

18mm lens

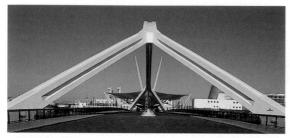

24mm lens

150mm lens

▲ ► Experimenting with lenses

This series of shots features the Barqueta bridge in Seville, Spain, which was built for the Expo '92 world fair. To find the most interesting angles and to create different patterns in the viewfinder, a wide range of lenses was used, from an 18mm wide-angle through to a 150mm telephoto. The symmetrical structure of the bridge lends itself well to semi-abstract compositions.

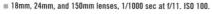

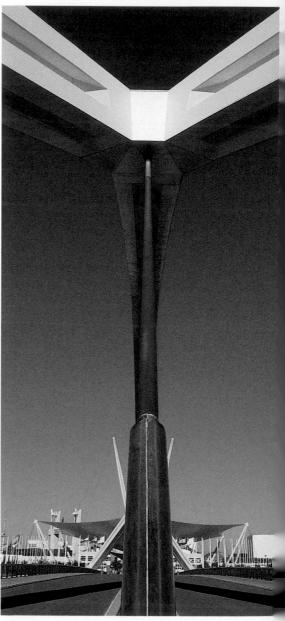

150mm lens

◆Low-angle approach

The Alamillo bridge in Seville is a striking landmark, but it is not easy to photograph because its design leaves lots of open space in the frame and there is little three-dimensional form. This low-angle approach helps to hide any human presence, while a polarizer increases contrast between the white wires and the blue sky.

24mm lens, 1/1000 sec at f/11. ISO 50.

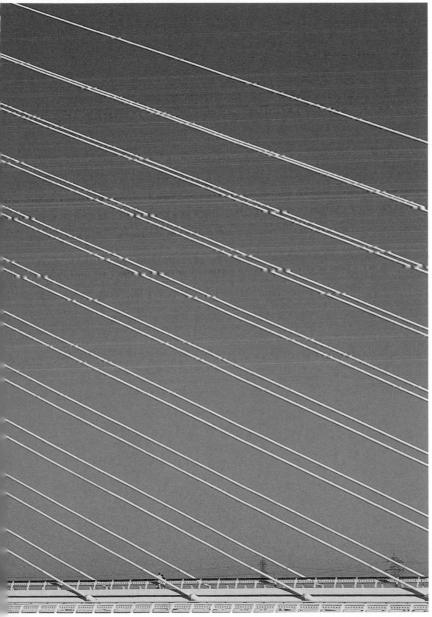

◄▲ Telephoto shots

If you crop in close with a telephoto lens, almost every view of the Alamillo bridge becomes an interesting abstract, full of pattern and shape.

■ 150mm lens, 1/1000 sec at f/11. ISO 50.

Lighting for architecture

Architectural photographers rely almost exclusively on ambient lighting. Photographers may be able to use artificial lighting effectively for interiors, but outdoors they are at the mercy of the weather and the quality of sunlight.

There is no such thing as the perfect lighting for architecture – different building designs benefit from different conditions. Sidelighting, as you might expect, has its role in accentuating the form of some buildings, while backlighting works well if the edifice has a strong, instantly recognizable shape. For straightforward shots, it is usually worth having the sun over your shoulder; the frontal lighting means that there are no strong shadows to worry about but, as the sun is not directly behind you, there is still just enough modelling to avoid the structure looking like a two-dimensional cardboard cutout. If the sun is low in the sky in the early morning or late afternoon, or obscured by cloud, so much the better.

Even extreme conditions can benefit some architectural shots. Snow reflects light evenly into crevices and hides foreground objects that otherwise make a viewpoint inadvisable; fog can provide a sense of mystery; while rain can create interesting reflections – and make old and worn surfaces look shiny and new.

▲ Transformation

With the right lighting, any building can be transformed. This Canadian grain store is a rather utilitarian structure that would not normally attract a second glance. But with the light catching its side, and with the strong diagonals created by the roofline and the railway line, it becomes an irresistibly photogenic scene.

■ 24mm lens, 1/125 sec at f/8. ISO 100.

▼ Reflective conditions

With early morning comes perfect lighting as well as typically tranquil weather. These excellent conditions provided some stunning reflections of the waterfront in this shot of Rio de Janeiro, Brazil.

■ 100mm lens, 1/500 sec at f/5.6. ISO 100.

▲ Using sunlight

This shot was taken with the strong sun behind and to the left of the camera. At this angle, there was enough shadow to give modelling to the statues of Venice's Arsenale while providing a bright, colourful image.

28mm lens, 1/500 sec at f/11. ISO 100.

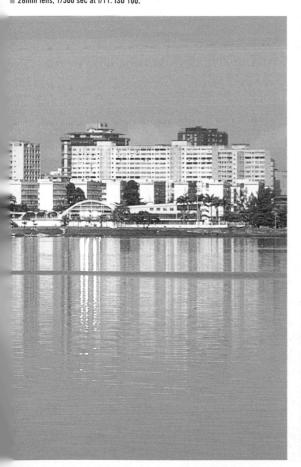

▲ Sense of mystery

Mist works particularly well in photographs of ruins, adding to the eerie atmosphere. It can also be effective when used as a compositional device for hiding an unwanted background.

■ 80mm lens, 1/4 sec at f/8 with tripod. ISO 100.

▼ High noon

Noon is not always the best time to shoot architecture because of the strong shadows. Here, however, the shadows repeat the arches and emphasize the decorative carving on this Moroccan building.

■ 100mm lens, 1/500 sec at f/8, ISO 50.

See also Direction of lighting p.160 Winter p.302 Rain p.304

Industrial landscapes

When photographing buildings, many photographers prefer to train their lenses on the spectacular and unusual. But it is too easy to think of architectural photography as just the art of producing photogenic pictures of humankind's more beautiful constructions.

In reality, towns and cities are much more than simply a collection of picture postcards. They have their ordinary, banal, and plain ugly sides as well. For the documentary photographer – who may want to show objects as they really are, or to convey a message about the way we live our lives – it is these less obvious scenes that become the subject of the photograph. With the right approach, this gritty realism can have its own raw beauty.

Pictures that juxtapose different types of development have a deep resonance. The scarcity of land in many parts of the Western world means that someone has to live next to factories and airports, while the countryside is always being punctured by new developments. Framed together, manmade and natural features can contrast to make a strong picture – as well as a powerful social statement.

▲ Unusual juxtaposition

The juxtaposition between this farmhouse and the aqueduct seems incongruous. The viewer is meant to be curious about how it came about.

35mm lens, 1/60 sec at f/5.6. ISO 100.

▶ Isolated structures

Few would find the reinforced concrete structure of this modern building interesting. By isolating the shape of the stairway, and taking advantage of available light, the scene has been turned into an intriguing, almost abstract, shot.

■ 135mm lens, 1/250 sec at f/8. ISO 100.

◆ Tonal compositions

This picture would not have worked on a bright day. The brooding clouds and gloomy conditions seem to suit the industrial landscape perfectly. In essence, this composition is a study in tone, with the white smoke and the black chimneys standing out against a grey sky.

■ 135mm lens, 1/15 sec at f/5.6. ISO 100.

◄ Backlit shapes

Industrial developments often contain distinctive shapes and strong contrasts. Photographing such scenes with the sun in front of you can simplify them, while still resulting in a recognizable industrial landscape.

■ 35mm lens, 1/60 sec at f/11. ISO 200.

■ Contrasting elements

The curvaceous forms of a power plant's cooling towers always make for interesting pictures. Here, a compositional contest is created by placing the towers in one corner and the isolated house in the other.

■ 200mm lens, 1/125 sec at f/5.6.

Sculpture

Statues and sculptures are frequently used as centrepieces or focal points to the interiors or exteriors of a building. They are designed to catch the eye as works of art, or as thought-provoking memorials.

Sculpture comes in all shapes and sizes and is one of the most ancient art forms. Classical sculpture portrays people and animals in a life-like way, while modern sculpture is more abstract in its approach. Although the similarities are not always easy to see, both are exercises in form, and this is the way they should be approached when they are being photographed.

It is also important to realize that most statues are commissioned and sculpted with their ultimate location in mind. They are conceived and designed to be part of their architectural surroundings. Therefore, when taking pictures of sculptures, it is always worth showing them within their surroundings, rather than in isolation.

▲ Chosen setting

Although his sculptures are mainly seen in cities around the world, Henry Moore preferred his work to be shown in the open landscape. Moore built this hill near his home at Hoglands, Hertfordshire, UK, in order to display this particular piece.

120mm lens, 1/125 sec at f/5.6, ISO 100.

► Scale reference

Henry Moore worked seven days a week throughout the year. This hangar-sized outdoor workshop shows the sheer size of his sculptures – with the sculptor himself providing the scale reference for the shot.

m 50mm lens, 1/15 sec at f/5.6, ISO 100.

▲ Sidelighting

The ideal lighting for statues (above and top) is similar to the lighting that could be used for a nude (see pp.280–1), although the sidelighting can be slightly harsher than would be used for a real person.

■ 135mm lens, 1/8 sec at f/8 with tripod. ISO 50.

▲ Overhead view

For overhead shots of these effigies of the Black Prince and Henry IV in Canterbury Cathedral, UK, it was necessary to climb on to the tombs. The flash was diffused to prevent strong highlights.

■ 50mm lens, 1/30 sec at f/8 with flash.

Objective photography

The goal of most architectural photographers is to come up with original pictures – capturing a location from an interesting angle, or using a technique that shows the scene in a fresh way. The difficulty is that the most popular subjects have all been covered before.

One artistic approach is to shoot buildings without the scene having been staged by the photographer, or without any obvious photographic technique. The idea behind this style of photography, known as objective photography, is to catch the scene as if it were shot by a closed-circuit television camera with no input from a photographer. However, although the objective style may look unplanned, the photographer has carefully chosen the angle of the viewpoint shown, and the moment it is captured. Similarly, even if the intention is to show a scene without people in the frame, the impromptu approach often shows a strong human presence through the inclusion of the clutter and possessions that are so often cropped out of more formal architectural shots.

▶ Wide-angle view

The objective style relies on keeping technique and equipment simple. However, an ultra wide-angle lens was needed to include all the pool.

20mm lens. 1/60 sec at f/11. ISO 100.

■ Intriguing entrance

A patterned screen surrounds a doorway that seems to lead nowhere. Objective photography should capture the imagination of the viewer.

50mm lens, 1/15 sec at 1/4. ISO 100.

▼ Enigmatic scene

Objective photography often creates enigmas. Why is this boardroom furniture set out in a garden? There may be a rational explanation, but the shot just presents it as an oddity.

28mm lens, 1/125 sec at f/11. ISO 100.

◄ Art imitating nature

Objective photographs force you to look at everyday scenes with a fresh eye. A shot of a car park may at first seem like a waste of time – but when you study it you notice how the trees in the mural create a line with the real trees beyond.

28mm lens, 1/125 sec at f/11. ISO 100.

PROFESSIONAL HINTS

■ Although currently in vogue, objective photography has its roots in the straight photography of the early 20th-century American photographers, such as Paul Strand. Looking at the work of past masters can help you to develop your own style.

■ Often the photographic records of yesteryear become

the artistic shots of tomorrow.

The natural world

Photographing the natural world involves a certain amount of unpredictability, whether you are shooting plants, landscapes, or wildlife.

The fact that the earth orbits the sun on a tilted axis means that, although there is little seasonal change between the tropics, in other parts of the globe there are marked differences in the hours of daylight, depending on the month of the year. These seasonal changes – from the low light of winter to the harsh colours of summer – provide both challenges and rewards for the photographer.

Spring

When the earth's northern hemisphere tilts towards the sun, spring starts to appear in temperate countries. In spring, days start to lengthen and temperatures are higher than in the preceding season, winter, when the northern hemisphere is tilted away from the sun.

Spring brings rapid change, and there are many signs of growth after the dormancy of winter. Buds appear on the trees, early flowers provide splashes of colour, and new grass provides a lush, green glow to the landscape. For the photographer, longer days mean that there is more time to take outdoor pictures – and more picture opportunities.

▼ Adding structure

Daffodils and other bulbs provide strong colour in the landscape garden in spring, but, in this shot, the sea of yellow blooms needed another focal point to add structure to the picture. Usually it is easy to find a garden ornament or building to perform this function – here a snow-white goose foraging in the foreground was the perfect subject to provide the focus for attention.

■ 70mm lens. 1/60 sec at f/8. ISO 100.

▲ Colour contrast

On the pond, it is too early for lilies, but this bright marsh marigold acts as the harbinger of spring – and creates a good colour contrast with the background.

28mm lens, 1/60 sec at f/11. ISO 100.

▲ Catching the moment

Buds breaking into leaves or blossom are a sure sign of spring. This picture was taken as part of a time-lapse sequence. The bud was cut and put in a vase, then shot at regular intervals to capture it at the moment of opening. The camera, tripod, and vase were left undisturbed where there was good natural light. Some cameras will fire automatically for you at set intervals; alternatively, you could take a picture whenever you see a change for yourself.

■ 100mm macro lens, 1/30 sec at f/11 with tripod. ISO 100.

◄ Backlit fern

The unfurling fiddleheads, or croziers, of many species of fern make stunning photographs – particularly when, as in this shot, the delicate, light green fronds are slightly backlit.

 100mm macro lens, 1/125 sec at f/5.6. ISO 100.

▼ Dappled bluebells

Trees are still developing their canopy of leaves in spring, and this is the time that woodland bulbs flower. Bluebells are a particularly favourite subject for the landscape photographer.

35mm lens, 1/60 sec at f/16. ISO 100.

See also Polaroid film p.128 Garden structure p.308 Garden flowers p.310

Summer

In summer, many landscapes and gardens are at their most colourful. The trees bear their full canopy of leaves, and flowers are prolific. Daylight hours are also long, and the sun is at its highest.

How high the sun reaches above the horizon depends on the latitude of your location. At the equator, the noonday sun is directly overhead in summer, while in Europe and North America it rises to about 60 degrees above the horizon. For the photographer, the bright light around midday is characterless and best avoided; the most productive times are early morning or late afternoon, when the light is softer and creates better shadow.

Direct sunlight

Diffuse sunlight

▲ Diffuse light

Strong direct lighting in summer produces short shadows that work best with large shapes. Direct sun (*top*) gives a good shot of the structural elements, but diffuse sunlight (*above*) reveals the colours and shapes in the flower beds.

- m (t) 50mm lens, 1/1000 sec at f/8. ISO 100.
- m (a) 50mm lens, 1/125 sec at f/8. ISO 100.

◆ Foreground filler

The abundance of flowers in summer is such that it is usually easy to find a bright patch to make an interesting foreground when shooting landscapes or architecture.

m 120mm lens, 1/30 sec at f/11 with tripod.

▼ Abstract design

Summer is when annuals take over the beds of public parks and small private gardens, creating swathes of colour that can make a bright semi-abstract composition.

■ 50mm lens, 1/125 sec at f/16. ISO 200.

▲ Relaxed pose

Long summer daylight hours mean there is plenty of opportunity to use the greenery of a garden or a park as a backdrop for informal and candid portraits.

■ 80mm lens, 1/500 sec at f/11, ISO 100.

▲ Maximizing colour

To capture the intense colour of greenery and summer flowers in the same shot, it is best to shoot early in the morning or late in the afternoon.

■ 120mm lens, 1/30 sec at f/11 with tripod. ISO 100.

◄ Family shot

The whole family enjoys the garden in summer. Here, a child is captured in an informal portrait against the lush iw. The door acts as a frame to the subject.

■ 100mm lens, 1/250 sec at f/11. ISO 100.

PROFESSIONAL HINTS

- To stop flowers moving while you are trying to photograph them with a long lens, carry wire stakes, which can be used to tie up stems.
- Often the best way in which to see a summer border is from a distance – compressing the different bands of colour together with a long lens, and filling the frame. This often shows the planting scheme as the designer originally envisaged it.

Autumn

As plants die back when the temperature drops and the days shorten, the colour of the landscape changes. The bright flowers and verdant green foliage of summer are replaced with warmer, softer shades. The most striking autumnal colours are produced by the leaves of deciduous trees, which provide a rich palette of golds, browns, yellows, and rusty reds. The intensity and timing of these colours vary according to weather conditions from year to year. The effect is also often short lived – a storm may strip the leaves from a tree overnight. It therefore pays to shoot good autumn scenes as soon as you see them.

CHOOSING EQUIPMENT

- Medium-format rangefinder cameras offer good image quality without being too difficult to carry around. Try using a 35mm SLR with a full range of lenses from 20mm through to 200mm plus.
- Focusing on details in the distance can often result in a better picture than taking an all-encompassing wide shot. Use a suitable combination of zooms, such as 17–35mm,
- 28-80mm, and 80-300mm.
- Work with a tripod to ensure maximum depth of field.

◆ Close-cropped shot

Richly coloured deciduous trees, such as Japanese maple and sycamore, make superb pictures when you crop in close on the shot to fill the frame with foliage. If you shoot really close to the subject, an almost abstract effect can be achieved.

■ 100mm lens, 1/125 sec at f/5.6. ISO 200.

▼ Focal point

The colours of autumn trees can be a subject in themselves. However, in order to show more of the landscape, it is useful to include a focal point, such as the man with his dog in this shot. This adds scale, emphasizing the size of the tree and making a stronger composition.

■ 100mm lens, 1/125 sec at f/5.6 ISO 200

■ Colours and forms

Trees are especially rewarding to shoot when their shapes come into view. The autumnal palette of gold, brown, and orange can merge the different elements in a woodland landscape into a harmonious composition.

■ 35mm lens, 1/30 sec at f/8

► Pattern in the landscape

Fallen leaves on the floor of a wood can make stunning patterns for the photographer. In this shot, taken on the British royal family's estate at Sandringham, a red and gold carpet surrounds the skeleton of a giant rhododendron.

■ 28mm lens, 1/30 sec at f/11.

Winter

Winter can be a bleak time for the photographer in temperate regions because of the limited hours of daylight. However, the low angle of the light suits many subjects, and the bare trees mean that wonderful views become visible that cannot be seen at any other time of the year.

Of all winter subjects, it is snow that deserves special comment. It has a significant compositional role to play, as it literally obliterates objects from view. It also acts as an efficient reflector – bouncing back light from the ground and providing more even illumination. Snow does, however, have the disadvantage of creating exposure difficulties – a built-in meter will tend to set an exposure that turns a vast expanse of white into a light grey. Depending on how bright the conditions, and how much of the frame the snow actually occupies, you might need to give between half and one whole stop more exposure than usual. Incident readings taken with a separate meter (*see pp.80–1*) are, of course, unaffected.

▼ Scene from above

Snow completely transforms a landscape, hiding much of the detail of the scene from view, and linking areas that are normally separated. This aerial view was taken during a helicopter ride. The bare trees create an abstract pattern of shadows and branches.

50mm lens, 1/250 sec at t/2.8. ISO 100.

▲ Black and white

The intricate pattern of a tortured willow tree is strengthened by a covering of hoar frost – creating a powerful monochromatic abstract.

200mm lens, 1/250 sec at f/4, ISO 200.

▲ Blue shadows

In this orchard at sunset, notice how the snow appears particularly blue because it is in shadow. Shadows are only indirectly lit by skylight, which the white surface of the snow reflects so well.

35mm lens, 1/60 sec at f/5.6. ISO 100.

▲ Revealing patterns in the landscape

Snow turns muddy fields into a landscape where the patterns created by roads, walls, and hedges are made much more evident than usual. Here the raking afternoon light helps to reveal these different layers and levels.

50mm lens, 1/250 sec at f/5.6. ISO 100.

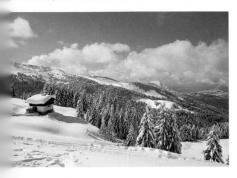

◄ Exposure adjustment

A sunny day on a snow-covered mountain can lead to exposure problems. To ensure that the snow appears white, take an incident light reading – or add one or half a stop more exposure to the through-the-lens reading.

50mm lens, 1/500 sec at f/8, ISO 100.

FROST

Frost, if particularly heavy, provides the same advantages and problems as snow. However, it has a particular appeal in the way that it can show up the patterns of leaves and trees. The secret here is the timing. Ideally, you should wait until the point when the frost just begins to melt, as this creates stronger patterns. On some occasions, this may mean getting up at dawn; on others, it means waiting for the sun to break through for the first time in the afternoon.

Leaf pattern

In this classic frost shot, the cold white covering accentuates the shape and delicate veins of the ivy leaves and stems.

100mm macro lens, 1/8 sec at f/16 with tripod. ISO 100.

Frost spikes

An early morning shot captures the thorny spikes of hoarfrost – but it is the red berries that initially grab our attention.

100mm macro lens, 1/15 sec at f/5.6 with tripod. ISO 100.

PROFESSIONAL HINTS

- To avoid the problem of overly blue shadows in snowy landscapes, use the aptly named skylight filter, or other warm-up filters, to help to correct colour balance.
- Cameras may not perform at their best in colder climates. In particular, batteries that seemed fine in the warm may suddenly die outside in the cold. Take lots of spare, fresh batteries with you when you are working outside. However, do not dispose of the seemingly sluggish cells too hastily they may rejuvenate once they are indoors again.
- Meep your camera (or battery pack) in a pocket or close to your body, so that it is kept as warm as possible until you need to take a picture.

Rain

Many photographers put their cameras away at the first sign of rain, but a downpour does not mean that there are no worthwhile pictures to be found. Heavy rain can, of course, pose a number of problems. Light levels can be dim, and the contrast can be so low that the photographs look flat and monochromatic. There is also the practical difficulty of trying to keep your camera dry, though this can be achieved with specialist equipment.

Sometimes rain is accompanied by relatively good light. This can often create unusual, atmospheric pictures, as the light is reflected so well by wet surfaces such as roads and pavements.

▲ Mirror image

Puddles become mirrors when the rain has stopped, creating reflections of the objects around them. This is a particularly good way of shooting neon signs and floodlit buildings.

■ 35mm lens, 1/30 sec at f/4. ISO 200.

▲ Urban rain

City streets provide interesting pictures in the rain – if there is enough light. The secret is to wait until the streets are saturated, and then shoot towards the sun.

50mm lens, 1/30 sec at f/2.8.
 ISO 200.

► Visible raindrops

The combination of sun and rain allows you to see the individual drops of rain if you make sure that the camera is pointing towards the sun, and you use a fast enough shutter speed.

135mm lens, 1/500 sec at f/5.6.
 ISO 100.

CREATING RAIN ARTIFICIALLY

▲ > Orenting rain artificially

You do not need to be a movio maker with specialist equipment to create your own rain. Using a hose or pressure washer, it is possible to create a convincing impression. This will work only over a small area, limiting the subjects you can tackle – but is still easier than shooting in a real storm. Set up the shot when it is sunny, so that the rain is backlit and every drop of water shows clearly in the picture.

◄ Backlit raindrops

Here, the rain droplets on a twig are beautifully backlit by the evening light. A wide aperture was used to ensure the out-offocus sun appeared as a sphere.

90mm macro lens, 1/125 sec at f/2.8. ISO 50.

PROFESSIONAL HINTS

- Keep the camera covered in a heavy downpour. An umbrella held by an assistant may suffice, or you could use a special waterproof housing or camera.
- A low-budget alternative is to wrap the camera in a highquality, clear plastic bag.

Sand

The light and form of a sandy setting will add interest and glowing colour to your images. However, sand itself is as potentially hazardous to photographic equipment as water. Like dust, sand can penetrate a camera's outer casing, where it can damage mechanical parts – but it also poses a risk to the exterior of equipment. Not only can it easily scratch LCD screens and viewfinders, but, if it defaces the front lens element of the camera, the damage may cause degradation in all your future pictures.

Care must therefore be taken when using a camera near the seashore, in the desert, or in dry, dusty conditions. Miniature sand particles can be blown in the wind, so the most sensible approach is to keep the camera inside a bag until you actually take a shot. In particularly windy conditions, the camera can be put into a clear plastic bag, through which pictures can be taken. Particular care should be taken when using film cameras, since the excessive heat of desert areas can deteriorate the film itself.

▼ Pillars of rock

The aptly named Pinnacle Desert in the Nambung National Park, Western Australia, is made up of small pillars of rock that look like a miniature Monument Valley. Three-quarter light provides just the right mixture of shadows and colour.

28mm lens, 1/1000 sec at f/11. ISO 50.

▶ Dusty conditions

A fast shutter speed froze the sand that was kicked up in the air by the horses' hooves. In conditions like these it is impossible to keep dust from your lens. One of the easiest solutions is to leave a round filter screwed into the lens.

■ 100mm lens, 1/1000 sec at f/11. ISO 50.

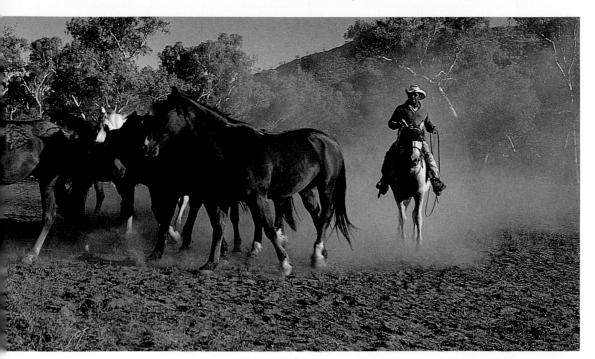

■ Reflective surface

Sand and sea are both highly reflective surfaces, and this can cause problems for the camera's built-in meter. This backlit shot was bracketed, so at least one frame was well exposed.

80mm lens, 1/1000 sec at f/8. ISO 100.

▲ Abstract study

Beaches can provide a wide range of possibilities, including wildlife shots, portraits, and landscapes. This shot is an abstract study, combining both pattern and colour.

200mm lens, 1/250 sec at f/5.6. ISO 100.

▲ Avoiding a silhouette

Since sand reflects light so well, a spot reading from the girl's face was needed to avoid this backlit portrait becoming a silhouette.

■ 35mm lens, 1/2000 sec at f/5.6. ISO 100.

PROFESSIONAL HINTS

Never be tempted to wipe sand or dust off a lens with your clothing – use a brush or blower to avoid scratches.
 Protect the front element of a lens in dusty or sandy

of a lens in dusty or sandy conditions with a screw-in filter – such as a skylight or UV filter (see pp.64–5).

In extreme conditions,

In extreme conditions, use an underwater camera or waterproof housing (see pp.344–5).

Garden structure

When professional gardeners design a new garden, they don't start with the flowers, they start with the landscaping: the contours and beds, the patios and ponds that provide focal points, coordination, and year-round interest.

It is this structure that later helps the visiting photographer. For example, a statue may be at the centre of a composition, while a path can lead the eye through a picture. Water, in particular, has been an essential garden feature for centuries. Ponds, fountains, and waterfalls can all benefit the photographer, reflecting light and providing mirror or rippled images of the foliage surrounding them and the sky above. Water can also be used in a garden to introduce movement into an otherwise static landscape. By using slow shutter speeds, the photographer can accentuate and transform this movement.

▲ Layered elements

In this shot, the garden's structural elements – the bridge, bushes, trees, and lawn – have been combined to form discrete layers and give a sense of depth.

■ 135mm lens, 1/250 sec at f/8. ISO 100.

▼ Running water

To shoot fountains, use a slow shutter speed of around 1/15 sec, or the water will look too thin. The lower the speed, the more foamy the water will appear.

■ 50mm lens, 1/15 sec at f/19 with tripod. ISO 50.

▲ Framing devices

Archways are used in architecture and garden design to provide windows that frame the view beyond. These should be exploited in garden photography.

■ 80mm lens, 1/15 sec at f/16 with tripod. ISO 100.

◆ Formal gardens

The symmetrical design of the garden of Castle Drummond in Scotland makes a more interesting composition than the elements within it. Io take the SIIUL, it was necessary to find the viewpoint from which the garden was designed to be seen.

■ 24mm lens, 1/125 sec at f/8. ISO 200.

CHOOSING EQUIPMENT

- Use a digital SLR with local lengths varying from 28mm to 200mm,
- Alternatively, use a medium-format SLR with wide-angle, standard, and short telephoto lenses.
- Use a tripod for full control of depth of field, and to help exploit early morning lighting.
- Buy a macro lens for shots of individual flowers.
- A fold-up reflector provides fill-in for macro shots, and can be used as a windbreak.
- Wire stakes can be used out of shot to keep stems rigid in a breeze.
- Keep a notebook to record botanical names.

Garden flowers

The best time to photograph gardens is usually early morning or late afternoon, particularly in summer when flowers are showing maximum colour. Direct lighting creates shadows that make individual flowers hard to pick out.

Using a wide-angle lens for shooting flower beds rarely shows them at their best, as blooms will appear spread out, gaps will be visible, and the structural impact of different plant sizes and shapes may be lost. Instead, use a longer lens from further away, allowing you to squeeze perspective so that the frame is packed tightly with blooms.

For shots of individual flowers, some form of close-up equipment, such as a macro lens (*see pp.56–9*), is essential. As ever with macro subjects, depth of field is severely limited – and this is compounded by the fact that flowers will move in the slightest breeze, making very long exposures impossible. Use a piece of card or a reflector as a temporary windbreak.

FLORAL CLOSE-UPS

The best all-round solution for close-up photographs of flowers is a macro lens with a focal length of 90mm or more. The diagram below shows the use of a stake and windbreak (which can also double as a reflector) to help keep the flower steady during a close-up shot. The stake can be made of wire or cane. A water sprayer is also on hand.

▲ False dew

Close-ups of flowers, especially roses, often look particularly photogenic after a shower of rain, when their petals are covered with water droplets. You can fake this with water from a hand sprayer.

100mm macro lens, 1/125 sec at f/8 with tripod. ISO 100.

◀ ▲ Finding the right angle

For flowers, camera angles are needed that fill the frame with colour and texture. Climbing may be required for a downward view on the bed (*above*). Alternatively, try lying on the ground or standing in the flowerbed (*left*).

(a) 50mm lens, 1/250 sec at f/8. ISO 100.

(I) 50mm lens, 1/125 sec at f/5.6. ISO 100.

▼ Diffused sunlight

To avoid strong shadows, it is usually preferable to have sunlight that is lightly diffused by cloud. This can also help to soften the colour of bright colour combinations.

85mm lens, 1/125 sec at 1/8. ISO 100.

▲ Backlighting glow

Colourful combinations can look rather brash in the direct light of high noon. Try using backlighting, as here, to soften the effect.

 100mm macro lons, 1/500 sec at f/8, ISO 100.

■ Using structural elements

Avoid taking shots of flowers in isolation.

Putting them in context by using the structural elements of a garden can create a more ordered image from Informal planting schemes

■ 24mm lens, 1/126 cec at f/16 ISU 100.

▲ Telephoto approach

One advantage of using a long lens with a focal length of 90mm for flower close-ups is that plants appear closer together, giving the scene a lush look.

■ 300mm lens, 1/250 sec at f/8. ISO 100.

PROFESSIONAL HINTS

- Actively search out new gardens to visit. Make a note of your favourites and shoot them in different seasons. Remember that gardens are always changing.
- Avoid using flash for close-ups if possible, as results tend to look unreal. Use a faster film or higher ISO setting instead.
- Enquire beforehand whether the garden you are interested in going to allows tripods. Some gardens do not, even though they are open to the public.
- Include hard landscaping in your pictures of flowers – the physical features give a garden its identity.

Animals

Actors are often advised never to work with animals or children. For the photographer, however, these subjects are rewarding and popular – although each requires very different skills. How easy or difficult it is to photograph wildlife depends greatly on the species and its

habitat. The smaller and more timid the fauna, the more careful you will have to be when photographing it – and the more specialist equipment you will need. Fortunately, there are many accessible birds, animals, and insects on which to practise your wildlife skills.

Wildlife

With most species of wildlife, it is not enough to have a long lens. Even with a powerful telephoto, you have to get into the right position, so that the animal is in view and close enough for you to get a good picture. This means that you need some knowledge of the animal's behaviour, a planned viewpoint, and lots of patience (or luck).

Before photographing animals in the wild, hone your skills at wildlife parks, nature reserves, rescue centres, and zoos. Nowadays, not only do these places provide a typical habitat to use as a naturalistic background, but also the photographer has a much clearer view. Viewing platforms, glass, and mesh have replaced bars, but make sure that the wires of the cage, or the glass of the tank, are not in focus. You can do this by getting the lens close to, or even touching, the obstruction. Use the largest aperture available, and the obstruction will disappear from view.

many animals, such as this beautifully marked tree frog, are camouflaged, and this means that they can easily get lost in their surroundings when photographed. For this shot, a wide open telephoto lens was used, so as to create as much distinction as possible between foreground and background.

m 135mm lens, 1/2000 sec at f/2.8. ISO 400.

▲ ▶ On safari

Safari parks provide a good opportunity for photographing animals, as the vehicle provides you with relative safety and a useful hide. You can use a clamp attachment specially designed for use on cars, which you attach to a window (right). An alternative method of steadying the camera is simply to rest the lens on a partially open window.

400mm lens, 1/250 sec at f/5.6. ISO 100.

▲ Safe shooting

Some height and distance are necessary to photograph an animal such as an alligator safely. This one was photographed from an observation platform, in order to get a good view of its head.

200mm lens, 1/250 sec at f/5.6. ISO 200.

CHOOSING EQUIPMENT

- A high-speed continuous shooting mode on a digital SLR can be useful. Some pro models have a low-noise setting, which reduces the risk of the camera shutter sound frightening off the animals.
- A long lens is essential: a minimum of 200mm for large or relatively tame species, and up to 600mm for small birds or dangerous mammals.
- Macro lenses are necessary for smaller creatures, such as insects. Twin-head macro flash or ringflash is useful.
- A portable tripod or monopod is vital for animal portraits.

■ Showing the surroundings

You do not need to zoom in tight for every wild animal picture you shoot. Sometimes it is worthwhile showing the creature's natural habitat as well.

■ 300mm lens, 1/1000 sec at f/11. ISO 100.

▼ Waiting for a pose

Even in captivity, you still have to be patient and wait for the animals to move to the right spot, or to make the right sort of pose. Munkeys, however, are known for being natural performers, so it did not take long to get this characteristic portrait.

 $\,$ $\,$ 200mm lens, 1/250 sec at f/5.6. ISO 200.

Birds

Although birds are often easier to spot in the wild than mammals, their size means that they are not necessarily easier to photograph. When they are in trees, the contrast in the lighting is too low to get a good shot, but when they are in flight against a bright sky, the contrast in the composition can be too great.

Attract birds into the back garden with suitable food. This will help you maintain some control over their position. Try to make sure that they are close to a window or shed, so you can photograph them and, at the same time, ensure there is a complementary backdrop (or one that can be thrown out of focus).

Permanent hides in conservation areas and parks give you access to a range of species – and to those who can help identify the targets. However, these hides are often a distance away from the animals, making a lens of 500–600mm necessary. A teleconverter could be used with a shorter telephoto, but either way a solid tripod is essential.

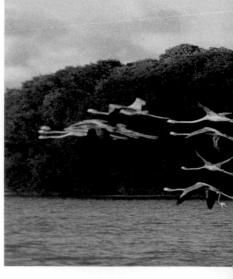

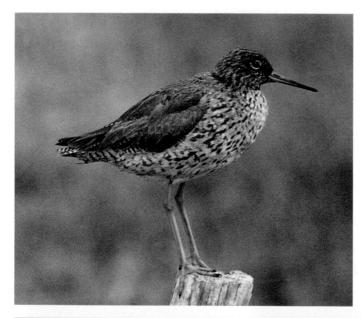

▲ Using a hide

You can buy simple tent hides that are portable and can be erected close to where birds feed or nest. The birds will soon become accustomed to the presence of the hide.

■ Regular spot

Birds often land in the same places every day. Once you identify these spots, you can set up your hide and prefocus on them — as was done for shooting this redshank.

400mm lens, 1/500 sec at 1/5.6 with tripod, ISO 200.

▲ On display

Country shows often give demonstrations of falconry, which provide an ideal opportunity to take portraits of birds that you will rarely see in the wild.

200mm lens, 1/250 sec at f/5.6. ISO 100.

▲ Getting close to the subject

Some birds are not wary of humans, and it is possible to get close enough to take photographs of them even without a long telephoto lens – as for this shot of a swan and her cygnets swimming in a park lake.

■ 100mm lens, 1/500 sec at f/5.6. ISO 100.

▲ Taking flight

This picture of flamingos was taken in Mexico. They are tremendously timid birds, and will take flight as soon as a human comes close to them in the water. With this in mind, and shooting from a moving boat, a fast shutter speed became even more essential than usual.

200mm lens, 1/2000 sec at f/5.6. ISO 200.

◆ Photogenic bird

Some birds are much more approachable than officers. Robins are known for landing close to gardeners – and as such are useful, photogenic, subjects to practise your skills on.

200mm lens, 1/500 sec at f/5.6. ISO 200.

USING HIGH-SPEED FLASH

To photograph birds in flight, you often need to find their nest and set up a camera with flash to catch them as they come and go. You can use a triggering device, where the bird itself fires the camera by breaking a beam of light.

▶ Bird in flight

For this shot of a barn owl (far right), two flash units were set up in the outbuilding where it lived, as shown in the diagram (right). The pictures were shot in the late evening as the owl came and went with food. The flash freezes the bird in mid-air with an effective exposure of 1/1000 sec.

■ 150mm lens, 1/60 sec at f/8 with tripod and long cable release. ISO 100.

Pets

In comparison with photographing animals in the wild, where you cannot choose the setting and where the animals are likely to run away, a domesticated animal should be simple. However much you think you are in control, though, the pet may not do exactly what you want. The owner of the animal, or another family member if it is your own pet, is an asset. Many pets will respond to a familiar voice or known commands, and move to the right spot or in the right direction. Favourite titbits are also worth having for bribery and reward.

Pets are particularly rewarding subjects to photograph in the studio. They rarely seem to mind the flash, and the brief burst of illumination freezes any movement. If you place the subject on a table, with a plain background, the owner can stand at the side keeping the animal on its spot. However well behaved it is, the animal will not stand still for long, so you must have everything prepared before you start – and then shoot quickly.

All pets have favourite places. This dog likes to watch the world through a hole in the fence. Once you know a pet's habits, you can set up an opportunity to grab a quick shot.

200mm lens, 1/250 sec at f/4.5. ISO 200.

▲ Emphasizing shadow

The duckling in this shot did not keep still – but could soon be put back into shot when he wandered off. This was simply shot on a special still-life table with a single diffused sidelight, as shown in the diagram (*left*). The table's reflective surface emphasizes the subject's shadow.

■ 100mm lens, 1/125 sec at f/11 with flash. ISO 100.

◀ ▲ Full body and close-up

When photographing a prized pet for its owner, try and shoot pictures that show the whole body of the animal, as well as a close-up of the face. Get the owner to stand just out of shot and give instructions to the dog.

120mm lens, 1/60 sec at f/11. ISO 50.

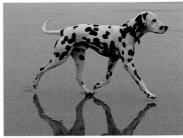

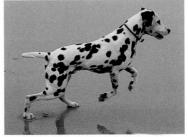

▲ Continuous drive

It is worth using the continuous motorwind to capture a dog, such as this Dalmatian, at play - this allows you to concentrate on framing the panned sequence of shots.

m 135mm lens, 1/125 sec at f/5.6. ISO 200.

▲ In a frame

This beautifully shaped window made a natural compositional frame (see pp. 184-5) for this equine portrait.

■ 90mm lens, 1/250 sec at f/8. ISO 100.

Choose a plain, neutral background for cat portraits so that the colour and texture of the fur show up well.

■ 80mm lens, 1/60 sec at f/8 with flash. ISO 50.

Sport

Sport is far from being the most straightforward of subjects to shoot. You can rarely get as close as you want, the target is continually moving, and it is easy to miss the crucial moment.

However, there are plenty of techniques to help you succeed in getting that great shot – and although every sport is different, the techniques can be applied to a wide variety of different sports. Sports photography involves a lot of anticipation – knowing which line the bikes will take, and sensing when a goal is going to be scored, for instance. Because of this, when you start, it will be helpful to practise your skills on those sports that are most familiar to you.

Freezing the action

Top shutter speeds are essential for capturing many sports. With the briefest of exposures, you can freeze even fast subjects in their tracks – and keep them looking sharp in your pictures. The exact shutter speed you need depends not only on the speed of the subject but also on how it appears in the viewfinder. Therefore the direction of the subject and its magnification are also crucial (*see pp.98–9*).

If a racing car fills the frame rather than just occupying a small part of it, you need a faster shutter speed. Similarly, you need a faster speed if the car is crossing the frame, rather than heading towards the camera.

CHOOSING EQUIPMENT

- Use a digital SLR with a high-speed continuous shooting mode of at least 5 frames per second. Larger format cameras are too cumbersome.

 A lens with 300mm focal length will give enough magnification for most sports; a zoom with a range of around 100–300mm would be ideal. Choose a lens with the widest maximum aperture at the 300mm setting that you can afford. Professional sports photographers tend to use a 300mm f/2.8 (see pp.50–1) fixed-length telephoto.
- A monopod not only gives extra stability to long lenses but also, unlike a tripod, allows a great deal of manoeuvrability.
- If you are using a film camera, a second camera body allows you to carry on shooting immediately when you reach the end of a roll.

▲ Forward movement

As the subject is heading towards the camera, you may be able to use a slower shutter speed than if it were moving across the frame. However, if you want the hooves sharp, you will have to allow for this.

300mm lens, 1/2000 sec at f/4. ISO 200.

▲ Retreating movement

A super-fast shutter speed is not essential for this shot, as the main direction of movement is away from the camera. A 1/250 sec was necessary to avoid camera shake with the 300mm lens setting.

m 300mm lens, 1/250 sec at f/5. ISO 100.

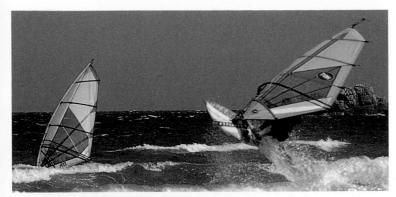

■ Distant subject

You are usually restricted to taking surfing and sailboarding shots from the beach, so choose a long telephoto lens with a focal length of 500mm or more. Catching the boards in mid-air is more about anticipation than shutter speed.

600mm lens, 1/1000 sec at 1/5.6. ISO 100.

▼ Crossing the frame

Shot from the speedboat, the waterskier is moving diagonally across the frame. The shutter speed is fast enough to catch him on film crisply, but the water spray is slightly blurred.

■ 135mm lens, 1/500 sec at f/5.6. ISO 100.

▲ Water spray

A shutter speed of 1/1000 sec is not only fast enough to catch the swimmer in mid-stroke in this outdoor pool, it also manages to freeze the droplets of water that are thrown up by his arm. These sunlit white points help to give a feeling of movement to the picture.

■ 200mm lens, 1/1000 sec at f/5.6. ISO 100.

PROFESSIONAL HINTS

- When starting out, avoid major sporting fixtures as it will be impossible to get close enough to the action or to change vantage points.
- Practise with smaller amateur matches and races, where it is possible to move around easily, and where you do not have thousands of spectators to contend with.
 In sports photography, a wide aperture is often more essential than the resulting fast shutter speed, because a wide aperture ensures that grandstands, crowds of spectators, and other distracting background features stay as out of focus as possible.

Impression of movement

One difficulty in showing a moving subject as a static picture is that the subject can look static, particularly if fast shutter speeds are used. The sports photographer, therefore, needs to use indirect ways of showing that the subject was moving when the shot was taken. One solution is to use a slower shutter speed. A bit of blur caused by movement across the image area during exposure suggests movement. However, this needs to be done with care. Too little blur, and the effect can look like a mistake; too much blur, and the subject may be unrecognizable.

Adding blur selectively to the image can work well. Panning is widely used in sports photography for this reason (*see pp.100–1*). How sharp the subject appears against the blurred backdrop depends on the exact shutter speed, how smooth the panning is, and the eccentricity of the movement. With a panned car, for instance, everything can look sharp except the revolving wheels.

► Hint of movement

The shutter speed used for this shot has completely frozen the main body of the aircraft and its pilot. It is the blurred blades, however, that provide that vital feeling of movement, and stop the picture from looking like a scale model.

400mm lens, 1/2000 sec at f/5.6. ISO 100.

◀ ▲ Following a target

This is a classic panning shot. By tracking the subject as it passes the camera (*left*), the central part of the frame looks reasonably sharp, while the blurred background (*above*) suggests that the subject is moving fast.

 135mm lens, 1/60 sec at f/8, ISO 100.

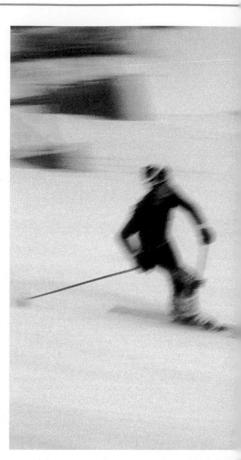

Abstract impression Constitution Abstract impression Constitution Abstract impression Constitution Constituti

Sometimes a very slow shutter speed can produce a picture that, although not a good record shot, produces a powerful feeling of speed. This panned shot of a skier in poor visibility, in which the skier and background are equally blurred, has an abstract quality to it.

200mm lens, 1/15 sec at f/5.6. ISO 100.

A greyhound at full pelt is moving so fast that even with the fastest available shutter speed it would not be possible to capture the subject sharply. Panning is an essential part of the approach – even if it has only a minimal effect on the background.

■ 300mm lens, 1/2000 sec at f/5.6. ISO 100.

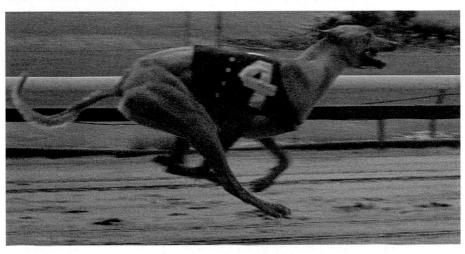

▼ Balanced approach

This panned shot of a water-skier streaks the background and turns the water spray into an indistinct white blur. There is a tremendous impression of speed, but the skier remains recognizable.

■ 80mm lens, 1/30 sec at f/11. ISO 100.

▼ Creating movement

The great advantage of zoom bursts in sports photography (see pp.100–1) is that they can give a strong feeling of action to a relatively static composition, as in this shot of a girl learning to skate.

■ 28-105mm zoom lens, 1/15 sec at f/11. ISO 200.

PROFESSIONAL HINTS

■ When panning, start to track the subject well before you take the shot, and continue after the shot is taken. This will help to keep the movement smooth.

Panning has the added advantage of helping to blur unsympathetic backgrounds, such as advertising hoardings, which may be impossible to hide using aperture alone.

■ Slow shutter speed effects are rewarding with a digital camera because you can see the exact impact of the speed you set after each exposure.

Dynamic framing

Composition is vital to the success of sports pictures. For example, catching the moment in a rugby match when the wing dodges the last defender to get the try is only the start – since the impact will be lost if the background is too distracting and the framing too loose.

Good composition can also help to create the feeling of drama that can sometimes be so hard to capture in a still photograph. By using diagonals in the framing to create maximum impact, movement is suggested even when the subject has been frozen by a fast shutter speed.

Find a shot where the subject creates a strong diagonal by finding the right viewpoint: a sprinter accelerating from the blocks will seem to lean forwards at 45 degrees to the bottom of the frame if shot from side on.

▲ Filling the frame

It is possible for subjects to create stronger diagonals within the frame just by altering the camera's viewpoint. In the shot above, the hanglider creates a strong angled line to fill the 35mm frame well. In the more straight-on composition (*left*), the resulting picture is less dramatic.

200mm lens, 1/1000 sec at 1/4. ISO 200.

▼ Leaning over

As speed skaters go around corners, they lean into the bends so far that they touch the ice with their hands. From the right vantage point, this makes a good dynamic composition that highlights their skill and speed.

300mm lens, 1/250 sec at f/4. ISO 400.

▲ Diagonal smoke trail

Smoke is used by stunt parachutists to make their demonstrations more visually appealing and to help spectators locate them in the sky. Here, the trail creates a strong diagonal line that leads the eye to the subject.

300mm lens, 1/1000 sec at f/5.6. ISO 200.

◆ At an angle

Caught at a perfect 45-degree angle, this well-timed shot creates an action-packed impression of the sport of land yachting.

■ 300mm lens, 1/2000 sec at f/4. ISO 100.

PROFESSIONAL HINTS

- Aerial shots allow you to turn the camera to any angle without the picture looking unnatural. Bridges make excellent vantage points for sports such as rowing.
- Use diagonal framing when there is a lot of action — you will be able to fill the frame more fully.
- Sometimes you can deliberately tilt the camera to create a more dynamic composition (known as a Dutch Tilt in the movie industry). Rotate the camera so the effect looks obvious, rather than a mistake.

Peak of the action

Although a lot of sports photography is about conveying speed, in many sports the best moments occur when the subject is not moving at all. These moments – the peak of the action – can make the most impressive pictures.

One classic example of this is when a skateboarder leaps in the air – for the first part of the move, they are heading quickly upwards, and at the end of the jump they are accelerating downwards. In the middle, at the precise moment when they get to the highest point in the move, they are moving neither up nor down. For a split second, the laws of physics tell us the boarder is stationary.

This, of course, is the perfect time to take the picture. There is a broad range of shutter speed settings to choose from to create a sharp image. In theory, at least, you may choose to use a shutter speed that just avoids camera shake, since you do not have to worry about subject movement. Spotting and anticipating these moments are all part of getting to know a sport.

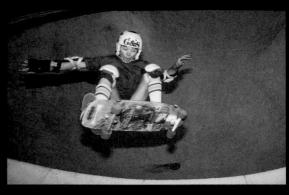

▲ Moment of suspension

Here, at the turn of the movement, the skateboarder appears suspended in mid-air. Flash has been used to brighten the vivid colours, freeze the image, and darken the neutral background.

■ 28mm lens, 1/125 sec at f/11 with flash, ISO 200.

▼ Almost immobile

The one moment during the pole vault when the athlete is almost stationary is at the precise moment when he or she negotiates the bar at the top of the climb.

■ 50mm lens, 1/250 sec at f/8. ISO 100.

▲ Moment of least movement Here, the moment has been captured when the skateboarder is at the slowest part of his move. The image is sharp and crisp.

■ 28mm lens, 1/250 sec at f/8. ISO 200.

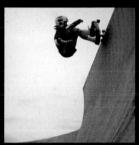

▲ Top of the movement

This shot shows the moment when the skateboarder reaches the top of his move, and also nicely shows the layout of the ramp.

■ 28mm lens, 1/250 sec at t/8. ISO 200.

◄ Turning point

A perfect example of catching the peak of the action is this shot of a goalie in a friendly soccer match. He has reached the top of his jump and is motionless in mid-air but the ball is still moving.

■ 135mm lens, 1/125 sec at f/8. ISO 50.

PROFESSIONAL HINTS

- Although there is no vertical movement when a subject is caught at its peak, there may still be movement of some other kind. The high jumper will be moving forwards, for example, so this must be allowed for.
- Some classic peak-of-theaction shots are set pieces within the sport — so there is plenty of warning that they are about to happen.

Prefocusing

With fast-moving subjects, there is no time to fiddle around with the camera's controls when a picture presents itself. You have to be ready and waiting with the camera switched on, the exposure set correctly, and your finger on the shutter.

One way of improving your success rate with action subjects is to focus the lens before the subject comes into view. Rather than focusing on the subject, focus on a point through which you know the subject will pass – the finishing post, for instance, or a corner of the track. When the subject passes this point, press the shutter – secure in the knowledge that the picture will be sharp.

This technique is useful for those with either autofocus cameras or manual-focus SLRs. Some autofocus systems are too slow and it is impossible to adjust the lens quickly enough by hand. Even if you have predictive autofocus, which can adjust to anticipate the fastest-moving subjects, you may find that this prefocusing technique is a more reliable way of getting the picture you want.

▲ Focusing in lowlight

Focusing can be difficult in lowlight conditions, whether done manually or automatically. In this gymnastics shot, the camera was carefully focused on the front parallel bar before the routine began.

m 70mm lens, 1/125 sec at f/4 with flash. ISO 200.

▲ Perfect timing

When prefocusing, it is essential to press the shutter at the right moment. An SLR camera can take a quarter of a second between firing and the exposure being made – so it is important to allow for this delay when shooting fastmoving subjects.

■ 200mm lens, 1/1000 sec at f/5.6.

► In mid-air

Although there was no physical object on which to prefocus the lens for this mid-air shot, there was a point slightly downhill from the mound the snowboarders used for making their jumps. Focusing on this, it was possible to take a whole series of shots without readjusting the lens.

70mm lens, 1/1000 sec at f/8. ISO 100.

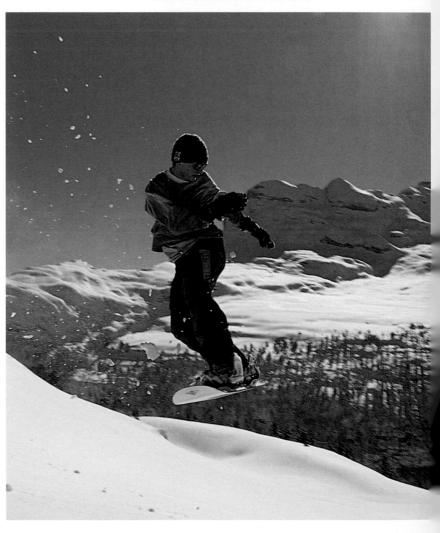

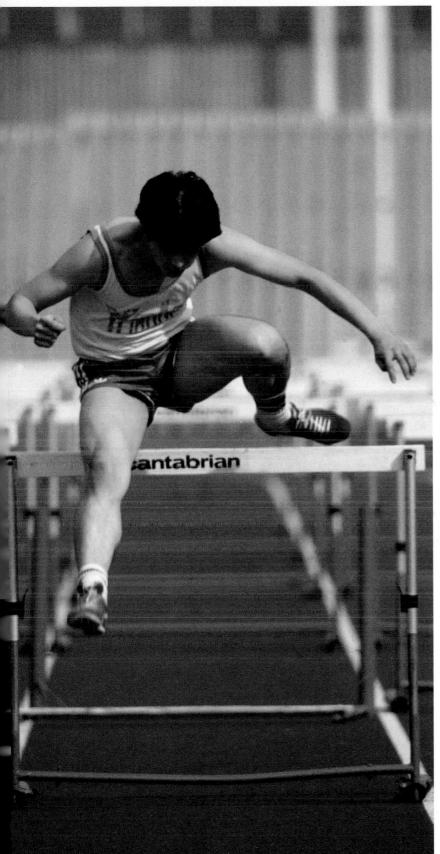

▲ Waiting by the fence

To get a sharp picture of this hurdler, it was necessary to focus manually on the hurdle before the athlete even got near it, then release the shutter as he jumped. The bar of the hurdle provided a precise point on which to focus (above).

300mm lens, 1/1000 sec at f/2.8. ISO 100.

PROFESSIONAL HINTS

- If you have an autofocus camera, you should ideally switch to manual focus to prefocus on a chosen spot. Even after the autofocus has been switched off, many models will still confirm that the camera is correctly focused on this spot.
- If your camera does not have a manual focus option, you can still lock the focus on the target area before the subject arrives. The focus lock is usually engaged by pressing down the shutter button halfway, and keeping it there (see p.72).

Wide approaches

One of the main reasons why amateurs are disappointed with their sports photographs is because their lenses are not long enough. Compact cameras or even SLRs with zooms usually have too great an angle of view – and the subject ends up little more than a speck in the frame. Great sport shots are usually those where the frame is packed full of action – and for that a long telephoto lens is generally preferred.

However, with some action subjects it is possible to get close enough to the competitors to use a lens shorter than 200mm – without getting in their way or putting yourself and your equipment at risk. One example of this is cycling, where competitors pass within a pace or two of the spectators. In addition, when taking a wide-angle shot like this, a flash can be used to great advantage to brighten up the colours on a dull day, and to make the main exposure much shorter than the actual shutter speed used.

Using a wide-angle lens occasionally can make a pleasant, revealing change from close-ups. It allows you to show the whole sporting spectacle – including stadium, spectators, and surroundings – not just the individual competitor.

▲ Seen from below

With the cooperation of an athlete during a practice session, it is possible to use a wide-angle lens to get unusual low-angle shots of events such as the pole vault and high jump.

50mm lens, 1/250 sec at 1/8, ISO 100.

■ Capturing the thrill

Generally it is better to avoid the subject appearing as just a speck within the frame. However, in this case, the wide framing helps to show what abseiling is all about – giving a great sense of its thrill, as well as portraying the spectacular landscape.

■ 35mm lens, 1/250 sec at f/8, ISO 100,

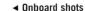

With the limited space on board a yacht, a wide-angle lens is essential. But even on the calmest of days, try to ensure that the camera is protected against the salt spray.

m 35mm lens, 1/2000 sec at f/16. ISO 100.

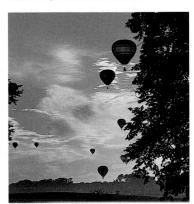

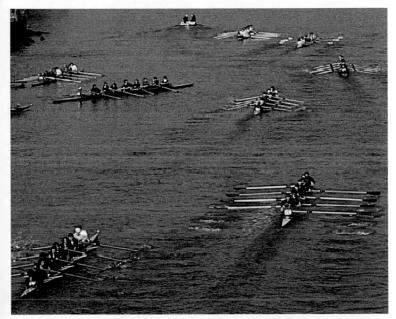

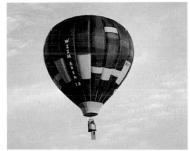

▲ Panorama or close-up

A close-up shot of a balloon (above) makes a good picture, but a panoramic shot (top) gives a more accurate portrayal of a balloon fiesta.

- $_{\mbox{\scriptsize III}}$ (t) 35mm lens, 1/500 sec at f/8. ISO 200.
- ≡ (a) 200mm iens, 1/500 sec at 1/5.6. ISO 100.

✓ view from a bridge

Regattas are not just about individual boats — this wide shot gives an idea of the full activity on a river during a rowing contest.

■ 50mm lens, 1/250 sec at f/5.6. ISO 100.

◆ Demonstrating teamwork

Here, a wide-angle lens shows not only the setting but also the teamwork involved in the sport of curling, where each competitor uses a broom to guide the stones across the ice.

■ 35mm lens, 1/1000 sec at f/11. ISO 100.

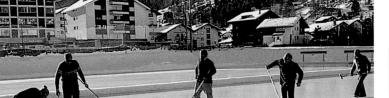

PROFESSIONAL HINTS

If you have two camera bodies, put the one with the telephoto zoom on a monopod, and the one fitted with a standard zoom around your neck. You will then be ready for a wide-angle shot as soon as it happens.
 Alternatively, carry around a point-and-shoot compact, kept ready for these occasional non-telephoto moments.

Catching the expression

There is a saying in sport that it is not the winning that counts, but the taking part. Whether a world champion is trying to regain a title, or a school child is trying to win his or her first medal, sport is about effort and emotion, and it is crucial that the photographer keeps sight of this. A portfolio of superb pictures not only shows the chosen sport beautifully but also tells us something about the competitors themselves. Sport is all about people – their sweat, their frustration, their tears, and their triumph. That is why it is often worthwhile to stop paying attention to what the sportspeople are actually doing and to concentrate on their facial expressions. It is here that you will really see what they are thinking and how they are feeling.

▲ A champion's pain

This portrait of the Hawaiian sumo legend Konishiki, aka The Dumptruck, not only shows how much larger he was than most sumo wrestlers, but also shows his pained expression.

100mm lens, 1/30 sec at f/2.8. ISQ 200.

■ Ready for action

This American footballer's expression shows that he is psyched up and ready for the game. Such shots give an insight into competitors' feelings.

200mm lens, 1/250 sec at f/4. ISO 100.

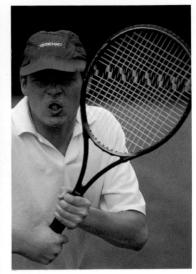

▲ Aggressive stance

Pre-match posturing allows you to take photographs that catch the competitive character of the player.

m 200mm lens, 1/200 and at f/4. ISO 200.

■ Moment of triumph

This fantastic shot shows the elation UII the rugby player's mud-covered face as he touches the ball down for a try.

m 300mm lens, 1/250 sec at f/4. ISO 400.

▼ Feeling the strain

We can see the size of the weights, but it is the pained expression on the lifter's face that tells the real story of his efforts.

■ 120mm lēlis, 1/60 poc at f/11. ISO 50.

◆ Preparing for a portrait

In the studio, a sportsperson has time to arrange himself the way he wants. This bodybuilder spent ages pumping himself up before his picture was taken – but his chosen pose and facial expression are reflective. Sidelighting was used to accentuate his muscles, which were oiled to further exaggerate the highlights.

120mm lens, 1/60 sec at f/8. ISO 50.

PROFESSIONAL HINTS

- Use a telephoto lens with a focal length of around 200mm, as you would with candid portraiture.
- Use a longer lens than usual if players are competing on a pitch in which case a teleconverter will also be useful.
- \blacksquare If possible, focus on the eyes if these look sharp, then so will the whole picture.

Picking a vantage point

The real advantage that professional photographers have over the average spectator is not their cameras, with the fast 300mm lenses and the eight-frames-per-second motordrives, or the other equipment, but the different vantage points they have available to them. Accredited professionals at big sporting events are either given the best seats or are allowed to roam freely. The ticket-buying beginner may be restricted to taking shots from one seat (if allowed to use a camera at all).

This is why it is best to start off with smaller competitions, or with minority sports, where amateur photographers may get a full choice of viewpoints. A friendly word with a local club may well gain you access to training sessions or to privileged viewpoints (such as the waterskier's speedboat or the team's dug-out). An offer to let them have copies of your pictures for publicity purposes will frequently help you to gain the cooperation you seek.

▼ Ringside view

The only really successful camera position for wrestling or boxing contests is at ringside. This gives an unobstructed view of the fight (below). Buy a less expensive ticket and the action is always going to be at least partially obscured by the ropes (left).

■ 35mm lens, 1/250 sec at f/4. ISO 100.

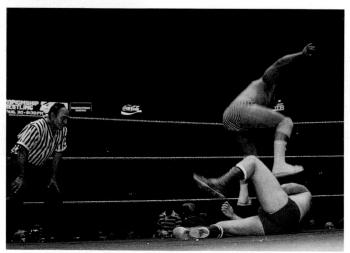

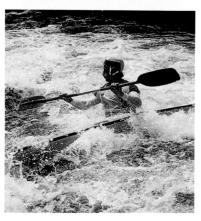

◆ ► Effects of height

Look for different camera positions that allow you to shoot the subject from different heights. Standing by the bank gives a view of the canoeist framed against the surf (*left*). A bridge, on the other hand, gives a very different aerial view of the event (*right*).

- (I) 200mm lens, 1/1000 sec at f/4. ISO 200.
- (r) 50mm lens, 1/1000 sec at f/4. ISO 200.

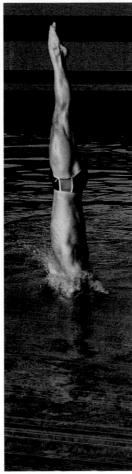

▲ ► Unusual view

Look for vantage points that will give you unusual views of your coort. The shot of the high diver taken from poolside catches this faultless entry perfectly, but the shot taken from the observation window, showing the underwater view, is more unusual.

- (t) 135mm lens, 1/250 sec at f/2.8. ISO 200.
- (r) 50mm lens, 1/60 sec at f/1.4. ISO 100.

PROFESSIONAL HINTS

- If in doubt, always ask marshals and officials if a particular vantage point is safe, and make sure that you and your equipment will not interfere with the competition.
- When watching your favourite sports on television, note where professional photographers sit. This will give you ideas as to the best places to position yourself when shooting less prestigious events.
- Look out for viewpoints where the backgrounds are not distracting, or where they are far enough behind where the subject will be to be thrown well out of focus.
- Arrive at an event early so that you can explore the ground for the best position, and so set up before the event takes place. Good spots soon get taken by spectators and other photographers.

The studio

Although the number of subjects that can be tackled successfully indoors is limited, the advantage of studio photography over a location shoot is that you have much more control over

the result. Most significantly, a studio allows the photographer absolute control over the lighting, background, and setting. The size of a studio depends on what you intend to shoot.

Building a studio

A huge area, or expensive equipment, is not necessary for a home studio. A small still-life set-up can be arranged on a table top, and may even be lit with a couple of desk lamps, if you use black-and-white film. But to tackle the widest range of subjects, proper lighting control (*see pp.338–9*) and a reasonable amount of space are essential.

There needs to be enough room between the subject and the camera for a suitable lens to be used. Space behind the subject is essential for the backdrop, and at the sides, out of camera view, for lights to be arranged. Windows give the option of natural lighting. They should have curtains or blinds, so the room can be darkened when necessary.

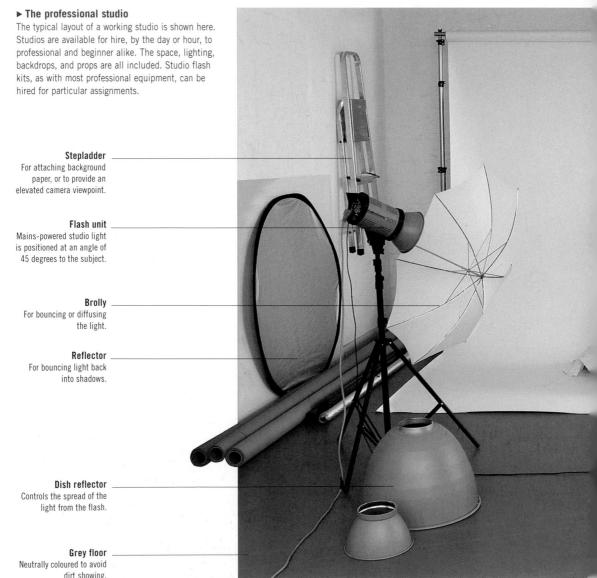

USING A FLASH METER

Unlike portable dedicated flashguns, studio flash units are not controlled by the camera - so exposure has to be set manually by the photographer. The synchronization speed of the camera defines the shutter speed, so it is only the aperture that is usually important. This can be measured using a special meter which can react fast enough to the brief duration of flash. Flash meters can also be used to take ambient light readings. and some can be used to assess colour temperature (see pp.136-7).

Flash meter

◄ Incident reading

An incident reading from a flash meter was useful in this portrait - avoiding metering problems from the black jumper and pale backdrop. The meter fires the flash directly, giving a readout of the aperture needed. If this aperture is unsuitable, the flash power can be adjusted.

■ 120mm lens, 1/60 sec at f/8. ISO 50.

Subject on table

A height-adjustable table is useful fui small subjects.

Camera and tripod

A tripod locks the camera in position while the composition and lighting are adjusted.

Neutral wall

Black, grey, or white walls avoid colour casts from reflected light. White also acts as a reflector.

Background paper

Paper is rolled down under the subject to form a seamless foreground and background (see pp.272-3).

Make up mirror

For shooting portraits, essential for models to adjust hair and make-up.

Snoot

Fits over the lighting head and funnels light into a narrow beam.

Make-up table

For cosmetics, hair accessuries, and brushes when shooting portraits.

Lighting stand

Can be lowered and raised to adjust the direction of the lighting.

Flash meter

For accurate assessment of exposure.

Power pack

For plugging in large lighting units.

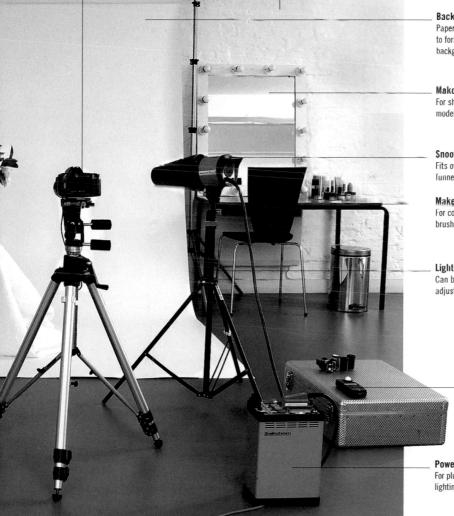

Lighting control

angle will vary upon the design - but typically

gives a 60-90-degree spread.

Studio lights should be as powerful as possible. Much of the power of a flash head is deliberately dissipated, as it is bounced or diffused to give the right quality of lighting. It is also essential that the smallest apertures are available, as depth of field frequently needs to be maximized. The power of the flash is measured in joules (watts per second); this quantifies how much energy the capacitors can store, rather than how much light is actually transmitted. A small unit would typically have a rating of 200–300 joules. The largest units might have a maximum

output of several thousand joules. Direct conversions from joules to traditional guide numbers (*see pp.166–7*) are not possible – however, a 250-joule head would typically have a guide number of 45–60 (m/ISO 100).

To see the quantity and quality of light used, a studio flash unit usually has a modelling lamp. This tungsten bulb allows you to see the lighting effect and to spot problem shadows and highlights. Both modelling light and flash output should be variable, so that the relative effect of each light can be seen when two or more heads are used.

spread of light. Barn doors are used in

conjunction with a dish reflector.

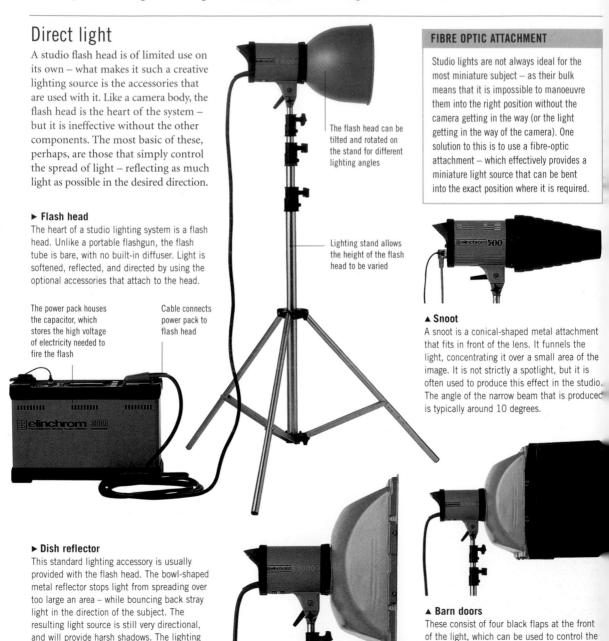

POWER PACK

The power pack provides basic controls and connections for the flash heads that run off it. These include the ability to dump stored power by firing the flash (needed when lowering flash output). Individual controls for the flash output and modelling light are on the head itself.

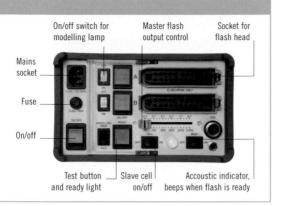

FRESNEL LENS

■ A fresnel lens turns a flash head into a spotlight. The spread of the light can be altered, so that the beam is focused on a point. It is often used with gobos — masks that project a shadow pattern on the scene. ■ Giant softboxes use more than one flash head and are known as "light banks". The largest light banks are designed for big subjects — such as motor vehicles — which may need a dozen or more flash heads. They need special rigging so that their weight can be supported and manoeuvred.

Diffused light

When shooting outdoors, it may be necessary to wait for cloud to diffuse the sunlight, or take advantage of buildings to bounce light into the shadows, but in the studio the softness and harshness of the illumination are completely controlled by the photographer. A bare studio flash is a particularly harsh, direct light source – even when used with dish reflectors – and so frequently needs to be diffused or bounced to get the quality of light required.

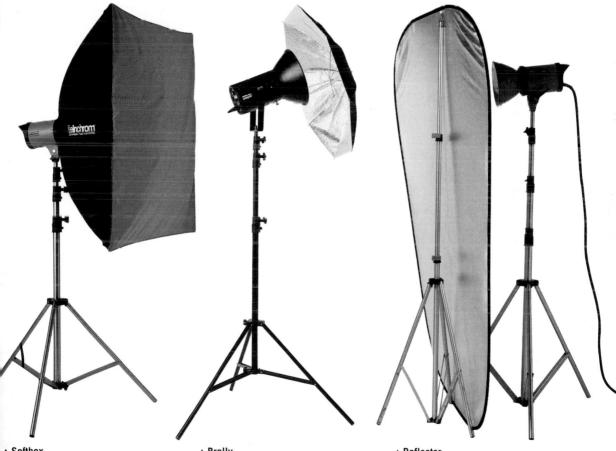

▲ Softbox

This tent-like, dome-shaped structure fits over the flash head. The material used for the sides is generally silvered on the inside, so that all the light is reflected forwards. At the front is a large, rectangular expanse of white diffusing material, which substantially softens the light. The larger the softbox, the wider the spread of light and the more diffuse the effect.

▲ Brolly

Brollies are usually reflectors. The flash bounces back, greatly diffused, off the brolly. Different colours are used: white is neutral; gold gives a warm glow; silver is brighter and less diffuse. Coverage is changed by altering the distance between the light and the reflector. Translucent brollies are used as diffusers, with the head pointing towards the subject.

▲ Reflector

This is used to control shadow density. One or more reflectors are usually placed on the opposite side of the subject from the flash light to provide fill-in to soften contrast. Reflectors can also be used as a surface to bounce the flash light off. Shop-bought portable reflectors can be used, but it is possible to make your own (see pp.270–1).

Atmospheric effects

In a photographic studio, a wide range of weather conditions and other natural effects can be achieved artificially. Rain can easily be produced in the studio (*see pp.304*–5). Other effects generators can be bought or borrowed that create mist, fog, smoke, or cobwebs. For smoke effects, ordinary cigarette smoke is often all that is necessary, especially if combined with backlighting;

however, special smoke pellets are also available when a greater quantity of smoke is required. These should be burnt in a suitable non-flammable dish.

One of the most common atmospheric effects machines used in photography is a wind generator. A gust of wind will make clothes and hair come alive – which is particularly useful in fashion shots.

Smoke effects

Used by professional photographers, the smoke generator — which might alternatively be required to suggest mist or fog — burns a liquid substance to produce smoke in a controlled environment. The liquid itself is usually a solution of glycol or glycerol, and takes just a couple of minutes to warm up in the mains-powered machine. The equipment can be hired from theatrical effects specialists. The skill lies in getting the right quantity of smoke in the frame — and in the right parts of the image. It is all too easy to have either not enough smoke or to obscure the subject completely.

▼ Simple smoke effect

An ordinary cigarette can provide enough smoke to be seen clearly in a photograph, particularly if the effect is controlled by the model. Here, the smoke is backlit by a spotlight behind the model's head, with a second light positioned slightly to the right of the camera, providing the main illumination for the portrait.

■ 120mm lens, 1/60 sec at f/16 with flash. ISO 100.

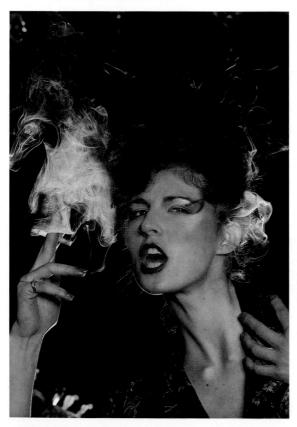

Subtle use of smoke - suggesting mist

Moderate amount of smoke - suggesting clouds

Heavy use of smoke - suggesting dense fog

▲ Taking shots through smoke

Smoke machines do not give you complete control over their output. You must watch carefully to capture the exact moment when there is just enough smoke, and take plenty of shots to get the effect that you want. This sequence shows that it is easy to produce too much smoke.

120mm lens, 1/60 sec at 1/11 with flash, ISO 100.

On film sets, wind machines using jet engines can create gale-force gusts. For the photographer, such power is rarely needed. Fans can be hired, and petrol-powered versions for use on location are particularly useful. However, a household fan normally suffices — providing enough puff to make hair, scarves, and so on blow across the frame. For close-up shots, even a handheld hairdryer will sometimes do.

► Simple wind effect

Although you cannot see the wind, you can see its effect. In this shot, a portable electric fan, designed for domestic use, was put on full blast, and a series of shots were taken to catch the model's blonde hair blowing across her face.

120mm lens, 1/60 sec at f/11 with flash. ISO 100.

Cobweb effect

Resembling an electric fan, and fitting to an ordinary electric drill, a cobweb generator is used with a latex-based liquid, which is spun in the machine to give extremely realistic cobwebs in seconds. Be warned, however: the best effects are created with freshly spun cobwebs, so you should be ready to take the shot as soon as you have applied them. They may also leave a deposit on any materials they come into contact with; in some cases, this can be impossible to remove.

▼ Setting up the shot

To create this tongue-in-cheek depiction of the legal profession, the set was quickly covered in latex web – but clearing up the mess afterwards took much longer. For small sets, spray-on cobweb aerosols can be bought.

50mm lens, 1/60 sec at f/11 with flash. ISO 100.

Projected backdrops

Using a projector, it is possible to create almost any background. Your model can be transported to a tropical beach or any other location, placed against an abstract image of your own design, or juxtaposed with any object, animal, or person. All that is required is a simple slide or digital image that can be projected on to a screen at the back of the studio, while the subject is photographed, and separately lit, in front of it.

Projected backdrops, which are used extensively in the film industry, present the photographer with the problem of how to light the subject without casting either light or shadows on the screen behind.

A projector can sometimes create a shadow. The simple way of avoiding this is to place it to the side of the subject, so that it illuminates the screen from an angle. The problem with this technique is that the picture will be severely distorted, because the projector is not square on to the screen. A clever way around this is to project the image on to the screen from straight on, and rephotograph it from the position you will later want to place the slide projector. Use the same focal length lens on the camera as used by your projector. Process the slide, and then reverse the positions of the projector and camera. The picture will appear without distortion.

Projected pattern

A projector is not only useful for providing backdrops, it can also be used as a way of projecting pattern and colour over the subject itself. Think of the projector as a spotlight (*see* Fresnel Lens, *p.339*). Instead of using gobos and filters, the light from the projector is transformed using transparencies. The image (as with a spotlight's fresnel lens) can be focused, or left unsharp, depending on the effect required.

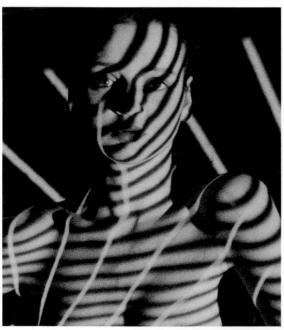

▲ ► Projected pattern

The elaborate shadow pattern was provided by a section of a slide projected at the model. The straight lines of the grid are distorted by the curves of the model's body. The colour balance of the projector's bulb may need filtration and tungsten film for accurate results with slide film.

120mm lens, 1/8 sec at f/5.6 with tripod. ISO 160.

Front projection

The professional solution to projecting backdrops is to use a front projection unit. This is a specially designed slide projector, a camera mount, and a semi-silvered mirror. The lenses of the camera and projector are perfectly aligned, so that any shadow cast by the projector is completely hidden by the subject. These units can be rented, or found at hire studios. A high-reflectance screen should be used.

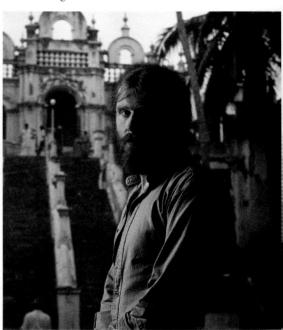

▲ ► Quick scenery change

A front projection unit allows the seamless alignment of projector and camera, and, once set up, backgrounds can be changed simply by swapping slides, allowing a range of portraits to be taken in a very short space of time. This shot was taken with a Hensel FrontPro Vario Compact.

120mm, 1/15 sec at f/8. ISO 100.

Back projection

One of the simplest solutions, if you have a long enough room, is to use back projection. For this, a translucent screen is used and the projector is placed on the other side of the screen from the subject. Special back projection screens are available from AV specialists, but one can be easily fashioned using tracing paper or a frosted acetate. Sidelighting is normally used for the subject, as this makes it easier to avoid flash light falling on the projected backdrop.

▼ Careful lighting

With back or front projection, it is essential to minimize the amount of subject lighting reaching the screen. For this sequence, precise sidelighting was provided using barndoors, and a large black screen blocked any stray light.

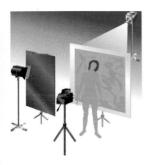

▲ Lighting effect

In order for the background to look roalistic, lighting must be perfectly matched to the correct colour temperature for the subject and background image. However, this is not necessary if the intention is to deliberately create a moody atmosphere using a false backdrop. Here, the mysterious blue monotone background suits the sequence of portraits perfectly.

80mm lens, 1/15 sec at f/5.6 with tripod. ISO 160.

DIGITAL BACKDROP

The background image does not have to be taken from a slide — it is possible to use a bright video or data projector; these use LCD technology to create a projectable image. A digital backdrop allows the use of a wider range of material, including digital image files, and creates a more lifelike, 3D effect.

▶ Digital images

This shot was taken using an LCD projector, with the image of the cathedral provided directly in digital form from a laptop computer. Used in back projection set-ups, LCD projectors are ideal for creating large-scale backgrounds.

80mm lens, 1/15 sec at f/8 with tripod. ISO 100.

Specialist techniques

Specialist camera equipment and techniques, including digital technology, have applications in areas as diverse as medicine, defence, and security. Medical practitioners, for example, use different types of photography for a range of diagnostic purposes, including X-rays, endoscopy, and ultrasound, while the armed forces rely heavily on aerial and satellite photography.

There is a wide range of equipment and techniques available that can give most photographers the capability of tackling all the subjects they will ever shoot, but there are also areas of photography that require specialist skills and equipment. Those that are more likely to appeal to the keen photographer include underwater work, shooting the night sky, and using large-format equipment.

Underwater photography

Photographing underwater demands specialist equipment, since the camera must not only be completely waterproof but also be able to withstand the pressure exerted by tons of water. This pressure increases the deeper you dive, and while some cameras can be used to depths of 100m (300ft) or more, many can be used down to only 2m (6ft 6in).

Underwater cameras need not be expensive. Fully waterproof disposable cameras are available for use while snorkelling or in a pool, and reusable compact models can be found at affordable prices. Even sophisticated models tend to use a compact design for ease of use.

Protective underwater housings are available for most types of camera, including SLRs and digital cameras.

Although discontinued, the Nikonos camera is the only dedicated underwater model with interchangeable lenses – and it is still widely used by serious divers.

LIGHT ABSORPTION IN WATER

Underwater photographs often look blue because some wavelengths of light are absorbed more efficiently by water than others. Red light is the first to disappear underwater, and the last colour to be absorbed is blue. At depths of 30m (100ft) or more, most natural light has been absorbed, so you will need to use artificial light. Brightness is also reduced by the water's surface, particularly if the surface is rough.

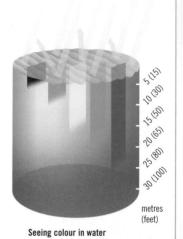

CHOOSING EQUIPMENT

Underwater cameras are designed to be easy to use — as it is hard to make fiddly adjustments when diving. A direct-view viewfinder is used for composing pictures, but a gunsight-like target attached to the top of the camera is often easier to use when composing underwater shots.

Waterproof digital compact

Compact waterproof housing

▲ Background colour

Objects underwater vary in colour, texture, and brightness, so choose a background for your subject that will highlight its qualities. A close-up shot, such as the one above, shows the shape of the fins.

■ 35mm lens with extension tube, 1/60 sec at f/11, ISO 200.

▼ ► Underwater enlargement

Objects appear larger than life underwater; the focal length of the lens is a third longer than on land, turning a wide-angle into a standard lens. Underwater housings have a domed glass port in front of the lens to compensate.

■ 35mm lens, 1/125 sec at f/4. ISO 200.

Left: apparent enlarged size. Right: real size.

▲ Back scatter

Millions of particles suspended in the water reflect the light from an on-camera flash, giving a hazy picture. To minimize this effect, use an off-camera flash so that the subject is lit at 45 degrees from the top or the side.

50mm lens, 1/60 sec at f/8 with flash. ISO 200.

PROFESSIONAL HINTS

- Observe safety procedures obtain a recognized diving qualification before trying scuba photography, and never dive alone.
- The camera's 0-ring rubber seals must be checked before each dive. Oil them according to the maker's instructions to ensure free movement of mechanical parts.
- For general views, shoot upwards towards the surface, rather than down.
- For underwater shots, take double exposures, combining, for instance, a close-up with a general view of a wreck.
- Soak underwater cameras in fresh water after use to remove traces of salt.

Astrophotography

Pictures of planets, nebulae, and open clusters can be taken with relative ease — as long as a powerful enough telescope is used to see these objects clearly. Many modern telescopes are computer-guided and automatically fix on the most interesting sights on a clear night, if they are calibrated by the positions of the brightest stars. Most telescopes allow the eyepiece to be swapped for an adaptor, so that a digital or film camera can be attached.

Bright objects, such as Saturn and Neptune, make excellent subjects if you have limited experience of night-time photography because they allow you to use relatively short exposures. For dimmer subjects, you need to take into account the apparent movement of the stars. To counteract this, so that long exposures lasting minutes rather than seconds can be used, the telescope must be fitted with a motorized equatorial drive. Long exposures can reveal phenomena that are not visible to the eye, even with a telescope.

CHOOSING EQUIPMENT

A powerful telescope is required for astrophotography. A budget model may have only an equivalent 35mm focal length of 300mm — which is then magnified using eyepieces. Howevever, the eyepieces are removed in order to fit the camera. The telescope shown here has a focal length equivalent to 2000mm, with a fixed aperture of f/100.

The moon

Due to an optical illusion, the moon appears larger to the human eye than it is in reality. To get a decent-sized image of the moon, a powerful telephoto lens is needed. On a 35mm camera, a 1000mm lens will give an image of just over 9mm (1/3in) in diameter; a 2000mm lens will give an image of about 18mm (23in) across. For most cameras, a powerful teleconverter (*see pp.48*–9) will be necessary to achieve these magnifications. To avoid blurred images caused by the moon's movement, the exposure should not last more than a few seconds.

▲ Photographing the moon

Although a full moon looks more photogenic, the lunar craters are more visible at its partial stages. The clarity of the image is highly dependent upon the atmospheric conditions.

■ 1000mm lens, 1/30 sec at f/8. ISO 200.

▲ Landscape by moonlight

Sometimes you may want to include the moon in a landscape, rather than photograph it directly. A full moon will illuminate a landscape without any additional lighting but a long exposure may be necessary.

■ 35mm lens, 1min at f/5.6 with tripod. ISO 200.

▲ Lunar eclipse

For a shot that fills this much of the frame, you need a huge telephoto lens. Here a 500mm lens was combined with a 2x teleconverter. The orange colour is created by light spill during a total lunar eclipse.

■ 1000mm lens, 1/8 sec at f/8 with tripod. ISO 400.

Star trails

To shoot star trails, the only equipment needed is a solid tripod and a camera with a B or T setting. Over time, stars appear to move in a circle, revolving around the North Star – with one revolution taking 23 hours and 56 minutes. To get an exposure where each star moves through 10 degrees, which gives a reasonable impression of movement, an exposure of 40 minutes is needed. Longer exposures will give correspondingly longer trails. With digital SLRs it is usual to take a succession of images lasting 3–5 minutes each, due to power constraints, then merge them together on a computer to make long light trails.

▲ Trails of light

For this shot, the camera was set up on a solid tripod, and locked open for 40 minutes using the B (bulb) setting. The stars are more colourful and numerous than would be seen with the naked eye.

■ 50mm lens, 40 mins at f/4, using B setting and tripod. ISO 200.

CELESTIAL EVENTS

Although the night sky remains relatively constant — with gradual variation produced by the phases of the moon, the seasonal tilting of the earth, and the movement of the planets — there are periodically more dramatic events. Eclipses, transits, comets, and meterorite showers occur more frequently than most people realize. However, their impact on the observer will depend on clear skies and location. Many, including lunar and solar eclipses, do not require a telescope — but a powerful telephoto is needed for frame-filling images.

The "diamond ring" effect Totality

Total eclipse with the solar corona

Total solar eclipse

These three shots show the different stages of a total eclipse of the sun, when the moon blocks the sun's rays. Special filters must always be used when viewing or photographing the sun – except during the few moments of totality, when the filtration needs to be removed from the camera,

■ 500mm lens with 2x teleconverter, 1/125—1/500 sec at f/8 with tripod. ISO 100.

Comet

From time to time, comets become visible in the night sky over several days. The most spectacular do not need high magnification. A long exposure in total darkness will reveal an even clearer tail than is visible to the human eve.

■ 200mm lens, 10 mins at f/5.6. ISO 200.

Copying techniques

Photography is not always about taking original images – it is also a useful way of copying existing pictures and artwork. Although the subject cannot move, and there is no depth of field to worry about, photographing a flat subject can still require special techniques.

Most types of camera can be used for copy, or "rostrum", photography, as it is usually known, although close-up capability is often critical. A digital camera can

be particularly useful as a low-cost colour photocopier. It allows you to keep visual records of diagrams, plans, and even text that you may need to refer to at a later date.

The key to making good copies of artwork is even lighting. This can be provided using a specialist copystand, but it is possible to make do with daylight or artificial lighting, as long as you avoid all reflections and shadows on the surface of the object that is being photographed.

Copystand

A copystand facilitates the mounting of a camera to a stable column, so that the distance between the lens and the item on the baseboard or rostrum can be altered. This varies the magnification while ensuring the camera remains parallel to the artwork. Even lighting is provided by a pair of lights, mounted at 45 degrees to the artwork to eliminate reflections.

▲ Slight relief

A coin is not completely flat, and lighting must therefore be adapted to help show the surface detail. A single sidelight helps to throw the embossed surface into relief.

■ 100mm macro lens, 1/60 sec at f/8. ISO 100.

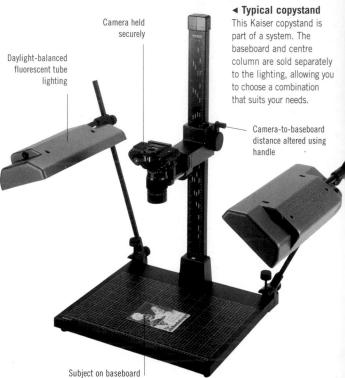

IMPROVISING A COPYSTAND

It is not essential to go out and buy a copystand, as this can be an expensive piece of equipment that many photographers would require only infrequently. It is possible to improvise a copystand at home using a tripod and two desk lamps placed on either side to provide even lighting. The tripod must be one that allows the camera to be positioned so that it is pointing straight down and therefore parallel to the artwork.

► Repeat prints

An improvised copystand can be useful for rephotographing favourite prints if the negatives have been mislaid.

▲ Testing the light

Test the evenness of the lighting before you shoot. Place a pen or pencil at right angles to the baseboard. Put the lights in place and check that shadows fall evenly in length and intensity on either side of the pencil.

MAKING INSURANCE RECORDS

In the event of having to make an insurance claim after a robbery, fire, or natural disaster, it may be necessary to provide proof of the valuables in question. It is worth spending an hour photographing personal treasures so that a visual record exists, should the worst happen. Close-up shots of more valuable items can also aid the authorities for theft recovery purposes. Keep the pictures, or digital files, in a separate location from the valuables themselves, so that in a worst-case scenario of a fire, these records remain safe.

▶ Heirloom

A stolen or destroyed teapot is hard to describe, let alone value. A good photograph can significantly speed up insurance claims, and aid the police.

m 100mm macro lens, 1/60 sec at f/11 with flash. ISO 100

Using the wall as a rostrum

When photographing a print, piece of paper, or painting, a good method is to mount it on a wall using adhesive putty, keeping the artwork as flat as possible. In an evenly lit room, additional light may not be necessary, but it can be provided by two lamps at 45 degrees to the wall on either side of the camera. The advantage of using a wall as a rostrum is that a tripod can be used to keep the camera completely stable.

➤ ▼ Avoiding reflections

When shooting framed pictures, ensure that any glass over the surface does not reflect the camera. One solution is to surround the camera setup with a sheet of black card, cutting a hole for the lens.

100mm macro lons, 1/15 sec at f/5.6 with tripod, ISO 100,

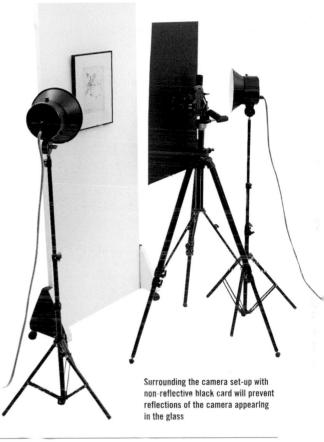

picture is often reflective, which makes it difficult to photograph

Slide copying

The glass in a framed

There are a number of different ways to copy transparencies. If a macro lens or close-up accessories offering life-size reproduction are available, simply rephotograph the slide positioned on a daylight-balanced lightbox, carefully masking around the slide with black card or cloth to avoid flare. However, it is also possible to buy purpose-built solutions.

One method is to use 35mm slide copiers, which are available for most 35mm SLRs and many digital cameras. Light can be provided by pointing the whole set-up towards a bright, white cloud, or by using diffused flash. Many bellows systems for SLR cameras have purpose-built slide holders for copying work.

Slides can also be copied on to negative film, providing a low-cost method of obtaining colour (or black-and-white) prints from favourite shots. To obtain copy slides, use special duplicating film, as this will avoid problems with excessive contrast.

▲ Slide copier

This has a built-in fixed-focus lens that fits directly to either the camera body or the camera's built-in zoom lens. At the end of the attachment is a holder for the slide, and a diffusing window that ensures even backlighting.

Large-format cameras

Large-format cameras have an established place in modern photography, despite the fact that it is not a common sight to see people out on the streets today using them. In this digital age, the idea of someone using a huge camera that looks as if it were designed over 100 years ago, and using a black sheet over their heads to check and focus the image, may seem ridiculous. However, these cameras are still widely used by professionals, and by commercial and advertising photographers in particular, for the size and quality of their results. The sheer size of

the film used is the immediate advantage of large format, but this is not the only benefit. Large-format cameras may not have autofocus, motorwinds, superfast shutter speeds, intelligent metering, or even the automatic exposure that other types of camera have, but they provide a degree of control over the final image that is rarely available with cameras using other formats. Both film plane and lens plane can typically be tilted, rotated, and moved up and down, giving a tremendous degree of management over perspective and depth of field (*see pp.352–3*).

Large-format camera design

A typical large-format camera has a lens mounted on a board, which clips into a support called the front standard. At the back of the camera is a similar rear standard, which supports the viewing screen. This shows the image upside down, and needs to be viewed in dim light – hence the need for a hood (although image-inverting finders are available for some models). In between the two standards is a bellows, which allows the standards to move forwards and backwards to alter focus and magnification. Both standards can also usually be moved vertically and horizontally, as well as being capable of being rotated on both axes (*see pp.352–3*). The amount of movement actually possible may be restricted by the design of the bellows (sometimes "bag bellows" or double bellows are used to maximize movements), and by the coverage area of the lens being used.

▶ Sheet-film camera

Relying on mechanics rather than electronics, large-format cameras can be bought surprisingly cheaply, especially when compared to the price of other professional-quality cameras.

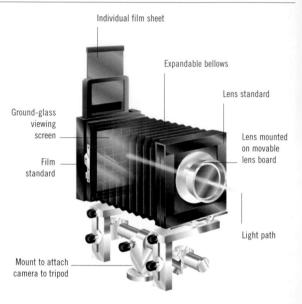

The size advantage

The first, and most obvious, appeal of large-format cameras is the image quality that the cameras can provide. The size of the film used typically measures 5 x 4in (12.5 x 10cm), but some cameras can even use 5 x 7in (12.5 x 18cm) or 10×8 in (25 x 20cm) sheet film. For a company wanting to advertise its products on billboards, this extra quality can be essential; for a big company producing an annual report, the cost and time needed to commission large-format pictures is a very small price to pay in comparison to the total expenditure and effort put into producing a first-class result.

► Billboard enlargement

This is typical of the type of shot that is taken using large-format cameras in the commercial world. An advertising agency wants a picture of a museum exhibit for a poster campaign. The subject needs to be photographed in the studio to give careful control of lighting. Large format gives the benefit of complete control over depth of field and distortion. The image can be enlarged to billboard size without noticeable loss of detail.

210mm lens, 1/60 sec at f/11 with tripod and studio lighting. ISO 100.

Original image

Image enlarged for advertising hoarding

Types of large-format camera

There are two types of large-format camera: the field and monorail. The field, or technical, camera is the more portable of the two. The lens can be completely pushed back into the body, and the base folded up to produce a camera system that can be carried around with relative ease. The monorail camera is designed primarily for studio work, and provides a wider range and degree of camera movement than the field camera.

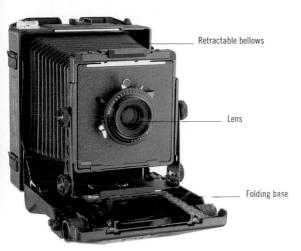

▲ Field camera

The field camera folds up into a less bulky piece of equipment than the monorail camera, making it ideal for location use. Some models even have rangefinder focusing, avoiding the need to have a ground-glass focusing screen, which must be viewed in lowlight.

► The monorail camera

This type of large-format camera uses a modular design. The front standard, which supports the long and shutter, and the rear standard, which houses the focusing screen and film back, are supported on a rail. In between the two standards stretches a bellows unit.

EXPOSURE METERING

All large-format cameras are manual only: shutter speed and aperture are set by hand. The shutter is either built into the lens or sited behind it on the front standard. Metering is not standard, but metering backs that provide a probe to take exposure readings at the film plane are occasionally used. A handheld meter, in conjunction with Polaroid instant proofing film (see below), is more often used to obtain correct exposure.

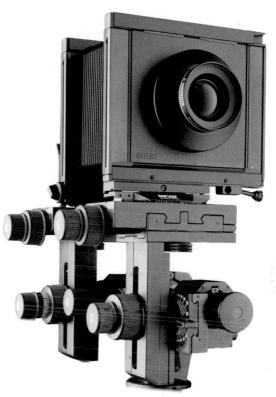

Film for large-format cameras

The film for large-format cameras normally has to be loaded into special holders in total darkness, one sheet at a time. The picture is framed and focused using the focusing screen, which is strategically placed at the film plane. This is sprung backwards slightly to accommodate the film holder when a picture is to be taken (so you lose sight of the subject). The

cover of the film holder, the dark slide, must be removed before each exposure, and then replaced, so that the film is kept in darkness until processed. A typical film holder is double-sided, so can accommodate two sheets of film (and two dark slides). Some models have medium-format backs available that can use 120 roll film.

▲ Film holder

Transparency film in 5×4 in format is available from Fuji, which comes pre-loaded in its own throwaway holder and dark slide, made from card. This is loaded one sheet at a time into a special film holder, or into some types of 5×4 in Polaroid backs.

▲ Polaroid film holder

Polaroid produces 5 x 4in instant proofing films, which can produce colour, black-and-white, or sepia-toned prints. The film is used in a purpose-built holder and is helpful for checking composition, lighting, and exposure (see pp.128–9).

▲ Digital back

Digital backs are available for many largeformat cameras, and are generally linked direct to a laptop to provide both preview and recording facilities, as they do not have their own memory store or LCD screen. They usually scan the image line by line.

Camera movements

In most cameras, the lens and the image on the sensor or film remain permanently parallel to, and directly in line with, each other. This is such a fundamental part of camera design that we accept the distortions this arrangement brings. We also accept that subjects at different distances cannot be critically sharp at the same time. But on monorail or field cameras, the lens and digital or film back are designed to move independently (*see pp.350–1*). These movements let the photographer minimize and exaggerate perspective, and create a range of distortions in the picture. Such cameras are ideal for, for example, architecture, advertising product shots, and food photography.

There are three types of camera movement: shifts, swings, and tilts. These can be applied independently to the front and back of the camera, singly or in combination, so a huge variety of effects is possible. As well as playing around with perspective, depth of field can be controlled. By careful movement of the lens and image planes, the photographer can keep a surface that stretches away from the camera, and that is not parallel to the image, completely in focus even when using the widest of apertures. Alternatively, depth of field can be reduced to almost nothing while using the smallest apertures and widest lenses.

▲ The starting point

When the movements on a monorail camera are at zero, both standards (at the front and back of the camera) are centred and parallel.

▲ No movement

providing a far greater area of coverage than is needed

for the image area. The amount of movement depends

on the lens used and the type of bellows. With the right

equipment, the effect can be maximized by shifting the

front and rear standards in opposite directions. Shifting the

lens up produces a similar effect to moving the back down.

This view of the reference cube is the same as it would be with a normal SLR camera.

Shift movements

A shift movement is when the lens and/or the image plane is moved up, down, or sideways, so that the front and back of the camera are out of direct alignment with each other. It alters the field of view. Shift the front of the camera up, and the image moves downwards in the frame, useful for photographing architecture. The effect relies on the lens

Side view

Being able to shift the lens or back up or down, independently of each other, allows you to include objects that are otherwise out of frame without having to tilt the camera. Limited front rise and fall effects are provided by shift lenses (see pp.54–5), but large-format cameras usually offer far greater movement.

Moving the lens or image planes left or right, and independently of each other, has some useful applications. It allows you to shoot the subject from a side-on view without having to rotate the camera, while still achieving a straight-on view. This can be used to avoid reflections of the camera in a mirror (see pp.54–5).

Shift up

Image is dropped down

Shift down

Image is raised

Side shift

Image is moved sideways

▲ Rising front

Also known as shift up, this lets you shoot tall subjects, such as skyscrapers, from a low viewpoint. You can keep the top of the subject in view without having to tilt the camera, so avoiding converging verticals. Dropping the rear of the camera (falling back) achieves a similar effect, but the two are not identical, as moving the lens alters the viewpoint slightly.

▲ Drop front

Also known as shift down, this lets you photograph subjects from a high viewpoint, and keep in view the bottom of the subject without tilting the camera, thereby avoiding converging verticals. A similar effect is achieved by raising the rear of the camera (rising back); again, the two are not identical due to slight differences in the lens viewpoint.

▲ Cross front

Also known as side shift, this can be used to shoot around foreground obstructions. Parallel lines can also be made to appear to converge towards a point at the side of the frame, rather than dead centre. Moving the front to the right has almost the identical effect to moving the rear to the left, while moving the front left has a similar effect to moving the rear right.

Swing movements

The lens or image planes pivot independently of each other, swung around on a vertical axis. Back swing movements correct or create image distortions. Front swing movements are most commonly used in conjunction with back swings to maximize or minimize depth of field (see The Scheimpflug Principle below).

Top view

◆ Distorting the view

Swings twist the lens or image plane. The amount of movement depends on the type of camera. Field cameras offer fewer rear swing movements than monorail models because of their box-like baseboard design. Some mediumformat cameras offer a degree of swing control.

▲ Front swing

Camera movement Shape not significantly altered

Camera movement

Camera movement

Image is distorted

This alters the coverage of the lens, and so the shape of the image, and tilts the plane of sharp focus. It is combined with shift movements to extend their range, or with back swing to manipulate focus and depth of field.

▲ Left back swing

This radically distorts the shape of the image. The right side of the subject is closer to the image plane, so this side appears larger. The left side of the subject, meanwhile, seems smaller than in its unaltered state.

▲ Right back swing

Again the subject is distorted, with the lefthand side appearing closer to the camera than the right-hand side. These back swing effects can be useful for exaggerating perspective stretching subjects in interesting ways.

Tilt movements

The lens or the image planes are pivoted independently in the horizontal axis. Tilt movements are a type of swing. Back tilts correct or create image distortions. Front tilts, used with back tilts, maximize or minimize depth of field (see The Scheimpflug Principle below).

Side view

■ Tilting

Tilt movements are essentially the same as swing movements (and are sometimes called swings). The amount of control available depends on the type of camera - baseboard models typically offer limited rear tilt movement compared to monorail designs.

Shape not significantly altered

Camera movement

Top of cube appears larger

Camera movement

Front of cube appears larger

Camera movement ▲ Front tilt

This alters the coverage of the lens but, more importantly, changes the angle of the plane of sharp focus - the top of the cube becomes sharper, while the front becomes more blurred.

▲ Rear tilt forwards

This distorts the shape of the subject and changes the angle of the plane of sharp focus. It could be used as a way of making a studio subject appear taller than it is in reality.

▲ Rear tilt back

This again radically alters the shape of the image. This movement could be used to make a table seem longer, while at the same time making its legs appear perfectly parallel.

THE SCHEIMPFLUG PRINCIPLE

While swings and tilts can change the plane of focus in a shot, using these movements on their own can lead to image distortion, or to darkening at the corners of the picture. To minimize these problems, movements are applied in pairs: a swing right to the front is used with a swing left to the rear. For example, when photographing a table at an angle from above, the whole surface is unlikely to be in focus even with the smallest aperture. But, using the Scheimpflug principle (right), the camera can be adjusted so that subject, lens, and image planes all align. This ensures that the whole surface is sharp. Depth of field then extends at right angles below and above this plane (the extent depending on aperture, focal length, and subject distance).

Maximum sharpness

The Scheimpflug rule is used to work out how to adjust a large-format camera to maximize depth of field. When the subject plane (blue), lens plane (red), and image plane (yellow) all meet in a line, the entire subject plane is sharp, whatever the aperture.

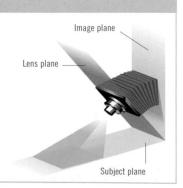

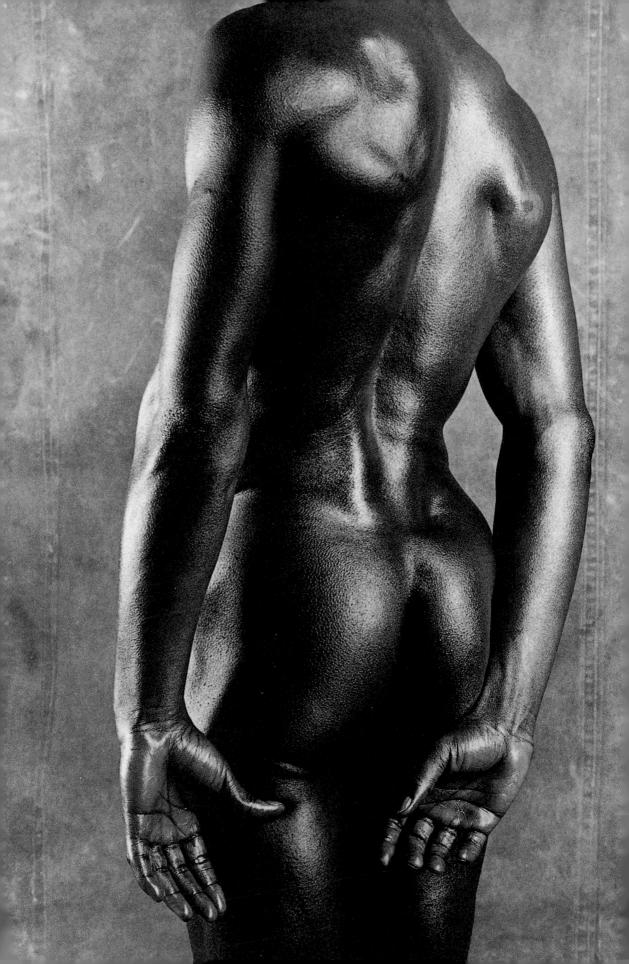

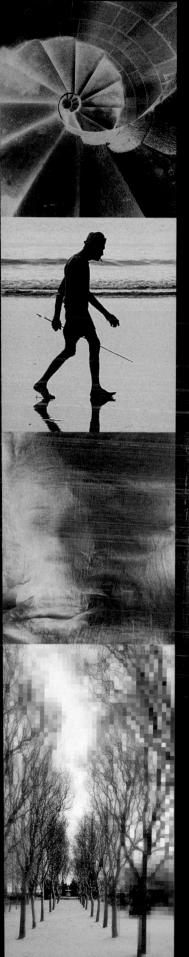

Post production

The camera is only the starting point. It creates an image that can be further crafted and manipulated in a wide variety of ways, using either conventional darkroom methods or digital techniques with a computer.

The darkroom

While the quality of prints and transparencies from commercial laboratories is reliably high, it is satisfying to process and print your own pictures – there is a thrill in seeing your photograph appear on a sheet of paper in a developing dish. For many photographers, the creative processes used in the darkroom are as important, or more

so, than the picture taking, especially with blackand-white film. Developing and processing black-and-white film is more straightforward than colour, and the scope for manipulating and enhancing results under the enlarger is greater. It takes experience to crop the picture and select the exposure and contrast successfully.

Equipping a darkroom

There are essentially two processes to print making: enlarging the negative, and processing the print. These two stages should be carried out in separate areas of the darkroom, so that the chemicals and water are kept apart from negatives, unexposed paper, and the enlarger. Wet (for processing) and dry (for enlarging) areas should ideally be on opposite sides of the room.

All light sources in the darkroom should be operated by pull-cords, since ordinary light switches used with wet hands can be dangerous. Ventilation units should be designed to keep outside light from entering the darkroom.

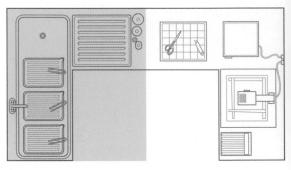

▲ Typical darkroom set-up

In a safe, efficient darkroom the wet bench for processing (shaded blue) is kept well apart from the dry bench for enlarging (yellow).

Wet bench

The wet bench is used for processing films and making prints. Running water is useful, but not essential, in a darkroom. A bucket can be used as temporary wash tank for storing

Wet-bench equipment

processed prints until they are transferred to a sink or bath elsewhere for thorough washing. Chemicals can be mixed here or elsewhere, in trays on the wet bench.

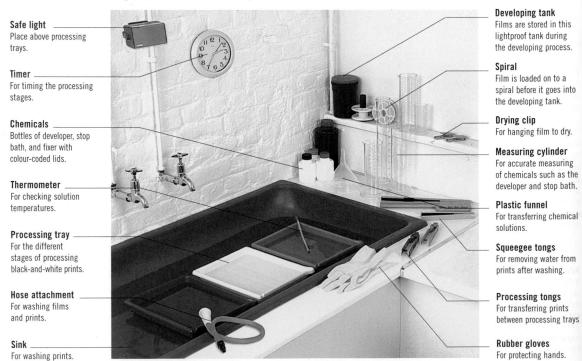

THE BASIC DARKROOM

A darkroom is essential for exposing and developing black-and-white prints. The first requirement is that the room is totally lightproof. If there are windows in the darkroom, they can be covered up effectively with plastic blackout material.

Ideally, you need a room where you can leave equipment out between sessions — and work undisturbed for a number of hours. It must be dust-free, have mains electricity and adequate ventilation. A darkroom should

not be too cold, or too hot, otherwise it will prove difficult to control the temperature of the chemicals. Possible rooms to use are:

- m a loft
- under the stairs
- m a bathroom
- a box room
- m a garage
- a cellar

Alternatively, local colleges and arts centres often hire out darkrooms.

THE BLACKOUT TEST

Even a little light creeping under a door or round a window frame can fog paper and film. To ensure that your darkroom is lightproof, take a scrap of printing paper, put a coin on top of it, and leave it on your work surface for an hour or longer.

The safelight can be left on, as blackand-white processing paper is sensitive only to blue light. When you process the paper, it should be completely white there should be no noticeable circle on it.

Dry bench

The dry bench houses the enlarger and all the equipment needed for enlarging negatives. Ideally, the wall behind the dry bench should be painted black, but this is not always possible, especially if the darkroom doubles as a bedroom. Walls elsewhere in the darkroom can be pale. There should be enough space here to set everything out in an organized way, and to move photographic paper, the printing easel, and the negative carrier around with ease.

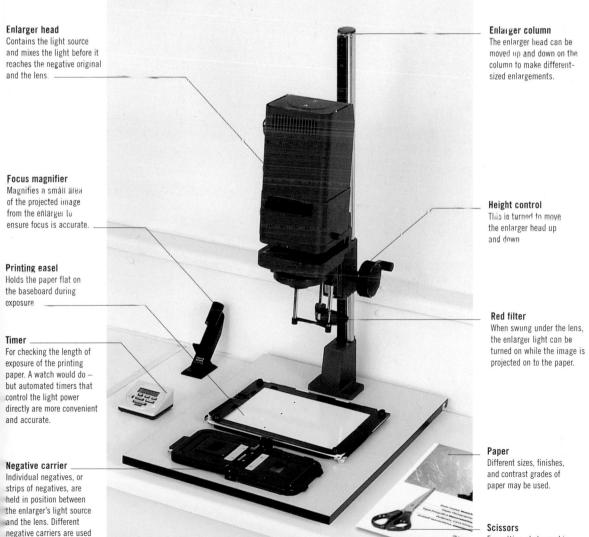

Dry-bench equipment

for different film formats.

For cutting photographic paper for test prints.

Stage 1 — Processing a black-and-white film

The beauty of developing your own black-and-white film is that you do not even need a dedicated darkroom. Much of the developing process can be done in daylight using a traditional film tank. The film must be loaded in total darkness, however, but this can be done in a dark closet, with a lightproof changing bag (*see pp.124*–5), or in a darkroom (*see pp.356*–7).

The chemicals must be diluted with warm water to bring them to the right temperature (usually 20°C/68°F), according to the maker's instructions. They can be mixed and used in daylight, as the film is in a lightproof tank. Most solutions can be reused, so they need to be stored in airtight containers until they are needed again. It is important to dispose of chemicals properly after use.

Loading the film on to the spiral

Familiarize yourself with loading film on to a spiral in total darkness before working with a precious roll of film. Practise using an unwanted roll of film, paying particular attention to how the spiral is loaded, and how the tank is

sealed. Lay everything out on a flat surface where you can find each component by touch. Memorize their positions before switching the lights off. The spiral must be bone dry, otherwise the film will refuse to load properly.

▲ Equipment needed

- Film-developing tank with lid, spiral, and spiral holder
- Cassette opener (or bottle opener)
- Scissors
- Film to be processed

Opening the cassette

In total darkness, open the 35mm cassette using the cassette or bottle opener, and carefully remove the spool of film. You can discard the metal film canister and lid.

Cutting the end of the film

With the scissors, cut off the tapered end of the roll of film so that it is square. Try to cut between the notches, as this will make the next stage easier. Hold the spool of film itself if you have discarded the canister.

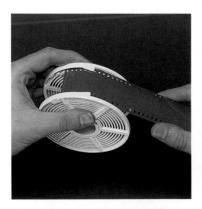

Inserting the film into the spiral

Feel for the two lugs at the entry slot of the reel. Take the end of the film and insert it into the jaws of the plastic spiral until you meet resistance. Try to handle the film at the edges only to avoid damage to the emulsion.

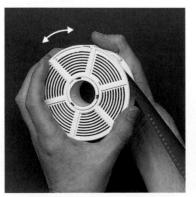

Twisting the spiral

Hold each side of the spiral. Twist each side alternately. This advances the roll of film into the spiral. Continue twisting until the film is completely loaded on to the spiral.

Loading the spiral into the tank

Cut the spool away from the film using the scissors. Load the spiral into the developing tank, and firmly close the lid. As the tank is lightproof, the developing stages can be done with the lights on.

Developing the film

This does not need to be performed in the dark. The chemicals used in film processing must be diluted as stated by the manufacturer, brought to the right temperature, and kept in contact with the film for exactly the right length of time. Be consistent with time and temperature.

Developing colour print and slide films involves essentially the same procedure as developing black-and-white films. However, there are more chemical stages. The working temperature also needs to be much higher – and is therefore harder to maintain during the process.

Equipment needed

- Loaded developing tank
- Developer, stop bath, and fixer
- Marked bottles for diluted chemicals
- Thermometer
- Tray of warm water
- Timer and funnel
- Hose, pegs or clips, squeegee tongs

Mixing the chemicals

Dilute all the chemicals (the developer, stop bath, and fixer) with water, and heat them to the correct working temperature, according to the manufacturer's instructions. Place them in a tray of warm water to help keep them at the correct temperature.

Removing the developer

A few seconds before the end of the development time, swiftly pour the developer into a marked bottle through a funnel. Many developers can be used for several films, on keep a record on the bottle of the number of times you have used it.

/ Pouring in the stop hath

Pour in the diluted stop bath immediately. This ensures that the development process is terminated. Tap the tank and leave for a minute or two, according to the manufaturer's instructions. Pour out and save the stop bath in a marked bottle – this can also be reused a number of times.

Pouring in the developer

tank as recommended for the particular

throughout the development time.

film surface. Put the Cap on and agitato the

developer. Typically, you need to turn the tank

over and back twice at half-minute intervals

Pour in the developer and start the timer.

Tap the tank to release air bubbles from the

Pouring in the fixer

Pour in the diluted fixer. Tap the tank gently to remove air bubbles, and agitate it once every minute. Leave for a few minutes, according to the manufacturer's instructions. Pour out and save the fixer for reuse, as with the developer and stop bath. It is now safe to open the tank.

Washing the film

It is easiest to wash the film – to remove any harmful chemical residues – while it is still on the spiral. The spiral needs to be totally immersed, with a constant flow of water, for at least half an hour. Remove the lid and push the hose well down into the centre of the reel, so that the water overflows steadily from the tank.

Hanging the film to dry

Add wetting solution to the water, according to the manufacturer's instructions, and leave for one minute – this will help to avoid drying marks. Hang the film to dry in a dust-free area, using a weighted peg or clip at the bottom to stop the film curling. Carefully remove excess water with squeegee tongs.

Stage 2 - Print preparation

Before turning negatives into prints, it is necessary to choose an enlarger and photographic paper. The enlarger is an important, and often expensive, piece of hardware and needs to be chosen carefully, depending largely on what type of negatives are likely to be printed.

Some enlargers are available with autofocus. This speeds up the operation, particularly when producing prints at a range of sizes or enlargements, and is also

useful for those with imperfect eyesight. However, if borrowing or renting equipment, it is possible to manage with most types of enlarger.

Different types of photographic paper can affect the result achieved with prints. As well as different surface finishes, some are resin-coated, which are easier to wash, and others are fibre-based, which give more aesthetically pleasing results.

The enlarger

An enlarger is essentially a projector. It houses a light that shines through the negative, producing an image on the baseboard. By raising the head of the enlarger, the distance to the baseboard is increased, allowing the image to be enlarged to the desired size.

Enlargers are available to suit all budgets, but it is vital to think about future needs when deciding which to buy. Some models are suitable for 35mm negatives only, and it might be worth spending a little extra on a multi-format model. Different negative carriers are supplied for each.

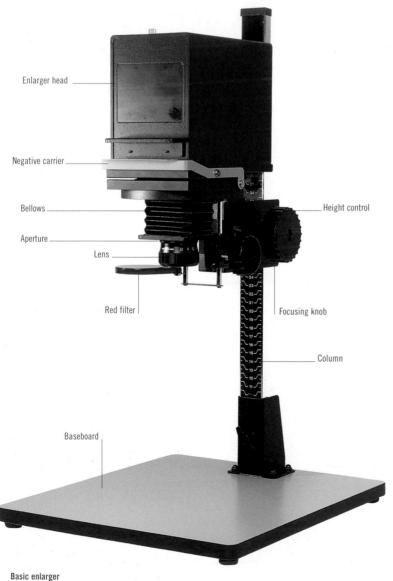

CHOOSING AN ENLARGER AND LENS

Choosing the right head

If you do any colour printing, you will need to use colour filters: the straightforward solution is a head that allows you to dial in the filtration. A colour head can also be used with variable-contrast black-and-white papers. However, many enlarger models are available with variable-contrast filtration heads, specially designed for this type of paper. Simple models often have a filter drawer allowing the use of acetate filters for variable-contrast or colour printing.

Choosing an enlarging lens

The lens forms the light passing through the negative into a sharp image. Many enlargers are sold without lenses, allowing you to pick the lens that best suits your needs and budget. The ideal focal length is the same as the standard focal length for the film format (see pp.56–7). A wider lens produces bigger enlargements on the baseboard. The lens has a number of aperture settings. Use a full aperture when focusing the lens and composing the shot. Stop down the lens by a couple of stops to maximize image quality when making the exposure. Use the smallest aperture settings for dodging and burning (see pp.364–5).

Three-element 50mm f/5.6 enlarging lens

Selecting photographic paper

There is a range of sizes, finishes, and grades of photographic paper. One of the advantages of black-and-white printing is that the contrast of the result can be altered. On a grade 2 piece of paper, there is an average distribution of greys. To create a stronger contrast between whites and blacks, opt for a harder grade of paper – grade 3, 4, or 5. For a softer, less harsh, result, choose grade 1 or grade 0. The grade needed will depend not only on the effect you want to achieve, but also on the density and tonal distribution in the negative.

Grade 5 - very high contrast

Grade 4 - high contrast (hard)

Variable-contrast or multigrade paper removes the need to have packets of differently graded paper. You can use the same paper each time, but change the grade by using a slightly different filter between the light and the negative. Without any filters, variable-contrast paper is grade 2.5.

▼ Changing contrast

Traditionally, the tonal range of the print was altered by using different grades of paper. Now variable-contrast paper with different filtration produces the same results much more simply.

Grade 2.5 - normal contrast

Grade 1 - low contrast (soft)

Making a contact print

The result of processing black-and-white film is negatives, which can be hard to view. Defore choosing which negatives to print, it is usual to make a contact print. The negatives are laid out on a piece of photographic paper and exposed to give a non-enlarged positive image of each frame. A contact print, if done well, not only helps you to view your shots, but also gives an initial guide to the exposure and contrast needed to print each negative properly. The contact print can be kept permanently with the negatives for future reference.

Put the piece of paper in the developer for the recommended time. Using the tongs, transfer the paper to the stop bath, and then to the fixer. Wash the print thoroughly. (See pp.362–3.)

Using the safe light, place the negatives on a piece of 10 x 8in printing paper, with a piece of glass on top to keep them flat, or use a purpose-made contact printer. Ensure that the film emulsion (the concave side) is in contact with the cont

Hang the contact print up to dry, using squeegee tongs to carefully remove any excess water, and weight the end so the paper does not curl. Use the print for detailed inspection only when it is thoroughly dry.

Expose the paper for about 10 seconds under the enlarger's unfiltered light (with the aperture closed down by two stops).

Alternatively, expose the contact print using the room light (actual exposures for both methods will be based on trial and error).

Finished contact sheet

Stage 3 - Making a print

Good print making is all about meticulous detail. Although printing black-and-white negatives is a straightforward process, the procedures need to be followed with scientific vigour to give repeated successful results. It is possible to be haphazard about exposure and processing times and still achieve acceptable results, but good methodology will minimize the amount of time and paper wasted in the darkroom and is important when developing successive prints. Careful procedure will also help you to reprint successful results, and learn from any mistakes.

However tempting it is to take a print out of the developing dish when it looks about the right density, in the long term it pays to let the image develop for the full recommended time. If you rush the fixing process, or skimp on the washing, the prints may become discoloured over time.

Similarly, it is essential to be slavish about removing dust on the negative (and in the darkroom in general). Otherwise, photographs may come out covered in small white blobs, and so be ruined.

Preparing to print

Before you start printing, it is necessary to prepare the chemicals used for processing the paper once it has been exposed under the enlarger. The chemicals are similar to those used for black-and-white film processing.

Equipment needed

- Developer, stop bath, and fixer
- Measuring cylinders
- Storage containers
- Thermometer
- Hot and cold water
- Three processing trays slightly larger than size of prints
- Sink or bucket for print washing
- Tongs and rubber gloves
- Timer
- Photographic paper

▲ Preparing the chemicals

Dilute all the print-processing chemicals, bringing them to their recommended working temperature (usually 20°C/68°F). Pour them into developing dishes in the order that they will be used – developer, then stop bath, then fixer. Have a sink, tray, or bucket filled with water ready for the preliminary washing.

DEEP TANKS

An alternative to processing trays is to use a deep tank. This custom-made piece of processing equipment has different vertical partitions for each of the chemical baths, and a built-in heater to ensure that the temperature is right. Deep tanks are traditionally used for processing colour prints or sheet film, but can also be used for black-and-white paper — some models are designed for this purpose. The chemicals can be left in the tank between sessions.

While trays cannot be used for colour print processing, as this must be done in total darkness, it is possible to use deep tanks. Colour prints can also be processed in lightproof drums that are similar to those used for film processing.

Making a test strip

While exposure meters are available for the enlarger, the amount of time that the negative needs to be projected is traditionally ascertained by trial and error. For economy, a strip of paper is often used, rather than a whole sheet.

Place the test strip under the enlarger, where the image has already been enlarged and focused to produce the size of print, and crop, desired. Position it, with the red filter in place, to cover the important elements of the image. Cover

► Procedure

The sheet (or part sheet) of photographic paper is gradually exposed to the projected image from the enlarger a strip at a time. Each successive strip receives less exposure than the one before.

it with a sheet of paper, and stop down the lens to around f/8. Remove the red filter and turn on the light. Expose the first quarter of the strip for 20 seconds, then move the cover across so that half the paper is now exposed. Ten seconds later, move the paper across so three-quarters is now exposed. After five seconds, move the cover away completely and expose the whole sheet for another five seconds. Each strip has received half as much light as the one before it.

40 secs

20 secs

10 secs

5 secs

▲ Testing exposure

Make a test strip (above) to ascertain the exposure necessary for the print. Once processed and dried, this will give a good indication of the ideal exposure. Further test strips may be necessary to refine your findings.

The printing process

Carry out the printing process in a darkroom with a safe light and running water for the final rinsing.

Equipment needed

- Prepared chemicals in their trays
- Negatives and negative carrier
- Enlarger
- Blower brush for cleaning negatives
- White paper
- Focus finder (optional)
- Printing easel (optional)
- Timer
- Tongs and print-drying clips or rack

Turn on the enlarger, with the lens at full aperture, and with the red filter out of the way. Project the image on to white paper of the same size as the print to be made, or use a printing easel, adjusted to the desired size.

Position a sheet of paper under the enlarger, either using an easel or lining it up with the projected image with the red filter in place.

Remove the red filter, expose the paper for the calculated time, and turn off the enlarger light.

Slide in the print in the same manner as for the developer, agitating the liquid to ensure even chemical action and avoid air bubbles. Leave the print in the fixer for the length of time recommended by manufacturer.

Place the negative in the negative carrier, so that the matt, emulsion side of the film is facing downwards. Then line up the frame you wish to enlarge with the frame of the carrier.

A Now focus the lens so that you can see the grain of the film as charply as possible. A focus finder will allow you to do this more accurately, as it magnifies the image, but this is not essential.

Tilt the dish of developer. Slide in the print as you simultaneously lower the tray, so the developer washes over the whole surface. Gently agitate the dish throughout the recommended time for the print to develop.

Wash the print in running water (store temporarily in a bucket/tray of water if necessary). The length of time required will depend on the paper type. Resin-coated papers require less time than fibre-based ones.

With the room light off and the safelight on, use the light of the enlarger to check the negative and carrier for dust before sliding the carrier into the enlarger. Ensure everything is free of dust, using a blower brush if necessary.

5 Stop down the lens by two or three stops to a working aperture of around f/8. This gives more dopth of field and compensates for the fact that the paper or negative might not be flat, or for any focusing inaccuracies.

When development is complete, drag the print out, so excess developer remains in the dish. Transfer the print to the stop bath. Insert the print into the dish as before. After 10–20 seconds, transfer the print to the fixer.

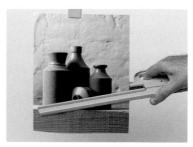

Remove any excess water from the print with scrupulously clean squeegee tongs before hanging it up to dry with clips or in a drying rack. Alternatively, dry prints on a flat surface

Print analysis

While a test strip can tell you the most suitable overall exposure for a print, it may not give the best results for all areas of the image. There is no need for compromise with exposure when black-and-white printing. Different parts of the photograph can be given longer under the enlarger to darken them, while other areas can be given less exposure to make them appear lighter.

Bright highlights in a picture, for example, can be burnt in (given more exposure), to show detail that would otherwise be lost. Burning in is a particularly useful technique for making a sky look darker or for hiding distracting detail. The opposite to burning in, and just as useful, is dodging. In the dodging process, areas of the picture are "held back" so that they receive less light than the rest of the image — making them appear paler than they would otherwise have done in the resulting print.

To give a particular area of the picture more or less exposure than the rest, all you need is your hands. Hold them slightly above the printing paper so that they cast shadows on the surface. Keep your hands constantly moving to avoid creating hard lines on the finished print. For more precise dodging, handmade dodgers may be used (*see opposite*, *below*).

Tools for burning in

As well as using your hands, you can cut masks from black card for burning in. Either cut out square and round "windows" of different sizes or use earlier test prints to provide a particular outline. Often smaller apertures than normal are used, to give more time for providing different areas with different exposures.

Homemade burning tools

▶ Burning in a highlight

In the straight print, a bright highlight bleaches the left of the image and distracts from the subject. Using a mask, this area was given more exposure to make it blend in.

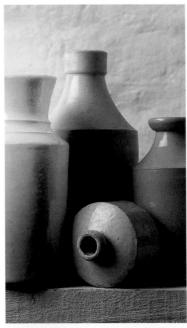

Image bleached at left

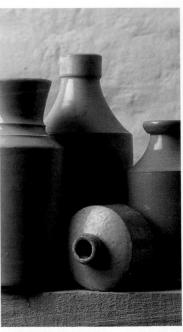

Burning in corrects the fault

▲ Burning in by hand

Restrict the pool of light from the enlarger with your hands, creating a space between your fingers. Keep them near the lens, and keep moving them to give a smooth gradation between differently exposed areas.

▲ Homemade masks for burning in

Masks can be cut to a specific shape to suit a subject area, or a "window" can be used. Move the mask between the enlarger and the paper. Use a small aperture to increase exposure time.

RETOUCHING MANUALLY

However careful you are, prints often show dust marks, hair lines, or even scratches on the negative. These become particularly noticeable the more you enlarge the picture. However, they can be hidden or removed with a little practice.

White specks can be painted in, a dot at a time, using a fine sable brush and black watercolour paint. The effect is less noticeable on non-gloss surfaces, and is much more effective with fibre-based papers. With resin-coated paper, it is necessary to scratch the surface of the print with a scalpel to break the plastic coating, before stippling the paint. Instead of paint, a soft pencil can be used.

Small black specks are removed by using bleach on a cotton bud, or are scratched off with a scalpel. Practise these techniques on a spare, or discarded, print before tackling a valuable picture.

Tools for retouching: black paint, fine brushes, soft pencil and scalpel

Tools for dodging

You can use your hands to block out the light or cut black card to different sizes and shapes and stick it on to wire handles. Homemade dodgers are useful for small areas of a print, such as the eyes in a portrait.

Dodging and burning techniques can be combined with filtration changes with variable-contrast paper to selectively alter contrast within the image.

Homemade dodging tools

► Combining techniques

The background is too prominent if the whole image is printed at grade 5. To solve this, use grade 2.5, then hold back the background while the still life is given more exposure at grade 5.

Background competes for attention (grade 5)

Background dodged, subject printed at grade 5

▲ Using hands to dodge areas

Use your hand for larger areas of a print and more general dodging to block out the light. Keep your hand moving the whole time so that there are no harsh lines in the final print.

▲ Using a homemade dodger

A homemade dodger is useful for holding back a small, intricate area. Hold it under the enlarger to create a shadow over an area that needs less exposure. As with the hands, keep moving the dodger.

Printing and processing tricks

As you become more experienced at producing your own black-and-white prints, you can start to experiment with a whole range of printing styles and techniques. Just as countless special effects can be achieved with the camera, so there are hundreds of different tricks that can be performed in the darkroom.

Some effects involve the use of different chemicals to change the results. Toning, for example, allows the production of monochromatic prints in a range of different subtly coloured shades – brown and blue are

the most common. Two or more shades may be used in combination for split-toned effects. More exotic colour effects can be added with tinting processes.

Other darkroom techniques rely on recreating processing techniques that were once widely used by photographers. Now they can provide a more abstract or antique feel to the finished result.

There are also techniques, such as solarization, in which printers deliberately break conventional darkroom rules in order to create eye-catching results.

Manipulating an image

Given the range of darkroom processes, it is possible to achieve hundreds of different prints from just one negative. Some of the techniques (such as toning or tinting) do not require a darkened room, so you can carry them out even if you do not have the facilities for basic print processing. Ideally, the effect should be chosen to suit the subject matter, rather than to disguise a less-than-perfect print or negative. The techniques described here are just a sample of the radical effects possible. All can be easily achieved digitally, but the traditional printing processes and tricks are extremely rewarding.

Original, unmanipulated print

Toning

The technique of toning is carried out on a previously developed print in full light. Chemicals are used that replace the silver in the print with another heavy metal. The immediate appeal is that it gives the print a colour wash. But the process is also used for archiving – helping the print to last longer. Toning can be unpredictable, and the print you start with needs to have been developed and fixed perfectly. How well it was fixed and washed, the paper used, and the temperature or dilution of the toner are just some factors that affect the consistency of results. Many toners are highly toxic and must be handled, and disposed of, with care.

Sepia effect using Agfa Viradon toner

Solarization (Sabattier effect)

This involves deliberately exposing the print to normal white light part-way through development by turning on the darkroom light for a second or so midway through the usual development time. The image becomes partly fogged – primarily in the lighter image areas. The result is a curious mixture of both negative and positive image. Results are unpredictable – and difficult to repeat.

Main darkroom light turned on during print development

Baseboard distortions

Curling the paper as it is exposed under the enlarger creates distorted images that are reminiscent of fairground mirrors. Use the smallest aperture that your enlarger lens allows.

The paper can also be tilted to correct converging verticals on building shots. By angling the paper so that the top of the picture is farther from the lens than the bottom, verticals can be made to appear parallel.

Paper curled between two cups under the enlarger

Tinting

This is an artistic process, in which the print is coloured in using special materials. Oils and dyes are applied with a brush, while specialist felt-tip pens and pastel crayons can be used directly on the print. The quality of the final result depends heavily on the hand and eye of the user. Usually, selective parts of the image are coloured, leaving the rest of the print monotone.

Colour selectively added to dry print with crayon

Texture screens

One way to add pattern to a picture is to print it through a translucent screen. Textured glass, placed directly on the printing paper, works well. An alternative is to sandwich the negative and screen in the film holder. Tracing paper and stockings make good screens, or shoot a patterned subject and use the negative as a screen. The effect can be softened by distancing the screen from the paper or negative.

Print made with patterned glass lying on the paper

Digital imaging

In a short time, digital cameras have completely altered the way in which most photographers work. The instant results and low running costs are distinct advantages to many users. However, the digital revolution does not stop at image acquisition. In the opinion of many professionals, the real advantage of digital images over film is the

ease with which computers allow you to store, broadcast, and manipulate pictures. Photographs can be viewed easily on a PC screen, shown to people all over the globe via email or the web, and, for news photographers particularly, they can be transmitted back to their offices direct and printed before the photographer is back in the office.

Getting into the digital domain

For many users, there are distinct advantages to using film in order to take pictures. Fortunately, film-users can also benefit from the post-production advantages of having an image in a digital format. Whatever type of prints, negatives, or slides you have, they can all be transformed into binary form. In this form, the images can have access to, and a presence in, the digital domain. Even for committed digital camera users, this transformation

process is important for getting older, archived material on to the computer, at home or in the office.

The key tool for converting images from analogue to digital is a scanner, but it is not necessary to own one, since most processing laboratories offer a digitizing service. Digital images are typically returned on DVD. Some companies offer an online service, where images, once scanned, can be downloaded from a secure web page.

▼ Pathways to a digital image

Whatever type of camera is used, it is possible to put the pictures on to a computer – the heart and the hub of the digital system (see pp.32–3). The number of different stages needed to move the digital file on to the

PC screen will depend on the starting point, and what equipment is available. Old photographs, prints, and slides can also be given a new lease of life and a new audience in the digital domain.

Photographic subject

Digital camera

This creates digital files, which are normally transferred to a computer via an appropriate lead.

Memory cards

These store the digital images taken by the camera as digital files, which can be read by the camera or by a special stand-alone reader.

Film camera

Conventional cameras record high-resolution images on film.

Film

This uses light-sensitive silver salts to record the image in analogue form, but its data can be converted into a digital form later.

TYPES OF SCANNER

The key tool for the analogue-to-digital conversion is a scanner. This records a copy of the source line by line using a moving imaging chip and its own colourcorrected light source. The most common type is the desktop or flat-bed scanner, which is principally designed for flat artwork and photographic prints. Most have an A4-sized scanning area - larger ones are much more expensive. It can have a transparency option for slides or negatives. Film scanners, however, are ideal for digitizing 35mm format slides and negatives. They generally have a higher-resolution sensor than flatbed scanners, compensating for the smaller size of the original. For top-quality results, drum scanners are used. They are not generally used by individual photographers, but a drum-scanning service is available from specialist bureaux.

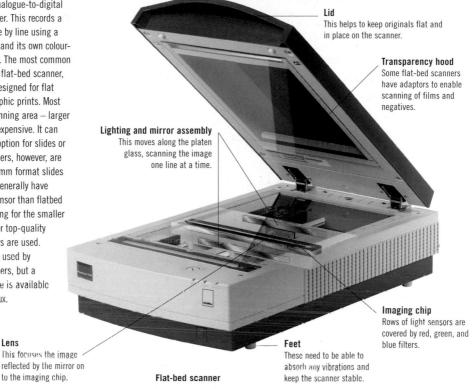

Lens

Memory card reader

This allows uploading of images from a card un to a computer without the need for the camera.

A bureau will transfer images from film on to DVD or put them on a secure website from where they can be downloaded. It can also print images direct from memory cards.

Processing

Films need to be processed to create a visible image, but laboratories can digitize the film while producing prints or slides (see above).

Digital image file

Once the image is on the computer, it can be printed, emailed, used in a variety of documents, and manipulated as required.

Scanner

A flat-bed or film scanner can be used to create a digital image file from a print, negative, or slide.

Image storage

Although digital image files take up no physical space, there are practical limitations to how large these files can be. In comparison with most other documents that are stored on a computer, digital images can be large, particularly if they are stored at the best available resolution. Within a short while it is easy to find that you have run out of room on what you thought was a

bottomless hard drive. Fortunately, there are dozens of different ways of increasing the storage space for digital files. The contents of a digital camera's memory card can be uploaded to your computer or to a high-capacity portable drive. Scanned or manipulated images from your computer can be archived on to CD or DVD – or any other storage medium you choose.

Managing image size

There are several reasons other than the cost of extra back-up capacity why it may be in your interests to keep the size of an image file small. The bigger the file, the longer it will take to process at every stage of its journey, and the longer it will take to get there. The higher the resolution that is set on a digital camera or scanner, the longer it will take to record the image. It will also take longer for the file to be opened on the computer, and longer to save any alterations the user makes on screen. In the event of emailing the file, it could take a long time to send, and for the recipient to download. However, once the size of the file is reduced, it cannot be increased, so before reducing the size of a file to send or work on, it is usually worth retaining a copy of the original (see opposite), so that you always have this one to fall back on.

COPYING AND BACKING-UP

■ One of the disadvantages of digital imaging is the ease with which you can lose a valuable picture. While you can damage a slide or negative, it is hard to lose it completely. A digital file, however, can be accidentally deleted — or irrevocably replaced by a version you did not want.

■ A first line of defence, however, before doing any image manipulation, is to make a copy of the file. You can then work on one, and keep one permanently

untouched as your master, back-up copy. As with any important computer file, these images should themselves be backed up from time to time, to safeguard against hard drive failure, fire, and so on, and stored off-site.

If you do not need top-quality results, save storage space by limiting the file size when the image is digitized. Whatever the maximum resolution of your scanner or camera, you can limit the resolution actually used.

MEMORY MEDIA

It is sensible to have a variety of media on which to store images. Initially, files are usually stored on the hard drive of a computer, although portable hard drives, such as the one shown below, are becoming increasingly more powerful, and consequently more popular. In addition, it is a good idea to have some means of storing images on separate disks as a form of back-up.

Hard drive

This is the main internal memory archive on a computer. A typical computer may have a hard drive with 500GB capacity, but this has to be used for all working documents and programs.

CD burner

A CD-R or CD-RW drive provides popular, low-cost storage for digital images. Each disk can save up to 700MB of data, and can be read by almost all modern PCs.

External hard drive

Additional external hard drives are a low-cost way of adding extra storage to a computer, or for archiving back-ups of your files. Typical capacities range from 250GB to 1TB.

DVD burner

This is the big brother to the CD burner, with a much larger data capacity (4.7GB). Blu-ray Discs offer users even more storage space.

Pocket hard drive

This portable storage device is designed to allow the photographer to free up space from a camera's memory card when out on location. Also known as a digital wallet, it typically has a capacity of 40–120GB.

File formats

An additional way to save space is to use a file format that automatically tries to save space. The most popular file format is the JPEG (Joint Photographic Expert Group), pronounced "jaypeg". This is a "lossy" file format, which means that it irretrievably loses some of the file information. But the quality loss is marginal in comparison with the space saved. File size can be reduced by 70 per cent without noticeable image degradation. You usually have a choice as to the amount of compression used, with usable images still possible from a file one tenth of its original size.

The other commonly used file format when saving and editing images is the TIFF (Tagged Image File Format). This is a lossless format, where all the image data is saved, and it is usually reserved for the top-quality settings from the top digital cameras. File sizes can be unwieldy, but as much quality as possible is preserved. Image-manipulation software can convert between different file formats, although it cannot recover previously discarded data.

Compressing a tile

It is possible to reduce a file, using the JPEG format, to just a fraction of its original size, making the file easier to use and store. However, the more a file is compressed, the more the image quality is degraded. Below, a small section of an image has been enlarged to show how the different JPEG settings affect the image quality, and how they compare to the lossless TIFF format. The amount of compression, and

the size of the image file, is best selected to suit the application it is going to be used for. If big prints are needed, the higher the resolution, the better – but for small prints, a large amount of detail is not necessary. When using images on web pages, or on-screen presentations, the quality can be even lower, and still look acceptable.

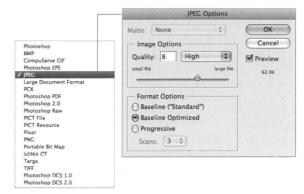

▲ Adjusting the compression

Image-editing programs typically provide a choice of formats to select from when saving a file—the one chosen will determine the size of the file, and how much information is retained. When selecting the JPEG option, compression can be adjusted by altering the quality setting before saving. The Adobe Photoshop dialogue box, seen above, shows roughly how large the file will be,

▲ Original slide

This shot was originally taken on fine-grain 35mm transparency film to provide maximum resolution and colour clarity.

▲ 4MB JPEG

This is a tenth of the size of the original tenth, but there is still enough quality preserved in the compressed file for A4 home printouts.

▲ 40MB TIFF

Digitized using a 4,000dpi film scanner, this lossless image file is good enough for professional quality printing at large sizes.

▲ 300KB JPEG

This is a low-quality scan, but the size is suitable for quality on-screen use (in a Powerpoint presentation, for instance), or to send via email.

▲ 10MB JPEG

Although this is a quarter of the size of the TIFF file, this compressed version still retains almost all the quality of the original.

▲ 60KB JPEG

The low quality of this small image file is plain to see. However, this file size is all that is generally required for website use.

Printing

To make prints from digital images, there is no need for trays or tanks of chemicals – just select the print command on the computer. Essentially, it is as easy as that, but the quality of the prints will depend on a number of different factors.

First, printing is usually the ultimate test for a digital image. It is here that the resolution of the camera or the scanner used will be found to stand up to scrutiny, or not. Printing out on a normal-sized piece of paper will show the reason why it can be worth investing in a camera with more pixels – the more detail there is available, the more it is possible to enlarge the picture (*see pp.24*–5). The type of printer and paper are also crucial.

Choosing a printer

Three types of colour printer can be used with the home computer. The most popular are inkjet, or bubble-jet, printers. Laser printers are faster and neater at printing text than the average inkjet, but generally inferior when printing photographs. As they are also more expensive than inkjets, they are of little interest to the photographer. The third type is the dye-sublimation printer. This vaporizes coloured ribbons – the gas created is forced below the surface of the purpose-made paper. It gives the results that most closely match those of a traditional photograph, but is no use for printing text. Dye-sublimation printers can be expensive, and the range of sizes they print at can be limited; some portable models provide credit card-sized pictures. Owning a printer, however, is not essential. Most labs will create prints at the size required, whether direct from a memory card, from a CD, or from an email attachment. Professional services can also provide enlargements, including billboard-sized pictures, that are not possible with home printers.

HOW INKJET PRINTERS WORK

Inkjet printers squirt microscopic blobs of ink on to the paper — building up the picture out of dots of four or more colours. The more colours used, the more economical the printer is for photographic printing. The steps below show how cyan (blue) is printed.

Instruction from the software turns on a heating element to vaporize the ink behind the nozzle.

Wires to hardware _______ Ink ______ Heating element ______ Nozzle

The heat is turned off, causing the bubble to collapse, while the ink

separates and drops.

Fresh ink from reservoir

Heating element off

Collapsing ink bubble

Ink droplet

The heated ink bubbles up and then pushes the ink out of the nozzle.

As the ink bubble collapses, fresh ink fills the reservoir while the ink hits the paper.

Ink hits paper _____

HOME PRINTERS

When choosing a home printer, look for special features for reproducing photographs, such as borderless printing, or printers that work straight from a memory card. Ensure that it is compatible with your computer.

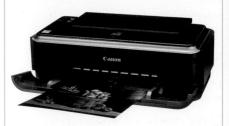

Canon PIXMA iP2600

Most standard desktop printers are capable of printing photographs, but you can ensure good-quality, long-lasting results by buying the best papers and inks available for your model.

Canon Selphy ES1

This dye-sublimation printer can print direct from a memory card, as well as from a computer. Images can be checked on a built-in LCD screen before printing. Most dye-sub printers have a maximum $10 \times 15 \text{cm}$ (4 x 6in) paper size.

Direct printing

Many digital cameras and printers offer a facility called PictBridge. By connecting the camera to the printer with a cable, you can print direct from the camera without the need for a computer.

Printer problems

The process of translating the image seen on screen into a finished print is complex. Printer problems can be reduced by using the correct printing medium, ink, and a file size that is manageable for the hardware and software being used. Always use good-quality paper and the ink recommended by the manufacturer – cheaper versions may block the nozzles and print unevenly. Remember that the maximum resolution for a printer will be much higher than the resolution that should be set when saving or scanning an image - 300dpi is more than adequate for a print size of 8 x 10in (20 x 25cm). The resolution on a printer is calculated differently, and may typically claim 2,880dpi or more; this figure signifies the accuracy of the inkjet nozzles.

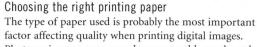

factor affecting quality when printing digital images. Photocopier paper may produce reasonable results at low cost, but the ink will tend to run. Special inkjet paper, which has a smoother finish, will produce better-quality images. Photo paper is thicker and has a coating that is specifically designed for photographic printing. Top grades of paper feel and look like traditional photographic paper - while some are designed to provide the texture and feel of art paper. To get the best results, you must tell the printing software which paper you are using. Special media for inkjet printers are available for producing a range of products, including transfers for T-shirts, business cards, and CD labels.

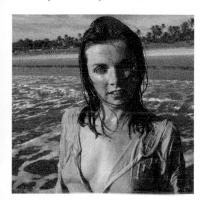

▲ Streaky print

The result of a poor-quality inkjet printer working on low-quality paper is an output imago that is streaky and uneven. The results might be improved by cleaning the nozzles.

á+ ⊑üźU±T±±σñ&]W■üź + σÑ π]W■ü½ U·±±+EQ⊩âò ϝ ±± ⊑ü2U±T±±T±áσ+EÖ⊩)§ ±]₩■ü½ j]₩■üU Tü½Ü±] ■ü¼ Ñ·±*σTü¾U±W ⊨ü¾ T ±×+(]₩■ü₺ W EÄÑÜÄÑ+E]W■ü½ [·±±T■¦W±Tü½U± tEÄÑT]W■ü¾ YÄ%(]W■ü¾ ᱇σ&]₩■ü½ (]₩■üU (] ■ü½ T±-T±±E⊩σW24]W■ü rüåU±.]W■üå FOÑTüðU±

▲ Garbled print

The printer may try to interpret an incorrect command, such as a print menu set to fax mode, but the result may be garbled. This can also happen if a print order is aborted.

▲ Unsuitable paper

Here, normal photographic paper has been used instead of special printer photographic paper. As a result, the ink has not been absorbed, and has settled in pools on the surface.

TROUBLESHOOTING PRINTER PROBLEMS

The most common printer problems are often the simplest to solve. If you have a problem, always check first that the power lead and

and paper, and that the printer is not jammed. Ensure the printer is correctly selected; often, cancelling a print command and starting

printer cable are correctly attached, that the pri	inter has sufficient ink again can solve temporary problems, as can rebooting the computer.
PROBLEM	CAUSE AND SOLUTION
Printing is very slow	The printer may be trying to print a very large or complex file. Avoid asking the printer to print at anything other than 100 per cent. If necessary, change the size of the image before printing.
Print colours do not match those on screen	Your printer and monitor are not correctly calibrated. To avoid unexpected results, you must calibrate your screen carefully, and then use colour management software.
Printing is dull, even at high resolution	You may be using the wrong paper or paper setting. Check that you are using the correct side of the paper — some papers are double-sided, others can be printed only on one side.
There are gaps in the printing	The nozzles of the printer may be blocked with ink. Clear the nozzles using the software utilities supplied with the printer. You may have to repeat this process a number of times.
Part of the printed image is missing	The output size is larger than the printable area. Most printers cannot print right to the paper's edge. Reduce the output size in your image-manipulation program.
Colours change during printing	One or more of the ink cartridges may have run out or become blocked. Clean the nozzles using the utilities supplied, and repeat as necessary.
Colours are bleeding into each other	The paper may have become damp, or the printing resolution may be too high for the weight of paper you are using. Check the paper settings, and make sure the printer rollers are clean.

Email and the web

The internet and email have revolutionized the way we communicate, and one real advantage of digitized images over conventional prints and slides is the ease and speed with which they can be sent or shown to anyone anywhere.

Whether the user is simply sharing images with friends and family, or hoping to reach a wider audience with a portfolio, the key consideration when producing images for use on web pages is the speed at which the viewer is able to download that image. A big image file might provide a beautiful, detailed, giant picture, but if it even takes half a minute for the image to come up on screen, the recipient will give up waiting.

The internet

The accepted wisdom in web page design is that content should be built for the lowest common denominator. While many people now have access to high-speed broadband internet connections through a variety of different technologies, and a number of different speeds, there are still those using traditional modems to go on-line, which typically operate at a maximum speed of 56kbps. Unless you want to alienate these people, you must assume low connection speeds and still provide pictures that load quickly. Even with broadband, the speed you can send (upload) large files is usually just a fraction of the advertised download speed.

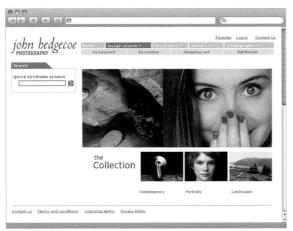

▲ Web home page

Images that are designed just to be seen on screen, rather than downloaded, need not have large file sizes. It is especially important that your home page loads quickly to keep viewers interested, as demonstrated by this mocked-up page for an online slide library.

Image size for email

When using email, you may not have to restrict file size as much as with the web. You may know that your recipient has a broadband link, and friends and colleagues will be genuinely interested in the shots you are sending them, so will wait. But it is tiresome to have your PC clogged up with unnecessarily fat files. Unless the recipient needs to print the image, it is only necessary to send an image that looks good on screen. Use JPEGs, as these can be opened with a range of software, including web browsers and word-processing packages.

▶ Image size

One way to minimize the size of a picture file is to use the "Image size" dialogue box in Photoshop. The size of a file can be reduced significantly by entering a lower resolution; 72ppi is the standard for on-screen use.

Saving files

When putting images on the web, there are often several pictures on a page, so the typical file size is 20–60KB. To help get around the difficulty of reconciling speed and quality, it is worth using the Progressive JPEG format; this is essentially a multi-resolution file, in which a low-size image appears on screen first so that there is something to see, then the quality of the image improves as the file downloads. An alternative, which works particularly well when using a site to exhibit photographs, is to run a small, low-resolution image, but provide a link for those who are interested in seeing (and waiting for) a high-resolution version.

▲ Displaying lots of photographs

Small, low-resolution images allow you to display a number of pictures at once without seriously impeding the download time for the page. The site can be set up so that when a visitor wants a more detailed view of an image, a higher-resolution file is displayed at the click of the mouse.

Alternative file formats

Most pictures on the web are saved in a highly compressed JPEG format (*see pp.370–1*). Occasionally, the Graphic Interchange Format (GIF) is used. This file format uses a limited palette of colours to reduce the file size, ranging from 256 colours to just four (which results in a posterized graphic-looking image). However, it is better suited to graphics than photographs. The PNG (Portable Network Graphics) format is specially designed so that the colours can be accurately reproduced on the web, and is capable of using millions of colours. Like JPEG, there is a progressive setting (*see opposite*), and it offers better compression than GIF. The advantages that the format has over GIF mean that it is becoming more widely used on the internet, but some older web browsers and imagemanipulation packages do not support it.

Original image

▲ GIF 256 colours

An image saved as a GIF, which is restricted to just 256 colours, looks more than acceptable, but the size of the original file has been reduced by some 75 per cent.

▲ GIF 32 colours

The image looks more grainy than it does with 256 colours, but for on-screen use the results are passable. Image size is reduced by 90 per cent from the original.

▲ PNG colours

This format can be set to use colours that can reliably be reproduced on the web, but the result is inferior to other options and the file size is reduced by only 75 per cent.

HOW FAST CAN YOU SEND IT?

Below are theoretical download times for different-sized files using different connection speeds. Confusingly, data communication speeds are measured in bits per second (or kilobits per second [kbps] and

megabits per second [Mbps]), while file sizes are measured in bytes: one byte equals eight bits. In practice, the download times will be at the very least 20 per cent slower than the times given here.

SIZE OF FILE	CONNECTION SPEED				
	56kbps	256kbps	4Mbps	24Mbps	128Mbps
150KB (typical web page)	21 sec	4.7 sec	0.3 sec	0.05 sec	0.009 sec
500KB (email with five 100KB pictures)	1 min 11 sec	16 sec	1 sec	0.17 sec	0.03 sec
4MB (top-resolution JPEG file from mid-range digital camera)	9 min 44 sec	2 min 8 sec	8 sec	1.3 sec	0.2 sec
80MB (top-resolution TIFF file from 35mm film scanner)	3 hr 14 min	42 min	2 min 40 sec	27 sec	5 sec

The digital darkroom

Once an image is in digital form, it is easy to tweak or transform it. Image-manipulation packages allow a whole range of changes to be made to the picture as a whole, or to just part of it. These techniques and processes are often referred to as the digital darkroom – because of the obvious similarities with traditional methods. On a

computer, most of the tricks of the skilled printer, toner, and retoucher can be performed, but much more easily, not least because the result of this manipulation can immediately be seen on the computer screen without printing it out. If the first preview is unsatisfactory, you simply undo the last step and try again.

Manipulating images

Image-editing programs also allow the user to perform a wide variety of techniques that are not available in the darkroom. Changing the contrast, colour, and the sharpness of individual areas of a colour photograph, for example, are techniques that are not feasible using conventional means. Once you find an effect you like, it can be applied in seconds to any picture you choose, and multiple prints can be made of a finished file without further labour.

While many photographers were once suspicious of digital systems, most now realize that the techniques available have brought a new level of artistry to photography. Important, too, is that fact that most of these techniques are now possible with modest computer equipment and low-cost software.

Choosing the program

There is a wide range of image-manipulation programs available. The best known of these is Adobe Photoshop, but as this is designed as a professional tool, it is expensive for many people's personal uses. A more affordable alternative for the home user is the stripped-down version of the same software, Adobe Photoshop Elements, which has more than enough sophistication and control for most users. These and rival programs can be downloaded for limited-period free trial. It is worth noting that many digital cameras and scanners come with some form of picture-editing software. Some packages can also be downloaded for free over the internet; these may offer only basic or automatic transformations, and may not be able to deal with RAW files.

Simple transformations

On these pages are a series of quick transformations that are possible with a digital image editor. While most software packages allow the user to create a bewildering array of effects, they are also invaluable for making simple adjustments to pictures that would take far longer in the traditional darkroom. Creating a black-and-white print from a slide traditionally means copying the slide to create an "interneg" before the darkroom work can even begin. On a computer, however, this mono conversion can be as simple as a one-click process.

▲ Original image

Even if the final result is intended to be monochrome, it is sensible to shoot or scan the image in colour.

▲ Mono conversion

Select image, mode, and change to grayscale. Keep a copy of the colour image since, once the colour is discarded, it cannot be retrieved.

▲ Tonal conversion

To convert an image to a toned image, change the image to grayscale (*see left*), then select duotone and choose the desired colour.

DIGITAL SOFTWARE

Your choice of software will depend on your technical requirements, computer operating system, and, of course, budget. Programs designed for professional use require powerful hardware and are expensive, but they do offer more options than the cheaper alternative programs.

Adobe Photoshop

This software is designed for use by professionals on either Windows PCs or Macs.

A more affordable version of

A more affordable version of Photoshop with most of its popular features.

Adobe Photoshop Lightroom

Designed to allow you to sort, batch process, and perform basic manipulations at speed.

Sloping horizons

Even when using a tripod, it is all too easy to take landscape pictures where the straight line marking the meeting of land and sky appears to be sloping. The human eye is so sensitive to this that even if the shot is just a degree or so off true it

can look wrong. This can be corrected, depending on the editing package, simply by rotating the image until it appears horizontal. Once the image appears straight, it will be necessary to crop some of it away.

Original image

▲ Rotated canvas

Select the rotate canvas command, and input the correction needed in degrees until you are happy with the result.

▲ Marguee selection of area

Use the marquee tool to select the right area, then crop to this size. If the whole image is wanted, crop any areas lost by the rotation.

Converging verticals

There is no need to invest in a shift lens (*see pp.54*–5) once you have a suitable editing package. Pictures of tall buildings can be taken without worrying that parallel lines will converge because you had to tilt the camera. This is done by using a facility that allows the image to be distorted

– it is pulled from the corners or the sides until you are happy with the result as it appears on the screen. Once the vertical lines are parallel, it will be necessary to crop the picture so that it is rectangular again. The three shots of the church below demonstrate how this is done.

▲ Original image

The church appears to be leaning backwards, and the tower appears narrower at the top than at the base.

▲ Transform distort

Squeeze the base of the building, so that it is as wide at the top as at the bottom, by moving the tabs at the corners of the image area.

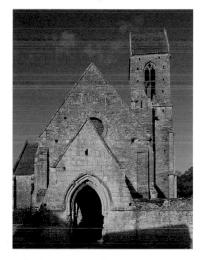

▲ Verticals corrected

Crop the edges of the picture. Some of the image area is lost, but the church tower now looks upright.

Apple Aperture

Mac-only software designed for professional photographers shooting in RAW format.

Corel Paint Shop Pro

Low-cost package for the hobby photographer, rivalling Adobe Photoshop Elements. PC only.

PROFESSIONAL HINTS

- Check that the operating system your computer uses is compatible with the software you are buying.
- Check how much random access memory (RAM) and disk space are recommended for running the software. Some programs can seem very demanding, but this processing power can be essential when performing complex transformations on large image files.
- Check that the software you decide to buy can handle and process the RAW files that are written by your specific camera. The main programs and RAW converters bring out regular updates to cater for new camera launches.

Selection tools

The foundation stone of digital manipulation is the picture, which is made up of distinct, individual dots of information. Each of these pixels can be changed separately, allowing you not only to alter the colour or brightness of a miniature area, but also to completely rewrite the image. However, most of the time the

photographer does not want to work in such detail. You can work on the whole image simultaneously, but at other times you may want to work on a particular element within the image, just as you might do when dodging in the traditional darkroom (*see pp.364–5*). This is where the selection tools of a manipulation program are invaluable.

Selecting an area

Image-editing packages provide a range of sophisticated ways in which to select the particular group of pixels that are required within a certain image, so allowing the user to work on a particular area. One of the simplest ways to do this is to draw around the relevant area. However, this can be restricting if, as is often the case, the area you wish to manipulate is an irregular shape. For more intricate work

it will be necessary to use a tool that allows more freedom, such as the magic wand or marquee tool. Once the required area has been selected, it is possible to make any desired changes, such as replacing the pixels with those of a different colour, or using the clone tool, which allows the user to replace the pixels with those from another part of the image.

ADOBE PHOTOSHOP ELEMENTS SELECTION TOOLS

As with most manipulation packages, most of the selection tools are found on the toolbar, while others are accessed using the drop-down menu at the top of the screen. Three of the most useful ones on the

Photoshop Elements toolbar are the lasso, the marquee, and the magic wand. Each of these has a selection of different modes that change the way in which the selection tool operates.

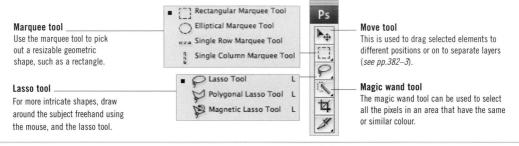

Cropping and cutting images

One of the most common uses for selection tools is cropping an image. Whether you want to focus in on one element of the picture, edit out an undesirable area, or simply amend the image to a particular printing size, this is a feature you will want to use frequently. It is good practice to crop the image as you want it before you embark on any further manipulation. By getting rid of the unwanted picture areas, and then saving the file, you are reducing the file size, sometimes quite substantially. The smaller the file size, the quicker any further transformations will be performed by the computer – as well as saving valuable disk space (*see pp.370–1*).

In addition to using the basic cropping tool to trim the picture to size, you can also crop out a background to give a "cut-out" image, or to change to another background.

As always, make sure that you retain a copy of the original image. You may wish to return to the original at some point, and you may want to experiment with a number of different crops to achieve the desired effect.

The magnetic lasso tool in Photoshop Elements can help to make drawing around objects easier. The line drawn is automatically attracted to the high-contrast edges between the subject and the background. These two images (right) show how this tool can be used to cut out an image.

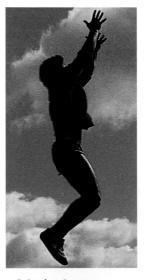

▲ Selecting the area Click on an edge point using the magnetic lasso, and, as the

magnetic lasso, and, as the mouse is moved to roughly trace the edge, anchor points are made around the outline of the object.

▲ Cut-out

Once the figure is outlined, reverse the selection (using the inverse command), and the background is deleted, leaving a cut-out of the soccer player.

Putting it all together

In practice, it is often necessary for the user to employ several of these selection tools together just so that it is possible to work on precisely the part of the picture that needs to be in altered. Having seen on the computer monitor exactly which areas have not been picked by the tool just used, it is then possible to swap to a more appropriate tool to bring these straggling pixels into the selection. Once a selection has been made, it is usually

necessary to soften the edges of it, so that the joins between the transformed and non-transformed areas are blurred. This is done using the feather command. How much feathering is needed depends largely on the number of pixels in the image.

The series of screen grabs below shows how the selection tools are used together to select an area of a shot (the model's top) that is to be altered.

▲ Crop

The first thing to do is to crop the image to reduce the total image size. In order to do this, select the crop tool and shade the unwanted area to give a better view of the new composition, before cropping. Once you have selected the correct area, crop the image.

▲ Feather

The final, tweaked, selection has hard edges; if this area were altered, the joins would make it obvious that the shot had been doctored. Feather the selection so that any effect is blurred at the edges for a smooth transition.

▲ Magic wand

The most spectacular tool is the magic wand. Choose all the pixels in an area that have a similar colour by clicking on a representative pixel. Its sensitivity can be altered by changing its tolerance setting. You have now selected the basic area you need to change.

▲ Replace colour

With the edges now feathered, it is possible to make changes to this area without affecting the rest of the image. Using the replace colour command, change the colour of the model's top from red to blue.

▲ Marquee tool

The marquee tool draws elliptical or roctangular selections, and is ideal for adding to the initial selection. Here, rectangular shapes quickly pull in areas of the models' top that the magic wand missed.

▲ Deselect

Other corrections can now be made to this area of the image, as this selection is still active. When all the changes have been made, choose the deselect command to remove the dotted line that surounds any selection.

Retouching

Probably the most compelling reason for using digital manipulation software, whatever your camera, is the ease with which it allows you to retouch an image. With traditional techniques and materials, removing scratches and dust spots from prints was perfectly possible, but doing it without leaving tell-tale marks took a degree of artistic skill. In the digital darkroom, such invisible mending is exceptionally easy.

The simplicity with which you can paint existing pixels over offending blemishes on the picture means that you can not only create a cleaner image, you can also make simple embellishments to the picture content. Some

irritating litter in the foreground, for example, which you did not notice at the time of shooting, telephone wires appearing from the walls of picturesque cottages, and cars that are impossible to exclude from the viewfinder can all be removed with just a few clicks of a mouse.

To the traditionalist, this might seem like laziness or cheating, but it is much simpler and more effective to remove a spot from a model's face on a PC than it is to use make-up to mask it (or to reschedule the shoot).

Once you start using the clone tool on your computer, you will find that there are practically no pictures that do not benefit from at least some minor surgery.

Removing dust

Old negatives and slides that are scanned are always likely to suffer from dust marks and dirt, however well they are stored or cleaned. This may be invisible to the naked eye, but when the digital version is blown-up on screen, the black specks will be all too obvious. Most manipulation programs have an automatic or semi-automatic function that allows the removal of small imperfections. However, resist using these filters, as they tend to soften the whole image. Removing dust and scratches manually is not

difficult, and allows you to tackle only the areas affected. The method used for this is to cover the offending marks with perfect copies of an adjoining, similarly toned area. This is done a blob at a time using the image-manipulation software's rubber stamp or clone tool (alternatively, the healing brush tool can often be used). You effectively use the image as your paint palette, spotting out the offending parts of the picture with a soft-edged brush, using a pointillist painting style.

▲ Original image

Magnify the image on screen so that you are working with relatively small areas at a time. Do not zoom in too close, otherwise you lose sight of what you are doing in relation to the rest of the picture. Choose 100–400% magnification – the higher the resolution of the digital image, the lower the magnification that is required.

▲ Choosing the brush

The rubber stamp tool has different brushes available. Choose a medium-sized brush that is slightly larger than the average dust mark. Hardness is usually set to 0% to ensure soft, feathered edges. Dab with the brush, a click at a time, rather than holding the mouse key down and painting, even when deleting larger marks (such as hairs or scatches).

▲ Amended image

Choose an area to clone from that appears to be the same shade, pattern, and colour as the area to be repaired. Select this area by pressing the alt key, while clicking the mouse. Move the cursor to the blemish and click. Repeat this for each mark. Check the appearance of each spot; if it looks wrong, use the undo command to go back and try again.

Removing larger parts of the picture

The procedure for removing small, or even large, unwanted elements from the composition is essentially the same as for removing dust marks. Again, the clone tool is all that is generally needed, although the more major the surgery, the more careful you should be about choosing the area from which you are going to clone. Often it is a matter of experimenting – save each stage to ensure that you can always go back to the last satisfactorily completed stage.

There are normally two main cloning modes available, which means that it is not necessary to define the source area each time. Using the aligned mode, the cloned area is taken from the same distance and direction from the target as when the source was previously set. It is important, though, to keep an eye on the source point, so that it does not stray into any inappropriate areas. With the non-aligned mode, the clone is taken from the same spot each time, which is useful when there is only a limited area of suitable source material.

▲ Original image

Telephone lines, aerials, and other eyesores ruin what is an otherwise interesting factory building. All can be removed relatively easily with image-editing software. Here, the chimney is the element to be removed.

Ensure that you choose the size of the rubber stamp brush (shown by the circle) to suit the area of the subject that you are working on.

Set the tool to the aligned mode, so that the point from which the brush clones (marked with the cross) is different each time the brush is moved.

The source coordinates for the clone are changed every few clicks; otherwise, tell-talc signs of the copying are likely to be clearly visible in the area being altered.

▲ Amended image

Save the manipulated version under a different file name, or contain it in a separate layer (see pp.382–3), so that it is always possible to go back to the original, unedited shot.

PROFESSIONAL HINTS

- Keep altering the brush size to suit the area being worked on. Sometimes a larger brush size produces a less-noticeable result than using a small brush repeatedly.
- Mow difficult it is to remove large areas from a picture will depend on the background against which they appear.
- If the unwanted element is framed nicely against a plain area of sky, or an out-of-focus backdrop, then painting over this will be simple.
- With a more complex, in-focus, backdrop, you will have to decide what there is in the picture that can feasibly be used as a source.
- Straight lines (of a window, say) can be extended realistically, as long as the source and destination points are chosen accurately. Guide marks can be added to the picture temporarily to help you.
- Dust and mark removal on an ill-treated slide or negative is a time-consuming process. Special film-cleaning solvents can get rid of the worst of the dirt before scanning. Some scanners have intelligent software that electronically removes obvious dust and scratches.

Using layers

While it is sensible to keep an untouched copy of an original digital image, there is another technique whereby the starting image can be preserved while simultaneously being changed in any way that the photographer desires. Most good manipulation software has a layers facility, which essentially allows the images to be stacked on top of each other within the same file. The original image is copied and sits underneath the copy

layer. The user can then try out some of the manipulation techniques to alter the picture. In this way, the original is preserved, the top layer can be deleted at any point, and it is easy to check quickly whether the picture has really been improved by comparing the layer being worked on with the background layer. A new layer can be added for each change, or set of changes, made to the picture, so there is always the option of going back a stage.

Explaining layers

Layers do not have to be opaque. The user has control over their transparency, allowing the merging of two or more layers in a number of different ways, and by different degrees. Layers are used extensively, therefore, when making photomontages, with different images or elements being kept on different sheets, so that they can be worked on separately.

▲ Adobe Photoshop layers palette

The on-screen menu (above right) shows the number of layers that are being used, and which are currently active. Each layer can be combined with the one below in a variety ways (Photoshop's drop-down options are shown above left), and at different levels of opacity.

Building layers

Layers are usually just different versions of the same picture, and are fundamental to good working practice. They should be used with any type of manipulation undertaken, however minor. They allow experimentation – they can be used for comparing different amounts of colour correction or blurring, for example. They also permit the user to go back one or more stages at any point, and to compare what has been done by turning different layers off and on.

In some editing programs, even the background image consists of different layers, where each of the three primary colours (red, green, and blue), for example, can be displayed, and worked on separately. These are called channels (rather than layers), and are often the key distinguishing feature between professional software and less-expensive imagemanipulation programs. As well as using layers for manipulating one image, they can also be used for combining two or more different pictures.

▲ Exploded layers

One way to think about layers is to imagine a stack of sheets, each with different images, or slightly different versions of the same image. Some of the layers are transparent, as drawn on sheets of acetate, so that you can see what is below; others are opaque, obscuring what is underneath.

FLATTENING FAT FILES

Each time a layer is added to a document, the file size increases. How much is added depends on the type of layer used. A new layer can double the size of the file, as it is treated as a separate image. For many alterations to the image, however, adjustment layers can be used. These effectively just note the settings for the changes being made to colour balance, contrast, exposure, and so on, so add little to the overall size of the file. When saving an image, there is a choice as to whether to preserve the layers or not. The image can be flattened, merging the layers in the way they have been left on screen. This loses the layers, but has to be done if the user wants to store the file in some file formats, such as JPEG. It is worth keeping the layers if the image may need tweaking, in order to avoid having to start from the beginning. For this, it is best to use the proprietary format used by the software (such as .psd offered by Photoshop).

Replacing the sky

This series of pictures shows how layers can be used to perform a number of different tasks during the process of image manipulation. Here, two different images are used, and parts of each image are combined to make a new photograph. Each of these is placed on separate layers and

manipulated in different ways in order to make adjustments, such as removing distracting detail, and improving the contrast and exposure. Further layers are then used to tweak the colour and brightness of both halves of the combined image to increase the impact of the final result.

The background layer

This is a pleasant landscape shot, showing the sun breaking over a field of corn, but the dark clouds are not quite dramatic enough for a classic storm lighting shot. The sky can be replaced in the digital darkroom. The starting point is to use this picture as the background layer.

Adding a second layer

This second landscape is chosen for its busy cloudscape. A section of these swirling clouds will serve as a suitable replacement for the clouds in the first landscape shot. This is put on a new layer, on top of the original, background laver.

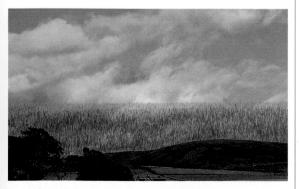

Merging the pictures: opacity control

To get a rough idea of how the two images will look when combined, it is possible to alter the opacity of the second layer. As this becomes more transparent, we can see the layer below coming through. The two scenes conflict, though, and must be combined more carefully.

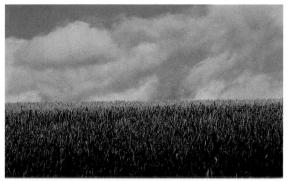

Combining the two layers

A mask is added to the picture that obscures the lower half of the second image, coinciding with where the field in the first layer occurs. The opacity of this masked area (which is effectively another layer) is adjusted to be completely transparent so the background shows through.

Adjusting hue/saturation

Once the new picture has been formed, the combined image can be tweaked. The first correction to make is to the colour of the field - its colour needed to be boosted to a more vibrant green. This correction is performed on a special adjustment layer (see Flattening Fat Files, opposite).

Adjusting brightness/contrast

The final manipulation is to alter the contrast and brightness of the combined image, so that the scene looks sunnier, and the clouds appear whiter. Again, this is done on a separate adjustment layer, so that this correction can always be undone.

Sharpening and blurring

Tools for sharpening and blurring can be found on most specialist image-manipulation programs. Unfortunately, the tools found on most programs will not perform miracles. However hard you try, they cannot retrieve or seriously improve an image that is actually out of focus. However, they can improve the apparent sharpness of an image slightly, and this effect can be useful with almost every picture that the photographer handles.

Digital cameras and scanners tend to produce images that are slightly soft compared to those created by traditional film photography. As a result of this, most provide the option to sharpen the image electronically before it is recorded. It is better practice, however, to turn this facility off and leave the sharpening as the last thing to be done when manipulating

an image. Sharpening is usually needed in some parts of the image more than others, and automatic sharpening can cause more problems than it solves if applied in equal measures to all pictures. Doing this at a later stage allows the user to be more selective. Furthermore, printing applications tend to require more sharpening than on-screen ones.

Just as useful to the photographer are the blur tools. Using these, it is possible to defocus elements within the image to which you do not want to draw attention. Blurring rarely needs to be applied to the whole frame, and the basic blur tool can usually be applied with a soft-edged brush, allowing the user to dab distracting details in the image until they are unnoticeable.

Unsharp masking

The basic sharpen option essentially increases the contrast of the picture, but this is best avoided for anything other than a quick fix. A slightly more useful tool increases contrast at the edges of objects within the image. However, for the best control over sharpness, the curiously named unsharp mask should be used. Unsharp masking gets its name from a procedure used in the printing trade. To make an image look sharper, it is sandwiched with a soft-focus negative copy of the same image. This increases contrast at the edges and gives the impression of a sharper image all over. This technique is recreated by better imagemanipulation packages.

UNSHARP MASKING CONTROLS

The unsharp mask (USM) in Photoshop, Photoshop Elements and other programs provides three different controls over selected parts of the image: the strength or amount setting, which defines the amount by which contrast is increased; the radius, which defines how many pixels on either side of the edge are affected; and the threshold, or clipping control, which allows you to select how different adjacent pixels have to be before they are counted as edges.

The amount setting: the higher the percentage, the greater the sharpening effect. A typical initial setting is 100%.

The radius: the higher the value, the greater the effect. A starting range would be 0.5–3 pixels.

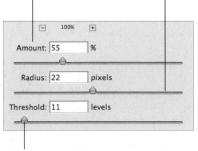

The threshold, or clipping, control: the lower the number of levels, the greater the sharpening effect. A typical starting point for sharpening an image would be to set this control to somewhere between 1 and 6 levels.

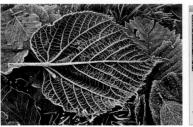

▲ Under-sharpening

This close-up shot of frost on a leaf includes a lot of fine detail, and is a subject that needs to look as sharp as possible. The settings used here raise the contrast slightly, but the threshold setting is too high.

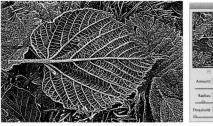

▲ Over-sharpening

With the strength setting at its maximum value, the grain of the image becomes more visible. This is useful if you want a "noisy" image, and may also help when printing on poor-quality paper.

▲ Ideal setting

Pictures with fine detail look best if the threshold is kept as low as possible (here, it is set to zero), and the radius is small (here, two pixels). Sharpness is mainly controlled with the amount/strength value.

Gaussian blur

Blur can also be used successfully to redefine the amount of depth of field within a picture by defocusing the foreground or the background. In order to achieve this, the Gaussian blur filter is normally the best tool to use, as it gives a variety of strengths of blur that can be previewed on screen before saving. Making the effect look

realistic can be a challenge, and it is important to remember that elements at different distances should be selected separately and given different amounts of blur. When trying to recreate a differential focus effect, both sharpening and blurring tools will often be used on different parts of the image.

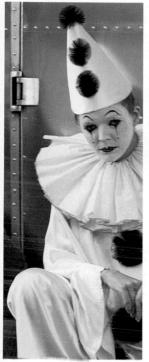

◆ A Original image

Distracting backgrounds are a problem with many subjects. Here, the trailer door was so close to the clown that it was not possible to blur it with aperture alone. On screen, the area was selected using the lasso tool, and then the Gausslan blur filter was chosen.

▲ A Gaussian blur

The feathered selection can then be thrown out of focus by adjusting the slider available in the Gaussian blur box. The higher the number of pixels set, the more blurred the selected area becomes. In this finished picture, the door has become unrecognizable.

BLUR OPTIONS

Blur can also be used to create special effects in pictures, long after the photograph was taken. Blur can be used selectively, for example, to give an impression of movement with action subjects, allowing you to mimic all manner of slow-shutter effects (such as panning, and zoom bursts). Unlike performing these effects with a camera, the digital darkroom solution allows precise control on which areas of the picture are blurred, and just how streaked the image becomes.

■ Motion blur

This effect allows the angle of blur to be altered as well as the amount, so that it accurately catches the direction of movement.

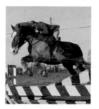

◄ Original image

Sports pictures shot with high shutter speeds can catch subjects so sharply that the appearance of movement can be lost.

Amount 10	(OK
Blur Method:	Cancel
Spin	Blur Center
○ Zoom	E.E.E.S.
Quality:	1 2 3 3
○ Draft	111(11-111)111
● Good	Milionerilli
○ Best	E.S. = 2.

▲ Radial blur

This provides a more abstract effect, in which the camera appears to have been spun around (or the lens zoomed) during the exposure.

Adjustments

As with most computer software, image-manipulation programmes typically have several different ways of achieving the same sort of result. Some are designed to be simple quick fixes for the beginner, while others are more sophisticated controls aimed at the more demanding user.

The software, therefore, allows the user to tweak the fundamental properties of the image (or a selection from it) in various ways. These include adjustments for contrast, colour, and brightness. The easiest way in

which these are altered is by using simple sliders, which adjust each of the properties in turn in much the same way as a televison remote control.

If you shoot in RAW, it is possible – and, indeed, preferable – to make corrections to contrast, exposure, and colour balance during the RAW conversion process. Fine-tuning and selective adjustments to parts of the picture are carried out after conversion, while the original RAW file is left (and saved) untouched.

Brightness and contrast

Contrast and brightness are two of the most basic types of digital image adjustment, and they are frequently used in unison. In popular image-manipulation programmes, slider controls for these are generally found in the drop-down window. Used in tandem, they provide a method for tweaking the exposure of the digital image.

As a general rule, an increase in brightness will need a simultaneous increase in contrast, although the amount of adjustment may well not be precisely the same for both. Conversely, any decrease in brightness will generally also necessitate a decrease in contrast.

These controls, of course, are well known to the user of the black-and-white darkroom, where the amount of time under the enlarger and the grade of paper are used as ways in which to translate the information contained in the negative. But in the digital darkroom these adjustments can be applied just as successfully to colour pictures – and with extremely fine control over the result.

However, this is a crude way of altering exposure that should generally be avoided; a far better method is to use the levels or curves adjustments (*see pp.388*–9).

▲ Original image

This studio image already uses bizarrely coloured make-up to create an arresting portrait, but adjustment was needed to give the image more contrast, and to make the colours stand out further.

VARIATIONS

The variations option found on Photoshop Elements provides an at-a-glance view of different colour adjustments that could be made to the image. This comparison of thumbnails can be fine-tuned to provide quite subtle changes over the result. The small images, however, mean that the option can be used only for rough editing.

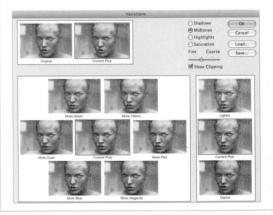

▲ Brightness and contrast control

In this shot, the brightness and contrast were changed using an adjustment layer (*see pp.382–3*). By boosting contrast and brightness, the whites of the model's eyes and the red of her lips stand out better.

Colour controls

The saturation tool can be used to improve drab colour in a picture, in much the same way as by boosting the contrast. Turned right down, the saturation slider will provide a monochrome image; when set to maximum, it will depict the scene in psychedelic tones.

The saturation control is normally found with those for hue and lightness. Used together, these can provide precise control of the colour balance. Changes can be made to individual tones, too, as different measurements can be applied to the different colour channels.

Original image

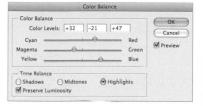

▲ ► Colour balance control

This colour control tool provides a slider control for each primary colour. The levels can be raised or reduced. Each is paired with its complementary colour – a decrease in green, for example, means an increase in magenta. Here, the rose has been given an enhanced pink appearance.

▲ ► Hue and saturation control

This set of controls can be used to change the colour range of the picture, to boost or reduce the colour saturation, and to change picture density. Here, the controls have been used to warm up the result and make it more vibrant.

▲► Selective colour control

This colour control can be used to change colours, or groups of tones, collectively. In this case, the midtones have been given a rich blue colouring, creating a surreal result.

Levels and curves

To the non-scientifically minded, the levels control found on good image-editing software can seem frightening, and also rather meaningless. However, even if you consider yourself more an artist than a technician, it is worth learning how to interpret these data, and how they can be adjusted, as this is by far the easiest and most foolproof way to correct exposure, contrast, and colour balance in photographs. Unlike other methods, image-editing software does not rely on the visual eye and is not influenced by subjective or environmental factors.

Every level of grey between pure black and pure white is given a value between 0 and 255; the software then counts this value for each pixel in the image, and plots the results as a graph. The shape of the graph shows how good the exposure of the image is. Ideally, you should expect readings all the way across the graph, with low readings at both extremes of black and white, and a peak, or peaks, towards the middle. If the readings are bunched to the right, the image is too bright (or intentionally high-key). If they are bunched to the left, the shot may be underexposed.

Correcting exposure

Exposure errors, or imperfect scans, can be adjusted simply by using the levels histogram. The first step is to move the pointers at 0 and at 255 inwards (if necessary), so that they are underneath the points where the graphs tail off completely. With these two movements you set new white and black points for the image, and immediately gain far better tonal distribution.

The next step is to move the point beneath the middle of the graph. This is the "gamma" adjustment, and it is essentially the level that the mid-grey is set to. It is set automatically to 1.00, but moving it up or down will increase or decrease the overall brightness of the picture.

Once set, the programme then resets the levels for the image, creating a new, better-shaped histogram for itself, based on your corrections. With practice, the histogram

adjustment takes just a few seconds, and should be undertaken (even if no adjustments seem, or prove, necessary) with every picture. The correction should ideally be made to an adjustment layer, rather than to the original file (*see pp.382–3*), so that you can make any additional adjustments using this layer at a subsequent stage (as well as allowing you to undo the adjustment).

Colour correction

As it is often possible to alter the histograms for each of the individual colour channels separately, the levels of control can also be used to correct or amend the colour balance. By using the same procedure of adjusting the white and black points alone for the red, green, and blue channels, colour casts can often be removed.

▲ Weak original

A poorly scanned transparency of this wonderful Henry Moore sculpture fails to do it justice. The histogram indicates that the digital image lacks dark tones.

■ White point

The white slider is only just beyond the end of the histogram; moving the slider in further lightens the image and reduces the contrast.

▲ Black point

Moving the black slider (the lefthand side of the line below the histogram) to where the graph begins creates a marked improvement.

▲▲ Optimum levels

Moving the gamma slider (the middle of the three arrows below the histogram) to the left provides a darker, punchier, final exposure.

UNBALANCED IMAGES

The histogram display gives an instant verdict as to the quality of an exposure or digital scan. However, seemingly imperfect results might be explained by the subject itself. Peaks at the two extremes of the graph are normal if the subject is made up of areas of pure white and

▲ Missing highlights

The problem with this graph is that there are no light tones present. Adjusting the white level slider will help here (see opposite).

▲ Shadow clipping

The main problem with this graph is that it is bunched up at the left-hand side, suggesting that significant shadow detail has been lost.

jet black. The comb-like effect (see below right) with periodic breaks in the graph is to be expected if the image has been posterized - and this effect has to be accepted if it has previously been heavily manipulated; it is not necessarily a symptom of disaster.

▲ Combed effect

Jagged peaks, with deep troughs with no reading at all in between, show an overprocessed file that should not be altered again.

Coping with curves

The curves control is another useful, scientific, way of manipulating exposure. Like levels, it presents the user with a graph, but the information it gives is very different from that of the levels histogram. The curve graph tells you nothing about the picture you have, it just gives a representation of how it is going to process the tones in the picture. Input density is plotted against output density. Curves can be altered in each channel, giving precise

■ Original

Upon opening, the graph is a 45-degree straight line, showing that no manipulation has taken place.

▲ Suppressing shadows

Here the line has been shifted so blacks become dark greys, and highlights are enlarged, giving a high-key result.

control over colour balance. However, by playing around with the shape of the line, you can change the densities of different tones. The midtones can be lightened separately from the shadows and highlights. The curves control is particularly useful for creating special effects. By creating a U-shaped graph with a black-and-white image, a darkroom Sabattier effect (see pp.366-7) can be recreated within seconds, and with more control than is possible in the traditional darkioom.

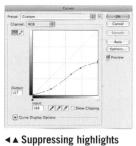

The highlights have been turned into midtones, and shadows made darker, creating a low-key effect.

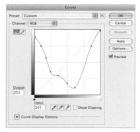

▲ Solarization

By creating a U-shaped graph with a colour image, a solarized effect can be created.

Quick tricks

Digital manipulation software is capable of creating spectacular effects and producing images that were practically impossible with conventional photographic means. The real allure for most people of programmes such as Photoshop, however, is not major reconstruction, but the minor corrective surgery that they can deliver. This can be anything from removing red eye on a portrait, to changing the colour of a major element of the picture

with very little effort. As well as tweaking colour and exposure, and removing unwanted details, image editing also allows the user to overcome many of photography's traditional problems. It can be a relief, therefore, to find that such problems can be eliminated in the post-production stage with minimal effort. All the fixes shown here can be done relatively quickly, allowing easy experimentation with different aspects of the image.

Using masks for montage

Masking is a vital tool for advanced manipulation work. Essentially, it is a way of displaying and editing a selection within an image. However, the mask can be worked on independently from the actual image, which is particularly useful with intricately shaped edges. The mask can be saved to be changed later on, or for use with other images. Masks are greyscale channels and are useful when merging two images, allowing the user to make the transition roughly first to see the effect, before defining the edges more precisely for the final version.

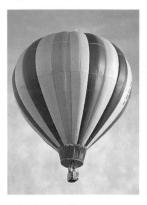

▲ Background layer
The aim was to cut the balloon
out of this picture, so that the
background could be changed to

a variety of different patterns.

▲ Creating the mask
Using Photoshop Elements' quick
mask mode, the sky was selected
and converted into a mask for use
with this shot of peeling paint.

▲ Quick mask layers screen
The mask can be saved as a
layer, which is attached to the
background layer, so it can be
refined at any point.

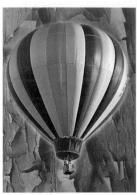

▲ Final image
The final combination was quickly completed. Since the mask was saved, other patterns can be tried without redrawing the mask.

Removing red eye

While avoiding red eye is a well-known priority for all photographers (see pp.168–9), most people will find that their pictures suffer from this disfiguring side-effect of flash at some time. To fix this digitally, the red pupils of the eye are selected and turned dark grey. Many basic image-manipulation programmes have a facility that does

this semi-automatically; however, it is simple enough to do by hand. Zoom in on the eyes, so that the area can be seen clearly. When selecting the red area, try to leave the white reflections – the catchlights of the eye – unselected, and feather the area. The red can then be recoloured a dark grey using the hue/saturation control.

▲ Selecting the red eye
Select the red area using the magic

Select the red area using the magic wand tool, adjusting the tolerance so that all affected pixels are selected. Feather the selection.

▲ Alter hue/saturation

Using the hue/saturation controls, alter the lightness and hue of the area until it appears a natural blackish grey.

▲ Altered image

The finished image still retains the white highlighted areas of the pupils to prevent the effect from looking unrealistic.

Mono conversion

Changing a colour image to black and white is a simple, one-step process using digital image-manipulation software (*see pp.376–7*). It is possible, however, to improve on the sometimes rather flat result of such a greyscale conversion by having far more control over the tonal range of the image. The channel mixer or black-and-white adjustment

layer on professional software such as Adobe Photoshop effectively allows you to convert the scene as if you were using colour filters with black-and-white film (*see pp.64–5*). As each colour channel can be adjusted individually, these tools allow more precise control than with filters – and you can actually see the effect you are getting on screen.

▲ Original image

Starting with a colour image provides far greater goope than if the Irrage was shot or scanned in black-and white, eyen if the intention was always to use the shot in monochrome. This is because the tonal range can be more accurately controlled during conversion if the colour information is present.

reset: Custom	(A) 5	E ny
Output Channel: Gray		(Cantel)
- Source Channels		Preview
Red:	+100 %	
Creen	[U]	
Blue:	0 3	
Total:	0 %	
Constant:	0 9	

▲ Greyscale conversion

With all the sliders set to their default values, the effect was the some as a straight greyscale conversion, and the result looked flat.

▲ Changing the channels

By boosting the red channel, and making minor corrections with the other sliders, a better black-and-white shot was produced.

Image framing

Black-and-white printers who work in darkrooms producing prints for professional photographers sometimes print intricate borders on their work, which act as a signature and an acknowledgement of their often unsung part in the creative process. Such borders can be added very simply in the digital darkroom, and most image-editing

programmes have a selection of borders that can be added as a one-step operation (others can be added using "plug-in" software). Borders look particularly effective in brochures and websites, helping to link different images with a common style. Do not over-use these effects, though — most pictures look best with clean-cut rectangular outlines.

▲ Textured frame

This border suits the shot of this marble carving well, since the textured material adds to the oriental feel of the subject matter.

▲ Jagged edges

This built-in border from Photoshop Elements provides a broken edge to the image, as if the picture were printed with a wood block.

▲ Matte mask

Neutrally coloured borders can take the place of a matte mask (*see pp.394–5*), containing the image within the borders of the printing paper.

Special effects

Many of the most breathtaking special effects in digital imaging come from the use of "filters". These are special effects that work within a manipulation package to control the image in a huge variety of different ways. While a programme will come with a range of filters that provide blur and sharpening tools as well as other artistic effects, additional filters can be bought or downloaded to add to the creative toolbox. These "plug-ins" are essentially

little bits of software that are designed to add functionality to an existing image-editing programme.

While some of these filters and plug-ins are designed for more advanced use than others, as with any type of special effect they should be used sparingly to retain their impact. The ease with which pictures can be made to look like oil paintings or pencil drawings is impressive, but the effect will become tedious if over-used.

Photomontage

Although many effects can be applied to digital images with little input from the user, some of the more creative uses of digital photography are more involved. Combining two or more images to make one can be done in a fairly straightforward way (*see pp.390–1*); however, if two completely different images are to be montaged so that the

joins cannot be seen, the whole process may take hours or even days to complete, rather than just minutes. Patience and artistic flair are necessary to make the job convincing. It is essential that different elements, effects, and masks are saved in separate layers, so that stages do not need to be repeated unnecessarily.

▲ First layer

The first element for the photomontage was a statue, from which the head was carefully selected for use in the final composition.

▲ Second layer

The background for the final image was a crevice in a wall, the colour and density of which were manipulated to match the statue.

▲ Finished result

Careful working on the mask meant that the joins in the final photograph could not be seen – and the head looks like part of the wall.

Photomerge

While photographers have traditionally made panoramic images by sticking a set of prints together (see pp.130–1), with digital files it is possible to do this without the joins showing. Some manipulation programmes have a facility that helps you to do this, but the facility is also available as a separate programme. These programmes not only allow you to line up the different frames accurately, they also let you adjust slight differences in exposure and perspective before the different frames are merged together.

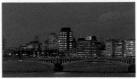

▲ Photomerge screen

Photoshop Elements has a facility to allow you to stitch together different shots from a panoramic sequence. The program will attempt to arrange and blend your selected images together automatically.

◆ Original sequence

These pictures of the River Thames, UK, were taken from a sequence shot at twilight. They could be assembled into a panorama with conventional means, but the results are more convincing when this is done digitally.

Filter effects

Filters allow you to transform your image at the touch of a button to create myriad decorative effects. They can be used to recreate art effects, to distort an image, to create a stylized, geometric effect, or to add texture. Some filters can make heavy demands on your computer, so you may find your computer works slowly on a large file.

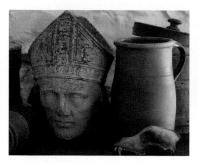

▲ Original image

Use filters after the image has been cropped. Depending on the chosen filter effect, it may be useful to adjust the levels first.

▲ Palette knife

This is one of a number of effects available with Photoshop that turns images into paintings, mimicking different artistic styles.

▲ Bas relief

This filter re-creates a darkroom special effect. It mimics a negative and positive that have been printed together out of alignment.

▲ Grain filter

One reason why photographers use fast film is to get a grainy image, but this effect can be added digitally, however the shot was taken.

▲ Posterization

This filter has posterized the image, creating distinct areas of colour, as might be seen in a painting-by-numbers picture.

▲ Negative

In this shot, the filter has reversed the tones of the image, creating a monochromatic image that looks as if it has been toned blue.

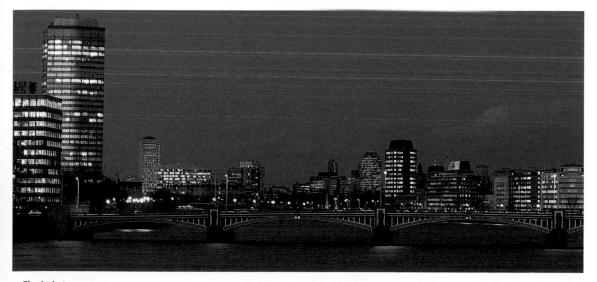

▲ Final photomerge

Photo-stitching programs tend to work only semi-automatically – the user needs to guide them in order to get the right results. Even when they are finished, the joins can sometimes still be seen, though these can be masked easily using the cloning tool and retouching techniques (see pp.380–1).

Storage and display

Whatever the subject matter, and whatever camera equipment you use, it is important to store your pictures safely. Putting them in a drawer or saving them on a CD are easy solutions, but neither do justice to your photographs. You need to be able to look at your pictures, and your best shots should be made available for all to see.

There are many ways of keeping pictures stored safely, whether recording images on film or in digital form. When working digitally, it is essential to protect files from deletion or corruption (*see pp.374*–5), but the priority when

storing film and prints is preventing damage from fingerprints, dirt and dust, chemical contaminants, and living organisms.

How easy it is to display pictures will vary depending on how they are presented. Negatives are usually processed to give prints, which are easy for all to view. Digital files can be transmitted far and wide by email or as web pages. Slides are harder for groups of people to see easily. But using slide projectors and lightboxes are perfectly feasible ways of sharing images with large or small groups, without the need to have the images printed or digitized.

Albums and files

One of the simplest ways of storing a large number of pictures, whether small prints, negatives, or slides, is in an album. Loose-leaf file pages can be bought to fit a wide variety of formats and picture types, and are designed to fit into binders or filing cabinets. Negatives are best stored in protective sheets to prevent scratching, and are easier to locate if filed alongside their respective contact sheets (*see p.361*).

Albums come in a huge range of designs for print storage. Slot-in pages are available for some common print sizes, but a more flexible approach is to use albums with either blank pages or self-adhesive plastic-covered leaves.

DATE _24/04/2003 LOCATION _London SUBJECT _Big Ben

▲ ► Cataloguing

Slides can be stored in clear plastic sleeves or black cardboard grids (*right*). Captions can be added to the slide mount with adhesive labels (*above*).

■ Viewing prints

Shop-bought albums allow you to store prints neatly and safely. In this spiral-bound album, prints are held undamaged under a removable plastic overlay, which sticks to the self-adhesive surface of the page.

Frames

Pre-cut frames can be bought in a wide variety of designs. However, the range of sizes is often limited, so it pays to explore which frames are available before printing out an image at anything but the most common sizes. Bespoke frames can be made by many high-street outlets, but it can be fun to make your own. To give your picture a professional finish, you need a special tool that cuts the cardboard mount sitting between the glass and picture at a 45-degree angle. This mat cutter can be bought at art supply shops.

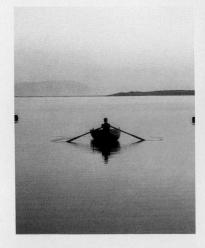

▲ Framing prints

Frames can be bought at many photographic and print stores to fit most standard print sizes. A simple wooden frame (*above*) or a clip frame (*left*) both offer inexpensive ways to exhibit your pictures on a wall.

Digital frame

A modern method of displaying your pictures is to buy an LCD display, which sits on a wall or shelf like a picture frame. The screen has a memory card slot, and can either display a single picture or run through your favourite JPEGs as a continual slide show.

A similar effect, without the expense, can be obtained by using one of your best shots as a screensaver or slide show on your computer. One way of ensuring that your pictures are seen more regularly is to put them on television. Many companies offer the service of transferring slides, prints, or negatives on to video tape or DVD. They will even add background music to your pictures.

▲ Personal screensaver

A low-cost means of viewing a favourite picture is to use it as a screensaver or desktop wallpaper on a home or office PC. Many operating systems will allow you to choose an image, or selection of images, for this purpose.

Transparencies

A slide projector creates an enlarged image of a transparency on a wall or screen using a bright lamp and a lens. Professional models have interchangeable lenses, so that the projecting distance and field of view can be adapted to suit the size of the room. ICD projectors take images direct from a computer screen and project them on to a screen. The brightness and resolution of these units vary significantly depending on how much is spent. However, with digital images stored on a laptop, these digital projectors provide a useful way of showing work to a group of people.

When using slide and LCD projectors, the type of screen has a dramatic effect on the picture. Some slide projectors have a built-in screen.

► Slide projector

Projectors can be found for hoth 35mm and medium-format mounted slides; images can be inserted separately, but are usually loaded in magazines so that the pictures can be changed quickly. Some models have the advantage of autofocus.

▼ Viewing slides

Slides need backlight to be viewed. This can be provided by using a lightbox (a backlit screen), which lets you see shots either individually or, if they are in storage sleeves,

JOHN HEISECOE STUDIO

one sheet at a time. Storage sleeves help to prevent slides being scratched or damaged.

Archival permanence

Nothing lasts for ever, including photographs. However you take or store your pictures, they are prone to decay. Negatives react with gases commonly found around the home, will fade if exposed to light, can be damaged by mould, and can also be inadvertently impaired from poor handling. Some materials last longer than others - unless you use archival photo inks and paper, inkjet prints can deteriorate in weeks in strong sunlight conditions. Slides and negatives should ideally be stored in archival-quality filing sheets at an even temperature and low level of humidity.

▲ Discoloured photographs

Often the first sign of decay is a change in the colours of a print or slide, because each layer reacts with the environment at a different rate. Photographers who wish to keep their pictures for posterity should use storage materials that have been made with archival permanence in mind and that contain no acids that might react with the film or restrict airflow to the film's surface.

Working in photography

Photographs taken by professionals appear everywhere. The images on every advertisement poster, in every newspaper, magazine, and illustrated book, in company reports and on corporate websites, in shopping catalogues and holiday brochures – all of these were shot by someone, and most of the photographers were paid. Millions of pictures are shot and sold every year by those taking photographs for a living, or by those who are supplementing their income.

Turning a hobby into a career can be appealing. But to do so successfully means finding either someone to employ you or a successful way of marketing your pictures yourself. A few photographers make small fortunes as papparazzi, or by shooting fashion pictures in exotic locations. Most earn their income by doing work that is much less glamorous, and more humbly paid.

There are many ways in which a self-taught enthusiast can make money from photography. However, for some types of work, formal training is either essential or highly desirable. A college will give you a good grounding in the use of professional equipment and an in-depth knowledge of lighting, as well as career guidance.

High-street photography

Despite the number of cameras in the world, many people still pay to have their picture taken. Family portrait and wedding photographers can be found in every town. And as there is a steady stream of people getting married and having babies, there is always a supply of customers. Your portfolio will be your main sales brochure, but developing a reliable reputation is just as important. Good communication skills and the ability to work well, and without mistakes, are essential when shooting an unrepeatable event such as a wedding.

▶ Wedding portraits

The vast majority of working photographers are general practitioners: working in a high-street studio, they may be commissioned to take all manner of pictures. The majority of most photographers' work, however, consists of portraits of family members – and, above all, weddings.

Press photography

Every newspaper, large or small, employs photographers, even if they are paid only by the picture. If you are interested in press photography, there is no better place to start than asking at your local paper. They may be happy for you to shoot events that they would otherwise not be able to attend, particularly if you can provide your own accompanying text or caption. Good pictures sell newspapers, and an editor will always be willing to pay for a strong image, particularly of a one-off occasion, even if he or she did not ask for it beforehand.

Consider more specialist magazines and journals – they all need a regular stream of new pictorial material. Try submitting to periodicals that might be interested in your shots, but contact them before sending your images to find out any particular requirements they may have.

▶ Shooting an event

Suit your picture to the publication. For instance, a shot of an artist's exhibition, such as this one of sculptor Bryan Kneale, may be of interest to a local paper or an art magazine. Magazine and newspaper photographers are not all employees – many are freelance. If you have a suitable photograph for a publication, the picture editor may well pay you for it, whatever your experience.

Image libraries

Not all pictures are commissioned, or even shot, for a specific purpose. If an advertising agency wants a photograph of a penguin for a campaign, the chances are it will use the services of a picture library. These often hold millions of images covering every subject imaginable, and can therefore react to any requests that they have from their clients. Images are most often available through the libraries' websites. These pictures are supplied by all sorts of photographers – the library is interested only in the quality and the subject matter. Libraries handle all the sales and marketing, and typically they take a commission of 50 per cent on any work they sell.

▼ ► Onscreen images for sale

The style of web pages found at online image libraries is shown left. Shots are searched for using keywords, and the results are shown as thumbnails – a larger example is shown below. You then buy or hire the image you like.

Specialization

While more pictures of travel are bought and sold than of other subjects, there are many people around the world already supplying the market. It sometimes pays to specialize in a particular subject and then gain a reputation as the person to contact for this type of picture. You could then combine an area of expertise or a personal enthusiasm with your new career. Some photographers, for example, have made a living just taking pictures of polo or another minor sport.

In photography, if often pays to have a passion for your subject matter, as well as some business acumen. The more you know about a sport, a type of wildlife, gardening, a particular region, or any other specialist topic, the better equipped you will be to take pictures of it for the widest number of markets.

▶ Finding a niche

Magazines are published on all manner of subjects, and they must all obtain their pictures from somewhere. By specializing in particular markets and subjects, you can build a reputation for your work with the relevant clientele. Shots of snowboarders may sell to snowboard magazines, to men's monthlies, to advertising agencies, or to hundreds of other clients who require a macho image.

Glossary

Aberration Optical defect in a lens.

Accessory shoe Mounting on a camera or other piece of equipment for attaching accessories. Those with electrical contacts are known as hotshoes.

Achromat Type of lens designed to correct for chromatic aberration.

Active autofocus Automatic focusing system in which the subject distance is actively measured by the camera. This is usually done using an infrared beam. Used on film compact cameras.

Acutance Measurement of image sharpness, calculated by analyzing the edges of a subject. While the actual sharpness of an image is subjective, acutance can be measured objectively by shooting a high-contrast target and seeing how distinct the boundaries are between black and white.

Adobe RGB One of two colour settings commonly found on digital SLRs. It allows a wider range of colours to be recorded than the alternative sRGB setting and is the option used by most serious photographers. See sRGB.

AE Commonly used abbreviation for automatic exposure.

AEL (automatic exposure lock) Pushbutton device on some cameras that allows choice of which part of the scene the camera takes its meter reading from, and then locks this setting while the image is reframed.

Aerial perspective Sense of depth created in a picture by haze or pollution, giving different layers of tonal separation. The farther away an object is from the camera, the more air and particles the light has to pass through, so distant subjects appear paler than closer ones.

AF Common abbreviation for autofocus.

AF illuminator System used in some cameras to assist autofocus in lowlight situations. A red pattern of light is projected on to the subject, which aids the contrast-detection autofocus to adjust the lens correctly.

Air release Accessory used for firing a camera from a distance, or for minimizing vibration when firing. By squeezing a rubber balloon at the end, a jet of air is used to press the trigger.

Alkaline battery Most common type of non-rechargeable single-use battery. Commonly used to power compact cameras and portable flashguns.

Alpha channel Monochromatic copy of a digital image, sometimes used in digital manipulation as a way of masking selected parts of the image.

Ambient light Existing light in the scene, excluding any light source artificially added by the photographer.

Analogue Non-digital recording system in which the strength of the signal is in direct proportion to the strength of the source.

Anamorphic lens Type of lens that squeezes the image in one of its dimensions. The image can be restored to normal by using the same type of lens for printing or projection.

Angle of view Measure of how much a lens can see of a scene from a particular position. Usually measured in degrees diagonally, horizontally, or vertically. The longer the focal length of the lens, the smaller the angle of view. Zoom lenses have adjustable angles of view.

Anti-aliasing Method of smoothing diagonal lines in digital images to avoid a staircase, or stepping, effect created by the individual pixels.

Aperture Opening in the lens that helps to restrict how much light reaches the film or image sensor. In most cameras, the size of the aperture is adjustable. The aperture setting used has an important role to play in both exposure and depth of field.

Aperture priority Semi-automatic exposure system in which the aperture is set by the photographer, and the shutter speed is then set by the camera to suit the measured light level readings taken by the camera's metering system.

Apochromat Lens that is designed to compensate for chromatic aberration by bringing all colours of light into the same point of focus. Used for some telephoto lenses, where chromatic aberration can be a particular problem.

APS (Advanced Photo System) Miniature film format once widely used by compact cameras. The sprocketless film is never seen by the user. It is automatically loaded from the cassette by the camera, and returned to the cassette after processing. The image area is 30.2 x 16.7mm, but three different print proportions can be chosen at the time of shooting.

APS-C Size of sensor used by many popular digital SLRs, measuring around 22.5 x 15mm.

Archival Any process or material that is specifically designed to improve the life expectancy of the image.

Array Arrangement of image sensors in a digital device.

Artefacts Unwanted information in a digital image, caused by limitations in the recording process.

Aspect ratio Relationship between the width and height of a picture, describing the proportions of an image format or a photograph. The aspect ratio of most digital SLRs is 3:2, or three units wide to two units high. Most digital compacts have an aspect ratio of 4:3 (four units wide by three units high).

Aspherical lens Lens element with surface that is not perfectly spherical. Aspherical lenses are used in wideangle and wide-apertured lenses to help prevent distortion.

Astigmatism Lens fault, or aberration, whereby horizontal and vertical lines cannot be focused correctly in the same focal plane.

Attachment Digital file that is sent with an email.

Autofocus System in which the lens is adjusted automatically by the camera to bring the image into sharp focus.

Autofocus illuminator See AF illuminator.

AWB (automatic white balance) System on a digital camera that automatically adjusts the colour of the recorded picture so it looks normal to the eye.

B (bulb) setting Shutter speed setting on a camera that allows you to keep the shutter open for as long as the trigger release is pressed down. Used for providing exposures that are seconds or minutes long.

Back projection Projection system in which the image is projected from behind a translucent screen; it hides the projector from the audience, and creates a backdrop in the studio from a slide or a digital image.

Back-up Copy of a digital file, kept in case of damage to, or accidental deletion of, the original.

Backlight button Simple manual exposure adjustment that allows the user to give the image more exposure than the camera's built-in meter suggests. A backlight button adds one to two stops more exposure, and is particularly useful when the principal light source is behind the subject.

Backlighting Light source on the far side of the subject, in relation to the camera.

Ball-and-socket Type of tripod head that allows simultaneous movement of the camera in two different planes. Allows

- quick adjustment of camera, but does not provide the precision of a panand-tilt head.
- **Barn doors** Hinged flaps on the front of studio lights that allow control of the spread of light.
- Barrel distortion Type of lens distortion, or aberration, in which straight lines at the edge of an image tend to bow outwards, as on a barrel.
- Bas relief Darkroom effect in which a negative and positive are sandwiched together and printed slightly out of alignment. It gives a carved-in-stone look to the resulting picture.
- Baseboard camera Type of large-format camera designed for location use, which can be folded up when carried. It allows a more limited range of camera movements in comparison to a monorail camera.
- Battery grip Accessory for an SLR camera that provides a higher battery capacity and often improves handling characteristics of the camera for some photographers. Some grips increase the maximum burst rate or motordrive speed of the camera.
- Bellows Accessory used in macro
 (and large-format) photography.
 A rectangular tube of black material
 creates a chamber between the lens and
 the film. This chamber can be adjusted
 to make it longer or shorter, to alter the
 magnification of the image.
- Bit Basic unit from which any digital piece of data is made up. Each bit has a value of either 0 or 1. The size of digital files are usually counted in bytes, which are each made up of 8 bits.
- **Bit depth** Alternative term for colour depth.
- Bleaching Darkroom process whereby the black metallic silver is removed from the emulsion. The procedure is an integral stage in using many toners.
- Bleed Picture that is printed, or subsequently cut, so that the image goes right up to the edge of the paper.
- Blu-ray Disc Compact-disk format that typically has a memory capacity of 25GB. Some can be written to only once; others are rewritable. Used for back-up and storage of digital files.
- Bluetooth Type of wireless connection that links different computer peripherals and digital devices using radio signals.
- **Bokeh** Description of the out-of-focus characteristics of an image, or the lens that created them.
- Bounce flash Indirect flash lighting

- technique whereby the flash is deliberately angled to bounce off a wall, ceiling, or other reflector – to scatter and soften the illumination.
- **Bracketing** Way of ensuring the right exposure by taking a sequence of pictures with a slightly different exposure setting for each.
- **Brolly** Umbrella-like reflector that attaches to a studio light. It produces soft lighting over a wide area.
- Bromide paper Type of photographic paper used for black-and-white printing. It takes longer to wash and dry than more popular resin-coated papers, but is capable of producing a different quality of result.
- Buffer Temporary memory used by a camera. The size of the buffer helps dictate the maximum burst rate and the number of continuous shots that can be recorded at this rate.
- Bulk loader Device used to help load bulk lengths of 35mm film into their individual cassettes. Loading cassettes by hand can save money, but care must be taken to ensure that the film is not scratched during the procedure.
- Burning in Giving additional exposure to selected areas of the image at printing stage, or during digital manipulation. See also dodging.
- Burst rate Continuous shooting speed of a digital camera, similar in functionality to the motordrive of a film camera. It enables a sequence of images to be taken in rapid succession and is measured in frames per second (fps). This rate can only be sustained for a number of shots, determined by the camera model and the recording format being used.
- Byte Standard unit for measuring memory capacity of digital storage devices. Each byte can have one of 256 different values, and is equal to 8 bits.
- 0
- C41 Name for the chemical process most frequently used for developing colour print films.
- Cable release Mechanical or electrical device for firing a camera from a distance, or for minimizing vibration when using a tripod, in conjunction with a slow shutter speed.
- Camera movements Ability to manoeuvre the lens and image plane independently of each other. This allows a high degree of control over perspective, image distortion, and the plane of focus. Normally found only

- on large-format cameras. Very limited camera movements, however, are provided by shift lenses.
- Camera shake Blurring of the image caused by movement of the camera during the exposure. Handheld cameras are particularly prone to camera shake, and therefore faster shutter speeds need to be used.
- **Capacitor** Part of the flash unit that temporarily stores electrical charge.
- Catadioptric Type of telephoto lens (also called a mirror lens) that uses a mirror to increase the length of light path and focal length, while keeping the length and weight of the lens relatively small.
- Catchlight White highlight in the eye of the subject, which is a reflection of the light source. The shape, size, and intensity of the highlight will vary, depending on the lighting set-up.
- CC filters Colour conversion filters pale colour filters designed to provide small changes in colour balance when using colour slide film.
- CCD (charge coupled device) One of the types of imaging sensor used in digital cameras. It is found at the focal plane, and converts the focused image into an electrical signal. Similar in function to alternative CMOS sensor.
- CD-R (compact disk recordable)

 Compact disk format that can be recorded on once; typically has a maximum memory capacity of 700Mb.

 Widely used for back up and storage of digital files.
- CD-Rom (compact disk, read only memory) Compact disk with prerecorded data that cannot be recorded over by the user. Used for the distribution of computer software.
- CD RW (compact disk rewritable)
 Compact disk format that can be recorded over many times; typically has a maximum memory capacity of 700Mb. Widely used for back-up and storage of digital files.
- Centre-weighted Traditional type of built-in metering system, still used on many modern cameras. Centreweighted average metering measures light intensity across the whole image area, but biases readings to those taken towards the middle of the frame.
- Changing bag Lightproof pouch with armholes that allows you to load and unload films without a darkroom.
- Characteristic curve Graph used to represent the characteristics of a film, in which the film density is plotted against exposure.

- Chromatic aberration Lens fault in which different colours of white light are focused at slightly different distances. Prevalent with telephoto lenses.
- Chromogenic film Film in which dyes are used to create the image; these replace the light-sensitive silver crystals during the processing. This is the usual type of colour print and slide film.
- Circle of confusion Circular disk of light on the image, created by the lens from points of light on the subject. The smaller these disks are, the sharper the image appears. If small enough, the disks appear as points to the human eye, so look acceptably sharp. The largest-sized disk that looks like a point is known as the least circle of confusion; this measurement is fundamental to accurate calculation of depth of field.
- Circular polarizer See polarizer.
- Clip test Processing procedure in which the first few frames are cut off an exposed roll of film, and developed separately. Any under- or overexposure problems can then be corrected for when developing the remaining exposures.
- Clipping Losing detail in the highlights or shadows of an image due to overor under-exposure.
- Clipping path Line used in digital imageediting software to define a cutout in an image.
- Clipping warning Facility found on some digital cameras in which the areas affected by clipping are indicated on the LCD screen.
- Clone tool Facility on many digital image-manipulation programs that allows replacement of one area of the image with a copy taken from another part. Used for removing blemishes, dust marks, and unwanted subject matter from a digital photograph.
- Close-up lens Filter-like device that fits on the front of the camera lens to magnify the image. This low-cost macro accessory can be used on a wide variety of different cameras. Close-up lenses come in a variety of different strengths, measured in diopters.
- CMOS (complementary metal oxide semiconductor) One of the types of imaging sensor used in digital cameras. It is found at the focal plane, and converts the focused image into an electrical signal. Similar in function to alternative CCD sensor.
- CMYK Cyan, magenta, yellow, and black: the four primary inks used in commercial and desktop printing to produce full-colour images. Digital

- photographs and scans are recorded in RGB (red, green, and blue); however, they can be converted to the CMYK colour space using image-editing software. It is not necessary to convert before printing.
- Colour balance Matching of film, or imaging chip settings, to ensure that white and grey tones appear in a picture as they would to the human eye. With colour film, colour balance can be changed using filters. With digital cameras, colour balance is changed electronically using the white balance system but can also be easily corrected using imagemanipulation software.
- Colour cast Unwanted colour tint to an image usually created by either incorrect colour balance or a reflection from a strongly coloured object.
- Colour depth Amount of colour information in a digital image. Most digital cameras offer 24-bit colour depth, offering 16.7 million different possible colour values for each pixel matching the number of colours that are distinguishable by the human eye. To do this, each of the sensor's three primary colours (red, green, and blue) offers an 8-bit depth (with 256 possible values). Some digital SLRs offer 12-bit or 14-bit depth for each of these colours; this extra detail is particularly useful for preserving quality during image editing.
- Colour gamut Range of colours that can be displayed by a computer screen or printed by a printer. This range of possible colours may well be different for both – and different from those recorded in the digital file.
- Colour management System that warns of colour gamut problems, and helps to ensure that the pictures printed look the same as those seen on screen.
- **Colour meter** Handheld exposure meter that can make objective colour temperature readings.
- Colour profile Description of how a camera, printer, monitor, or other device displays or records colour. It provides a universal way in which different devices can produce similar-looking results. Also known as an ICC profile, as the standards are set by the ICC (International Color Consortium).
- Colour temperature Measurement of the colour of light, often expressed in Kelvin. The human eye automatically adjusts for colour temperature most of the time. Digital cameras can make electronic adjustments using their white balance system. With colour film,

- correct filtration is often necessary when shooting or printing, if accurate colour balance is essential.
- **Coma** Lens fault that can create blurring at the edge of the image.
- Compact Camera that has a shutter mechanism built into the lens. Compact cameras are generally point-and-shoot designs that are easy to carry around.
- CompactFlash Type of removable memory card that is used by some digital cameras.
- Complementary colours Pair of colours that create white light when mixed together. The complementary colour of red is cyan; the complementary colours of green and blue are magenta and yellow respectively.
- Condenser Type of simple lens that concentrates and directs the light.
 Used, for example, in a spotlight or in some types of enlarger.
- Contact printer Darkroom accessory that helps to hold negatives in place accurately to produce a contact sheet.
- Contact sheet Darkroom print made by exposing the paper with the paper and negative sandwiched together. Often made to provide a first guide to a newly processed negative film, showing which are the better exposures on the roll before enlargement.
- Continuous AF Autofocus setting in which focus is constantly adjusted until the shutter is fired. Useful for moving subjects, when it is inappropriate for the focus distance to be locked once correct focus is initially found.
- Contrast range Measurement of the difference in brightness between the darkest and lightest parts of an image. Films and image sensors are capable of dealing successfully with differing, but generally limited, contrast ranges.
- Contrejour Against the light a picture shot where the light is behind the subject. Otherwise known as backlight.
- Copystand Apparatus designed for photographing flat artwork. The camera is supported on a platform that can be raised and lowered on a column to adjust magnification.
- Cove Curved background used in studios designed so that there is no visible join between walls and flooring, or between backdrop and surface.
- Covering power Largest image area possible from a particular lens. This is usually circular in shape, and just large enough to completely cover the actual format used. When using cameras with movements, or with shift lenses, the covering power must be greater to allow for these movements.

- Crop factor A way of comparing the zoom magnification of digital SLRs with different-sized sensors. The crop factor allows you to convert the actual focal length used to the focal length that would be needed to give that visual effect on a full-frame digital SLR or 35mm film SLR. Cameras with APS-C sized sensors have a crop factor of 1.5x, so a 200mm lens gives the same visual magnification as a traditional 300mm SLR lens. The crop factor on four-thirds cameras is 2x. Also known as format factor or focal length multiplier (FLM).
- Cropping Removing unwanted parts of an image by enlarging only part of the frame during printing, or during digital manipulation.
- **Cross front** Camera movement in which the lens is shifted sideways.
- Cross-polarization Special effect in which both light source and camera are fitted with polarizing filters. The technique is useful for revealing colourful stress patterns in plastic and certain crystals.
- Cross-screen filter See starburst.
- Curves Powerful image-manipulation tool that allows you to adjust the exposure, colour balance, and contrast of an image.
- Cyan Colour that is a mixture of blue and green light; the complementary colour of red.
- Dark slide Metal or plastic sheet that keeps the film in the dark when changing film backs on a medium-

D

- format camera, or when handling large-format film holders. **Databack** Accessory, or built-in facility, on some film cameras that
- allows you to record date, time, and other information on the film during exposure.
- Daylight film Type of film that is designed to give accurate colours when used with light with a colour temperature of 5,500K which is said to be average noonday light.
- Daylight tank Film-processing tank designed so that it can be loaded without the need for total darkness.
- Dedicated Type of flashgun designed to provide direct one-way or two-way communication with the camera. The amount of dedication actually given varies greatly. Increased dedication tends to provide more accurate flash metering, as well as making the flash system easier to use successfully.
- Deep tank Processing system in which the

- photographic paper or film is immersed in vertical troughs, rather than drums or dishes, of chemicals.
- Definition Term used to describe how much detail an image shows – or that a device is capable of showing. The definition of digital sensors and films varies, as does that of different lenses.
- Density Opaqueness of film or blackness of paper after exposure and development. Density is usually measured with a logarithmic scale.
- Depth of field Measure of how much of a picture is in focus, from the nearest point in the scene to the camera that looks sharp, to the furthermost point that looks sharp. Depth of field is dependent on the aperture used, the distance at which that lens is focused, and the focal length of the lens.
- Depth of field preview Device on some cameras that allows you to see the viewfinder image at the actual aperture you will be using for the exposure. This gives a visual indication of how much depth of field there is, and which parts of the picture will be sharp or blurred.
- Depth of field scale Markings found on some lens barrels that can be used to work out the depth of field for particular apertures, and for manual focus adjustments to maximize or minimize depth of field.
- **Depth of focus** Distance that the film plane can be moved for given lens settings while still recording an acceptably sharp image.
- Depth program Program exposure mode by which aperture and shutter speed are set automatically with the intention of providing maximum depth of field while maintaining a fast enough shutter speed for handheld camera use. On some cameras, the different subject distances, measured by the autofocus system, are also taken into account and the focus adjusted to suit.
- Detent Click stop, or catch, on an aperture ring of some lenses, indicating the different settings available. Some lenses have intermediate detents as well as detents for full aperture stops.
- **Developer** Chemical solution that converts the latent image created by exposure to light into a visible image.
- Developing tank Light-tight receptacle for holding the film during processing. It usually contains a spiral on which the film is mounted. The spiral allows the chemicals to reach the whole surface of the emulsion. A wide, light-tight opening allows different solutions to be poured in and out quickly.
- Diaphragm Another term for aperture -

- the adjustable blades that regulate how much light enters the lens.
- **Diapositive** Another name for a transparency slide.
- Differential focusing Using depth of field to ensure that one element in the picture is sharp while the other is as out of focus as possible.
- Diffraction Scattering of light caused by deflection at edges of an opaque object. Diffraction causes fuzziness in the image when the smallest apertures of a lens are used.
- Diffuser Any material that scatters the light as it passes through it. A diffuser softens the light, making it less directional, so that shadows are less marked. Diffusers are used widely with artificial light sources. With sunlight, clouds and particles in the atmosphere can have a strong diffusing effect.
- **Digital darkroom** *See* digital manipulation.
- Digital manipulation Any alteration to a digital image on a computer that changes its appearance. Digital manipulation software provides a range of tools and techniques that are similar to those of the traditional darkroom, and is often referred to as the digital darkroom.
- Diopter Optical measurement that describes the light-bending power of a lens. The diopter value is equal to the number of times that its focal length will divide into 1,000mm. Diopters are used to measure the strength of supplementary close-up lenses and viewfinder lenses.
- Dioptric correction Adjustment found on some cameras that allows alteration of the viewfinder lens to suit the individual user's eyesight.
- DNG (digital negative) Digital file format that offers the advantage of RAW but is an open standard so can be used by any manufacturer. The DNG format is used to record images by some digital SLRs. It is also used as a way of converting other formats into a form in which they can be read by imagemanipulation programs that cannot access all types of RAW file. Unlike other RAW formats, edited image files can be saved in the DNG format.
- Dodging Masking selected areas of the image at the printing stage to reduce exposure in that area in relation to the rest of the image. Image-manipulation programs have a dodge tool that mimics this effect. See also burning in.
- **Double exposure** Two images superimposed on each other. May be

- created accidentally, or deliberately for special effect.
- **Down rating** Alternative term for pull processing.
- dpi (dots per inch) Measure of the resolution of a printer or other digital device.
- DPOF (digital print order format) Facility available on some digital cameras that allows users to mark which images they wish to have prints made from.
- **Driver** Piece of software used by a computer to control a printer, scanner, or other peripheral.
- **Drop front** Camera movement in which the lens is shifted downwards.
- **Drying cabinet** Box that provides a dustfree, ventilated area in which films can be dried after processing.
- Drying mark Chemical residue left on the surface of a film or print after processing. This is usually caused by minerals in the water used in the washing process.
- Duotone Black-and-white print that has been treated with two different toners to create a two-coloured image. The effect can be recreated using some digital manipulation packages.
- **Dupe** Short for duplicate. Term used for a copy made from a slide or negative.
- **Duplicating film** Low-contrast fine-grain film that is specifically designed for making copies of slides.
- Dye sublimation Type of printer used to make high-quality prints from digital image files; the results look similar to traditional photographic prints.
- DX coding Black and silver markings on a 35mm film canister that can be read by many cameras. These usually tell the camera only the film's ISO speed, but they can also communicate information regarding the length of the roll and its exposure latitude.

F

- **E6** The chemical process most often used for developing transparency films.
- EFL (effective focal length) Measure that lets you compare the angle of view and magnification of different lenses and lens settings, whatever size of imaging chip is being used. The actual focal length is converted to the equivalent focal length that would give the same angle of view on a camera using 35mm film or a sensor measuring 36 x 24mm (1½ x 1in). See also crop factor.
- **Emulsion** The light-sensitive layer of a film or photographic paper.
- Enlarger Darkroom device used to project the negative on to the lightsensitive photographic paper.

- EPS (Encapsulated PostScript) Digital file format used for saving graphics and image files.
- EV (exposure value) Scale used to denote the amount of exposure needed without having to specify either shutter speed or aperture. A particular EV setting has its own set pairs of shutter speed and aperture. Exposure values are quoted in conjunction with film speed to denote a particular light level.
- Evaluative metering Metering system on some cameras by which light readings are taken from different zones across the image area. These are compared to data preprogrammed into the camera, so that it can work out which of the exposure settings are the most appropriate. Also known as matrix or multi-zone metering.
- EVF (electronic viewfinder) Miniature eye-level colour LCD screen, used as a viewfinder on hybrid digital cameras and some camcorders.
- EXIF (Exchangeable Image File) Data recorded by many digital cameras as part of the image file. These data automatically record a wide range of information about the picture, including the date and time it was recorded, aperture, shutter speed, number of pixels used, metering mode, exposure mode, exposure compensation used, and zoom setting. This information can be read by certain software, but can easily be lost if the image is subsequently saved in an incompatible file format.
- **Exposure** Total amount of light used to create the image.
- Exposure compensation Facility to manually override the built-in exposure meter of a camera to make the image lighter or darker.
- Exposure latitude Tolerance of a film or digital sensor to differences in overall exposure. Some films, particularly transparency films, have a small exposure latitude and so require precise metering and exposure setting to get an acceptable picture. Colour print film has a wide exposure latitude a feature that is exploited by some cheaper cameras with a limited range of exposure settings.
- Extension tubes Accessories used in macro and close-up photography that fit between the camera body and the lens. The extra extension between the lens and the film allows the lens to focus closer and to provide a higher image magnification than would otherwise be possible.

- Eye relief Measurement of the optimum distance between the user's eye and the camera's viewfinder.
- Eyepiece correction See dioptric correction.
- Eyepiece shutter Blind that obscures the viewfinder of an SLR camera. This is useful for long exposures as it prevents stray light from reaching the film through the pentaprism.

F

- F number Aperture setting. The number is the focal length of the lens divided by the diameter of the aperture. For this reason, larger f numbers represent smaller aperture sizes. F numbers are used so that exposure settings for a particular scene can be expressed independent of the focal length actually used; an f/8 setting on a telephoto lens effectively lets in the same amount of light as an f/8 setting on a wide-angle lens.
- F stop Alternative term for f number. Face detection Autofocus system found on many digital zoom compacts that identifies when people are within the frame and focuses on their faces.
- Fall-off Gradual loss of light or sharpness towards the corners of an image, caused, for example, by the lens not having enough covering power.
- Farmer's reducer Bleach used for reducing the density of negatives or prints; made from potassium ferricyanide and sodium thiosulphate.
- Fast film Film more sensitive to light than average, requiring less exposure than usual. Fast films are useful for those lowlight shots where long shutter speeds are inappropriate. A drawback is that the grain is larger than usual. Fast films have a high ISO rating, typically with an ISO speed of over 400.
- Fast lens Lens that has a wider than usual maximum aperture for that particular focal length or zoom range. Fast lenses are useful in lowlight, and capable of throwing backgrounds more out of focus than is usually possible.
- FB paper Fibre-based photographic paper used in black-and-white printing. Unlike resin-coated (RC) paper, it does not have a plastic coating over the emulsion.
- **Feathering** Technique used in digital manipulation to soften the edge of a selection or an effect. Some feathering is necessary with most selective operations so the joins do not show.
- File format Way in which a digital file is saved. A digital image can be saved in a variety of file formats,

the most common being RAW, TIFF, and JPEG. The format dictates which programs can open the file – as well as the amount of information and detail stored.

Fill-in flash Flash used as a secondary light source. A fill-in flash is provided as an option on many cameras with a built-in flash unit. It allows you to soften or eliminate shadows on foreground subjects, particularly with backlighting. It can also be used to boost the colours and contrast of foreground subjects in dull ambient light.

Film leader retriever Device that allows you to extract the end of a 35mm roll of film from its canister. Useful if the leader is accidentally rewound, or for some film development systems.

Film plane The flat surface where the image is focused in a camera. See also focal plane.

Film speed Sensitivity of a film to light; measured on the ISO scale.

Filter Transparent attachment that fits in front of a lens or a light source, which modifies the light or the image in some way. The term is also used for a wide number of special effects available with digital image-manipulation software.

Firewire Computer connection system used to connect digital devices. Also known as IEEE1394 and ILIIIA.

Fisheye Ultra wide-angle lens in which the image is left deliberately distorted, showing marked barrel distortion and typically offering a field of view of 180°. Circular fisheyes create a circular image in the centre of the frame, surrounded by a black border. Full-frame or diagonal fisheye lenses create an image that uses the whole of the available image area.

Fixed focal length lens See prime lens.
Fixed focus lens Lens with no focus
adjustment, as used on low-cost
compact cameras. A wide-angle lens
and small maximum aperture are used
so that everything from around 2m
(6%ft) to the horizon is sharp.

Fixer Chemical bath that removes unwanted silver salts from the emulsion. It stabilizes the image so that it is permanent and can be viewed in normal light.

FL-D (fluorescent-daylight) Colour balancing filter that compensates for the green colour cast that occurs when using daylight-balanced colour film under normal fluorescent light. The filter is magenta coloured.

Flare Stray light that reaches the film or image sensor, creating unwanted highlights or softening in the image. Lens coatings and lens hoods are designed to minimize flare; however, it is often a problem when shooting in the direction of a bright light source.

Flash synchronization Process by which the peak output from the flash bulb coincides with the shutter being fully open. With cameras using focal plane shutters, the shutter speed must be chosen with care to ensure that flash synchronization is achieved.

Flashing Darkroom technique whereby photographic paper is given a very brief exposure to white light. Although this creates no visible image, it reduces the contrast of the emulsion slightly. It is used as a way of gaining detail in highlights without losing detail in the shadows. The paper may be flashed before exposure under the enlarger (known as preflashing), or part-way through development.

Flashmeter Handheld exposure meter designed to measure output from a studio flash set up. The lights are connected to and fired from the flashmeter, and can be used to take incident and reflected light readings.

FLM (focal length multiplier) *See* crop factor.

Fluorescent lighting The lighting produced by striplight tubes. The colour halance can vary enormously depending on the tube type, with some designed to offer a white balance that is close to daylight. Digital cameras often provide several manual white-balance settings to allow for different types of tube. With film photography, an FL-D filter is usually used. See also FL-D.

Focal length Distance between the optical centre of a lens and its focal point. In practice, the focal length is a measure of the magnification and angle of view of a given lens or zoom setting. It is usually measured in millimetres.

Focal length multiplier (FLM) See crop factor.

Focal plane Flat surface where the image is focused in a camera. It is the plane where the film or imaging chip sits.

Also referred to as the film plane.

Focal plane shutter Shutter mechanism that sits just in front of the film plane. Used on most SLR cameras.

Focal point Point at which parallel lines of light entering a lens converge.

Focus finder Magnification device that enables you to focus an enlarger accurately in the darkroom.

Focusing screen Surface upon which the viewfinder image is projected. Its textured surface is designed to accentuate whether the image is sharp or not, thereby providing assistance when focusing.

Focusing steps Number of distinct positions that the lens can be manoeuvred to by the autofocus system. Basic autofocus cameras have a limited number of steps. Those with longer lenses, close focusing capabilities, and wider apertures may need hundreds or thousands of steps to focus accurately. On some cameras, the autofocus system is essentially stepless.

Fogging Exposure to film or photographic paper that creates density without being part of the image. This can be done by exposure to light, accidental or deliberate, or by the use of chemicals.

Follow focus Technique whereby the focus is continually adjusted to track a moving subject.

Format Dimensions and shape of the image recorded by a camera.

Format factor See crop factor.

Four thirds Size of sensor used by some digital SLRs, measuring 18 x 13.5 mm. Unlike most SLRs, it has an aspect ratio of 4:3.

fps (frames per second) Measurement of the continuous shooting rate of a camera system.

Front projection Way of creating a backdrop in the studio from a slide or a digital image. The image is projected on to a highly reflective screen, in front of which stands the subject. To avoid shadows on the screen, the camera and projector are positioned along the same axis using a semi-silvered screen to keep them in alignment. Digital manipulation techniques have made front projection redundant.

Frontal lighting Lighting that is directed towards the subject but behind or away from the camera.

Full frame Size of sensor used by some professional digital SLRs, measuring around 36 x 24mm (1½ x 1in). The image size is the same as that of 35mm film, so no crop factor is necessary.

G

Gain Amplification of an electrical circuit; used in digital cameras to electronically boost the sensitivity of the imaging chip in low light.

Gamma Method for measuring or setting the contrast.

Gaussian blur Image-manipulation filter that allows you to blur some or all of a digital image – to create an out-of-focus effect, for example.

Gel Gelatin filter, most often used for changing the colour balance of artificial lights. GIF (graphic interchange format) Digital file format that can be used for saving graphics and images.

GN See guide number.

Gobo Mask that is placed in, or in front of, a light to create a pattern over the image area. These can be bought in a wide variety of designs to fit spotlights; they can also be made to order to create projectable logos.

Golden mean Compositional technique, similar to the rule of thirds, used by artists to determine the ideal spot to place the subject within the frame.

Grade Measure of the contrast of lightsensitive photographic paper. Grade 0 has the least contrast, grade 5 has the most. The lower grades are described as soft; the higher grades are called hard.

Graduate Type of filter, coloured on one half, graduating to clear on the other half, used primarily to darken or add colour to the sky area in an image.

Grain Clumps of silver halide produced during development of the image. The faster the film speed, the larger these clumps become; they are more visible at high magnifications. Visible grain sometimes provides a useful textural quality, but it can be added using image-manipulation software. The noise at high ISO settings on digital cameras may also be called grain.

Grey card Card with an 18 per cent grey tint used for exposure metering. A meter reading is taken from the surface of the card, rather than from the subject, in order to measure ambient light levels. The card provides a tonal representation of an average scene. This is useful when photographing non-average scenes, such as ones that are predominantly white, as these would otherwise mislead the meter.

Greyscale Number of different shades of grey, including black and white, that are in a scene. For digital imaging purposes, 256 shades of grey are usually used to provide black-and-white images that appear to have continuous, stepless tone.

Guide number (GN) Measurement of the range or power of a flash unit for a given ISO setting (usually measured in metres at ISO 100: m/ISO 100). By dividing the guide number by the distance of the subject, the appropriate f number for the flash exposure can then be calculated.

H

Half frame Film format used by some cameras that uses 35mm film to produce a 17 x 24mm image area.

Half lens See split-field attachment.

Hand tinting Process by which colour is painted on to a black-and-white, or toned, print using special paints, dyes, or pastels. The effect can be recreated digitally with image-manipulation software.

Hardener Chemical often used in film processing, incorporated into the fixer solution to strengthen the emulsion.

HDR (high dynamic range) A digital imaging technique in which a series of identical pictures of a scene are taken at different exposure brightnesses and then combined into one image.

This provides detail in shadow and highlight areas that is not usually seen, and is particularly useful for high-contrast subjects, such as landcapes, interiors, and night scenes.

Healing brush Intelligent alternative to the clone tool found in some image-manipulation programs. It attempts to blend in the source pixels automatically into the image area you are working on.

High key Image in which bright, white tones dominate.

Highlight Brightest areas of an image; the white areas in a picture.

Histogram Graphical display used as a way of depicting and manipulating the brightness, tonal range, and contrast of a digital image. Histogram displays are used on digital SLRs as a way to assess exposure and contrast problems.

Hotshoe Accessory shoe with an electrical contact, used as the way of connecting a flashgun to a camera.

HSS (high-speed synchronization) Flash mode that uses a rapid series of flashes so that fast shutter speeds can be used without synchronization problems. *See* flash synchronization.

Hyperfocal distance Shortest distance at which a lens can be focused so that depth of field stretches to infinity for a given aperture and focal length. When focused at the hyperfocal length, depth of field stretches from exactly half the hyperfocal distance to infinity.

Hypo Colloquial term for fixer; short for hyposulfite of soda, a chemical used as a fixing agent by early photographers.

ICC See colour profile.

IEEE 1394 See Firewire.

iLink See Firewire.

Image stabilization System found on some digital cameras and some SLR lenses that automatically compensates for camera shake. The amount of camera movement is measured and compensated for by movement of the camera sensor or lens elements.

Incident light meter Light meter capable of measuring the amount of light falling on a scene, rather than the amount being reflected. An incident reading has the advantage of not being affected by the overall tone of the scene.

Infinity Optical term to describe objects so far away that light from them reaches the lens as parallel rays. It is generally used to mean objects that are on or near the horizon. Infinity is represented on lenses by the symbol ∞.

Infrared film Film sensitive to light rays in the invisible, infrared part of the spectrum. These films are usually also sensitive to visible light, so are most often used with filters to maximize their infrared sensitivity.

Infrared mark Red dot or line found adjacent to the focusing scale of some lenses. Infrared light is focused at a focal point in front of that for visible light. This mark is used to make adjustments to focusing or depth of field, when using infrared film.

Interpolation Artificial way of increasing resolution of a digital image used by some scanners, and digital cameras. The software guesses the values of imaginary pixels in between those it has actually measured.

Intervalometer Facility that allows the photographer to take pictures automatically at preset intervals.

Inverse square law Property of light stating that the intensity of light decreases in proportion to the square of the distance from its source. This has no noticeable effect with natural light, since the sun is so far away to begin with. However, it has a significant influence over the effective range and characteristics of artificial light sources.

Iris Alternative name for the aperture, or diaphragm, of the lens.

ISO (International Standards
Organization) Scale used for
measuring the sensitivity of a digital
sensor or film.

IX240 Another name for APS film.

J, K

JPEG (Joint Photographic Experts Group) File format used widely for digital images. A variable amount of compression can be used to vary both the detail stored and the resulting size of the file. It is the standard format used by most digital cameras. **Kelvin** Unit used in measuring colour temperature.

Key light The main or dominant light source.

-

- LAB colour Colour space that can be used in saving or processing digital image files. The files consist of three channels: a luminance channel (L) that shows brightness, and two colour channels, A (green to red) and B (blue to yellow). Some manipulation procedures tend to benefit from applying a change to the luminance channel alone. The luminance channel can also form a good basis for black-and-white conversions.
- Large format Camera format using sheet film measuring 5 x 4in or larger. Some models can also use digital backs.
- Lasso Selection tool used in digital manipulation software. Allows you to outline an area to work on by drawing a series of points around it.
- Latent image Invisible image created on the film or photographic print after exposure, but before development.

Latitude See exposure latitude.

- Layer Feature available on some digital manipulation software that lets you lay different versions or different elements of an image on top of each other. The original image can be protected as the background layer, while alterations are made to copy layers. Layers can be opaque or merged with layers below in a number of ways.
- LCD (liquid crystal display) Type of display panel used widely on cameras to provide information to the user. Colour LCDs are capable of showing detailed images, and are often used as viewing screens on digital cameras.

Leaf shutter See lens shutter.

- **LED** (light-emitting diode) Coloured indicator lamp used on many cameras for a variety of purposes.
- Lens aberration See aberration.
- Lens hood Attaches to front of lens to prevent stray light from outside the image area entering the lens; important for preventing flare, and needs to be designed for the specific lens it is used on so as not to cause image fall-off.
- Lens shutter Shutter mechanism that is positioned within the lens. Found on all compact cameras, and some medium- and large-format cameras. Unlike focal plane shutters, lens shutters can synchronize with flash at any shutter speed.
- **Levels** Image-manipulation tool that allows you to adjust the exposure and

contrast of an image using its histogram as a guide.

- Light tent Translucent drapes hung entirely around a subject to diffuse light sources and eliminate identifiable surface reflections. A small hole or slit is made for the lens; used particularly with highly reflective subjects such as glass and polished metal.
- **Lightbox** Backlit screen used for viewing transparencies and negatives.
- **Lightmeter** Measures illumination levels and determines exposure.
- Linear polarizer See polarizer.
- **Lithium battery** Type of high-power single-use battery, widely used for cameras.
- Lithium ion Type of rechargeable battery, lighter and smaller than traditional nickel cadmium and nickel metal hydride rechargeable cells.
- Lithium polymer Type of rechargeable battery, much lighter and smaller than traditional nickel cadmium and nickel metal hydride rechargeable cells.
- Live View Facility found on some digital SLRs that allows you to view the image as you frame the shot using the rear LCD screen, rather than the usual eye-level finder. The mirror that usually prevents this from being possible is swung out of the way so you see exactly the same image as the camera sensor.

Long lens Telephoto lens.

- Lossless compression Process where the size of a digital image file is made smaller, without losing information.

 RAW files use this technique.
- Lossy compression Process in which information is lost from a digital image file in order to make the size of the digital file smaller. JPEGs are the most frequently used file format that takes advantage of this technique.
- Loupe Magnifying glass designed to view negatives and transparencies on a lightbox. Can also be used to check sharpness of image on the focusing screen of a large-format camera.
- **Low key** Type of picture that is dominated by dark tones.

M

- Macro Term used to describe equipment or facility that allows you to take pictures at a closer shooting distance than usual, to provide a bigger image. Macro usually refers to a recorded image of life-size or larger, with a magnification ratio of 1:1 or greater.
- Magenta Purple colour a mixture of blue and red light. Magenta is the complementary colour to green.

- Magic wand Selection tool used in digital image manipulation that allows you to select an area of similar colour or tone by simply clicking on it.
- Magnification ratio Relationship between the width of the focused image and the width of the subject.
- mAh (milliampere hour) Measure of the power capacity of a rechargeable battery.
- Manual exposure Exposure mode in which both aperture and shutter speed are set by the camera user.
- Marquee Selection tool used in digital image-manipulation programs that allows you to draw regular shapes, such as ovals or rectangles.
- Matrix metering See evaluative metering.

 Matte screen Most common type of surface found on focusing screens. The textured surface shows up which parts of the image are sharp. The result is not as clear to see as with microprism or split-prism focusing areas; however, the matte screen can be used in low light and with all lenses.
- Megabyte (MB) Unit that measures the capacity of computer memory; equal to 1,024 bytes (two to the power of ten bytes).
- Megapixel Measurement of the resolution of a digital camera, equal to one million pixels.
- MemoryStick Family of removable memory cards used by some digital cameras. Types available include MemoryStick Duo, MemoryStick Pro, and MemoryStick M2.
- Mctered manual Exposure mode in which shutter speed and aperture are set manually by the user, but guidance as to their suitability is offered by the camera's built-in metering system.
- Micro SD Miniature digital memory card, popular on mobile phones. Also known as Transflash.
- Microprism Type of surface found on some focusing screens. The surface comprises a grid of tiny prisms, which gives a fragmented appearance when the image is out of focus.
- **Miniature format** Old-fashioned term for the 35mm film format.
- Mired Measurement of colour temperature, calculated by dividing one million by the colour temperature as measured in Kelvin. The scale shows the filtration needed to convert one light source to another, so is widely used as a way of describing colour balancing and colour correcting filters.

Mirror lens See catadioptric.

Mirror lock Facility that allows you to lock the mirror of an SLR camera in

the up position in advance of the picture being taken. This minimizes vibration when the shutter is fired. Useful when using slow shutter speeds, for example.

Model release form Written legal agreement between a photographer and a photographic subject, setting out the rights of both parties as to how the photograph is subsequently used.

Modelling light Facility provided with most studio flash lights, which uses a bright tungsten bulb to provide a visual representation of the lighting that the flash will provide. Used in setting up the lights and deciding on their individual power settings and positions.

Monobloc Studio flash head with a builtin capacitor. Also known as monolight.

Monochromatic Single coloured; used to describe black-and-white and toned photographs. Can also be used to describe any scene where there is a very restricted range of colours.

Monopod One-legged camera support. It allows slightly slower shutter speeds to be used than with a handheld camera, and is far more manoeuvrable than a tripod.

Motordrive Motorized device that winds on the film and resets the shutter after each exposure; also rewinds the film when it is finished. Strictly speaking, a motordrive should also provide fast continuous shooting, allowing several frames to be taken each second. Those that do not allow this, or have slower continuous advance speeds, are traditionally called motorwinds. However, the two terms are now virtually interchangeable. Can also be used to describe the high-speed continuous shooting drive mode of a digital camera.

Motorwind See motordrive.

MTF (modular transfer function)
Method used for testing the optical
quality of lenses at different apertures.

Multigrade The best-known brand of variable-contrast black-and-white photographic paper. The contrast of the paper can be changed simply by fitting the relevant filter to the enlarger. A full range of grades, therefore, is available from the one type of paper. Different grades can even be used within the same image.

MultiMediaCard (MMC) Type of removable memory card used by some older digital cameras.

Multiple exposure Two or more images superimposed on each other. *See also* double exposure.

N

ND (neutral density) Type of filter that reduces the amount of light reaching the digital sensor or film equally across the whole field of view. It is grey colour and designed not to affect the colour of the image; used to allow longer shutter speeds and/or wider apertures than would otherwise be possible.

ND grad (neutral density graduate) Type of filter that reduces the brightness of one half of the picture while having no effect on the other half. Used widely by landscape photographers to reduce the brightness of the sky, so as to limit the contrast of the scene and achieve a more satisfactory overall exposure. See also graduate.

Nicad (nickel cadmium) Traditional type of rechargeable battery used as the power source for a wide range of portable appliances. It can be used in some photographic equipment.

NiMH (nickel metal hydride) Type of rechargeable battery similar to nicad, but with easier handling characteristics and better power output.

Noise Unwanted interference in an electrical signal. Seen as a grain-like pattern in dark areas of a digital image. Noise increases with a digital camera when a higher image sensitivity (or ISO setting) is used.

Normal lens A standard lens.

0

One-shot developer Developer solution that is discarded after a single use.

Open flash Facility for firing the flash manually, independent of the shutter. See painting with light.

Out of gamut Colours that are not able to be displayed correctly in a particular colour space. An out-of-gamut warning found on professional image-manipulation software typically can be set up to show colours that will not be printed properly with a particular printing process.

P, (

Painting with light Technique in which a flashgun is fired a number of times to increase overall lighting output and coverage. Useful, for example, for lighting large interiors or caves.

Pan-and-tilt head Tripod attachment that allows independent movement of the camera in the horizontal and vertical axes.

Panning Moving the camera horizontally during exposure to follow a moving subject so that it stays roughly in the same place in the viewfinder. **Panoramic** Image ratio in which width is significantly greater than height.

Parallax error Difference between what is seen in the viewfinder and what is recorded on film or by the imaging chip. The problem is caused when the viewfinder and lens have slightly different viewpoints. At close shooting distances, this may mean that the subject becomes inaccurately framed.

Partial metering Type of metering system in which a meter reading is taken from a small area in the centre of the frame. Similar to spot metering, but the reading is taking from a significantly larger area of the image.

Passive autofocus Autofocus system that adjusts the focus of the lens by analyzing the image itself, rather than actively measuring the subject distance. Used on most digital cameras.

PC (perspective control) lens Another name for a shift lens.

PC socket (Prontor-Compur socket)
Electrical connection found on some cameras for linking a flash to a camera to ensure synchronization.

Pentaprism Five-sided prism used in the construction of the eyelevel viewfinder of SLR cameras. It ensures the image appears the right way up and the right way around, after being rotated by the lens and reversed by the mirror.

Photoflood High-power tungsten bulb used by some studio lights.

Photomicrography Taking pictures through a microscope.

PictBridge System for printing directly from a camera to a compatible printer without the need of a computer.

Pincushion distortion Lens fault causing straight, parallel lines at the edges of the image to bow inwards.

Pinhole camera Basic form of camera in which the image is formed through a tiny hole, rather than through a lens.

Pixel Short for picture element. A single light-sensitive cell in a digital camera's image sensor. The basic unit used when measuring the maximum resolution of a digital camera or a digital image.

Pixellated Digital image in which its individual picture elements have become visible as squares of colour, usually due to poor resolution or overenlargement of the original image.

Plug-in Piece of software that adds functionality to an existing computer program. Plug-ins are available for some digital image-manipulation programs, providing an increased range of effects and transformations.

Polarizer Filter that lets through only light vibrating in one plane. It can be

used to deepen the colour of part of a picture, such as the sky. It can also be used to reduce reflections from nonmetallic surfaces such as water or glass. It must be rotated to get the desired effect. Linear polarizers can be used with some cameras, but can interfere with the metering and autofocus systems of many models; circular polarizers circumvent this problem.

Portrait lens Short telephoto lens that is ideal for head-and-shoulder portraits as it provides a shooting distance that gives a flattering facial perspective while still allowing you to be relatively close to the subject. For a 35mm-format SLR or a digital SLR with a full-frame sensor, an ideal focal length would be 80–120mm.

Posterization Technique whereby the number of colours or tones in a photograph are drastically reduced. Instead of gradual changes in density and colour, the picture is made up of bands of identical colour, similar to a painting-by-numbers picture.

ppi (points per inch, or pixels per inch) Indication of the resolution of a digital image produced by a digital camera or scanner.

Predictive autofocus Autofocus setting in which the focus is not only constantly adjusted up until the shutter is actually fired, but also continues to be adjusted during the delay between pressing the trigger and the shutter opening. The camera can therefore track and focus more accurately on moving subjects.

Preflashing See flashing.

Prefocusing Focusing technique used for moving subjects. The lens is focused in advance by deciding where the subject will be when you take the picture.

Pressure plate Sprung surface at the back of a film camera. It ensures that the section of film about to be exposed is absolutely flat.

Prime lens Non-zoom lens with a single, fixed focal length.

Prism finder Interchangeable viewfinder, used at eyelevel, that uses a pentaprism. *See also* pentaprism.

Program exposure Any exposure mode in which the camera sets both the shutter speed and aperture automatically.

Program shift Exposure mode in which the camera sets the shutter speed and aperture automatically, but the photographer can alter the bias between the two readings to achieve the preferred shutter speed or aperture without changing the overall exposure.

Pull processing Method of exposure and processing in which a film is exposed at

a slower ISO rating than usual so as to produce an overexposed image. To compensate, the film is developed for a shorter time than usual.

Push processing Method of exposure and processing in which a film is exposed at a higher ISO rating than usual so as to produce an underexposed image. To compensate, the film is developed for longer than usual (or at a higher temperature).

Quick-release plate Method for attaching and removing a camera from a tripod or other camera support. A plate attaches to the camera using the usual screw-in arrangement, and then slots into a recess on the tripod.

R

RAM (random access memory) A computer's working memory – the storage area it uses while working on files and processing information.

Rangefinder Focusing system used by some cameras. The device shows two images seen from slightly different viewpoints; when the two are superimposed, the shot is in focus.

RAW A file format offered by all recent digital SLRs and other high-end digital cameras. Image data is stored in a semiprocessed state and needs to be fully processed on a computer. It enables colour balance, exposure, and other settings to be adjusted after the picture is taken without any loss of image quality. The RAW format used varies from manufacturer to manufacturer and from camera to camera, so it is necessary to ensure that software (and devices such as digital frames) are fully compatible. The RAW format typically provides more colour depth than using the alternative IPEG options.

RAW converter Program or application plug-in that allows you to process and adjust RAW image files. Once they have been converted, they are then saved in another file format, such as TIFF or JPEG.

RC paper (resin-coated paper)
Photographic paper with a waterresistant, plastic layer. Practically all
colour and many black-and-white
papers are resin coated. They require
less washing and dry more quickly than
fibre-based (FB) papers.

Rear curtain sync Facility found on some SLRs and flashguns that synchronizes the flash output with the time the second shutter curtain is about to close. Normally the flashgun fires when the first shutter is fully open. The facility gives more natural-looking images when using slow sync flash with moving subjects, as the blurred afterimage created by the ambient light appears behind the line of movement, rather than in front of it. Also known as second curtain sync.

Reciprocity failure Loss of sensitivity of a film or photographic paper when exposed using an extremely long (or short) shutter speed. This causes a breakdown in the usual reciprocal relationship between aperture and shutter speed. It is most commonly experienced when taking photographs using exposures that are seconds or even minutes long.

Red eye Effect often caused by flash in which light reflects from the retina of a subject's eye, producing a bright red pupil in the image.

Reflected light reading Most usual type of exposure meter reading, in which the amount of light reflecting off a subject is measured.

Reflex lens Type of telephoto lens. See also catadioptric.

Refractive index Measurement of the light-bending power of a translucent substance such as glass or water.

Resin-coated paper See RC paper.

Resolution Ability of a lens, film, or digital imaging device to record fine detail.

Reticulation Effect whereby the surface of a film has a cracked appearance, caused by the emulsion being subjected to a sudden change of temperature.

Retouching Process whereby blemishes are removed from negatives, transparencies, prints, or digital images.

Reversal film Photographic material designed to produce a positive image after processing. Alternative name for slide or transparency film.

Reversing ring Macro accessory that makes it possible to mount a lens on an SLR camera back to front, This can produce a high magnification ratio with a normal lens. The ratio can be improved further by using the reversing ring in conjunction with extension tubes or bellows.

RGB Red, green, and blue: the three colours used by digital cameras, scanners, and computer monitors to display or record images. Digital images therefore usually use the RGB model but can be converted to other colour models using suitable software.

Rim lighting Type of backlighting in which the edges of the subject are illuminated, creating a halo-like effect.

Ring flash Flash lighting system that attaches to the front of the lens, which

evenly illuminates a close-up subject from all around.

Rising front Camera movement in which the lens is shifted upwards.

Roll film Type of sprocketless film that has an opaque paper backing, and is supplied on an open spool. It is wound on to another spool in the camera, the original spool becoming the take-up spool for the next roll of film. General term for the 120 and 220 film used by medium-format cameras.

Rubber stamp Alternative name for the clone tool.

Rule of thirds Compositional approach in which key elements are deliberately placed off-centre within the frame.

S

Sabattier effect Darkroom effect in which photographic paper is exposed to white light part way through the development of the image. This creates a semisolarized image, which appears to be a cross between a positive and a negative; can be recreated digitally.

Safelight Darkroom light designed so it will not fog or expose photographic paper. The light can be red, orange, or green, depending on the types of material it is designed to be used with.

Sandwich Mounting two slides together to create a double-exposure effect.

Scanner Device that converts a physical picture into a digital one.

Scheimpflug Principle used in largeformat cameras and in other types of photography with camera movements. By combining swing movements to both lens and film planes, it is possible to manoeuvre the plane of focus.

Scrim Material placed in front of a light source so as to diffuse it.

SD (secure digital) Removable memory card used by some digital cameras.

SDHC (secure digital high capacity)

Removable memory card used by some digital cameras.

Second curtain sync Alternative name for rear curtain sync.

Selective enlargement Enlargement made from a section of the negative, slide, or digital file. A method of cropping used to strengthen or change the original composition.

Selective focusing Alternative term for differential focusing.

Selftimer Device that adds a delay between pressing the trigger and the beginning of the exposure.

Shift lens Interchangeable lens that allows a limited range of camera movements. These include allowing the lens to be shifted upwards to avoid converging verticals when shooting tall subjects. Also known as a PC lens.

Shutter lag The delay between pressing the trigger of a digital camera and the picture actually being recorded. This delay can be frustratingly lengthy with older and lower-cost digital models.

Shutter priority Semi-automatic exposure system in which the shutter speed is set by the photographer, and the aperture is set by the camera to suit the measured light level readings taken by the camera's metering system.

Side shift Camera movement in which the lens is shifted to the left or right.

Silver halide Salt of silver – the lightsensitive chemical used in films and photographic papers.

Skylight filter UV and warm-up filter combined.

Slave Device that triggers a flash unit to fire simultaneously with another.

Slide Transparency, usually mounted.

Slow sync flash Technique whereby a slow shutter speed is combined with a burst of flash. The flash provides the main illumination, but the ambient light creates a secondary image that can be useful for suggesting movement or to provide more background detail.

SLR (single lens reflex) Type of camera in which the viewfinder image shows the subject through the same lens that will be used to expose the film or imaging chip; uses a mirror to reflect the image to the viewfinder, which moves out of the way when the picture is taken.

SmartMedia Type of removable memory card used by some older digital cameras.

Snoot Cone-shaped or cylindrical accessory that is fitted to studio lights to restrict the spread of light.

Soft focus Technique whereby the image is deliberately left unsharp or is diffused. This gives a dreamy, romantic view.

Softbox Accessory fitted to studio lights that diffuses the illumination. Usually square, rectangular, or octagonal, it produces even lighting over a restricted area.

Solarization Reversal of tones caused by vast overexposure; often used as a way of describing the Sabattier effect. The effect can be mimicked using digital image-manipulation software.

Split-field attachment Filter-like device that fits to the front of a lens, comprising a magnifying close-up lens that covers just half of the viewing area. It allows sharp focus on subjects in the foreground with simultaneous focus on objects in the far distance. It gives the appearance of greatly

enhanced depth of field, although there is slight blurring between the two halves. Also known as a half-lens.

Split toning Technique whereby the toner used affects only some of the tones, giving a two-tone effect.

Spot meter Type of metering system in which an exposure reading is taken from a small area in the centre of the frame.

Spotting Traditional retouching technique whereby the ink, for example, is applied to a print or negative a spot at a time.

sRGB One of two colour settings commonly found on digital cameras. It produces a narrower range of colours than the alternative Adobe RGB setting, but is designed to match more closely the colour space of a computer screen. See Adobe RGB.

Standard lens Focal length of lens roughly equal to the diagonal of the image area. For the 35mm format, the standard lens is normally considered to be the 50mm. The lens approximates to the central, non-periphery angle of view of our eyes.

Starburst Filter with an etched grid-like pattern on its surface that causes bright highlights to turn into star-like patterns. Also called a cross-screen filter.

Stop Unit of exposure. A change of a single stop is equal to doubling or halving the amount of light reaching the film or image sensor. The distance between standard aperture settings (f/4, f/5.6, f/8, and so on) is a full stop.

Stop bath Chemical used directly after the development of a film or print that completely stops the process.

Stop down Close down the aperture.
Strobe Alternative term for a flash unit
(used particularly in North America).
Confusingly, can also be used to
describe the flash effect in which light
flashes on and off in rapid succession
(particularly in UK).

Swing back Camera movement in which the film plane is rotated.

Swing front Camera movement in which the lens is rotated.

Sync speed The fastest shutter speed that can be used on a camera in order to achieve correct synchronization with the flash.

Synchro sun An alternative term for fill-in flash.

1

T (time) setting Shutter speed setting for long exposures found on some cameras. Once the trigger is pressed, the shutter remains open until the trigger is pressed a second time.

T2 mount Connection system that allows some lenses and other accessories to be used, via an adaptor, with a wide range of different manufacturers' SLRs.

Teleconverter Accessory that increases the focal length range of a lens.

Teleconverters may attach to the front of the existing lens or fit between the lens and the camera body. A 2x teleconverter will double the focal length of a lens or zoom setting.

Test strip Trial print made in the darkroom showing the effect of different exposure times, or filtration values.

TFT (thin film transistor) High-quality colour LCD technology, widely used on digital camera screens.

TIFF (Tagged Image File Format) Digital image format used to save files with maximum available detail. Files are often large, although their size can be reduced using lossless compression if necessary.

Time lapse Technique whereby shots are taken of the same subject at regular intervals; used for events that occur over a long time, such as plant growth.

TLR (twin lens reflex) Camera that has a pair of lenses; one is used by the viewfinder, and the other is used for taking the picture.

Tone separation Darkroom technique similar to posterization.

Toner Chemical bath used to change the colour of a black-and-white print. May also be used to change the image contrast, in order to improve the archival permanence of the print. The toner replaces the silver in the print with that of another metal, such as copper, selenium, gold, or iron.

Transparency (tranny) Type of film designed to provide a positive image after processing; reversal or slide film.

Tripod Three-legged camera support.

Tripod bush Screw hole found on most cameras, used for attaching tripods, camera supports, and other accessories.

TTL (through the lens) metering

Exposure system in which the intensity of light is measured through the main camera lens.

Tungsten film Film designed to be used with light sources with a colour temperature of around 3,200K.

Tungsten lighting Type of bulb lighting that has a colour temperature of between 2,600 and 3,500K.

Tv An abbreviation of "time value"; a term used for shutter priority.

TWAIN (technology without an interesting name) Piece of software, like a driver, which allows control of a scanner, or similar peripheral, from another application, such as a digital image-manipulation package.

Two-touch zoom Lens with separate control rings for zooming and focusing.

11

Ultra wide-angle Lens with a wider-thanusual angle of view. For full-frame digital SLRs or 35mm SLRs, it is a lens offering a focal length of 17mm or less. Umbrella See brolly.

Universal developer Developer that can be used for black-and-white film and black-and-white photographic paper.

Unsharp mask (USM) Sophisticated sharpening facility used on digital image-manipulation programs.

Up rating Another term for push processing.

USB (Universal Serial Bus) Connection system for linking digital cameras and other peripherals to a computer.

UV filter Filter designed to absorb ultraviolet (UV) radiation. Can be used to improve clarity for landscapes, especially in mountain or ocean areas.

V

Variable-contrast paper See Multigrade.
Vertical grip Type of battery grip with additional buttons to improve an SLR's handling when taking portrait-format images.

View camera Large-format camera.

Vignetting Darkening of the corners of an image, normally due to fall-off. Can usually be corrected for using digital image-manipulation software.

W

Wetting agent Chemical added to the final wash of a print or film that helps prevent drying marks forming.

White balance System by which a digital camera measures the colour temperature of a light source and corrects it so that the whites, and all the other colours, appear normally to the human eye.

Wide-angle converter Accessory that attaches to the end of a lens to increase the angle of view.

WiFi High-speed wireless system that is used to connect different devices using radio waves. Sometimes used to connect a digital camera to a remote computer or printer.

X, Y, Z

X3 Type of CMOS digital image sensor, invented by Fovcon, in which each pixel can take readings for all three primary colours of light.

x1) card Type of removable memory card used by some digital cameras.

Zone system Total approach to exposure and darkroom development of black-and-white images, pioneered by Ansel Adams. The tones are previsualized as one of nine tones. The contrast range is measured, and processing is carried out to achieve the desired result.

Zoom Lens with a variable angle of view.
Zoom effect Special effect in which the
angle of view of a zoom lens is changed
during exposing, creating blurred
radial lines across the picture.

Zoom ratio Relationship between the shortest and longest focal length setting of a zoom lens. A 35–70mm lens has a zoom ratio of 2:1 or 2x. An 8–80mm lens has a zoom ratio of 10:1 or 10x.

Index

abstracts 47, 228, 321 architecture 286-7, 290 colour 238-9, 307 detail 228 nature 298, 300, 302 nudes 282-3 overexposure 82 reflections 208 texture 216-17 unfocused image 69, 385 zoom bursts 101 accessories 20, 26, 30 lens attachments 60-1 macro 58-9 action 99 analyzing movement 108-9 autofocus 28, 70-1, 73, 74 diagonal movement 98, 319 freezing 50, 51, 77, 98-9, 171, 318-19 high-speed film 122 panning 100 sequences 108-9 shutter priority 79 shutter speeds 77 stop-motion events 106-7 suggesting movement 101, 102-3, 181, 320-1, 385 aerial perspective 145, 198 aerial photography 125, 176, 222, 302, 323 afternoon 146-7 late 150-1, 219 albums 394 anamorphic lens 60-1 angle converter 60 angle of view 18, 38, 39 and shutter speed 93 standard lens 40, 41 animals 312-17 caged 90, 312 see also wildlife aperture 12 control 14-15, 18 and depth of field 86-7 exposure 13, 28, 76-7 f/numbers 77 for flash 170 range 77 selecting 77 wide 50, 77, 319 aperture control ring 19 aperture priority 79 apochromatic lenses 49 APS-C sensor digital SLR 44 APS system 113, 117 architecture 284-95 abstracts 286-7

converging verticals 42, 43, 54, 55, 284-5 detail 188-9, 286-7 diagonals 181 diminishing size 196 equipment 285 fisheye lens 53 floodlit 154 frame-within-frame 185 industrial landscapes 197, 290 - 1lenses 16, 285 lighting 148, 151, 288-9 modelling 215 objective photography 294-5 pattern 189, 220 ruins 153, 289 shift lens 54-5, 284, 285 viewpoint 186-7 wide-angle lens 42, 284 see also interiors archiving 33, 395 archways 185 artwork, copying 348-9 ASA 113 aspect ratio 116, 184 astrophotography 346-7 atmospheric effects 340-1 auto-exposure bracketing (AEB) 83 autofocus 70-5 active (infrared) 23, 70 continuous 71, 73 and depth of field 89 enlarger 360 intelligent 74-5 medium-format camera 20 multipoint 72, 75, 89 one-shot 71 overriding 23, 73, 75 passive 70, 71, 73 predictive 73, 74, 75, 326 prefocusing 326 SLR camera 28-9, 71 using 72-3 autofocus illuminator 28, 71 automatic exposure lock (AEL) 81 autumn 223, 300 B setting 77, 104, 106-7 back projection 343 backdrop 272-3, 337 digital 343 projected 342-3 background 204-5

portraits 182-3, 204, 258-9,

blurring 100, 312, 385

cropping out 378

depth layers 200-1

distracting 90, 91, 187, 321

dark 248

270

still lifes 254 backlighting 160, 162, 288, 297, 311 colour loss 232 rain 305 silhouettes 147, 210 translucent objects 59, 164 backs, interchangeable digital 25, 351 film 21, 129 metering 351 barn doors 256, 338 bas-relief 393 batteries 22, 27, 303 battery grips 30, 109 beaches 307 beanbag 94, 95 bellows unit 58, 59 binocular camera 35 binocular-effect mask 60 birds 16, 121, 314-15 black and white 118-19 chromogenic film 110, 119 colour filters 63 exposure 82 film 110-11, 114-15 infrared film 124-5 lighting 127, 256 nudes 118, 280 processing, see darkroom tone 224, 225 visualization 120-1 blow-ups 14, 15, 99, 350 Bluetooth 35 blur effects 62, 64, 77 colour 236, 237 image-manipulation 385 suggesting movement 99, 102, 320-1 borders 390 bounced flash 169 bracing camera 94-5 bracketing 83, 105 brightness 386 brolly 142, 256, 336, 339 bubble-jet printer 372 buffers 109 buildings, see architecture burning-in 364 burnishing 128-9 burst rates 109

cable release 95, 107, 164 camera choosing 14-15 in cold climate 303 compact 14, 22-3

convenience 14-15 cost 14-15, 28 creative control 14-15

holding 92-3

film or digital 15

lens coverage 16-17 light path 12-13 medium-format 15, 20-1, 254, 259 movements 352-3 parts of 12-13 protecting 305, 306, 329 resolution 14-15 size 15, 23, 25 SLR 15, 18-19, 28-9, 30-1, 259 steadying 94-5, 312 unusual types 34-5 waterproof 344 see also digital camera

large-format 15, 35, 254, 350-1

camera obscura 12 camera shake 93-7 candid shots 60, 275 candlelight 137, 140 capturing moment 190-1 card reader 32, 33, 369 careers 396-7 caricatures 45, 267 cars 66, 144

lights 104, 105, 140 moving, shooting from 100, 207, 312

carving 149 catadioptropic lens 49 caving 173 CCD chip 24, 27, 71 CD burner 370 ceilings 173, 188 centre spot filter 65 changing bag 358 children 241, 266-7, 276-9

chromatic aberration 49 chromogenic film 110, 119 circles 182-3, 204, 229 circles of confusion 86 clamps 96, 97 clone tool 380-1 close-up adaptors 60 close-up lens 31, 58

close-ups abstracts 228, 238 digital 58

macro lenses/accessories 17, 56-9

rostrum photography 348 telephoto lens 47, 311 clouds 63

diffusing light 132, 142, 147 reflected colour 155

shafts of light 156-7 CMOS imaging chip 24, 71 cobwebs 341

colour 230-51 abstract 238-9

autumnal 300-1 blue 230, 240, 244, 246 bright 230, 246, 248-9

clashing 250–1	reflections 208–9	deep tank 362	viewfinder grid 285
complementary 246–7	scale 202–3	depth 45, 198–229, 282	white balance 135, 138-9, 155
contrasting 246–9	set-up shots 192–3	aerial perspective 198	230
emotional response 230–1	shadows 206–7	camera movements 352	digital imaging 368-93
greens 231, 244	shape 210-11	layers 200-1, 308	analogue to binary 368-9
harmonious 244–5	sports photography 322	linear perspective 194, 196	back-ups 33, 370
hot/cool 230	texture 216–19	overlapping forms 198-9	digital system 32-3
intensity 232-3, 234, 240	timing 190–1	using frames 184, 185	download times 375
light and 232-5, 244	tone 224–7	depth of field 68, 86-91	email 370, 374-5
mono conversion 121, 366–7,	varying shots 188-9	aperture priority 79	file formats 371, 375
391	viewpoint 186–7	lens choice 41, 43	file size 370
monochromatic 242-3, 366	compressed planes 47	maximizing 88-9, 95	frame 395
muted 236-7	computer 32-3, 106, 368, 395	minimizing 62, 90-1	image storage 370-1, 382
primary 240, 249	see also digital imaging	preview 28, 88	internet 14, 24, 374-5
red 230, 240-1, 246	contact prints 361	scale 89	printing 372–3
secondary 240, 249	contrast 121, 171	split-field adaptor 62	see also image-editing softwar
theory of 240	colour 235, 238, 246-9, 296	detail 14	diminishing size 196-7
yellow 231, 240-1	high-contrast 224-5, 226	abstracts 228	DIN 113
colour absorption 232	image-manipulation 386	architecture 188-9, 286-7	dioptric correction 23, 29, 30, 69
colour balance 136, 140-1, 232,	and paper grade 361	black-and-white film 119	display 394–5
387	push processing 122	and film speed 112-13	disposable camera 14, 23, 42, 344
colour correction 26, 136-7	sharpening 384	split images 130	distance
filters 62, 126, 136-7	variable-contrast paper 365	telephoto lens 47	creating depth 200-1
image-editing 387, 388, 389	contrast-detection system 23	developing 358-9	distant subjects 17
colour filters 63, 64, 120, 360	converging lines 43, 194, 195	developing tank 358	focused distance 86-7
colour meter 137	converging verticals 42, 284-5	diagonals 180-1, 186, 226, 258,	long-distance shots 46-9, 71,
colour print film 114-15, 230	baseboard correction 367	288	177
developing 359	image-editing 377	diagonal framing 322-3	and shutter speed 99
drawbacks 114, 230	chift lens 54, 55	diminishing size 197	distortion
exposure latitude 82	copying techniques 348-9	subject placing 187	anamorphic lens 60
how it works 110-11	copystand 348	suggesting movement 181,	barrel 52, 53
overexposing 82	creative control 14-15	322 3	hasehoard 367
printing 360	darkroom 118	diaphragm 19	camera movements 352
colour saturation 82, 146, 387	digital camera 24, 26	diffraction filter 65	shadows 206
colour temperature 134-5, 144,	large-format camera 350	diffuser 168, 237, 270, 271, 339	wide-angle lens 42, 44, 264,
146, 150	monorall camera 20	digital back 25	265, 266
colour transparencies,	SLR camera 15, 18, 28, 29, 30	digital backdrop 343	dodging 364, 365
see slide film; slides	crop factors 16, 93	digital camera 14-15, 24-5, 26-7,	double-exposure mask 84
colour wheel 240, 245	cropping 378, 379	32-3, 368	doubler 48
comets 347	cross-front shift 54	autofocus 71	dusk 51, 132
compact camera 14, 22-3	cross-polarization 59	black-and-white 121	dust 306-7, 362, 380, 394
digital 14-15, 22-3 24-5	cut-outs 378	camcorder as 34	Dutch tilt 323
disposable 23		close-ups 58	DVD 370, 395
exposure metering 78	dance 181, 191, 207	and colour temperature 127,	DX coding 113
focusing 68–9	darkroom 118, 356-67	138–9, 141	dye couplers 110
lens coverage 16, 17	contact prints 361	compact 14-15, 23, 24-5	dye-sublimation printer 372
luxury 14, 23	developing 359	depth of field preview 88	
types 23, 344	digital, see image-editing	exposure latitude 82	eclipses 347
zoom 14, 15, 22-3, 71	software	hybrid 24-5, 26-7	email 370, 374-5
complementary colours 246-7	equipment 356-7, 360, 362	image sensor 24, 26, 27, 29, 71,	emulsion lift-off 128-9
composition 176-7	layout 356-7	112	enlargements
backgrounds 204-5	loading spiral 358	as instant camera 128	blow-ups 14, 15, 99, 350
converging lines 194-5	print analysis 364–5	motorwind speeds 109	digital 26, 372
depth 198-201	print preparation 360-1	multiple exposures 85	enlarger 357, 360
diagonals 180-1	printing 357, 362-3	as photocopier 348	evening 133, 244
diminishing size 196-7	processing 356, 358-9	photomicrography 59	exposure 13, 76–85
form 212-15	test strip 362	resolution 14, 24	automated 170
framing 184–5	tricks 366–7	shutter speeds 93, 321	B setting 77, 104, 106–7
linear perspective 194-7	data panel 28	SLR 15, 24–5, 28–9	bracketing 83, 105, 307
pattern 182-3, 220-3	dawn 132, 144	storing images 27	creative 82–3
photographer's eye 228-9	daylight-balanced film 134, 136,	sunsets 155	exposure value (EV) 76
placing subject 178-9	140-1	types 24–5	with flash 170-1

image-editing 386, 388	medium-format 18, 117	flowers 199, 232	front 302 303
latitude 82, 114, 119	film speed 112–13		frost 302, 303
light streaks 105	colour intensity 235	close-ups 57–9, 80, 309, 310	fur 317
long 62, 94	DX coding 113	colour 239, 246, 251	
manual 80–1	fast 112, 122–3	garden flowers 310–11	garden photography 308–11
modes 28	infrared film 124	holding rigid 299, 309	birds 214
multiple 20, 84–5	ISO scale 76, 112–13	seasonal 296–9	equipment for 309
for sand 307		fluorescent lights 137, 139	flowers 310–11
setting 79	slow 112	focal length 13, 16, 38–9	infrared 125
	film transport 18, 19	abstract colour 239	lighting 148, 310–11
for snow 302, 303	motorized 15, 23	and depth of field 86–7	seasons 296, 298–9
and tonal range 226	filters 30, 60, 62–7	fisheye lens 52	tone 224
under-/over- 80, 82	with black and white 63, 65,	and format 38, 40	Gaussian blur 385
exposure compensation 29, 80–1,	121	long/short 13	gelatin filters 62
127	colour 63, 64, 120	macro 56	gels 127, 272
dial 19, 80	colour correction 62, 126,	matching subject 16-17	ghost image 102, 170
exposure lock 81	136–7	minimum handheld shutter	GIF files 375
exposure meter 78–9	creative use 64–5	speed 93	glass 23
enlarger 362	gelatin 52, 62	and perspective 194	focusing through 73
flash 79, 337	graduated 64, 65	standard 40	reducing reflection 51, 66-7
large-format camera 351	image-manipulation 393	telephoto 46	shooting reflections 208
see also light meter	infrared (IR) 125	ultra wide-angle 44	gobos 221, 261, 272, 339
exposure mode 27, 28, 79, 81	for infrared film 124	underwater 345	graduates 64, 65
"extended red" film 125	neutral density 62, 65	wide-angle 42	grain 112, 113, 119, 122
extension rings/tubes 31, 58, 59	polarizer 59, 65, 66–7, 209	focal plane 12, 13, 26, 38, 86	grain filter 393
eye 176-7, 228-9, 230	skylight 62, 303	focal plane shutter 19, 167	grey card 80
eye sensor 29	special effects 65	focal point 178–9, 195	grey scale 227
eyesight 23, 28, 30, 69, 360	systems 49, 62	focusing 38, 68–75	grip sensor 28
-,,,,,,,,,,	UV 62		
f/number 77		locking 72, 73, 81, 327	group portraits 43, 49, 266, 274–5
face detection 71	warm-up 137, 140, 303 fire 140	macro lens 57	1-1-11-1-1-1
facial expressions 268–9, 279,		manual 19, 26, 28, 69, 73	hair, blonde 162, 163
	fireworks 28, 73, 104, 105	maximizing depth of field	half-lens 61
330–1 foirement 105	fisheye converter 44, 52, 53	88–9	hammerhead flash 167, 259
fairground 105	fisheye lens 39, 44, 45, 52–3, 285	minimum distance 16, 17, 56	hand colouring 367
fast lenses 50–1	flash 166–73	off-centre subject 72, 75	handheld camera 92–3
feathering 379	autofocus 70	plane of focus 68	steadying 94–5
fibre-optic lights 338	bounced 31, 169	prefocusing 326–7	hands and feet 241, 276, 281
field camera 351, 352–3	built-in 29, 167	selective 91, 199	hard drive 32, 370
figure shots	dedicated 170	telephoto lens 47	harmonious colours 244-5
form 213, 214	diffused 168	see also autofocus	hats 276
lens 41, 47	disadvantages 166	focusing ring 19, 26	haze 62, 67, 135
shape 211	exposure 170–1	focusing screen 18, 21, 69, 284,	hides 314
split image 131	fill-in 104, 105, 161, 171	351	high/low key effects 226-7, 389
texture 218	flashguns 31, 167	fog 235, 243, 288, 340	highlights 49, 65, 256-7
see also nudes	guide numbers 166, 167, 338	foliage 119, 223, 300-1, 303	burning in 364
files 394	high-speed 315	foreground 177, 298	high-speed film 122-3
fill-in flash 104, 105, 161, 171	joule rating 338	colour 241	histograms 29, 79, 388–9
film 12, 110–33	low-power setting 265	depth layers 200-1	horizon 157, 179, 186, 377
brands 114-15	off-camera 168, 169, 345	detail 186, 187	hot-air balloons 151, 196, 329
casings 117	painting with light 172-3	minimizing 91, 176, 385	hotshoe flash 27, 167
exposure latitude 82, 119	portable, using 168–9	form 212–15, 280, 292	hyperfocal distance 89
heat-damage 306	red eye 169	frame-within-frame 184–5, 193,	ny periodal diotance of
how it works 110–11	slow shutter speed 102, 104	265, 299, 309, 317	image-editing software 32, 65,
rerunning 84	studio 161, 166, 256, 336–7,	frames, display 394	376–93
types 114–15	338	framing 186, 322–3	adjustments 249, 386–9
see also individual types	synchronization 106, 167, 336	borders 391	blurring 385, 392
film back 20	triggering device 315		
film chamber 19, 23	types 167	freezing movement, see	borders 390
film format 116–17	underwater 345	action, freezing	colour adjustment 386–7
35mm 14, 15, 18, 22, 40, 117		fresnel lens 339	converging verticals 285, 377
aspect ratio 116	flash bracket 167, 169	front projection 342	cropping and cutting 378
image size 116	flash bulbs 173 flash meter 79, 337	frontal lighting 160–1, 288	curves control 386, 389
large-format 117, 351		and colour 158, 232	exposure adjustment 386,
iaige-ioimat 117, 331	flash modes 23, 28	reflections 209	388–9

filter effects 393	exposure 78	backlighting 147, 160, 162,	macro photography 57, 309, 310,
layers 249, 382–3, 392	filters 63, 64, 66	288	313
levels 386, 388–9	focal points 179	changing 132–3, 135, 186, 234	abstracts 228, 238
mono conversion 121, 376	form 212	and colour 232–3, 244, 248,	accessories 58–9
multiple exposures 85	framing 185	257	blurring backgrounds 90
photomerge 130, 392–3	high-contrast 224–5	creative use 260–1	flash 167 lens 16, 17, 56–7, 254, 310
photomontage 390, 392	lens coverage 16	depth layers 201	magic wand 379
removing large areas 381	monochromatic 242, 243	direction of 160–1	magnifier, pop-up 21
removing red eye 390	moonlight 346	fluorescent 137, 139	marquee tool 379
retouching 380	panoramic camera 20	frontal 158, 160–1, 209, 232–3,	masks
selection tools 378–9	rays of light 156–7	288	for burning-in 364
sharpening 384, 392	replacing sky 383	hard and soft 142–3 mixed 127, 135, 138	double exposure 84
software 376–7	seasons 297, 300–3	modelling 214–15	gobos 221, 261, 272, 339
special effects 385, 389, 392–3	standard lens 41	momentary effects 234–5	image manipulation 390
tonal range 225, 388, 391	telephoto lens 49	for nudes 280–2	lens attachments 60
tricks 390	texture 144, 146, 217, 219		matrix metering 78
image size and format 116	wide-angle lens 42, 43	over-/underlighting 257	medium-format camera 15, 20–1,
image stabilizer 29, 94	large-format camera 15, 35, 254,	patterns of light 260–1 photomicrography 59	254, 259
incident light 79	350–1	1 0 1 7	digital 25
industrial landscapes 197, 290 1	film 117, 351	for portraits 143, 258, 260–1, 270–1	digital backs 25
information screen 18	lenses 44, 48		film 18, 117
infrared 124	movements 352–3	rim lighting 162–3	lens 16, 40, 44, 48, 52
autofocus 70	typeo 350	for rostrum work 348	
film 124–5	laser printer 372	sidelighting 142, 146, 160–1,	types 20 memory card 22, 27, 32, 368
remote control 22, 31	layers 200–1, 308, 382–3, 392	214–15, 218, 232–3, 256,	menu button 29
inkjet printer 372	LCD 19, 23, 24, 27, 28, 29, 79, 88	288, 293	microprism focusing 69
insects 56	wall screen 395	soft 142–3, 214, 236–7, 257 for still lifes 256–7	microscope 59
instant camera 34	leaves, see foliage		midday 146, 148–9, 206, 289, 298,
instant film 128–9	lens 12, 13, 38–9	storms 158 9	311
backs 34, 129	add-on 58	sunsets 152–5	middle ground 200–1
burnishing 128–9	anatomy of 38	for texture 218 three-quarter 161, 233	mired value 137
emulsion lift-off 128-9	attachments 60	-	mirror lens 49
large-tormat 351	coverage 16–17	time of day 132 3, 135,	mirror viewfinder 18, 19, 21
transparency 129	enlarger 360	144–54, 186, 298	mist 145, 159, 243, 289, 340
insurance records 349	fast-aperture 50 -1	translucent objects 164–5	mobile phone 14, 24, 34, 35
interiors 191, 285	interchangeable 15, 16, 18, 38	tungsten 139	mode dial 29
churches 161, 187, 188-9	medium-format camera 21	warm 140–1, 260, 261 see also low light; sunlight	modelling 214–15, 233, 289
painting with light 172–3	protecting 62, 307		modelling lamp 338
ultra wide-angle lens 45	rotating 34	lighting equipment 338–9 diffused light 339	monochrome colour 242–3, 302,
wide-angle lens 16, 17, 43,	sand/dust-damage 306–7	direct light 338	366
183, 189	selecting 16	fibre-optic 338	monopod 47, 97, 318
internet 14, 24, 374–5	SLR camera 19, 28–9, 30, 31		monorail camera 20, 254, 351–3
inverse square law 161, 167	speed 50	photofloods 126, 336 stands 338	moon 346–7
ISO scale 76, 112–13	standard 39, 40–1		morning 132–3, 146–7
	types 39 see also individual types	tungsten 134, 137 see also flash	early 144–5, 219, 288
joiners 130–1	/1		mosaic 130–1
joules 338	lens cap, auto 22	lightning 106–7 linear perspective 43, 55, 194–7,	motordrive/-wind and continuous
JPEG files 28, 82, 109, 371, 382	libraries, image 397		shooting 108–9, 313, 317, 318
Progressive 374	light	210 Liva View 20, 88	mountains 62, 67, 198, 199
Valvin and 124 127	absorption 232, 344	Live View 29, 88 long exposure 62, 94–5, 346	movement, see action
Kelvin scale 134, 137	city 134, 154, 209, 304 Kelvin scale 134	low light 166	multiple exposure 20, 84–5, 126
labo commercial 22, 360, 372	shafts/rays 156–7, 189, 190,	autofocus 70, 71	multipoint autofocus 75
labs, commercial 32, 369, 372 ladders 164, 336	234, 235, 260	black-and-white film 118	munipoint autolocus 75
landscape photography	streaks/trails 104–5, 347	fast film 112–13	nature photography
aerial perspective 198	wavelength 124, 134	fast lenses 50, 51	lighting 162, 297
backlighting 210	light banks 339	focusing aids 35	timelapse sequence 297
black and white 63	lightbox 395	high-speed film 122–3	tripod 97
creating depth 198	light meter 79	long exposure 95	negative 115
depth of field, maximum 89	light path 12–13	manual focus 28, 73	filter effect 393
diminishing size 196	lighting	prefocusing 326	neutral density filter 62, 64, 65, 67,
equipment 300	for architecture 288–9	standard lenses 40, 41	103
-quip			

noon, see midday	backgrounds 182-3, 204,	rain 288, 304-5	shift movements 352
nudes 184, 280-3	258-9, 270, 272-3	faking 305, 310, 340	shutter 12, 19
	candid 60, 275, 299	puddles 209, 304	low-noise setting 313
objective photography 294-5	caricatures 45, 267	raindrops 304, 305	shutter control dial 18
opening camera 23	children 266, 276-9	rangefinder camera 22, 35, 69, 300	shutter priority 79
optical converter 24, 26	depth of field 90, 91	RAW file format 28, 82, 109, 377,	shutter release 18, 21
overcast conditions 139, 142, 145,	in environment 204, 264-5	386	shutter speed 92–109
224	equipment 259	reciprocity failure 77, 127	control 14-15, 18
overexposure 82, 227, 237	expressions 268–9	red eye 169, 390	and exposure 13, 76-7
see also exposure	focusing 68	reflections 51, 147	fast 77, 98-9, 318-19
overlapping forms 198-9	group 43, 49, 266, 274-5	coloured 154, 234	for flash 170
	lenses 17, 41, 46, 47, 90, 259,	pattern 223	freezing action 98-9, 318-19
painting-effect filters 393	264	in rain 288, 304	measuring 77
painting with light 172-3	life and work 264-5	reducing 66, 209	range 77
panning 98, 100, 320-1	light direction 160-1	shooting 150, 208–9, 210,	selection 106–7
effect 385	light effects 234, 235,	288	slow 22, 77, 94-7, 102-5,
panoramic photographs	260-1	reflective surfaces 256, 257	320–1
anamorphic lens 60-1	lighting 143, 258, 262	framed pictures 349	steadying camera 92-7
APS 117	monochromatic 242, 243	sea and sand 307	suggesting movement 102–3
aspect ratio 116	outdoors 148, 258-9, 270-1	snow 302, 307	sidelighting 146, 160, 189, 293
camera 20, 34	placing subject 179	studio backdrops 273	colour loss 232–3
digital manipulation 130,	profiles 262–3, 272	reflector 143, 214, 256	and form 214-15, 288
392–3	red eye 169, 390	clip-on 169	hard 142
paper 128, 219, 361, 373	rim lighting 162	dish 336, 338	studio 161
variable-contrast 365	setting 258–9	making 271	texture 216, 218, 256
parallax error 22	silhouettes 262–3	outdoors 259, 270–1, 309	silhouettes 64, 69
passers by, removing 62, 103	split images 131	studio 336, 339	architecture 288, 290
pattern 189, 216, 220–3	studio 258, 272–3	types 270	avoiding 307
circles 182–3, 204	texture 218–19	reflex lenses 49	composition 210–11
in landscape 300, 303	ultra-wide angle 267	remote control 22, 31	exposure 81
of light 260–1	warm-up filter 137	resolution 14–15, 24, 26, 370, 372	lighting 147, 262
projected 221, 342	see also figure shots; nudes	retouching 365, 380–1	portraits 262–3
texture screens 367	positioning subject 178–9	right-angle finder 30	at sunset 153, 154–5
PC lens, see shift lens	posterization 393	rim lighting 162–3	silver halides 110
PC terminal 27	power pack 337, 338, 339	ringflash 167	single lens reflex, see SLR
pentaprism 19	predictive autofocus 74	roll film 117, 359	skateboarding 16, 324–5
perspective 35, 44, 46, 47, 352	prefocusing 326–7	rostrum work 56, 348–9	sky 157, 179
see also aerial perspective;	press photographer 396	ruins 153, 289	black-and-white 120, 121
linear perspective	pressure plate 20	14113 133, 207	colour filters 63
pets 316–17	print analysis 364–5	Sabattier effect 367, 389	darkening 63, 67, 125, 364
phase-detection autofocus 71	printer 33, 372–3	sand 306–7	graduated filter 64, 65
photofloods 126, 336	printing 114, 115	scale 47, 202–3, 292, 300	polarizer 65, 66, 67
photographer, professional	darkroom 219, 362–3	scanner 368, 369	replacing 383
396–7	digital images 372–3	Scheimpflug principle 353	skylight 135
photomerge 392–3	prism 18, 21, 22, 26, 69	sculpture 292–3	skylight filter 62, 303
photomicrography 59	prism filter 65	seasons 296–303	slide film 114–15
photomortage 390, 392	processing 110–11, 114–15	secondary colours 240, 249	bracketing 83
picture libraries 397	darkroom 356, 358–9	secondhand equipment 15, 42,	
picture programme 79	push processing 122	50, 52	daylight-balanced 134, 136, 140–1
pinhole camera 12	profiles 262–3, 272		
pixels 14, 24, 26, 27, 372	program mode 79	selective focusing 91, 199	developing 359
placing subject 178–9	program shift 70	self-portraits 22, 53 self-timer 22, 95	drawbacks 114
playback button 29	1 0		exposure latitude 82, 114
PNG files 375	projector 395	set-up shots 192–3	how it works 110–11
point-and-shoot camera 15, 22,	backdrops 342–3	shadows 142–3, 148, 160	tungsten-balanced 126–7,
23, 117, 329	back projection 343	colour of 247, 303	134, 136
polarizer 65, 66–7, 209	front projection 342	creating form 213, 214	underexposing 82, 235
cross-polarization 59	multiple exposures 85, 126	as subject 206–7	slides
Polaroid camera and film,	pattern 221, 342	shafts of light 156–7, 189, 190, 234	copying 349
see instant camera and film	spotlight effects 260 props 254, 255	shape 210–11, 256, 300	combining for double
portraits 258–83	push processing 122	sharpening 384 sheet film 117, 359	exposure 85
alternative 266–7, 275	pyramids 176–7		display 395
arternative 200-1, 2/3	Pyrainus 1/0-/	shift lens 54-5, 188, 352	storing 394

SLR camera 18-19, 28-9, 30-1,	storage 394	tilt movements 353	water
259, 318	digital camera 27, 32, 33	time-lapse sequences 297	fountains 308
accessories 30-1	digital files 33, 370-1, 394	timing 303	freezing movement 99, 319
advanced 15	storms 158–9, 190, 234	capturing moment 190–1	reflections 66, 147, 209
autofocus 28-9, 71	lightning 106–7	peak of action 324-5	spray 319, 321
basic 15, 18-19	studio 336-43	prefocusing 326	waterfalls 62
digital 15, 24-5, 28-9	atmospheric effects 340-1	tinting 367	waterproof camera 344
film 15	backdrops 204	TLR camera 20	waterproof housing 34, 305, 307,
lenses 19, 30, 31	flash 161, 166, 256, 336-7, 338	tone 121, 224-5	344
manual-focus 69	layout/equipment 336-7	creative use 226-7, 290	web images 14, 24, 374-5
medium-format 20-1	lighting 338–9	and form 212, 256	white balance 25, 26, 138-9, 230
shutter speeds 93	portraiture 258	grey scale 227	auto 135, 138
viewing system 18	projected backdrop 342–3	image editing 388, 391	manual 139, 155
smoke effects 340	sub-mirror 29	tonal balance 125	wide-angle adaptor 60
snapshots 16, 22, 26	summer 298–9	tonal range 224, 225, 226	wide-angle converter 42, 44
snoot 337, 338	sun 49, 152-3, 298, 347	toning 366	wide-angle lens 16, 17, 38, 42-3
snow 80, 225, 288, 302-3	sunlight 132, 135, 144	translucent objects 59, 162,	angle of view 39
exposure 302, 303	dappled 260, 271, 297	164–5	distortion 42, 44, 264, 265, 26
softbox 142, 161, 214, 256, 257,	direct/diffused 142–3, 298, 310	transparencies, see slides	fast 51
339	shafts of light 156-7	trees 82, 154, 199, 210, 225,	focal lengths 42, 44
miniature 168	shooting into 156	300–3	for interiors 16, 17, 43, 183,
soft focus 46, 65	sunset 152–3, 210, 234, 237	tripod 96–7, 102, 106, 172	189
solarization 367, 389	afterglow 154 5	mini 97	and perspective 194, 195
special effects filters 65	colour balance 138, 140	nature photography 300, 309,	portraits 264 5, 267
image editing 392–3	lens choice 41, 49	313, 314	types 42
spikes 96, 97	swing movements 353	tor split images 130	ultra wide-angle 39, 44–5, 267
-	O .	for still lifes 254	285, 294
split-field adaptor 61	symmetry 178, 183, 189	studio 337	WiFi transmitter 30
split-field focusing 69	portraits 277, 278		wildlife 312–13
split-toning 366	reflections 209	for telephoto lens 47	binocular camera 35
splitting images 130–1	shadows 206, 207	tungsten film 84, 126–9, 134	
sports photography 318–33	widc-angle lens 44, 45	tungsten lights 126, 137, 139	birds 16, 121, 314–15
dietant subject 17, 319		TV 27, 106, 395	equipment 313
dynamic framing 322-3	T-setting 107	twilight 51	lenses 16, 17, 48, 313
equipment 97, 318	teleconverter 31, 48, 60, 314,	twin lens reflex, see TLR	long-distance shots 71
facial expressions 330–1	331, 346		macro lens 57
freezing action 50, 98, 171,	with shift lens 54	umbrella, see brolly	rim lighting 162
318-19	telephoto lens 38, 46-7	underexposure 80, 82, 237	windbreaks 309, 310
lenses 16, 17, 48, 50, 318–19,	aerial perspective 199	push processing 122	wind machine 341
328–9	angle of view 39	underwater photography 34, 307,	winter 302–3
panning 100, 320-1	astrophotography 347	344–5	wireless (WiFi) transmitter 30
peak of action 324-5	depth of field 90	unsharp masking 384	
prefocusing 326–7	fast 50	UV filter 62	X3 imaging chip 24
sports program 79	focal lengths 46, 48		
suggesting movement 320-1	mirror lenses 49	vanishing point 195	zoom burst 100, 101, 321, 385
vantage points 332-3	and perspective 194	variable-contrast paper 365	zoom flash 168
wide/long approach 328-9	short 17, 46	video 34, 395	zoom lens 13, 22, 38, 40
spot meter 78, 79, 259	supports 47, 97	viewfinder 12	autofocus 28
spotlight effects 260-1	types 48, 50	compact camera 22	built-in 14, 22, 24, 25, 26
spring 296–7	ultra-telephoto 39, 48-9	digital camera 24, 27	for detail 189, 300
spy camera 35	telescope 346	interchangeable 21	fast-aperture lens 50
stained glass 164, 189	test exposure 34, 128, 129	modifications 30	focal lengths 16
stars 106, 347	test strip 362	parallax error 22	focusing aid 72
statues 87, 88, 292-3	tethered operation 31	SLR camera 18, 19, 29	macro settings 57
step-up/-down rings 62	texture 118, 124, 216–19	waistlevel 21	superzoom 40, 42
stereo camera 35	landscape 144, 146, 217, 219	zooming 23	telephoto 46, 48
still-life 215, 254-7	lighting 148, 216, 218–19, 256	viewpoint 186-7, 322	ultra wide-angle 44
composition 192	paper 128	architecture 285	wide-angle 42
equipment 254	still lifes 254, 256	child portraits 276-7	zoom ring 19
framing 185	texture screens 367	sport 332–3	zooming viewfinder 23
lighting 214, 256–7	thirds, rule of 179	vignetting 65	220
set-up 254, 336	three-quarter lighting 161, 233		
shafts of light 235	TIFF files 371	warm-up filter 137, 140, 303	

Acknowledgments

Author's acknowledgments

With thanks to the following: Andreas Constanti, Michelle Summers, Liz Adams, the Carter family, Alexandra and Angus Mackintosh, Emily Holland-Martin, Holly Newberry, Elaine Winkworth, Trevor Barber, Ray Woolcock, Rick Hambling, and Colin Grapes.

Thanks to the tourist offices of the following countries: Austria, Iceland, Jordan, Mexico, Switzerland.

Thanks to Minolta Cameras, Olympus Cameras, Pentax Cameras, and Agfa Films.

JOHN HEDGECOE

Dorling Kindersley would like to thank the following for their contributions:

Editorial: Corinne Asghar, Tracey Beresford, Alison Bolus, Marian Broderick, May Corfield, Anna Fischel;
Design: Gillian Andrews, Sarah Cowley, Michael Duffy, Janice English, Jo Grey, Tracey Miles, Steve Knowlden,
Amzie Viladot, Dawn Young; Jacket Editorial: Beth Apple; Jacket design: Nathalie Godwin; Index: Chris Bernstein;
Technical illustrations: Patrick Mulrey; Additional illustrations: Richard Burgess, Bob Warner; Equipment
photography: Dave King, Andy Crawford, Matthew Ward, Steve Gorton; Studio/darkroom hire: The Drill Hall,
16 Chenies Street, London WC1E 7EX, www.drillhall.co.uk.

Dorling Kindersley would also like to thank the following for their kind assistance and cooperation in the production of this book:

Camera World 14 Wells Street London WC1 3PB 020 7636 5005 www.cameraworld.co.uk

Fuji Photo Film UK Ltd. Fujifilm House 125 Finchley Road London NW3 6HY www.fujifilm.co.uk

Hasselblad UK Ltd. 385 Centennial Avenue Centennial Park Hertfordshire WD6 3TJ 020 8731 3250 www.hasselblad.co.uk R G Lewis Ltd. 29 Southampton Row London WC1B 5HL 020 7242 2916 www.rglewis.co.uk

Minolta UK Ltd. Precedent Drive Rooksley Milton Keynes MK13 8HF 01908 200400 www.minoltaeurope.com

Morco UK Ltd. 20 Oak Tree Business Park Oak Tree Lane, Mansfield Notts NG18 3HQ 01623 422828 www.morco.uk.com Nikon UK Ltd. 380 Richmond Road Kingston upon Thames Surrey KT2 5PR 020 8481 6875 www.nikon.co.uk

Olympus UK Ltd. Vision House 19 Colonial Way, Watford Hertfordshire WD24 4JL 01923 831100 www.olympus.co.uk

Pentax UK Ltd. Heron Drive, Langley Slough SL3 8PN 01753 792792 www.pentax.co.uk Pro Centre 5–6 Mallow Street London EC1Y 8RS 020 7490 3122 www.procentre.co.uk

Speed Graphic Unit 4 Woodlea Park Station Approach Four Marks, Alton Hampshire GU34 5AZ 08453 305530 www.speedgraphic.co.uk

The Widescreen Centre 47 Dorset Street London W1U 7ND 020 7935 2580 www.widescreen-centre.co.uk